GW01044419

RUSSIAN FILM POSTERS

CARTELES RUSOS CINEMATOGRAFICOS

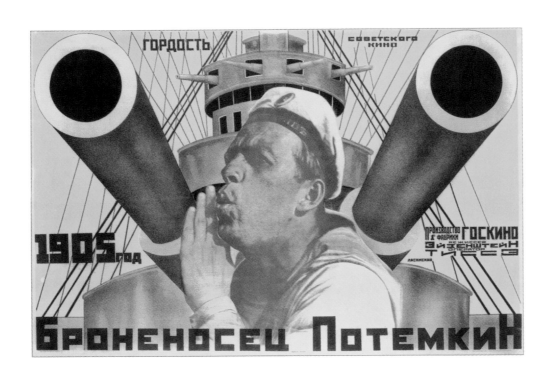

LES AFFICHES DE FILMS RUSSES

RUSSISCHE FILMPLAKATE

RUSSIAN FILM
POSTERS

1900–1930

With an introduction by Maria-Christina Boerner

Vivays Publishing

Published by Vivays Publishing Ltd
www.vivays-publishing.com

Copyright © 2001 Art Rodnik, Moscow
Copyright © 2012 Introduction text, Vivays Publishing Ltd

This book was produced by Vivays Publishing Ltd, London

All rights reserved. No part of this publication may be reproduced or transmitted in any form
or by any means, electronic or mechanical, including photocopy, recording or any information
storage and retrieval system, without prior permission in writing from the publisher.

A catalogue record for this book is available from the British Library

ISBN 978-1-908126-15-3

Introduction by: Maria-Christina Boerner, Rennes
Translation into French, English and Spanish: LocTeam, Barcelona
Design: Alex Shubny, Moscow

Printed in China

Introduction
Maria-Christina Boerner

Anatoly Vasilyevich Lunacharsky, Lenin's People's Commissar for Education and patron of Soviet avant-garde art, once described the cinema as an "animated poster", aptly characterising both the close link between the two art forms and the chronological primacy of poster art. With the development of the modern advertising poster in the 19th century, the example of the so-called "luboks" played an important role in Russia, since these popular pictorial broadsheets had been combining image and text since the 17th century to create a generally intelligible whole. Their vivid, often dramatically effective compositions made the luboks forerunners of the event posters that advertised the theatre, the circus and, ultimately, the cinema.

The young medium of film had already found a broad resonance among all the social classes of Tsarist Russia, and secured a place for the country in the early 20th century among the leading cinema nations. Only a few months after brothers Auguste and Louis Lumière had first publicly demonstrated their "cinematograph" in December 1896 in Paris, the St. Petersburg public could marvel at the new technology of moving pictures. Russia's first public cinema opened shortly afterwards, screening French productions along with the first films by Russian film pioneers. But the real birth of Russia's cinemas occurred in 1908 when Vladimir Romashkov presented his ten-minute feature film *Stenka Razin* to the public. Since the film was based on a popular national topic from the 17th century, it was clear to the well-known caricaturist Paul Asaturov that he should design his advertising poster following the familiar formal principles of luboks (p. 14). He placed the emotional climax of the film in the centre of the picture, when the title character Razin throws his wife, who was accused of having been unfaithful, into the Volga, and arranged other scenes in small images around the dramatic core of his poster. Pyotr Mosiagin's announcement of the new film version in 1914 still used the popular luboks as the model for composition (p. 15) and was also used later for film posters on popular subjects.

Of course, this is not the only source of inspiration for the film poster; on the contrary, this newest species in the genus of advertising posters feeds from a variety of formal models. Typography in modern book art and its cover designs asserted its influence as did the graphical models in illustrated magazines. For example, Mikhail Kalmanson, a typical representative of the early days of cinema posters, produced the most detailed picture possible of a single cinema scene (p. 20) albeit without being able to match the cinematic narrative as an action sequence. Here he turned out to be more innovative, either reproducing small stills of several film scenes (p. 19) and thus taking into account the temporal character of the film, or transforming the black and white technique of the film into expressive and monumental frames with sharp black and white and coloured contrasts of light and shadow (p. 32). With his graphic reproductions of photography and expressive chiaroscuro effects (p. 30), P. Zhitkov could claim to be one of the first professional poster artists in pre-revolutionary Russia.

Russian poster artists also received crucial suggestions from international Art Nouveau, which attributed a key role to the graphic arts in the aestheticisation of everyday life. In Russia the "modern style", as it was known, developed into the dominant avant-garde art movement, defining poster design with floral ornamentation and a dynamically sweeping sense of line, continuing the October Revolution of 1917. Like the French masters of poster art Jules Chéret and Eugène Grasset or the Bohemian-born Alfons Mucha, their Russian colleagues preferred the elegant decorative forms of Art Nouveau for rendering the female form. Representations of women at the turn of the century varied between the delicate figure of a girl (p. 58) and the seductive woman (p. 57) that Franz von Stuck immortalized in his famous painting *Sin*. Painted in about eleven versions between 1891/92 and 1906, Stuck's work served as a direct model for the 1916 poster *Sin* (p. 51).

Apart from a few film adaptations of literary templates such as Yakov Protasanov's *The Queen of Spades* after Alexander Pushkin (p. 40) and some cinematic gems by Yevgény Franzevich Bauer, commercial cinema designed to entertain the masses initially prevailed in Russia. A preference for trivial and melodramatic subjects is also reflected in the posters of those years, in which the dramatic gestures of the silent film actor often had to provide the required attention (p. 48). However, Georgi Alexeev, already recognized as a sculptor and graphic artist, created a number of fascinating poster compositions, for example for the British production *Ultus and the Secret of the Night* (p. 41). Here Alexeev skilfully linked colour and writing, distorting proportions and spatial relationships to create a truly nightmarish image.

As Russian cinema gradually freed itself from the dominance of the French film industry and other international influences and began to develop an autonomous national and progressive language of film, the heyday of Russian film posters established itself at the same time. A unique aesthetic emerged based on the medium of film, and a number of artists specialized in this genre. Lenin, the Bolsheviks and many intellectuals saw film as the appropriate instrument for development and communist education of the people, especially after the outbreak of World War I in 1914. The increasingly state-controlled cultural policy advocated a rather traditional understanding of art and was quite sceptical towards avant-garde experimentation. After the fall of the Tsar in 1917 and the founding of the Soviet state, large numbers of famous directors and actors emigrated to the West. As a result of these events, a young guard of Russian film makers came to the fore, revolutionizing the cinema and creating their own socialist film language in the 1920s. Inspired by modern art movements such as the abstract Suprematism of Kazimir Malevich (p. 175) and Constructivism, Dziga Vertov (i.e. Denis Kaufman) and Sergei Mikhailovich Eisenstein in particular created the classics of Russian silent film that are still admired today.

One of the most important principles of cinematic innovation was the montage technique first applied in 1918 by Lev Vladimirovich Kuleshov, which Eisenstein also employed as a central stylistic device in his famous 1925 work *Battleship Potemkin*. Eisenstein had the intention of creating a new reality in film through the sudden collision of heterogeneous images. Since the montage principle stood in opposition to linear storytelling, spectators had to reconstruct the context of suggestive images for themselves and take a more active role in their reception.

This new aesthetic radically changed not only the medium of film but also the film poster, which quickly became a medium of expression for progressive artistic ideas thanks to the rapidly growing group of professional poster artists. The use of posters for propaganda and agitation purposes since 1917 led to an enormous appreciation of this art genre in general. This was also true for the film poster, which also benefited greatly from close ties to the adventurous film industry. Alexander Rodchenko was one of the first artists to transfer the montage technique to poster art by taking film fragments out of their context and assembling them into associative photomontages. An excellent example of this is the poster Rodchenko created for the documentary film *Kino-Eye – Life Caught Unawares* by Dziga Vertov. In the centre is a colossal eye, with two cameras below directed at two symmetrically arranged photos of a boy at the bottom edge (p. 59). Rodchenko worked in a similarly reduced way on the poster for Vertov's film *A Sixth of the World* (p. 75): The cut-out photo of a smiling woman stands out from the huge black surface of a peeling poster, exposing the red base with large white letters of the title. The poster clearly "unrolls" the message and meaning of Vertov's film ode that intended to reveal the hidden culture of the young Soviet Union. Compared to Rodchenko's cleverly simple, somewhat stark composition, the Stenberg brothers' poster for Vertov's programmatic work *Man with the Movie Camera* (p. 82) is distinguished by a witty, buoyant tone. Here the Stenbergs use almost the same fragmentary parts (eye, camera, a woman's face) used by Rodchenko; the combination of a tripod with the legs of a dancing woman makes the composition more humorous as well as more dynamic. The same playful lightness also marks the Stenberg brothers' poster for *Battleship Potemkin* (p. 60), which the two artists attain not least through an original use of the extreme low angle shot. However Anton Lavinsky, in his interpretation of this classic film, tries to evoke the revolutionary atmosphere with his strict constructionist triangular composition which places a sailor between two threatening muzzle openings pointed menacingly at the viewer (p. 61).

By 1933, the brothers Georgi and Vladimir Stenberg had produced nearly 200 posters for the state film company Sovkino, repeatedly demonstrating their inexhaustible inventiveness and establishing their reputation as masters of this genre. In their "Manifesto of Constructivism", they had declared that the modern techno-industrial world could only find itself again in art that was based on rational, geometric laws. The Stenbergs' graphic work, characterized by the use of abstract material and colour structures or simple geometric shapes, systematically reflects this demand on the performing arts. Their film posters, which were based on these guidelines, showed the significant elements of a film in a collage-like manner and conveyed the typical dynamics of this medium, for example by a selected excerpt (p. 123) or spiral-shaped arrangements (p. 137). Even if they designed cinematic means of expression in their graphics, such as cross fades, lighting effects

and facial expressions or gestures of the actors, the poster's flatness was still preserved. They liked to link the plastic-spatial elements with the two-dimensional components by a comprehensive colour outline, thus also stressing the graphic structure. However, they only rarely used photomontage of film fragments, instead tracing the film frames with a special lithography pencil. The technical perfection and surprising effects of their posters not only resulted in consumer attention but also brought them international recognition in 1927 at exhibitions in Monza and Milan, and influenced fellow artists such as Nikolai Prusakov, Pyotr Zhukov, Grigori Borisov, Alexander Naumov and Yakov Ruklevsky, with whom they had various successful collaborations. In Ruklevsky's own poster for Eisenstein's revolution-themed film *October* (p. 71), the leader Lenin dominates the scene, while the Stenbergs' design concentrates entirely on individual faces of the combat-ready populace (p. 73). But the drama of the film is probably best manifested in the joint work of the three artists, in which the design grid coalesces excitingly with the montage principle (p. 72).

Nikolai Prusakov, who from 1924 onwards worked for the advertising department of Sovkino and often designed posters in collaboration with Grigori Borisov and others, also made use of the montage technique. He liked to use still-frame fragments for his intriguing combinations: On the poster for the film adaptation of Chekhov's *The Ranks and the People* (p. 76) he formed four portraits of the actor Igor Borisovich Moskvin into a single head, and then made a grotesque figure out of an upturned car, a smiling woman's face and a pair of pince-nez. The creative transformation and strong graphic elements of cinematic alienation, such as close-ups or double exposures, document Prusakov's efforts to emphasize the aesthetic autonomy of art posters compared to film. But he also understood how to oppose advertising's occasional exuberant flood of colour and image with the utmost simplicity when, before a huge dark area, he balanced a tiny cannon on a pipe (p. 153).

In addition to the Stenbergs' work, Prusakov's posters were the models for artists who, like Anton Lavinsky, Semion Semionov-Menes and Anatoly Belsky, also linked the montage technique of film and constructivism to their own creations in the 1920s and thus contributed to the diversity of early Soviet poster art. The first Russian sound film *The Road to Life* of 1931 changed the art of film as well as poster design: Instead of associative imagery, actors' portraits and the "story" now moved into the foreground. From 1932 "Socialist Realism" as a state-imposed artistic direction suppressed both photomontage and constructivism, since the Russian avant-garde had now been outlawed as "counter-revolutionary". The poster by artist Yuri Pimenov for one of the last Soviet silent films shows the change with a large-scale portrait of the protagonist, and thus concludes the collection of Russian film posters (p. 179).

Introducción
Maria-Christina Boerner

Anatoli Vasílievich Lunacharski, Comisario del Pueblo de Cultura en el gobierno de Lenin y gran patrón del arte vanguardista soviético, calificó una vez el cine de «cartel animado», caracterizando así de un modo certero tanto la estrecha relación existente entre ambas formas de arte como la primacía cronológica del diseño de carteles. En la génesis del moderno cartel publicitario en el siglo XIX, en Rusia desempeñó un papel importante sobre todo el modelo de los llamados *lubki*, pues estas láminas con estampas populares ya combinaban en el siglo XVII dibujos y textos en un conjunto comprensible para todos. Sus vistosas composiciones y la escenificación a menudo dramática y efectista de las imágenes hicieron de los *lubki* los precursores de los carteles que anunciaban funciones teatrales, actuaciones circenses y, finalmente, proyecciones cinematográficas.

El cine ya obtuvo en la Rusia zarista, cuando empezó a popularizarse, una gran resonancia en todas las clases sociales, hasta el punto de que a comienzos del siglo XX el país ocupaba un puesto entre las principales potencias cinematográficas. Pasaron pocos meses desde que los hermanos Auguste y Louis Lumière hubieran presentado por primera vez públicamente, en diciembre de 1896 en París, su «cinematógrafo» para que el público de San Petersburgo pudiera admirar la nueva técnica de imágenes en movimiento. No mucho tiempo después se inauguró la primera sala rusa, en la que junto a producciones francesas también se proyectaron las primeras cintas de pioneros del cine rusos. De todos modos, la fecha de nacimiento propiamente dicha del cine ruso cayó en el año 1908, cuando Vladímir Romáshkov presentó al público su película de ficción *Stenka Rasin*, de diez minutos de duración. Puesto que la cinta trataba un tema nacional popular del siglo XVII, el dibujante Paul Asatúrov, conocido por sus caricaturas, tuvo la idea de diseñar el cartel que anunciaba la proyección con arreglo a los consabidos principios formales de los *lubki* (p. 14). Situó en el centro el clímax emocional de la película —el momento en el que el protagonista Rasin arroja a las aguas del Volga a su esposa, acusada de infidelidad— y dispuso alrededor de este núcleo dramático del cartel otras escenas en imágenes pequeñas. El anuncio de la nueva versión de la película, del año 1914, realizado por Piotr Mosiaguin, todavía echa mano del estilo composicional de los populares *lubki* (p. 15), que posteriormente siguió utilizándose para muchos carteles anunciadores de películas sobre temas populares.

Desde luego que esta no fue la única fuente de inspiración de los carteles cinematográficos y lo cierto es que este producto postrero del género del cartelismo publicitario se inspira en un gran número de modelos formales. Así, por ejemplo, la influencia de la tipografía moderna y del diseño de las cubiertas de libros fue tan importante como los modelos gráficos de las revistas ilustradas. En la obra de Mijaíl Kálmanson, un típico representante de la primera época del cartel cinematográfico, se encuentra, por ejemplo, una reproducción fiel hasta el detalle de una única escena de la película (p. 20), pero sin lograr ponerse a la altura de la narrativa cinematográfica entendida como secuencia de actos. No obstante, se muestra más innovador en los casos en que reproduce gráficamente pequeños fotogramas de varias escenas (p. 19), reflejando de este modo el carácter cronológico de la película, o cuando convierte la técnica del cine en blanco y negro en expresivas imágenes monumentales con fuertes contrastes incluso cromáticos entre luz y sombra (p. 32). P. Zhítkov logró triunfar con sus dibujos que imitan fotografías y sus expresivos efectos claroscuros (p. 30), como uno de los primeros cartelistas profesionales de la Rusia prerrevolucionaria.

Finalmente, los cartelistas rusos recibieron influencias decisivas del estilo modernista internacional (*art nouveau*), que otorgaba precisamente a los artistas gráficos un papel clave en la estetización de la vida cotidiana. En Rusia, el «estilo moderno», como se llamó en este país, se convirtió en el arte de vanguardia predominante que marcó el cartelismo hasta la Revolución de Octubre de 1917 con sus ornamentos florales y sus dinámicas líneas curvas. Al igual que los maestros franceses Jules Chéret y Eugène Grasset o que Alfons Mucha, originario de Bohemia, sus colegas rusos utilizaban las formas elegantes y decorativas del modernismo sobre todo para reproducir la figura femenina. Fieles a la imagen de la fémina que prevalecía hacia comienzos de siglo, las modalidades de representación variaban entre la figura de la tierna muchacha (p. 58) y la de la mujer fatal (p. 57), como la que inmortalizó Franz von Stuck en su famoso cuadro *El pecado*. Pintada en unas once versiones entre 1891-1892 y 1906, la obra de Stuck sirvió de modelo directo del cartel *Pecado*, creado en 1916 (p. 51).

Aparte de algunas adaptaciones literarias como la película *La dama de picas*, de Yákov Protasánov, basada en un cuento homónimo de Alexandr Pushkin (p. 40), y varias obras brillantes de Yevgueni Frantsévich Bauer, en Rusia predominó al principio el cine comercial de entretenimiento para las amplias masas. La predilección por temas triviales y melodramáticos también quedó reflejada en los carteles de aquellos años, en los que a menudo los gestos patéticos de los actores de cine mudo servían para atraer la atención necesaria (p. 48). En cambio, Gueorgui Alexéyev, un artista ya reconocido como escultor y grafista, logró componer algunos carteles fascinantes, como por ejemplo para la película británica *Ultus y el secreto de la noche* (p. 41). Alexéyev combina color y texto con mucho arte y altera las proporciones para componer una auténtica imagen de pesadilla.

Después de que el cine ruso se liberara paulatinamente del dominio de la industria cinematográfica francesa y de otras influencias internacionales y empezara a desarrollar un lenguaje fílmico nacional autónomo y progresista, comenzó paralelamente la época dorada del cartelismo cinematográfico ruso. Surgió una estética propia, orientada al medio cinematográfico, y toda una serie de artistas se especializaron en el género. Lenin, los bolcheviques y muchos intelectuales veían en el cine, sobre todo desde que estalló la guerra mundial en 1914, el instrumento idóneo para la formación y la educación comunista del pueblo. La política cultural, dirigida cada vez más desde el Estado, defendía una idea bastante tradicional del arte y se mostraba más bien escéptica ante los experimentos vanguardistas. Además, tras la caída del zarismo en 1917 y la fundación del Estado soviético, algunos directores y actores conocidos emigraron a Occidente. A raíz de estos acontecimientos entró en escena una joven guardia de cineastas rusos que revolucionaron el cine y desarrollaron en la década de 1920 un lenguaje cinematográfico socialista propio. Inspirándose en tendencias artísticas modernas como el

supremacismo abstracto de Kasimir Malévich (p. 175) y el constructivismo, Dsiga Vértov (de nombre real Denis Kaufman) y Serguéi Mijáilovich Eisenstein, sobre todo, crearon las obras clásicas del cine mudo ruso que siguen causando admiración en nuestros días.

Uno de los grandes principios de la renovación cinematográfica fue la técnica de montaje empleada por primera vez por Lev Vladimírovich Kuléshov en 1918, y que también utilizó Eisenstein en 1925 en su famosa película *El acorazado Potemkin* como medio estilístico fundamental. Eisenstein pretendía crear, mediante la colisión casi violenta de imágenes heterogéneas en el film, una nueva realidad. Puesto que este método de montaje se contraponía al método narrativo lineal, era el propio espectador quien tenía que reconstruir el nexo entre las sugerentes imágenes y asumir una función más activa en el proceso receptivo.

Esta nueva estética no solo transformó radicalmente el medio cinematográfico, sino también el cartelismo relacionado con el cine, que gracias al grupo creciente de cartelistas profesionales se convirtió rápidamente en vehículo de expresión de ideas artísticas progresistas. El uso del cartel con fines de propaganda y agitación comportó en general, a partir de 1917, una enorme revaluación de este género artístico. Lo mismo cabe decir del cartel cinematográfico, que además se benefició en gran medida de su estrecha relación con una industria cinematográfica muy dada a la experimentación. Alexandr Ródchenko fue uno de los primeros artistas que trasladó la nueva técnica de montaje al cartelismo, extrayendo fragmentos de las películas de su contexto y realizando con ellos fotomontajes asociativos. Un excelente ejemplo de ello es el cartel que diseñó Ródchenko para el documental *Cine-ojo*, de Dsiga Vértov. En el centro se halla un ojo sobredimensionado y debajo aparecen dos cámaras enfocadas hacia dos fotografías de un muchacho dispuestas simétricamente en el borde inferior (p. 59). Ródchenko plasma el mismo ánimo reductor en el cartel anunciador de la película *La sexta parte del mundo*, también de Vértov (p. 75): la foto seccionada de una mujer sonriente destaca sobre la enorme superficie negra de un cartel que se desprende, destapando así el fondo rojo con las grandes letras blancas del título de la película. El cartel «desenrolla» ilustrativamente el mensaje y el sentido de la oda fílmica de Vértov, que quería revelar la cultura oculta de la joven Unión Soviética. En comparación con esta composición refinadamente sencilla y más bien sobria de Ródchenko, el cartel de los hermanos Stenberg sobre la obra programática de Vértov, *El hombre con la cámara* (p. 82), se caracteriza por un tono humorístico y dinámico. Los Stenberg utilizaron en este caso casi los mismos fragmentos (ojo, cámara, rostro de una mujer) que había empleado Ródchenko, pero gracias a la combinación del trípode de la cámara con las danzarinas piernas femeninas, la composición no solo adquiere un aire más dinámico, sino también un toque de humor. La misma levedad lúdica caracteriza también el cartel de los hermanos Stenberg para *El acorazado Potemkin* (p. 60), un efecto que los dos artistas consiguen, entre otras cosas, recurriendo al insólito plano contrapicado. Anton Lavinski, en cambio, intenta con su interpretación de este clásico del cine evocar la atmósfera revolucionaria colocando en su severa composición triangular constructivista a un marinero entre dos bocas de cañón dirigidas amenazadoramente contra el espectador (p. 61).

Los hermanos Gueorgui y Vladímir Stenberg crearon hasta el año 1933 casi 200 carteles para la empresa cinematográfica estatal Sovkino, haciendo gala una y otra vez de su inagotable inventiva y consolidando su fama como maestros del género. En su «Manifiesto del constructivismo» habían declarado que el mundo técnico-industrial moderno únicamente podía identificarse con un arte basado en leyes racionales, geométricas. La obra gráfica

de los Stenberg, que se caracteriza por el uso de estructuras materiales y cromáticas abstractas o de formas geométricas sencillas, refleja de modo consecuente esta exigencia a las artes plásticas. Sus carteles cinematográficos, diseñados con arreglo a estas orientaciones, mostraban a modo de *collage* los elementos significativos de una película y transmitían el típico dinamismo del medio, por ejemplo, por el encuadre elegido (p. 123) o mediante disposiciones en espiral (p. 137). Al diseñar gráficamente formas de expresión fílmica como por ejemplo los fundidos, los efectos de luz, los gestos o la mímica de los actores, siempre supieron conservar el carácter bidimensional del cartel. Solían enlazar los elementos plásticos tridimensionales con los componentes planos mediante un dibujo de contorno de color, acentuando de este modo la estructura gráfica. En cambio, pocas veces utilizaban el fotomontaje de fragmentos de las películas, y en vez de ello copiaban los fotogramas con un lápiz litográfico especial. La perfección técnica y los sorprendentes efectos de sus carteles no solo despertaron la atención del público, sino que también reportaron a ambos artistas, en 1927, el reconocimiento internacional en sendas exposiciones en Monza y Milán e influyeron en cartelistas contemporáneos como Nikolai Prusákov, Piotr Zhúkov, Grigori Borísov, Alexandr Naumov y Yákov Ruklevski, con quien colaboraron ocasionalmente con gran éxito. En el cartel de Ruklevski para la película de Eisenstein *Octubre* (p. 71), sobre la Revolución rusa, el dirigente Lenin domina la composición, mientras que los Stenberg centran su diseño en diversos rostros del pueblo combativo (p. 73). Donde seguramente se pone mejor de manifiesto el dramatismo del argumento de la película es en la obra conjunta de los tres artistas, en la que la trama constructiva se funde generando tensión con el principio de montaje (p. 72).

Nikolai Prusákov, quien trabajó a partir de 1924 para el departamento de publicidad de Sovkino y a menudo diseñaba carteles junto con Grigori Borísov, entre otros, también utilizaba la técnica de montaje. Solía emplear fragmentos de fotogramas para sus asombrosas combinaciones: así, en el cartel para la película *Los funcionarios y la gente* (p. 76), adaptación de tres relatos de Chéjov, juntó los cuatro retratos del actor Ígor Borísovich Moskvin para formar una única cabeza y luego creó —con un carro volcado, el rostro de una mujer sonriente y unos quevedos— una figura grotesca. La transformación creativa y la fuerte alteración gráfica de elementos fílmicos como primeros planos o dobles exposiciones ilustran el deseo de Prusákov de recalcar la autonomía estética del cartelismo con respecto al cine. Sin embargo, también supo contraponer al torrente a veces desbordado de colores e imágenes en la publicidad unas composiciones de extrema sencillez, por ejemplo, cuando colocó un diminuto cañón manteniendo el equilibrio sobre una pipa en una enorme superficie oscura (p. 153).

Junto a los trabajos de los Stenberg, los carteles de Prusákov sirvieron de modelo para artistas que, como Anton Lavinski, Semyón Semyónov-Menes y Anatoli Belski, también combinaban en la década de 1920 la técnica de montaje del cine y el constructivismo para sus propias creaciones, contribuyendo de este modo a la variedad del cartelismo soviético temprano. Sin embargo, con la primera película sonora rusa, *El camino de la vida*, de 1931, no solo cambió el arte cinematográfico, sino también el diseño de carteles: en vez del lenguaje gráfico asociativo, pasaron a ocupar el primer plano los retratos de los actores y el «argumento». Después de 1932, además, el «realismo socialista» como orientación artística impuesta oficialmente desplazó tanto el fotomontaje como el constructivismo, pues a partir de entonces la vanguardia rusa fue tachada en general de «contrarrevolucionaria». El cartel del pintor Yuri Piménov sobre una de las últimas películas mudas soviéticas ya anuncia el cambio con el retrato en primer plano de la protagonista, y por tanto pone punto final a la colección de carteles cinematográficos rusos (p. 179).

Introduction
Maria-Christina Boerner

Anatoli Vasilievitch Lounatcharski, commissaire du peuple pour l'Instruction sous Lénine et protecteur de l'art soviétique d'avant-garde, a qualifié un jour le cinéma d'« affiche animée » ; c'était une façon pertinente de dépeindre le lien étroit unissant ces deux formes d'art. L'affiche russe puise sa source dans le loubok, imagerie russe traditionnelle, qui a servi de modèle et a accompagné l'essor de la publicité en Russie. Dès le 17ème siècle, cette imagerie populaire mêlait dessin et texte pour former un ensemble accessible à tous. De par leur composition expressive et leur mise en scène à la fois dramatique et sensationnelle, les loubki ont été les précurseurs des affiches de théâtre, de cirque et de cinéma.

Dans la Russie des tsars, le film, tout nouveau divertissement de masse, rencontre un large écho auprès de la population. À l'aube du 20ème siècle, le cinéma s'impose très rapidement dans la vie culturelle du pays ; quelques mois seulement après la première présentation officielle du « cinématographe » des frères Auguste et Louis Lumière à Paris en décembre 1896, le public de Saint-Pétersbourg peut admirer ces images animées. La première salle de projection du pays est inaugurée dans la foulée, et bientôt les bobines des pionniers du film russe côtoient les productions françaises. Mais le cinéma russe naît véritablement en 1908, lorsque Vladimir Romachkov présente au public son court-métrage de 10 minutes, *Stenka Razine*. L'intrigue, inspirée par les aventures d'un rebelle du 17ème siècle et enjolivée par la culture populaire, incite Paul Asatourov, un caricaturiste de renom, à concevoir une affiche sur les principes du loubok (p. 14). Le moment marquant du film est placé au centre de l'affiche ; Stenka Razine, le héros, précipite sa femme accusée d'adultère dans la Volga. Le dessinateur dispose autour de cet élément dramatique d'autres scènes représentées en plus petites images. Piotr Mosiagine, pour son affiche annonçant une nouvelle version du film en 1914, a également recours aux loubki (p. 15) ; d'autres films grand public auront également recours à l'imagerie populaire pour leur promotion publicitaire.

Les loubki ne sont cependant pas l'unique source d'inspiration des affiches de films ; les publicités de l'époque ont également laissé leur empreinte sur l'art de l'affiche cinématographique. De même, l'affiche est redevable au livre illustré, dont les couvertures et la typographie ont exercé leur influence, tout autant que certains magazines. On en trouve la trace dans l'œuvre graphique de Mikhaïl Kalmanson, qui est représentative des premières affiches de cinéma. Si certaines scènes de film y sont reproduites très fidèlement (p. 20), Kalmanson innove, par ailleurs, en montrant plusieurs passages du film (p. 19) à l'aide de petites images, ou bien en accentuant le contraste des images en noir et blanc par un jeu subtil d'ombre et de lumière (p. 32). P. Jitkov, avec un style marqué par la photographie et les effets de clair-obscur (p. 30), s'impose aussi comme l'un des premiers affichistes professionnels.

L'Art Nouveau, avec le rôle prépondérant que ce mouvement attribue aux arts graphiques dans l'embellissement du quotidien, est naturellement une source d'idées inépuisable pour l'affiche russe. Avec son ornementation florale et ses lignes fluides et ondoyantes, l'Art Nouveau, appelé « Style Moderne » en Russie, a dominé l'avant-garde russe jusqu'à la révolution d'Octobre de 1917. Tout comme Jules Chéret et Eugène Grasset, les maîtres français

de l'affiche, ou bien le tchèque Alfons Mucha, les dessinateurs d'affiches russes ont privilégié les formes élégantes et décoratives de l'Art Nouveau pour reproduire la silhouette féminine. Ces images reprennent la vision classique de la femme au début du 20ème siècle, de la silhouette délicate de jeune fille (p. 58) à la femme fatale (p. 57), proche de celle immortalisée par Franz von Stuck dans son tableau, *Le péché*. Peinte entre 1891-92 et 1906 dans onze versions différentes, cette œuvre a servi de modèle à l'affiche du film *Le péché* créée en 1916 (p. 51).

Hormis quelques adaptations cinématographiques d'œuvres littéraires, comme *La Dame de Pique*, d'après Alexandre Pouchkine, par Yakov Protasanov (p. 40), et certains films-culte d'Evgueni Franzevitch Bauer, le cinéma russe s'adressait surtout au grand public. La prédilection des spectateurs pour des sujets triviaux et mélodramatiques se retrouve dans nombre d'affiches ; elles reproduisent souvent les gestes pathétiques des acteurs de films muets (p. 48). En réaction, Guéorgui Alexeiev, déjà reconnu comme sculpteur et graphiste, compose plusieurs affiches fascinantes, notamment celle pour le film anglais *Ultus et les mystères de la nuit* (p. 41). Alexeiev y associe habilement la couleur et le texte; il déforme les proportions et la disposition des images pour renforcer l'effet dramatique.

Après s'être progressivement émancipé de l'industrie cinématographique française et d'autres influences, le cinéma russe commence à développer sa propre esthétique ; à la même époque débute l'âge d'or de l'affiche de film russe. L'affiche de film se distingue de plus en plus des encarts publicitaires et intègre désormais les particularités artistiques du cinéma, alors qu'un nombre croissant d'artistes s'essaie à ce nouveau genre. Lorsqu'éclate la Première Guerre Mondiale, les intellectuels russes ont compris que le film est l'instrument idéal d'instruction et d'éducation des masses. Lénine et les bolcheviques retiendront la leçon. Après la chute du régime tsariste en 1917 et la création de l'État soviétique, certains réalisateurs et interprètes connus émigrent en Occident. Mais, dans le même temps, de jeunes cinéastes russes prennent la relève et révolutionnent le cinéma, en créant dans les années 1920 un nouveau cinéma d'inspiration socialiste. Puisant dans les tendances artistiques en vogue, comme le suprématisme abstrait de Kazimir Malevitch (p. 175) et le constructivisme, des artistes comme Dziga Vertov (alias Denis Kaufman) et Serguei Mikhaïlovitch Eisenstein créent les grands classiques du film muet russe. Certains sont aujourd'hui encore des œuvres de référence.

La technique du montage d'images, utilisée pour la première fois en 1918 par Lev Vladimirovitch Koulechov, est l'un des principes fondamentaux de la nouvelle génération. Eisenstein s'en sert abondamment en 1925 dans *Le cuirassé Potemkine*. En mélangeant de façon abrupte des images hétérogènes tout au long du film, Eisenstein fait naître une nouvelle réalité. A l'opposé de la narration linéaire, la technique du montage oblige le spectateur à reconstituer lui-même l'intrigue et fixe son attention.

Cette nouvelle esthétique ne se limite pas seulement au cinéma ; elle s'étend à l'affiche. L'essor de l'affiche de propagande contribue par ailleurs

à un renouveau des arts graphiques. Alexandre Rodtchenko figure parmi les premiers artistes qui ont transposé la technique du montage à l'art de l'affiche, en extrayant des fragments de films de leur contexte et en ajoutant des photomontages associatifs. L'affiche réalisée par Rodtchenko pour le film documentaire de Dziga Vertov, *Ciné-Œil*, en est un parfait exemple. La partie centrale de l'affiche est occupée par un œil de Cyclope, sous lequel sont disposées deux caméras dirigées vers des portraits de garçon alignés symétriquement dans la partie inférieure (p. 59). Rodtchenko procède de façon similaire pour l'affiche du film de Vertov, *La sixième partie du monde* (p. 75) : une photo détourée d'une femme souriante se détache sur la vaste surface noire d'une affiche en train de se décoller, fournissant le fond rouge sur lequel apparaissent les grandes lettres blanches du titre. L'affiche « déroule » ici clairement le message et le sens de l'ode filmée de Vertov. Si l'on compare cette composition de Rodtchenko, d'une astucieuse simplicité et d'une grande sobriété, avec l'affiche des frères Stenberg pour *L'homme à la caméra* de Vertov (p. 82), on voit que celle-ci se distingue par son style badin et plein d'entrain. Les Stenberg utilisent ici quasiment les mêmes fragments que Rodtchenko (œil, caméra, visage de femme), mais l'association du trépied aux jambes de la femme en train de danser donne un effet à la fois plus dynamique et plus humoristique à l'affiche. Cette même légèreté désinvolte caractérise l'affiche des frères Stenberg pour *Le cuirassé Potemkine* (p. 60); l'effet est ici obtenu grâce à une utilisation originale de la perspective en contre-plongée. De son côté, Anton Lavinski tente, dans son interprétation de ce classique soviétique, d'évoquer l'atmosphère révolutionnaire en plaçant, dans une composition triangulaire strictement constructiviste, un marin entre deux bouches de canons dirigées vers le spectateur (p. 61).

Les frères Guéorgui et Vladimir Stenberg ont créé près de 200 affiches de films pour l'entreprise d'État Sovkino en faisant preuve pour chacune d'elles d'une créativité inépuisable. Leur réputation de maîtres du genre est largement justifiée. Dans leur « manifeste du constructivisme », ils expliquent que le monde moderne, régi par la technique et l'industrie, ne peut se retrouver que dans un art s'appuyant sur des lois rationnelles et géométriques. L'œuvre graphique des Stenberg, qui se caractérise par l'utilisation de structures abstraites, de matériaux, de couleurs et de formes géométriques simples, reflète par conséquent l'esprit du temps. Leurs affiches, structurées selon ces canons esthétiques, présentent les scènes phares d'un film sous la forme de collages ; la dynamique propre au cinéma est recréée grâce à des images qui semblent être prises sur le vif (p. 123) ou des compositions en cercles concentriques (p. 137). Ils transposent des moyens d'expression cinématographiques comme les fondus-enchaînés, les effets de lumière ou la gestuelle et les mimiques des acteurs dans l'espace bidimensionnel de l'affiche. Les effets tridimensionnels du cinéma sont rendus par l'intermédiaire de contours accentués. Ils ont rarement recours au photomontage, préférant dessiner les photos de films à l'aide d'un crayon

lithographique spécial. La perfection technique et les effets inattendus de leurs affiches leur permettent de gagner la reconnaissance du public et seront récompensés internationalement lors des expositions de Monza et de Milan en 1927. Ils ont aussi influencé leurs pairs, tels que Nicolas Prousakov, Piotr Joukov, Grigori Borisov, Alexandre Naoumov et Yakov Rouklevski, avec lequel ils eurent une coopération fructueuse. Sur l'affiche de Yakov Rouklevski illustrant le film d'Eisenstein sur la révolution, *Octobre* (p. 71), Lénine domine la scène, alors que la composition des frères Stenberg est centrée sur les différents visages du peuple prêt au combat (p. 73). Mais l'affiche la plus réussie est, sans conteste, celle créée en commun par les trois artistes ; le principe du montage (images superposées) y est harmonieusement associé à une trame constructiviste (p. 72).

Nicolas Prousakov, qui travaille à partir de 1924 pour le service publicité de Sovkino et crée de nombreuses affiches avec Grigori Borisov, s'est également servi de la technique de montage. Il utilise régulièrement des fragments d'arrêt sur image pour ses étonnantes compositions : pour l'affiche *Les tout-puissants et le peuple*, une adaptation de l'œuvre de Tchekhov, les quatre portraits de l'acteur Igor Borisovitch Moskvin forment un seul visage (p. 76). Alliés à une voiture renversée, une figure de femme souriante et un pince-nez, ces quatre visages forment un personnage grotesque. La transformation créatrice et la forte dissociation graphique d'éléments filmiques, comme des gros plans ou des doubles expositions à la lumière, témoignent du souci de Prousakov de souligner l'autonomie esthétique de l'art de l'affiche par rapport au film. Mais il sait aussi s'opposer, par une extrême sobriété, au flot parfois débordant d'images et de couleurs des publicités en représentant, par exemple un minuscule canon et une pipe sur un immense fond noir (p. 153).

Tout comme les œuvres des frères Stenberg, les affiches de Prousakov sont considérées comme des modèles par les artistes des années 1920, tels Anton Lavinski, Semion Semionov-Menes et Anatoli Belski. Ceux-ci associent la technique du montage de film et le constructivisme, contribuant ainsi au foisonnement créatif des débuts de l'affiche soviétique. Le premier film parlant russe, *Le chemin de la vie*, sorti en 1931, ne vas pas seulement transformer l'art cinématographique mais aussi la conception de l'affiche : au lieu d'un langage métaphorique associatif, ce sont désormais les portraits d'acteurs et l'histoire qui passent au premier plan. De plus, après 1932, le « Réalisme socialiste », en tant que tendance artistique imposée par l'État, supplante aussi bien le photomontage que le constructivisme, puisque l'avant-garde russe est dorénavant proscrite et jugée « contre-révolutionnaire ». L'affiche du peintre Youri Pimenov illustrant l'un des derniers films muets soviétiques, *Boule de Suif,* amorce ce changement, avec le portrait grand format de l'héroïne au centre de la composition (p. 179).

Einleitung
Maria-Christina Boerner

Anatoli Wasiljewitsch Lunatscharski, Lenins Volkskommissar für Bildung und Schutzherr der sowjetischen Avantgarde-Kunst, bezeichnete das Kino einmal als „belebtes Plakat" und charakterisierte damit treffend sowohl die enge Verknüpfung beider Kunstformen als auch die chronologische Vorrangstellung der Plakatkunst. Bei der Entstehung des modernen Werbeplakats im 19. Jahrhundert spielte in Russland vor allem das Vorbild der so genannten „Luboks" eine wichtige Rolle, denn diese Volksbilderbögen verbanden bereits seit dem 17. Jahrhundert Bild und Text zu einem allgemein verständlichen Ganzen. Ihre anschaulichen Kompositionen und die häufig dramatisch-effektvolle Bildinszenierung machten die Luboks zum Vorläufer der Veranstaltungsplakate, auf denen für das Theater, den Zirkus und schließlich für das Kino geworben wurde.

Bereits im zaristischen Russland stieß das junge Medium Film bei allen sozialen Klassen auf breite Resonanz und sicherte dem Land im frühen 20. Jahrhundert einen Platz unter den führenden Kino-Nationen. Nur wenige Monate, nachdem die Brüder Auguste und Louis Lumière im Dezember 1896 in Paris erstmals öffentlich ihren „Kinematographen" vorgeführt hatten, konnte das Publikum in St. Petersburg schon die neue Technik der bewegten Bilder bewundern. Bald darauf wurde auch der erste russische Kinosaal eingeweiht, in dem neben französischen Produktionen ebenso erste Streifen russischer Filmpioniere liefen. Doch die eigentliche Geburtsstunde des russischen Kinos fällt in das Jahr 1908, als Wladimir Romaschkow dem Publikum seinen zehnminütigen Spielfilm *Stenka Rasin* präsentierte. Da der Film auf einem populären nationalen Stoff aus dem 17. Jahrhundert basiert, lag es für den als Karikaturisten bekannten Zeichner Paul Asaturow nahe, sein Ankündigungsplakat mit den vertrauten Formprinzipien der Luboks zu gestalten (S. 14). Ins Bildzentrum rückte er den emotionalen Höhepunkt des Films, als der Titelheld Rasin seine der Untreue bezichtigte Gattin in die Wolga stürzt, und ordnete um diesen dramatischen Kern seines Plakats weitere Szenen in kleinen Bildern an. Noch Pjotr Mosiagins Ankündigung der neuen Filmversion aus dem Jahre 1914 bedient sich der volkstümlichen Luboks als Kompositionsform (S. 15), die auch später gern für Plakate zu populären Filmstoffen genutzt wurde.

Freilich blieb es nicht bei dieser einen Inspirationsquelle für das Filmplakat, vielmehr speist sich dieses jüngste Produkt aus der Gattung der Reklameplakate aus einer Vielzahl an formalen Modellen. Die Typografie in der modernen Buchkunst und deren Umschlaggestaltung etwa machten ihren Einfluss ebenso geltend wie grafische Vorbilder in den illustrierten Zeitschriften. Bei Michail Kalmanson, einem typischen Vertreter aus der Frühzeit des Kinoplakats, findet sich beispielsweise die möglichst detailgetreue Abbildung einer einzelnen Kinoszene (S. 20), ohne dass er dabei jedoch der filmischen Erzählweise als Abfolge einer Handlung gerecht werden konnte. Er erweist sich dort als innovativer, wo er entweder grafisch kleine Standfotos von mehreren Filmszenen reproduziert (S. 19) und somit den Zeitcharakter des Films berücksichtigt oder die Schwarz-Weiß-Technik des Films zu expressiv-monumentalen Einzelbildern mit scharfen, auch farbigen Licht-Schatten-Kontrasten umformt (S. 32). P. Schitkow konnte sich mit der zeichnerischen Nachahmung der Fotografie und ihrer ausdrucksstarken Hell-Dunkel-Effekte

(S. 30) als einer der ersten professionellen Plakatkünstler im vorrevolutionären Russland behaupten.

Entscheidende Anregungen erhielten die russischen Plakatkünstler schließlich auch vom internationalen Jugendstil (Art Nouveau), der gerade den grafischen Künsten bei der Ästhetisierung des Alltagslebens eine Schlüsselfunktion zuschrieb. In Russland entwickelte sich der „Moderne Stil", wie er hier bezeichnet wurde, zur dominierenden Avantgarde-Kunst, die bis zur Oktoberrevolution 1917 auch das Plakatdesign mit floraler Ornamentik und einer dynamisch geschwungenen Linienführung prägte. Wie die französischen Meister der Plakatkunst Jules Chéret und Eugène Grasset oder der gebürtige Böhme Alfons Mucha nutzten ihre russischen Kollegen die elegant-dekorativen Jugendstilformen bevorzugt für die Wiedergabe der weiblichen Figur. Gemäß dem Frauenbild der Jahrhundertwende variieren die Darstellungstypen dabei zwischen der zarten Mädchengestalt (S. 58) und dem verführerischen Weib (S. 57), wie es Franz von Stuck in seinem berühmten Gemälde *Die Sünde* verewigt hat. Zwischen 1891/92 und 1906 in rund elf Versionen gemalt, diente Stucks Werk als direktes Vorbild für das 1916 entstandene Plakat *Sünde* (S. 51).

Abgesehen von vereinzelten Verfilmungen literarischer Vorlagen wie Jakow Protasanows *Pique Dame* nach Alexander Puschkin (S. 40) und einigen filmischen Glanzstücken von Jewgeni Franzewitsch Bauer, herrschte in Russland anfangs das kommerzielle Unterhaltungskino für die breite Masse vor. Die Vorliebe für triviale und melodramatische Sujets spiegelt sich auch in den entsprechenden Plakaten jener Jahre wider, auf denen oftmals die pathetischen Gesten der Stummfilmschauspieler für die nötige Aufmerksamkeit sorgen mussten (S. 48). Dagegen gelangen dem als Bildhauer und Grafiker bereits anerkannten Künstler Georgi Alexejew einige faszinierende Plakat-Kompositionen, etwa für die britische Produktion *Ultus. Das Geheimnis einer Nacht* (S. 41). Gekonnt verknüpft Alexejew hier Farbe und Schrift und verfremdet Proportionen sowie Raumverhältnisse zu einem wahren Alptraumbild.

Nachdem sich das russische Kino allmählich von der Dominanz der französischen Filmindustrie und anderer internationaler Einflüsse befreit hatte und eine autonome nationale und progressive Filmsprache zu entwickeln begann, setzte parallel auch die Blütezeit des russischen Filmplakats ein. Es entstand eine eigene, am Medium Film orientierte Ästhetik, und eine ganze Reihe von Künstlern spezialisierte sich auf dieses Genre. Lenin, die Bolschewiki und viele Intellektuelle sahen im Film vor allem seit Ausbruch des Weltkriegs 1914 das geeignete Instrument zur Bildung und kommunistischen Erziehung des Volkes. Die zunehmend staatlich gelenkte Kulturpolitik vertrat dabei ein recht traditionelles Kunstverständnis und stand avantgardistischen Experimenten eher skeptisch gegenüber. Nach dem Sturz des Zaren 1917 und der Gründung des Sowjetstaates waren zudem etliche bekannte Regisseure und Darsteller in den Westen emigriert. Infolge dieser Ereignisse trat eine junge Garde russischer Filmemacher in den Vordergrund, die das Kino revolutionierte und in den 1920er Jahren eine eigene sozialistische Filmsprache kreierte. Inspiriert von modernen Kunst-

richtungen wie dem abstrakten Suprematismus von Kasimir Malewitsch (S. 175) und dem Konstruktivismus, schufen insbesondere Dsiga Wertow (d. i. Denis Kaufman) und Sergei Michailowitsch Eisenstein die heute noch bewunderten Klassiker des russischen Stummfilms.

Eines der wichtigsten Prinzipien der filmischen Erneuerung war die von Lew Wladimirowitsch Kuleschow erstmals 1918 angewandte Montagetechnik, die auch Eisenstein 1925 in seinem berühmten Werk *Panzerkreuzer Potemkin* als zentrales Stilmittel einsetzte. Eisenstein verfolgte die Absicht, durch das nahezu schockartige Aufeinanderprallen heterogener Bilder im Film eine neue Realität entstehen zu lassen. Da das Montageprinzip im Gegensatz zur linearen Erzählweise stand, musste der Zuschauer selbst den Zusammenhang der suggestiven Bilder rekonstruieren und eine aktivere Rolle bei der Rezeption einnehmen.

Diese neue Ästhetik veränderte aber nicht nur radikal das Medium Film, sondern auch das Kinoplakat, das dank der wachsenden Gruppe professioneller Plakatkünstler rasch zum Ausdrucksmittel progressiver künstlerischer Ideen wurde. Der Einsatz von Plakaten zu Propaganda- und Agitationszwecken führte seit 1917 generell zu einer enormen Aufwertung dieser Kunstgattung. Dies galt auch für das Kinoplakat, das aber darüber hinaus in hohem Maß von der engen Bindung an die experimentierfreudige Filmindustrie profitierte. Alexander Rodtschenko gehörte zu den ersten Künstlern, die die Montagetechnik auf die Plakatkunst übertrugen, indem sie Filmfragmente aus ihrem Kontext herauslösten und zu assoziativen Fotomontagen zusammenfügten. Ein ausgezeichnetes Beispiel dafür liefert das Plakat, das Rodtschenko für den Dokumentarfilm *Kino-Auge* von Dsiga Wertow entwarf. Im Zentrum steht ein überdimensionales Auge, darunter befinden sich zwei Kameras, die auf zwei symmetrisch angeordnete Fotos eines Jungen am unteren Rand gerichtet sind (S. 59). Ähnlich reduziert arbeitet Rodtschenko auf dem Plakat zu Wertows Film *Ein Sechstel der Erde* (S. 75): Das angeschnittene Foto einer lächelnden Frau hebt sich von der riesigen schwarzen Fläche eines sich ablösenden Plakats ab und gibt dabei den roten Grund mit den großen weißen Lettern des Titels frei. Das Plakat „entrollt" hier anschaulich die Botschaft und den Sinn der Film-Ode Wertows, die die verborgene Kultur der jungen Sowjetunion offenbaren wollte. Im Vergleich zu dieser raffiniert schlichten und eher nüchternen Komposition Rodtschenkos zeichnet sich das Plakat der Brüder Stenberg zu Wertows programmatischem Werk *Der Mann mit der Kamera* (S. 82) durch einen witzigen, beschwingten Ton aus. Die Stenbergs benutzen hier fast die gleichen Fragmentteile (Auge, Kamera, Gesicht einer Frau), die man auch bei Rodtschenko findet, durch die Kombination des Filmstativs mit den tänzelnden Frauenbeinen wirkt die Komposition aber nicht nur dynamischer, sondern auch humorvoller. Dieselbe spielerische Leichtigkeit kennzeichnet auch das Plakat der Stenberg-Brüder zu *Panzerkreuzer Potemkin* (S. 60), die die beiden Künstler nicht zuletzt durch den Einsatz der originellen Frosch-Perspektive erzielen. Anton Lawinski hingegen versucht in seiner Interpretation dieses Filmklassikers, die revolutionäre Atmosphäre heraufzubeschwören, indem er in seiner strengen, konstruktivistischen Dreieckskomposition einen Matrosen zwischen zwei bedrohlich auf den Betrachter gerichteten Geschützöffnungen stellt (S. 61).

Die Brüder Georgi und Wladimir Stenberg haben nahezu 200 Filmplakate bis 1933 für die staatliche Filmfirma Sowkino produziert und immer wieder ihren unerschöpflichen Erfindungsreichtum bewiesen sowie ihren Ruf als Meister dieses Genres begründet. In ihrem „Manifest des Konstruktivismus" hatten sie erklärt, dass sich die moderne technisch-industrielle Welt nur in einer auf rationalen, geometrischen Gesetzen beruhenden Kunst wiederfinden

könne. Das grafische Werk der Stenbergs, das durch die Verwendung abstrakter Material- und Farbstrukturen oder einfacher geometrischer Formen charakterisiert ist, spiegelt konsequent diese Forderung an die darstellende Kunst wider. Ihre Filmplakate, die auf diesen Leitlinien aufbauten, zeigten in collageartiger Weise die signifikanten Elemente eines Films und vermittelten die typische Dynamik dieses Mediums, beispielsweise durch den gewählten Ausschnitt (S. 123) oder spiralförmige Anordnungen (S. 137). Wenn sie filmische Ausdrucksmittel, wie etwa Überblendungen, Lichteffekte oder Gestik und Mimik der Schauspieler, grafisch gestalteten, blieb die Flächigkeit des Plakats dennoch immer erhalten. Sie verknüpften die plastisch-räumlichen Elemente mit den flächigen Bestandteilen gern durch eine übergreifende farbige Umrisszeichnung und betonten so zusätzlich die grafische Struktur. Die Fotomontage von Filmfragmenten kam dagegen bei ihnen nur selten zum Einsatz, stattdessen zeichneten sie die Filmfotos mit einem speziellen Lithografiestift nach. Die technische Perfektion und die überraschenden Effekte ihrer Plakate sorgten nicht nur für Aufmerksamkeit beim Rezipienten, sondern brachten ihnen 1927 auch internationale Anerkennung auf Ausstellungen in Monza und Mailand ein und beeinflussten Künstlerkollegen wie Nikolai Prusakow, Pjotr Schukow, Grigori Borisow, Alexander Naumow sowie Jakow Ruklewski, mit dem sie gelegentlich erfolgreich zusammenarbeiteten. Auf Ruklewskis eigenem Plakat zu Eisensteins Revolutionsfilm *Oktober* (S. 71) beherrscht der Anführer Lenin die Szenerie, während sich die Stenbergs bei ihrem Design ganz auf einzelne Gesichter des kampfbereiten Volks konzentrieren (S. 73). Am besten aber manifestiert sich wohl die Dramatik des Filmgeschehens in der gemeinsamen Arbeit der drei Künstler, bei der das konstruktive Raster spannungsvoll mit dem Montageprinzip verschmilzt (S. 72).

Nikolai Prusakow, der ab 1924 für die Reklameabteilung von Sowkino arbeitete und oft gemeinsam mit Grigori Borisow und anderen Plakate entwarf, hat sich ebenfalls der Montagetechnik bedient. Er verwendete dabei gern Standbildfragmente für seine verblüffenden Kombinationen: So formte er auf dem Plakat zur Tschechow-Verfilmung *Ränge und Menschen* (S. 76) die vier Porträts des Schauspielers Igor Borisowitsch Moskwin zu einem einzigen Kopf und bildete dann mit einem umgedrehten Wagen, einem lächelnden Frauengesicht und einem Zwicker eine groteske Figur. Die schöpferische Umgestaltung und starke grafische Verfremdung filmischer Elemente wie Großaufnahmen oder Doppelbelichtungen dokumentieren Prusakows Bestreben, die ästhetische Autonomie der Plakatkunst gegenüber dem Film zu betonen. Der gelegentlich überbordenden Farb- und Bilderflut von Reklamen wusste er aber auch mit äußerster Schlichtheit entgegenzutreten, wenn er etwa vor einer riesigen dunklen Fläche eine winzige Kanone auf einer Pfeife balancieren lässt (S. 153).

Neben den Arbeiten der Stenbergs galten Prusakows Plakate als Vorbild für Künstler, die wie Anton Lawinski, Semen Semenow-Menes und Anatoli Belski in den 1920er Jahren gleichfalls die Montagetechnik des Films und den Konstruktivismus zu eigenen Kreationen verbanden und damit zur Vielfalt der frühen sowjetischen Plakatkunst beitrugen. Schließlich veränderte sich mit dem ersten russischen Tonfilm *Der Weg ins Leben* von 1931 aber nicht nur die Filmkunst, sondern auch das Plakatdesign: Statt assoziativer Bildsprache rückten nun Schauspielerporträts und die „Story" in den Vordergrund. Nach 1932 verdrängte zudem der „Sozialistische Realismus" als staatlich verordnete Kunstrichtung sowohl die Fotomontage als auch den Konstruktivismus, da die russische Avantgarde nun generell als „konterrevolutionär" geächtet wurde. Das Plakat des Malers Juri Pimenow zu einem der letzten sowjetischen Stummfilme zeigt mit dem großformatigen Porträt der Protagonistin bereits den Wandel an und beschließt daher die Sammlung russischer Filmplakate (S. 179).

The Posters
Los carteles
Les affiches
Die Plakate

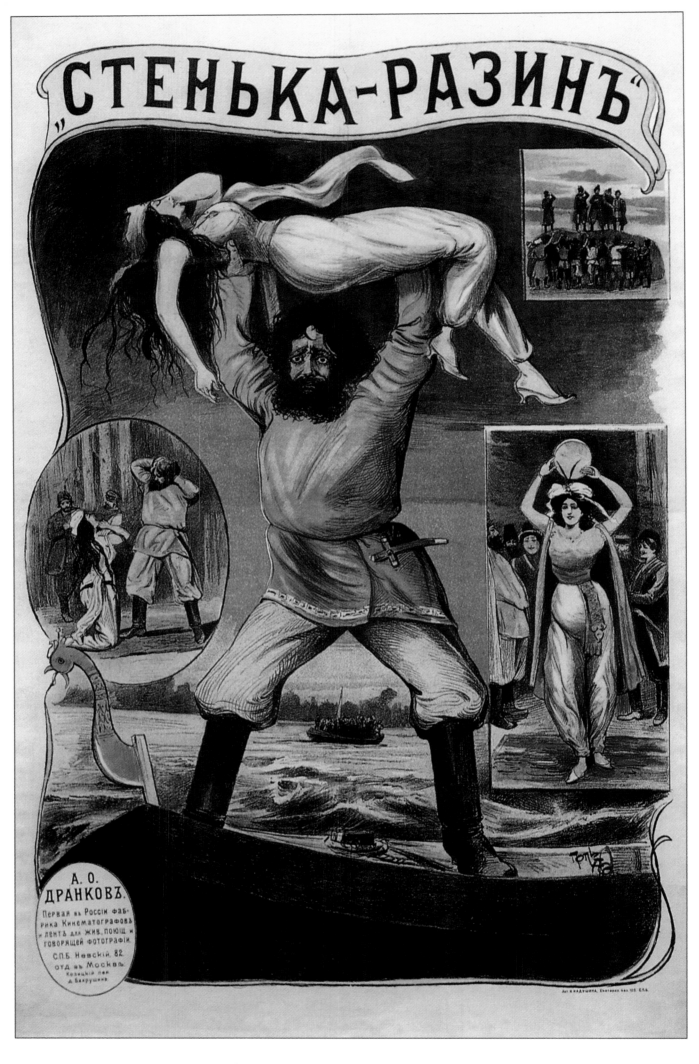

Paul Asaturov Stenka Razin • Paul Asatúrov Stenka Rasin
Paul Asatourov Stenka Razine • Paul Asaturow Stenka Rasin
1908

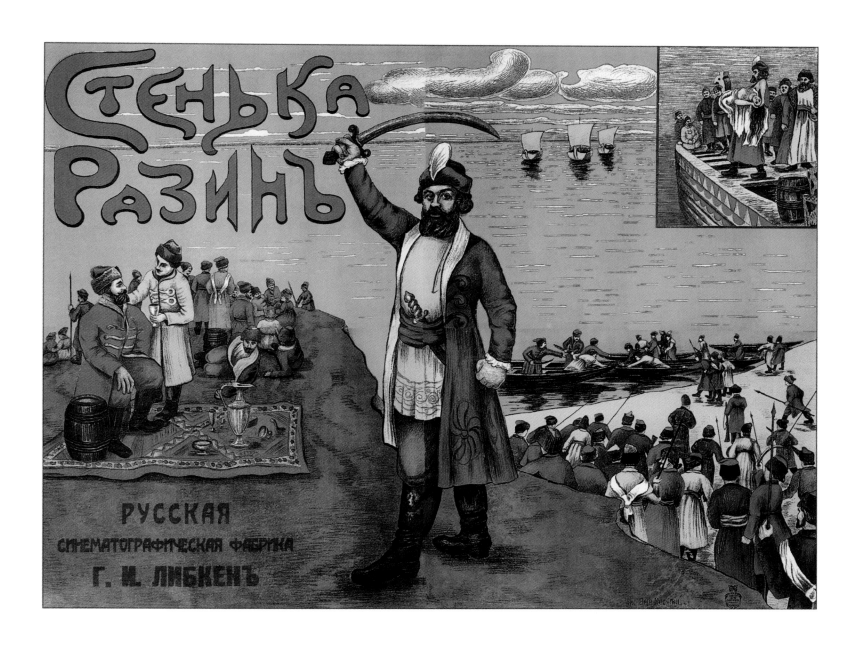

Pyotr Mosiagin Stenka Razin • **Piotr Mosiaguin** Stenka Rasin
Piotr Mosiagine Stenka Razine • **Pjotr Mosiagin** Stenka Rasin
1914

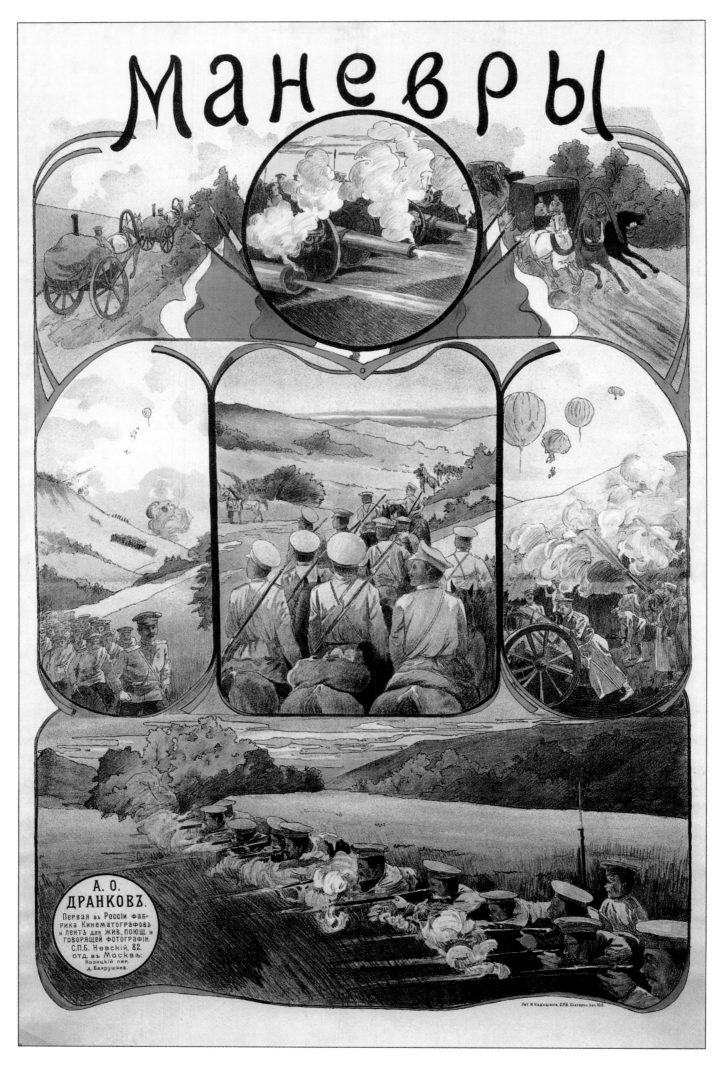

Anonymous Manoeuvres • Anónimo Maniobras
Anonyme Les manœuvres • Anonym Manöver
1910s

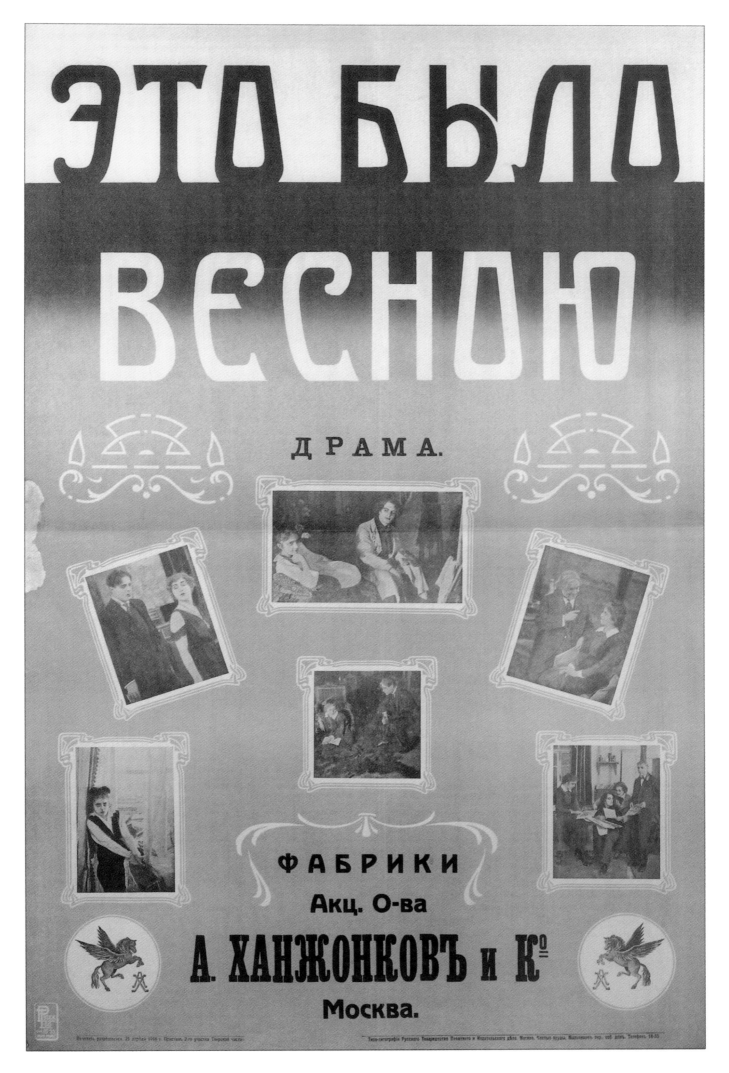

Anonymous It Was in Spring • Anónimo En primavera
Anonyme C'était au printemps • Anonym Es war im Frühling
1916

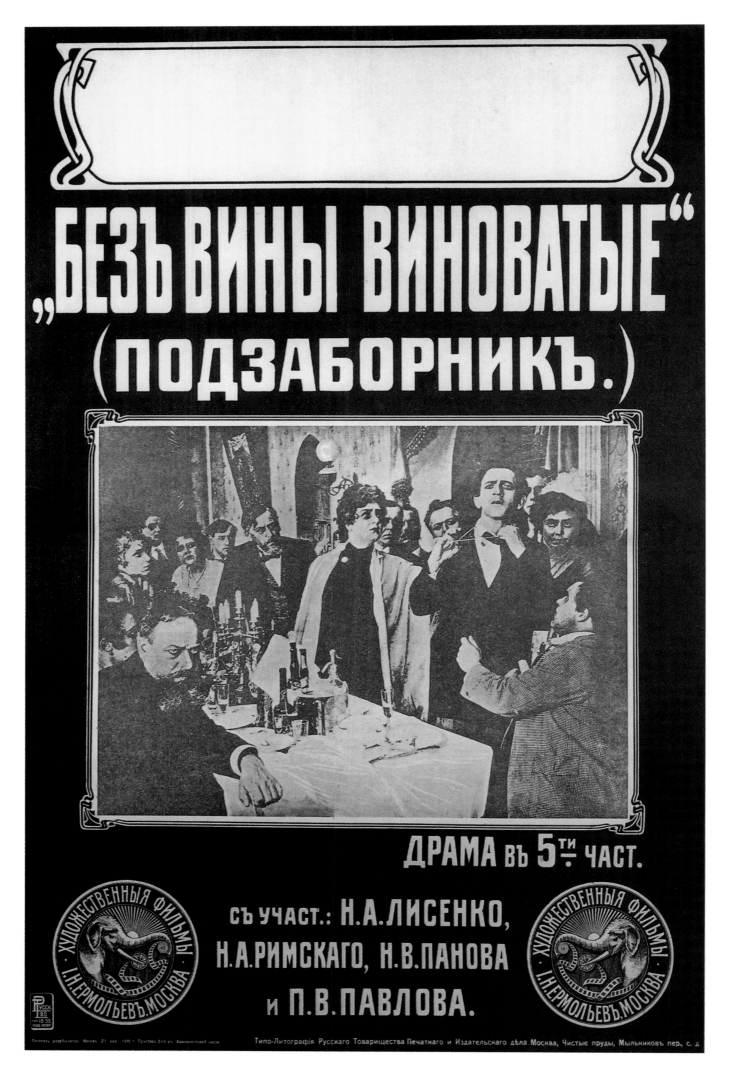

Anonymous Guilty though Guiltless • Anónimo Los inocentes culpables
Anonyme Les coupables innocents • Anonym Die schuldlos Schuldigen
1916

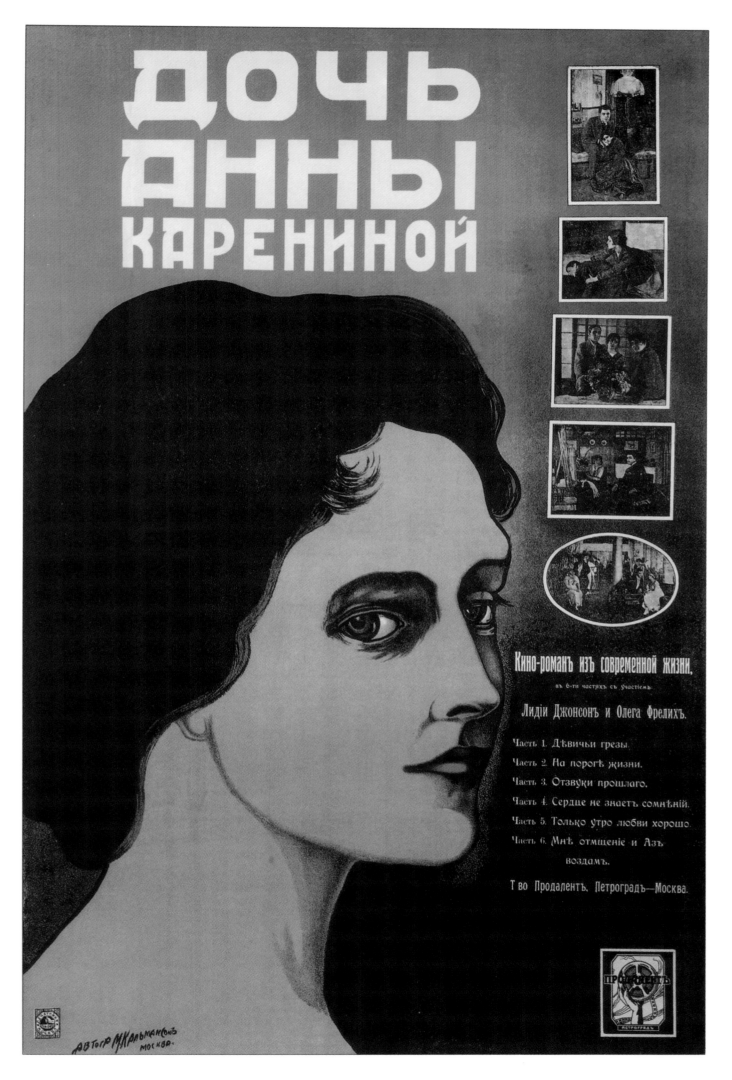

Mikhail **Kalmanson** Anna Karenina's Daughter • Mijaíl **Kálmanson** La hija de Ana Karenina

Mikhaïl **Kalmanson** La fille d'Anna Karénine • Michail **Kalmanson** Anna Kareninas Tochter

1916

Mikhail Kalmanson The Die Is Cast • Mijaíl Kálmanson La suerte está echada
Mikhaïl Kalmanson Les dés sont jetés • Michail Kalmanson Die Würfel sind gefallen
1900s

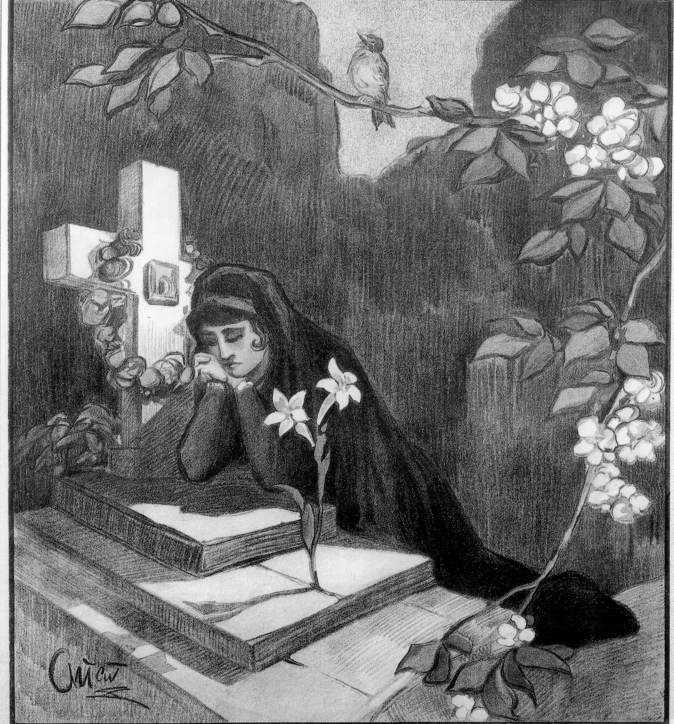

Alexander Apsit The Unfinished Love Song • Alexandr Apsit La canción de amor interminable
Alexandre Apsit Le chant d'amour inachevé • Alexander Apsit Das unvollendete Liebeslied
1918–1919

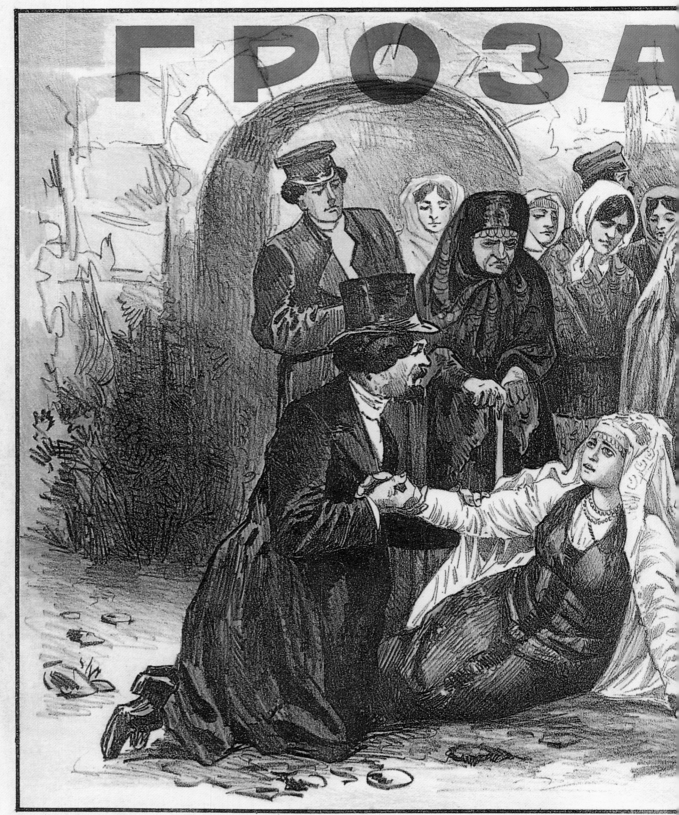

Anonymous The Storm • **Anónimo** La tempestad
Anonyme La tempête • **Anonym** Das Gewitter
1910s

ТИПО-ЛИТОГРАФІЯ С.М.МУХАРСКАГО МОСКВА

МОСКВА ТВЕРСКАЯ 38

Приложеніе къ журналу „Синема—пате"

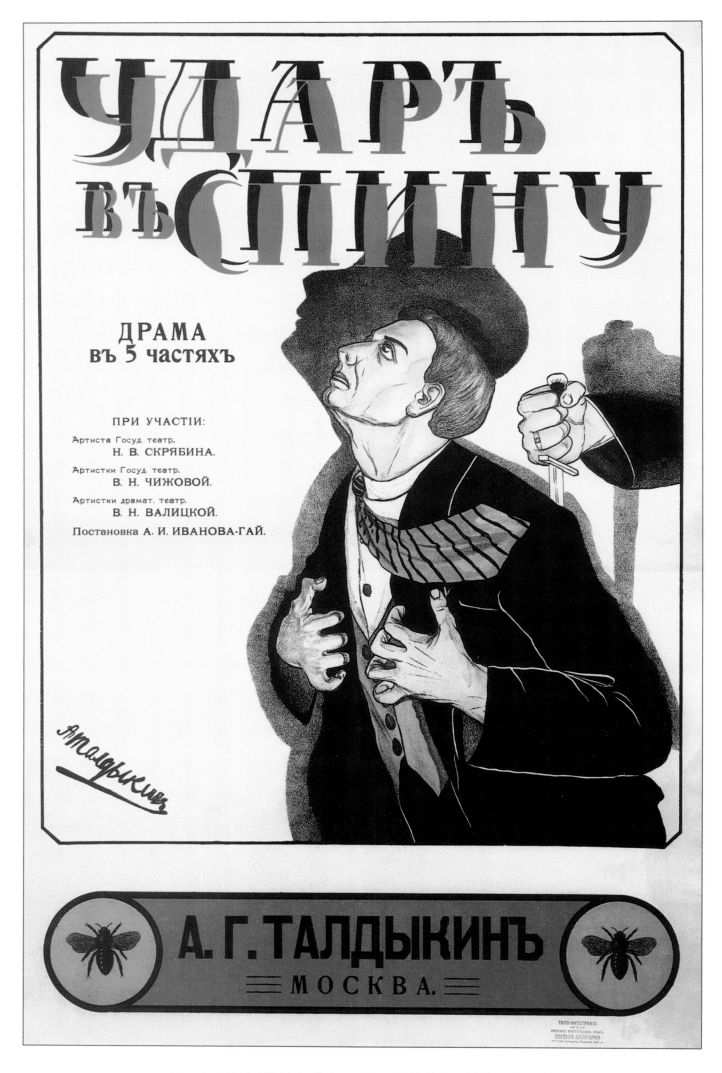

Alexander Taldykin A Stab in the Back • Alexandr Taldykin La puñalada por la espalda
Alexandre Taldykine Poignardé dans le dos • Alexander Taldykin Der Stich in den Rücken
1917

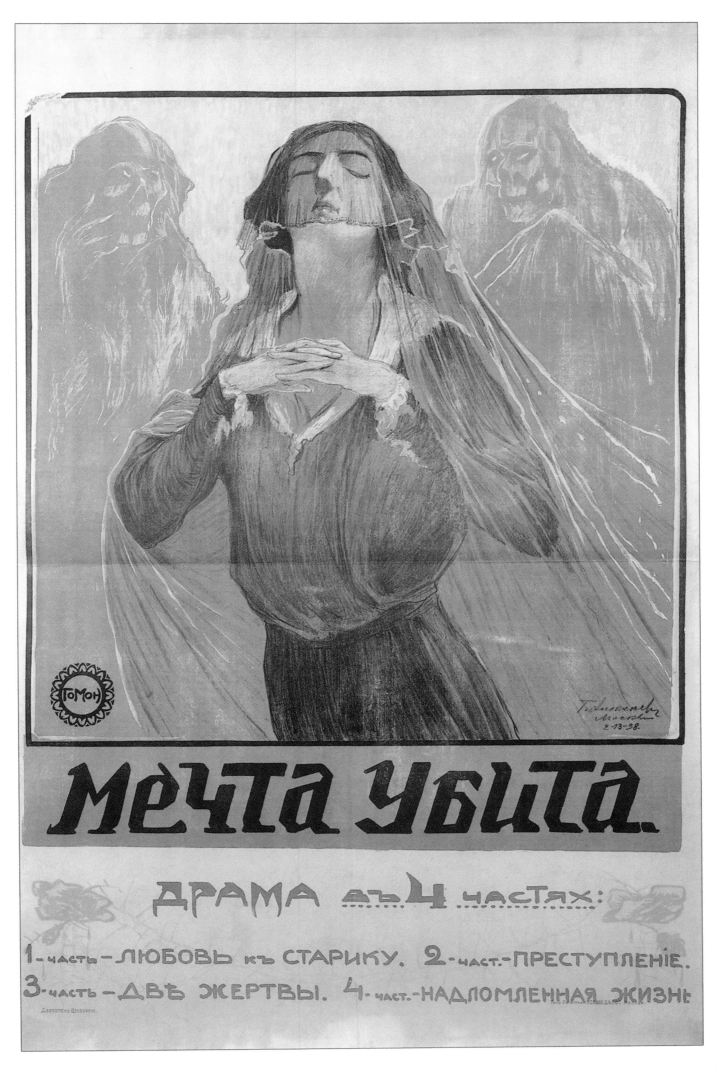

МЕЧТА УБИТА.

ДРАМА въ 4 частяхъ:

1-часть — ЛЮБОВЬ къ СТАРИКУ. 2-част.— ПРЕСТУПЛЕНІЕ.
3-часть — ДВѢ ЖЕРТВЫ. 4-част.— НАДЛОМЛЕННАЯ ЖИЗНЬ

Georgi Alexeev The Killed Dream • **Gueorgui Alexéyev** El sueño muerto
Guéorgui Alexeiev Le rêve évanoui • **Georgi Alexejew** Der getötete Traum
1910s

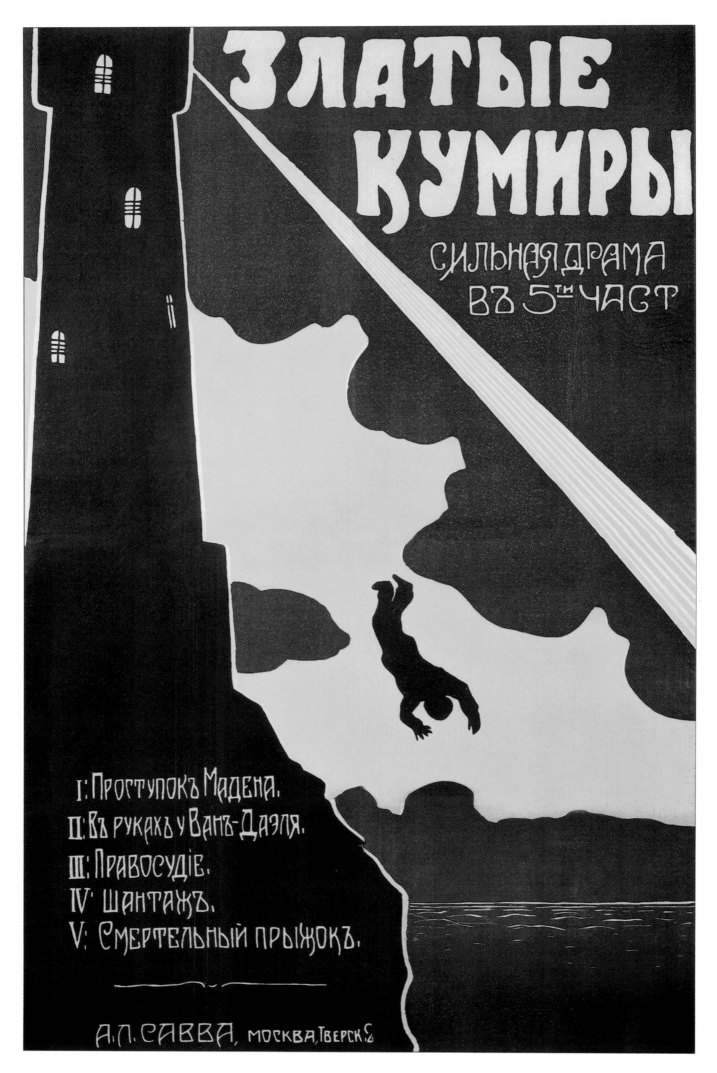

Anonymous The Golden Idols • **Anónimo** Ídolos dorados
Anonyme Les idoles dorées • **Anonym** Goldene Idole
1910s

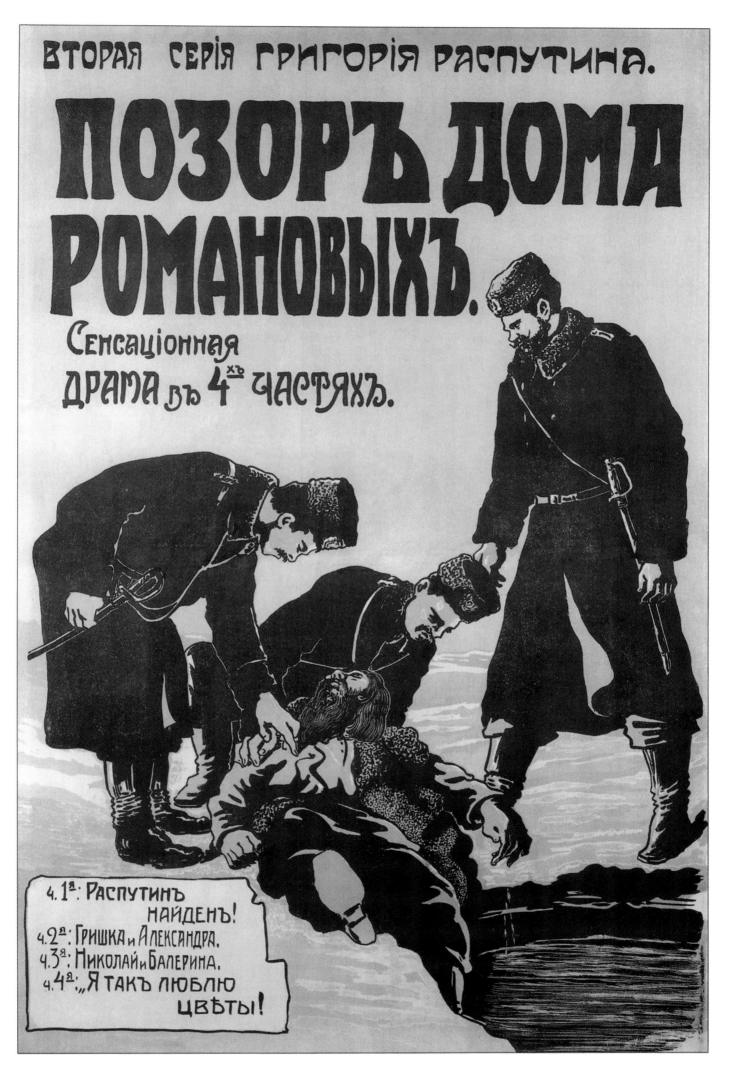

Anonymous The Shame of the Romanov House • Anónimo La infamia de la Casa Románov
Anonyme La honte de la Maison Romanov • Anonym Die Schande des Hauses Romanow
1917

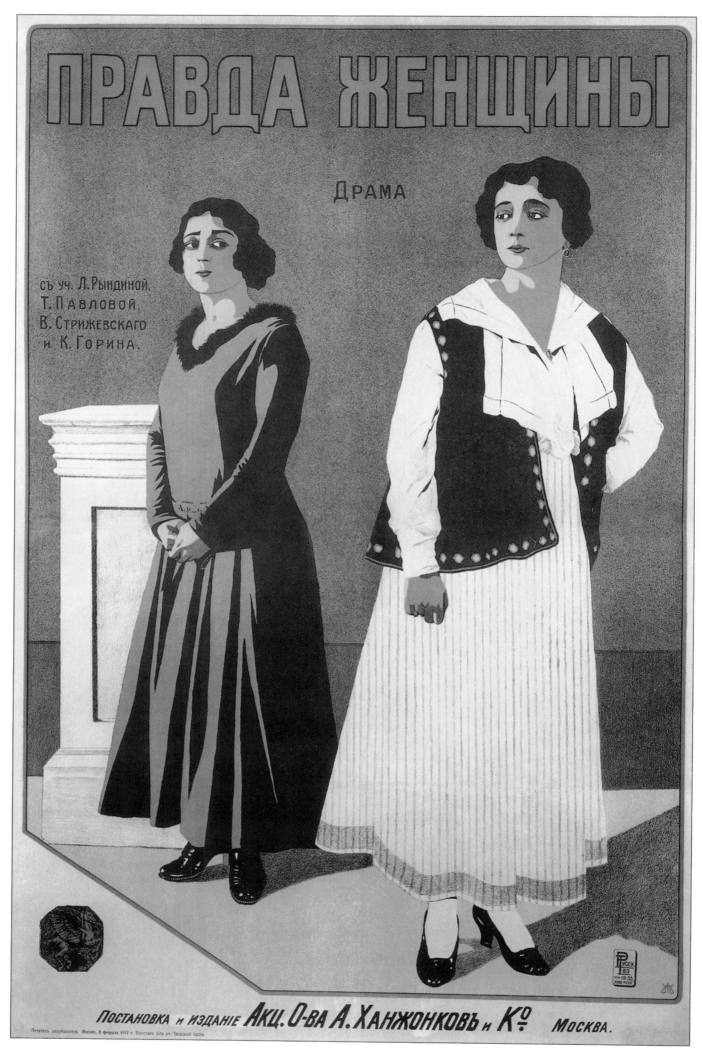

P. Zhitkov A Woman's Truth • P. Zhítkov La verdad de una mujer

P. Jitkov La vérité d'une femme • P. Schitkow Die Wahrheit einer Frau

1917

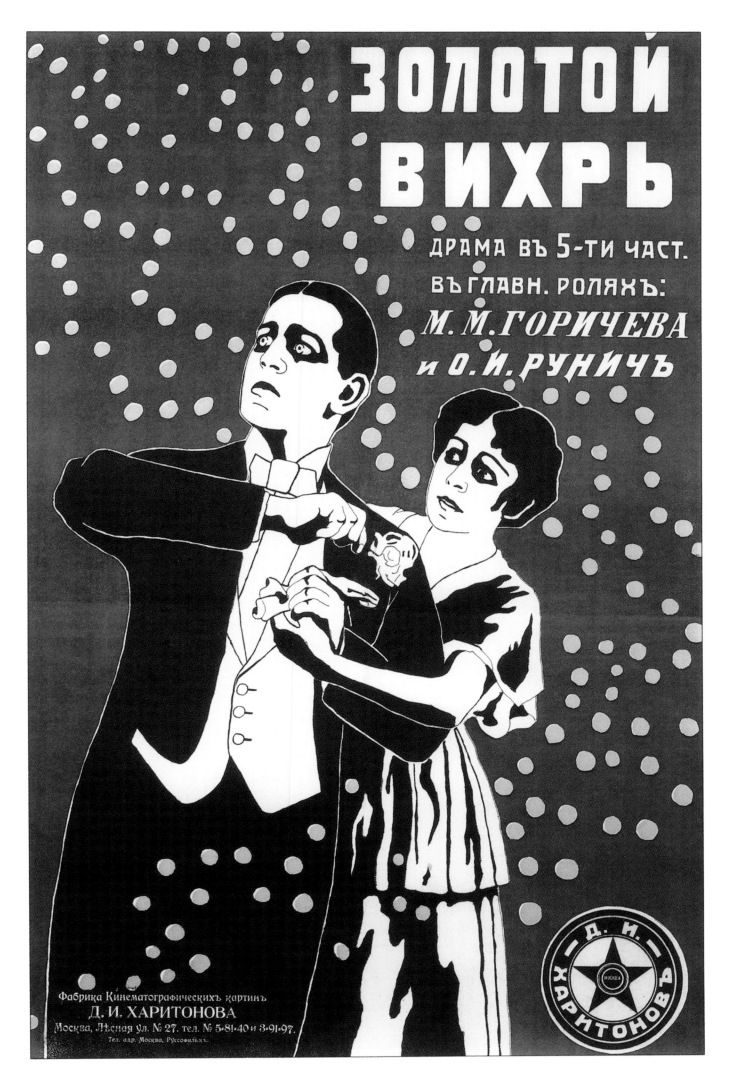

Anonymous The Golden Twist • Anónimo El remolino de oro
Anonyme Le tourbillon doré • Anonym Der Goldene Wirbel

1917

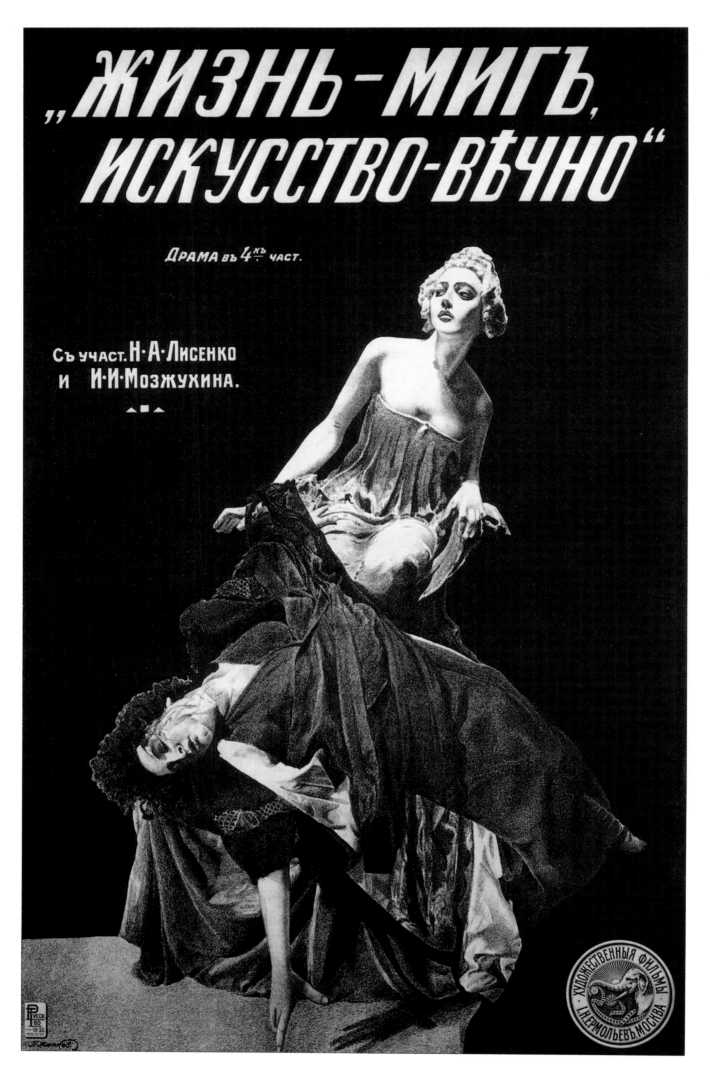

P. Zhitkov Life Goes By, Art Is Forever • P. Zhítkov La vida es un instante, el arte es para siempre
P. Jitkov La vie ne dure qu'un instant, l'art est éternel • P. Schitkow Das Leben ist ein Augenblick, die Kunst ist Ewigkeit

1916

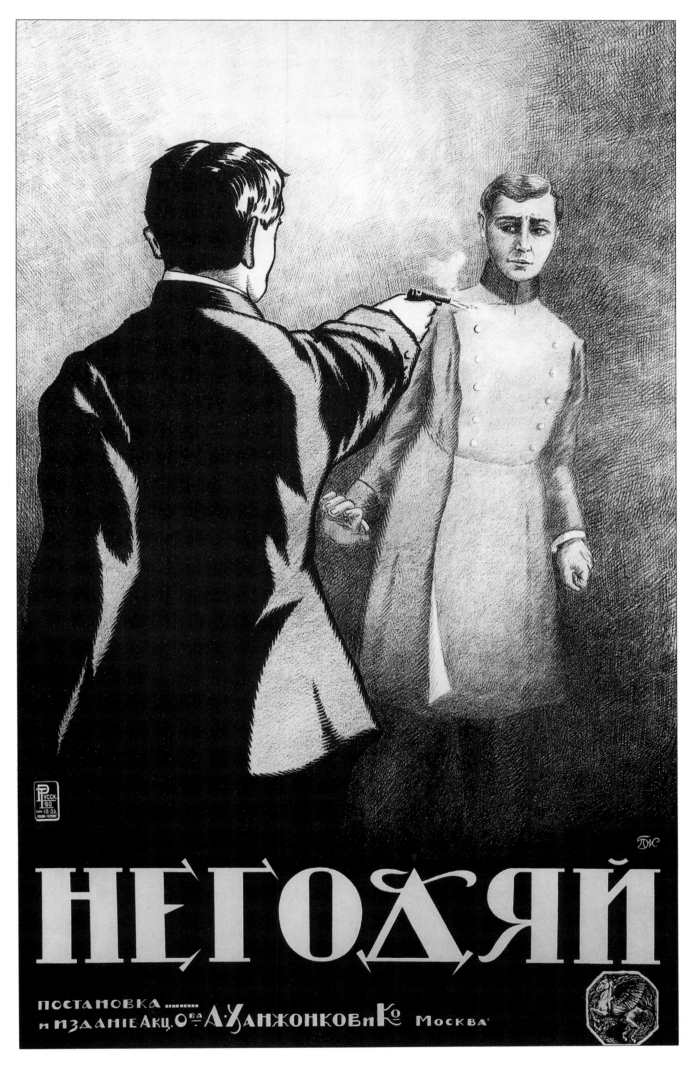

P. Zhitkov The Scoundrel • P. Zhítkov El bribón

P. Jitkov Le scélérat • P. Schitkow Der Lump

1917

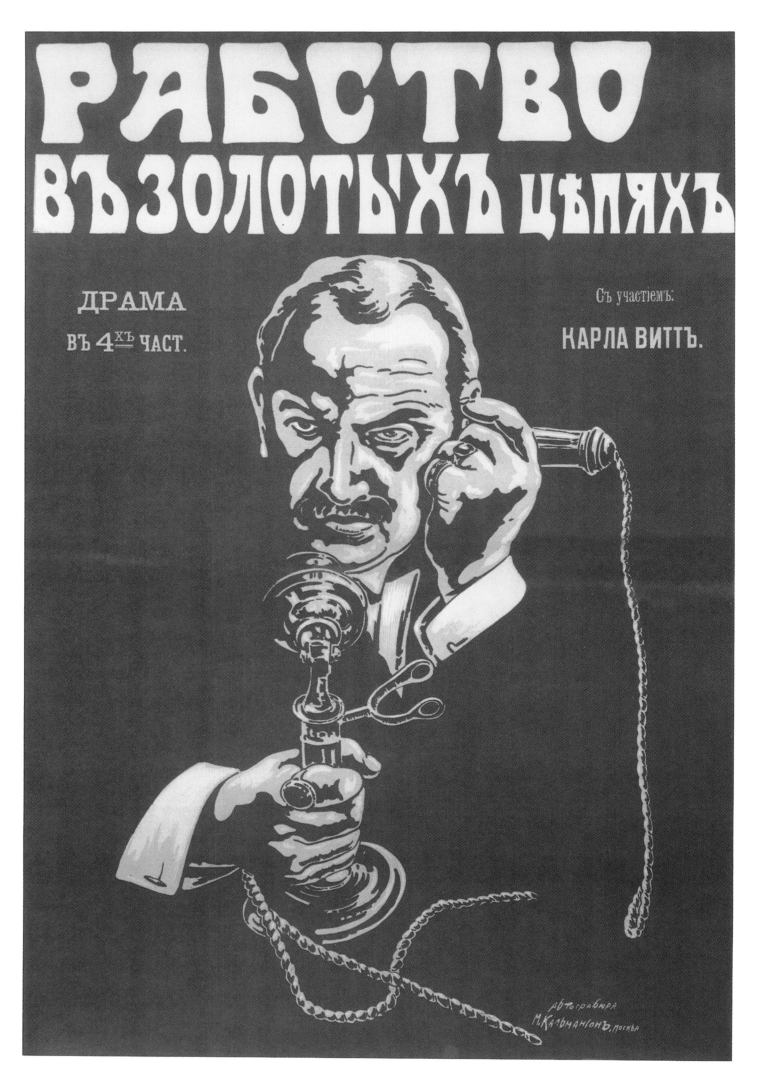

Mikhail Kalmanson Slavery in Gold Chains • **Mijaíl Kálmanson** Esclavos con cadenas de oro

Mikhaïl Kalmanson Les esclaves aux chaînes d'or • **Michail Kalmanson** Sklaven in goldenen Fesseln

1910s

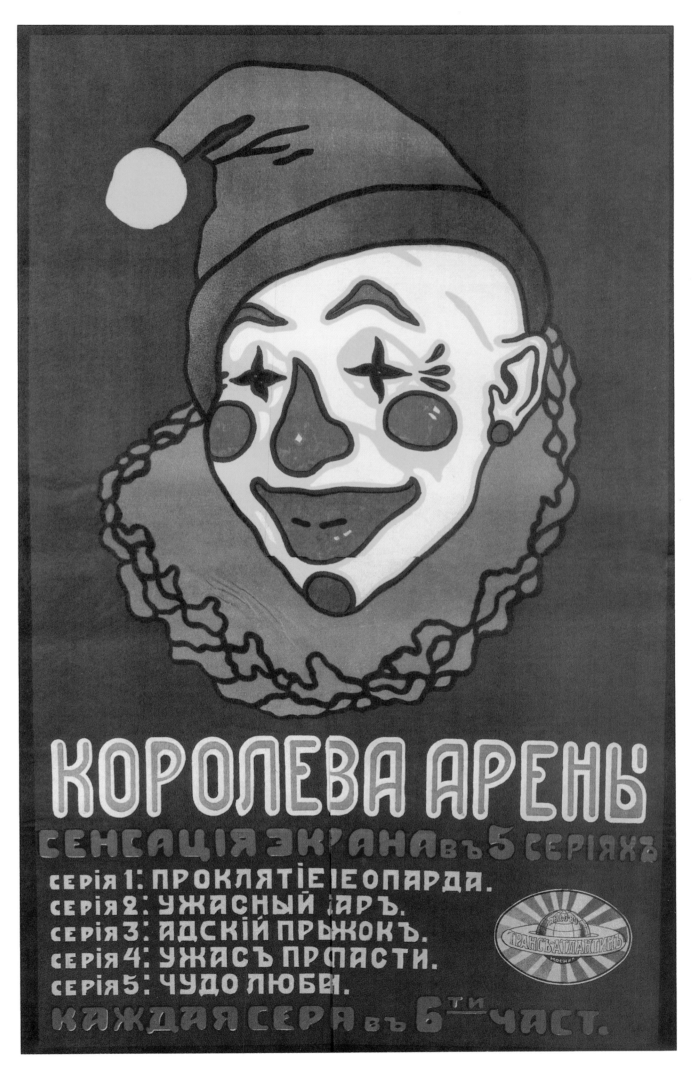

Mikhail Kalmanson The Queen of the Circus Ring • Mijaíl Kálmanson La reina de la arena del circo

Mikhaïl Kalmanson La reine du cirque • Michail Kalmanson Die Königin der Zirkusarena

1910s

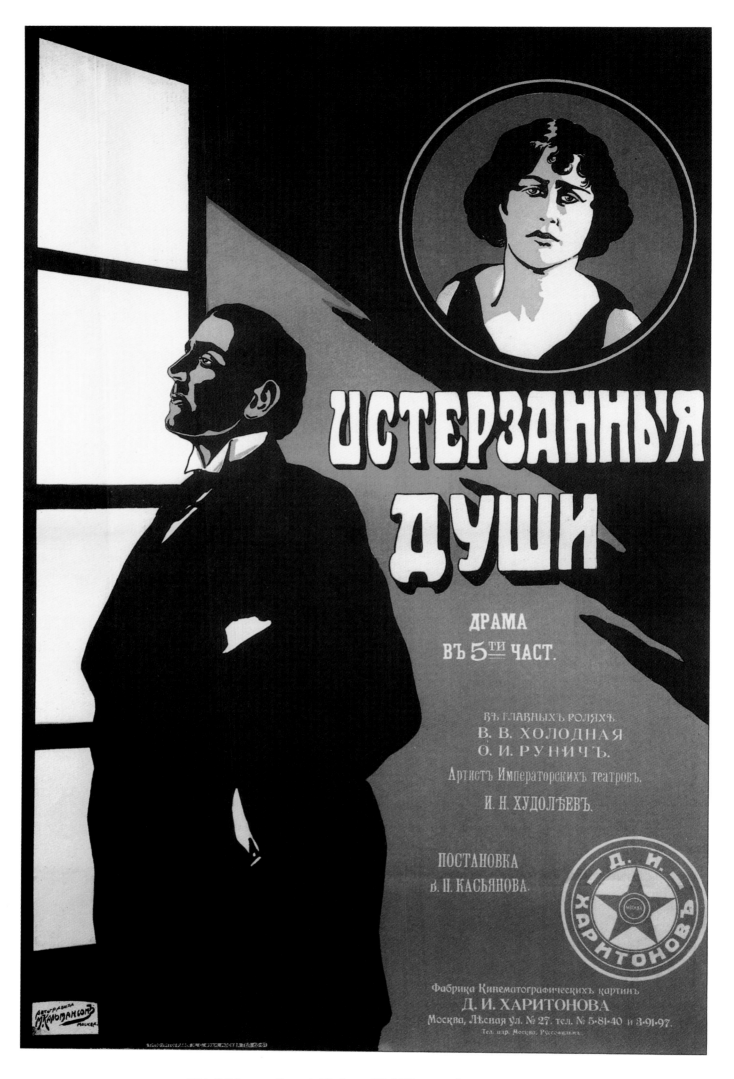

Mikhail Kalmanson Tormented Souls • **Mijaíl Kálmanson** Almas atormentadas

Mikhaïl Kalmanson Les âmes tourmentées • **Michail Kalmanson** Gequälte Seelen

1917

Anonymous In the Café-Concert Lights • Anónimo En los focos del café concierto
Anonyme Les feux de la rampe • Anonym Im Licht des Café-Concerts
1916

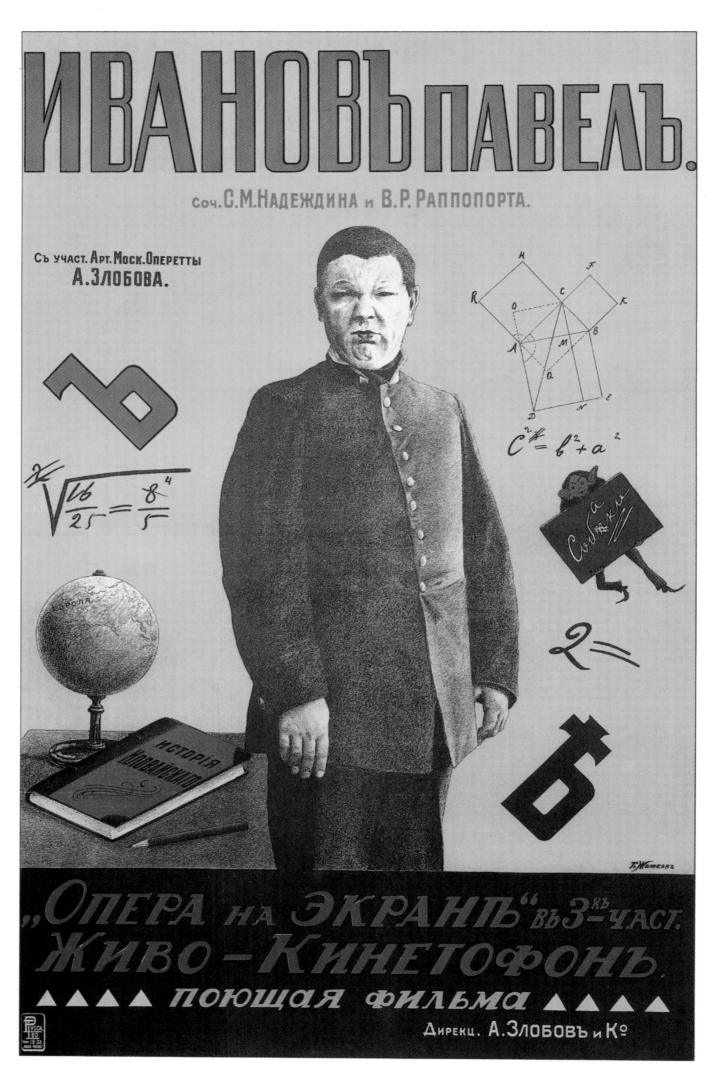

P. **Zhitkov** Ivanov, Pavel • P. **Zhítkov** Ivánov, Pável

P. **Jitkov** Ivanov, Pavel • P. **Schitkow** Iwanow, Pawel

1916

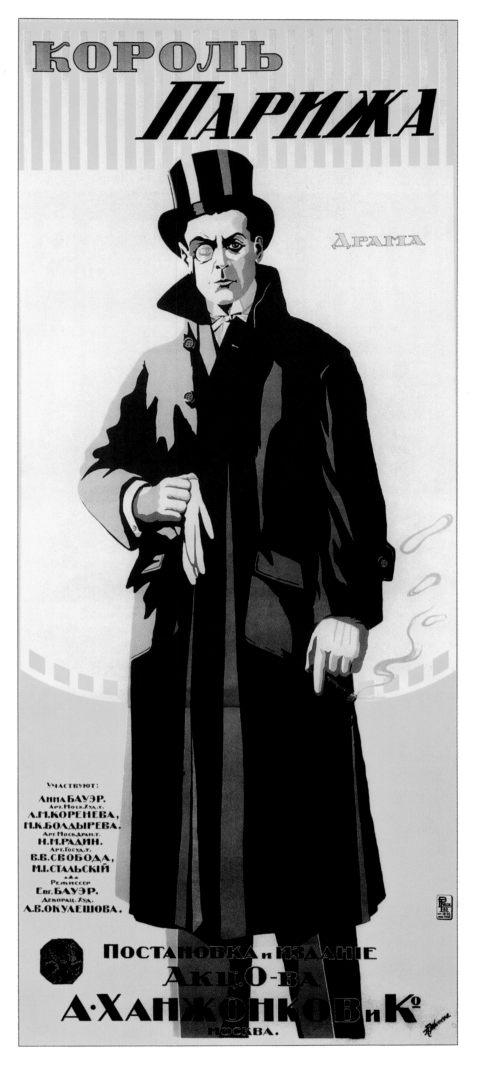

P. Zhitkov The King of Paris • P. Zhítkov El rey de París
P. Jitkov Le roi de Paris • P. Schitkow Der König von Paris

1917

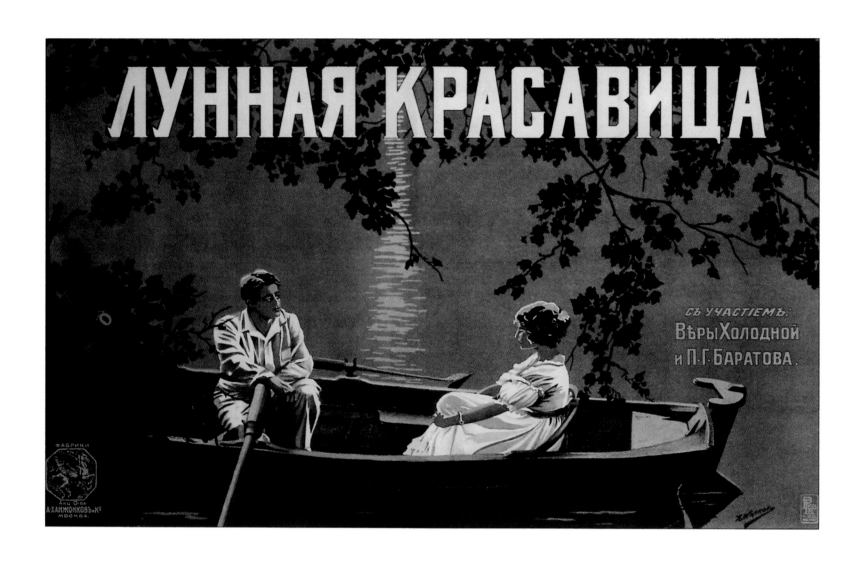

P. **Zhitkov** The Moon Beauty • P. **Zhítkov** Belleza lunar
P. **Jitkov** La beauté lunaire • P. **Schitkow** Mondschönheit
1916

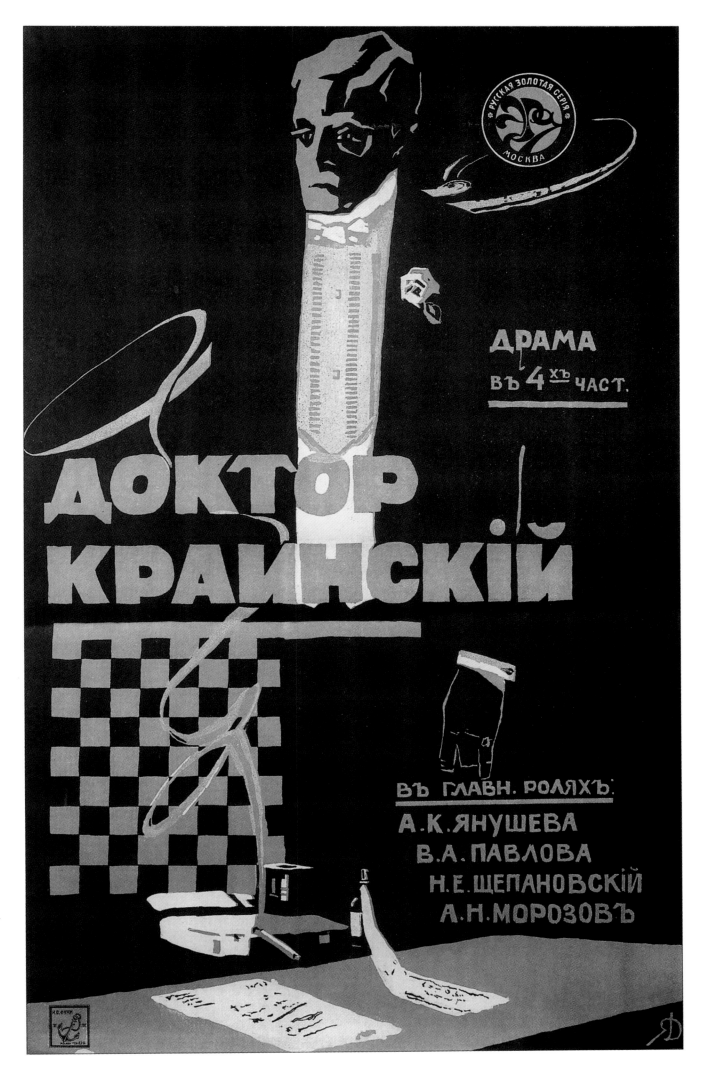

Anonymous Doctor Krainsky • Anónimo Doctor Krainski
Anonyme Docteur Krainsky • Anonym Doktor Krainski
1917

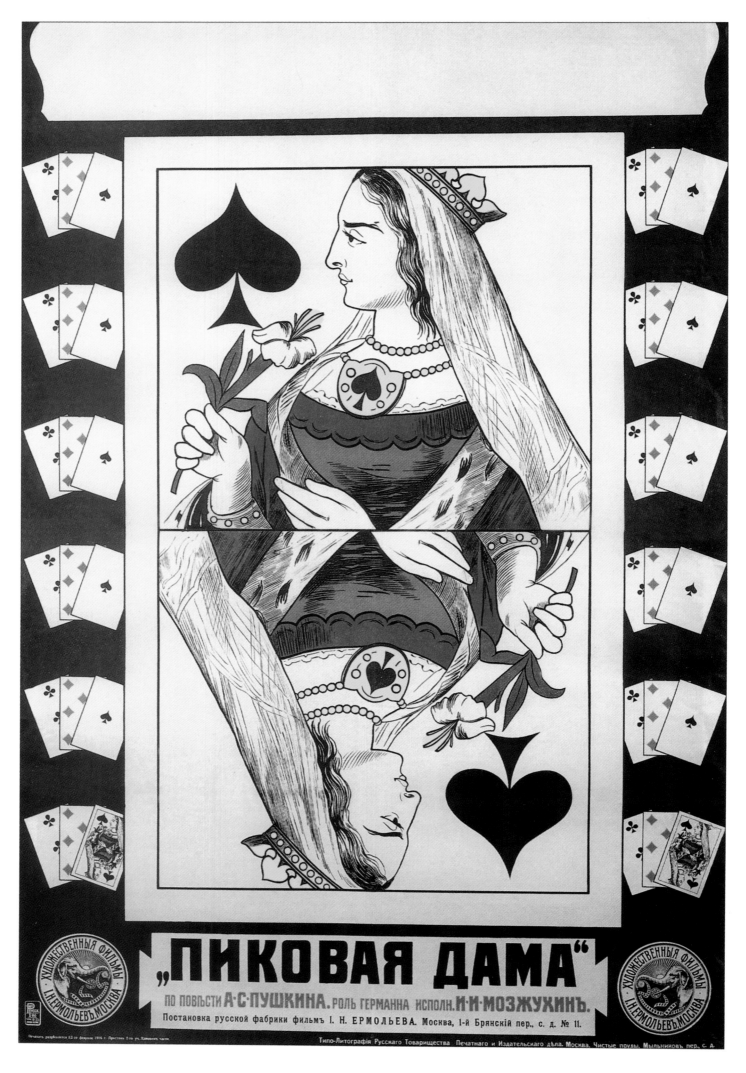

Anonymous The Queen of Spades • Anónimo La dama de picas
Anonyme La Dame de Pique • Anonym Pique Dame

1916

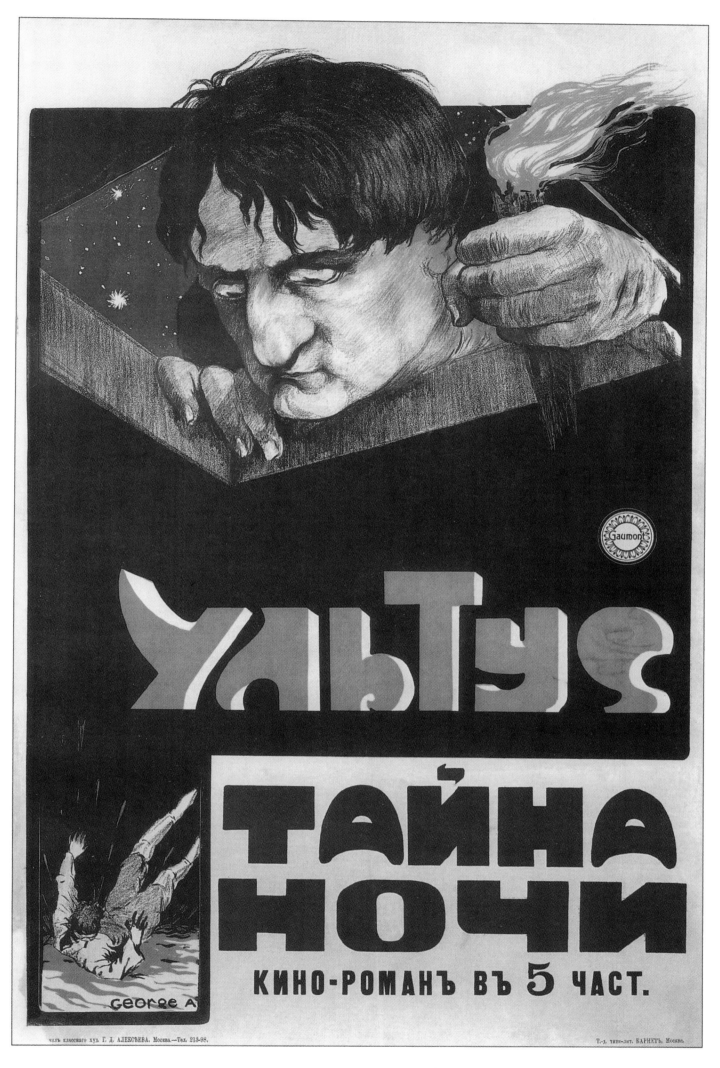

Georgi Alexeev Ultus and the Secret of the Night • **Gueorgui Alexéyev** Ultus y el secreto de la noche

Guéorgui Alexeiev Ultus et les mystères de la nuit • **Georgi Alexejew** Ultus. Das Geheimnis einer Nacht

1910s

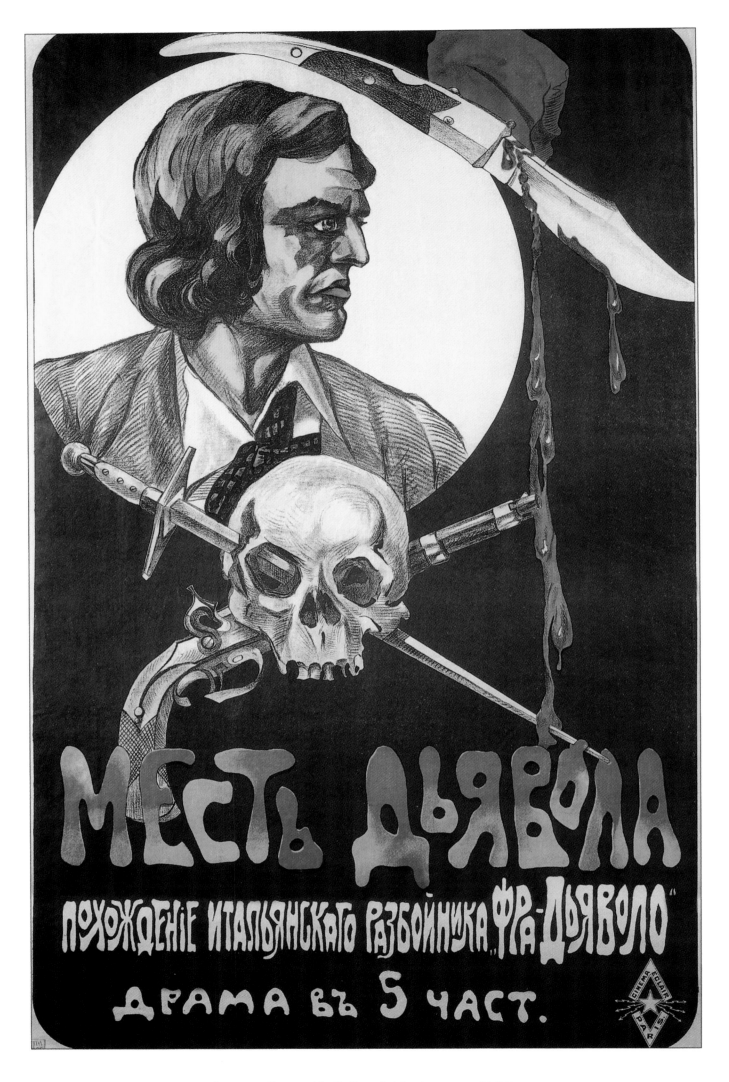

Anonymous Revenge of the Devil • Anónimo La venganza del diablo
Anonyme La vengeance du démon • Anonym Die Rache des Teufels
1910s

42

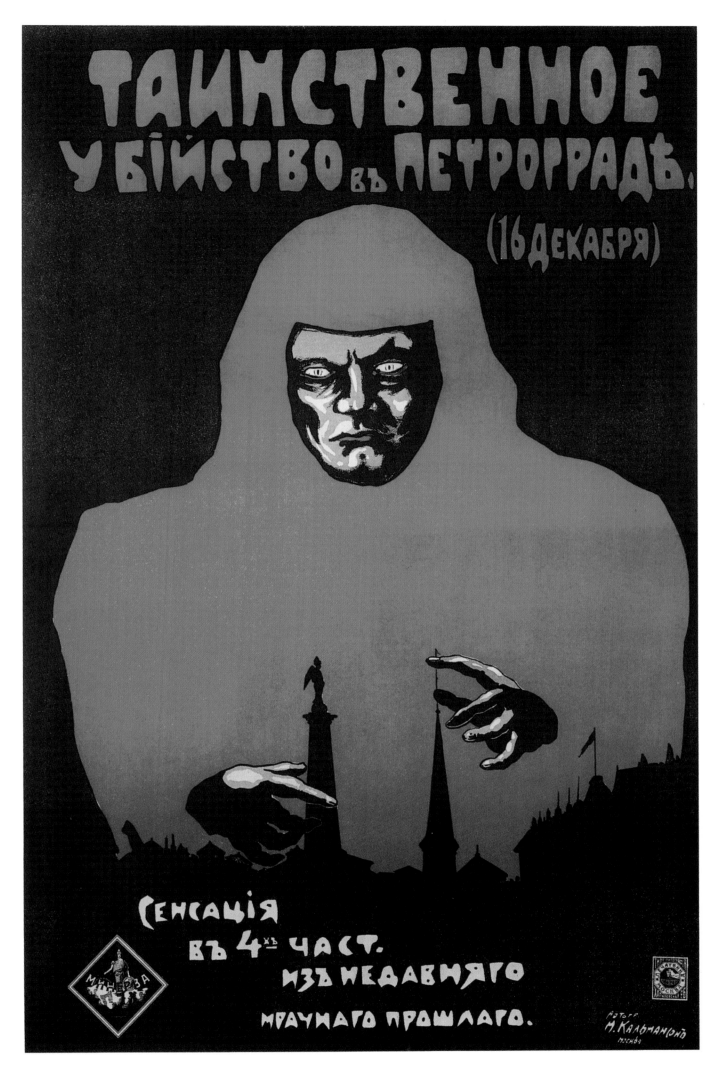

Mikhail Kalmanson The Mysterious Murder in Petrograd • **Mijaíl Kálmanson** El misterioso asesinato en Petrogrado

Mikhaïl Kalmanson Meurtre mystérieux à Pétrograd • **Michail Kalmanson** Der geheimnisvolle Mord in Petrograd

1917

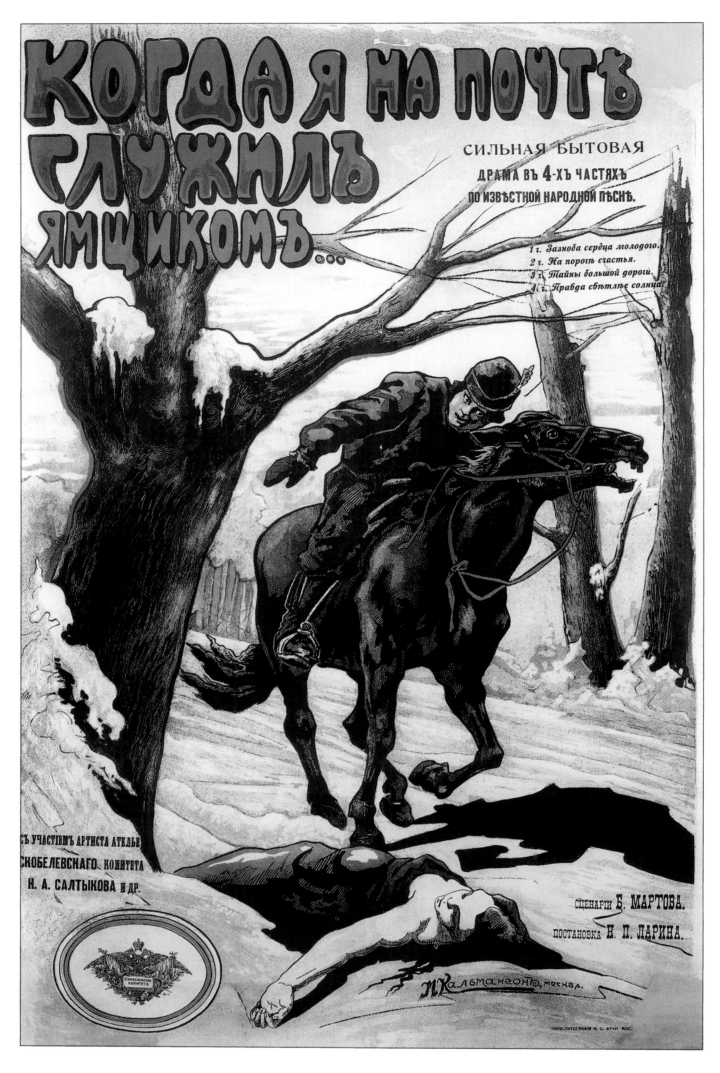

Mikhail Kalmanson When I Was a Mailcoach Man… • Mijaíl Kálmanson Cuando yo era cochero postal…

Mikhaïl Kalmanson Lorsque j'étais cocher de diligence… • Michail Kalmanson Als ich Postkutscher war…

1916

44

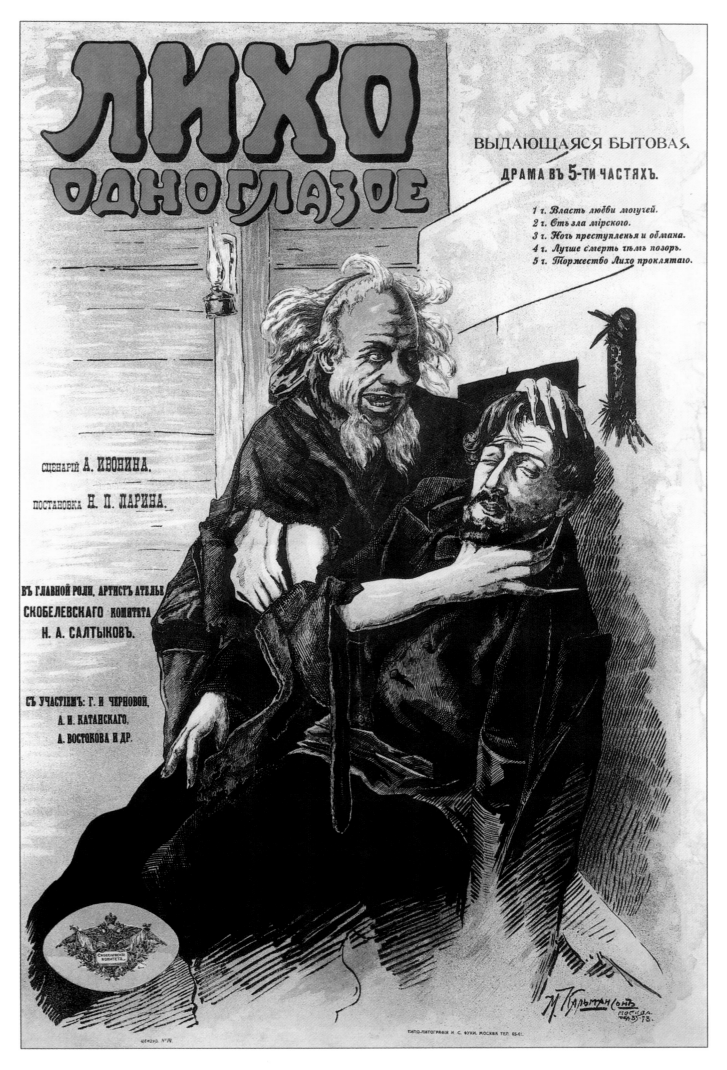

Mikhail Kalmanson One-Eyed Devil • Mijaíl Kálmanson El diablo tuerto
Mikhaïl Kalmanson Le démon borgne • Michail Kalmanson Der einäugige Teufel
1916

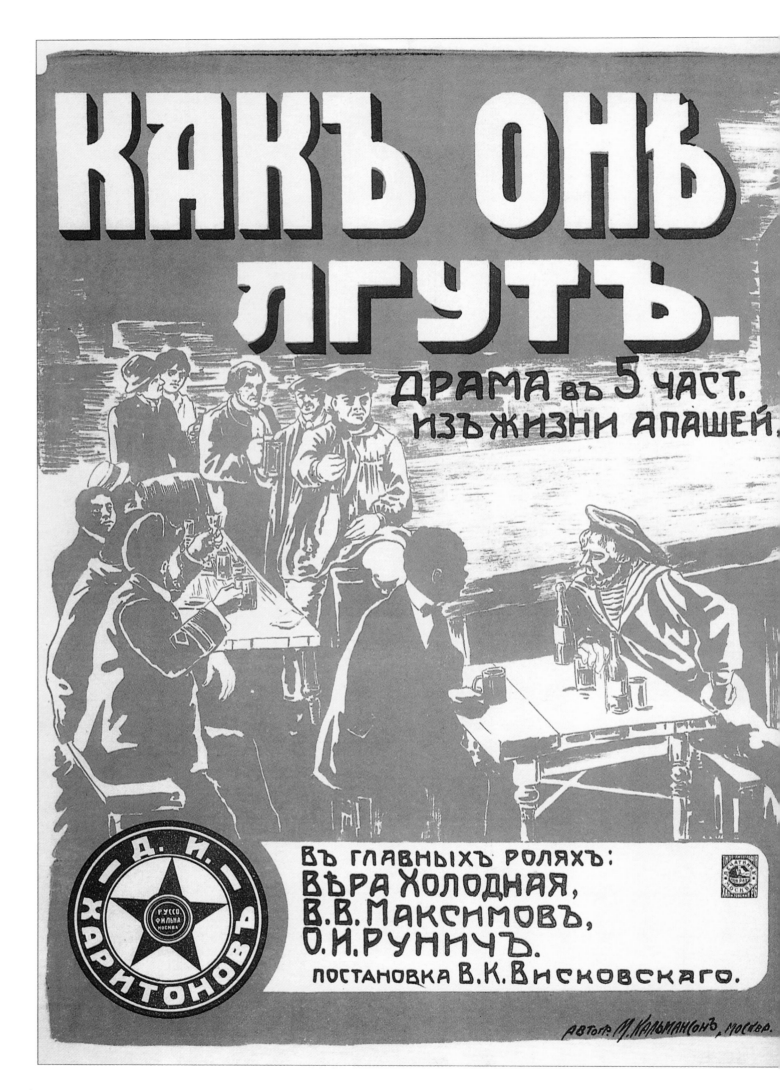

Mikhail Kalmanson As They Lie • Mijaíl Kálmanson Cuando mienten
Mikhaïl Kalmanson Comme ils mentent • Michail Kalmanson Wie sie lügen

1917

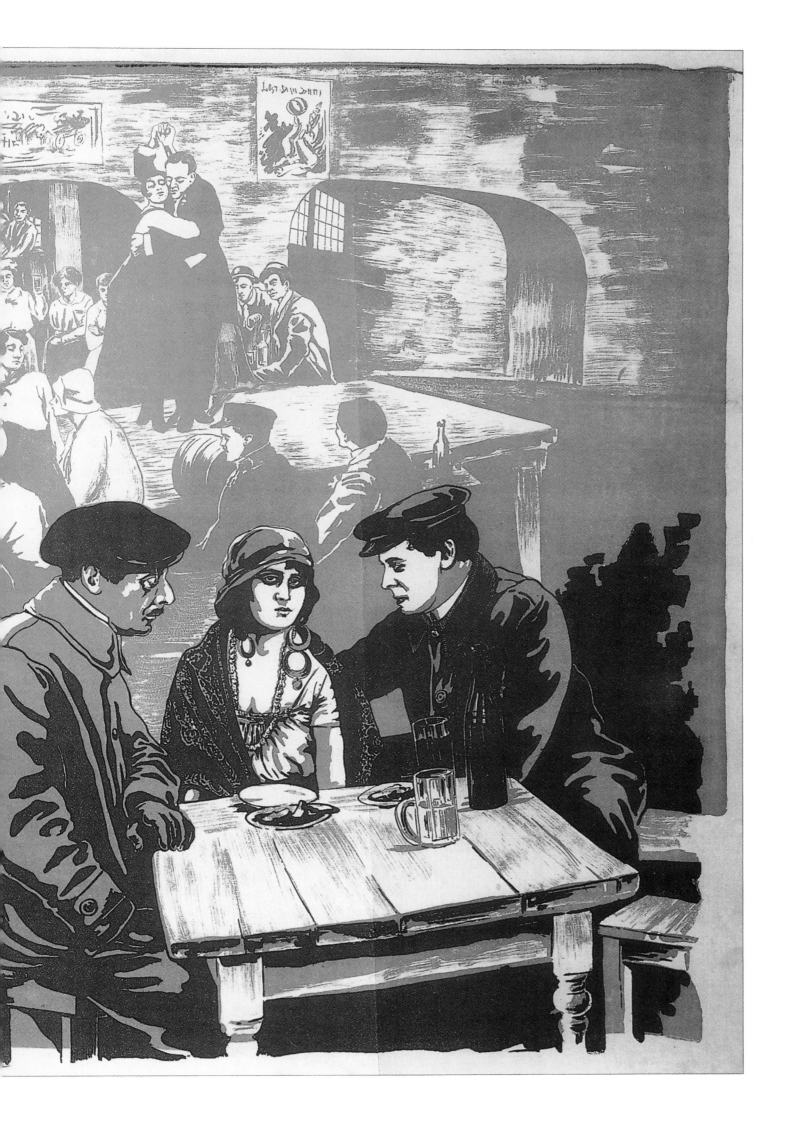

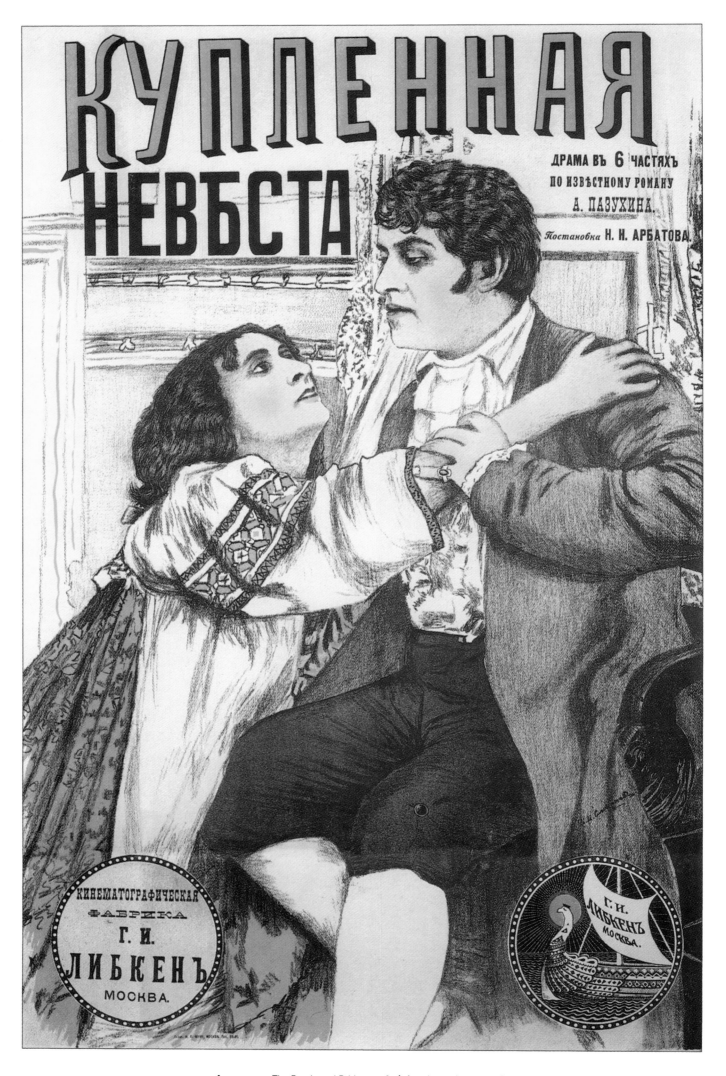

Anonymous *The Purchased Bride* • Anónimo *La novia comprada*
Anonyme *La fiancée achetée* • Anonym *Die gekaufte Braut*
1915

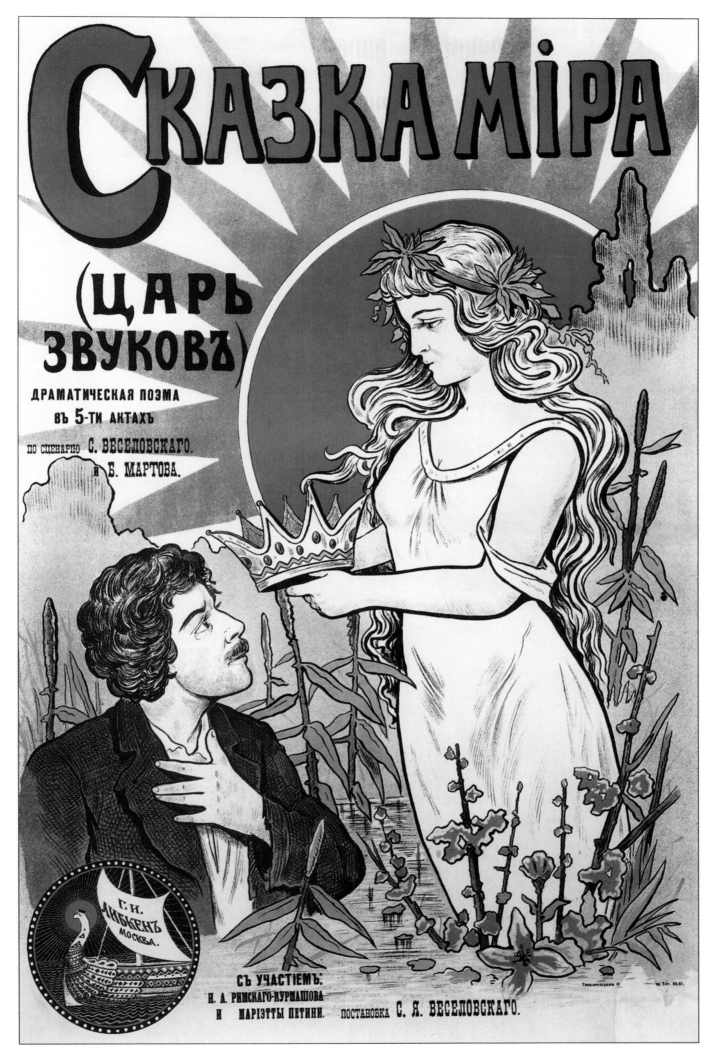

Anonymous The Tale of the World • Anónimo El cuento del mundo
Anonyme Le conte du monde • Anonym Das Weltmärchen

1916

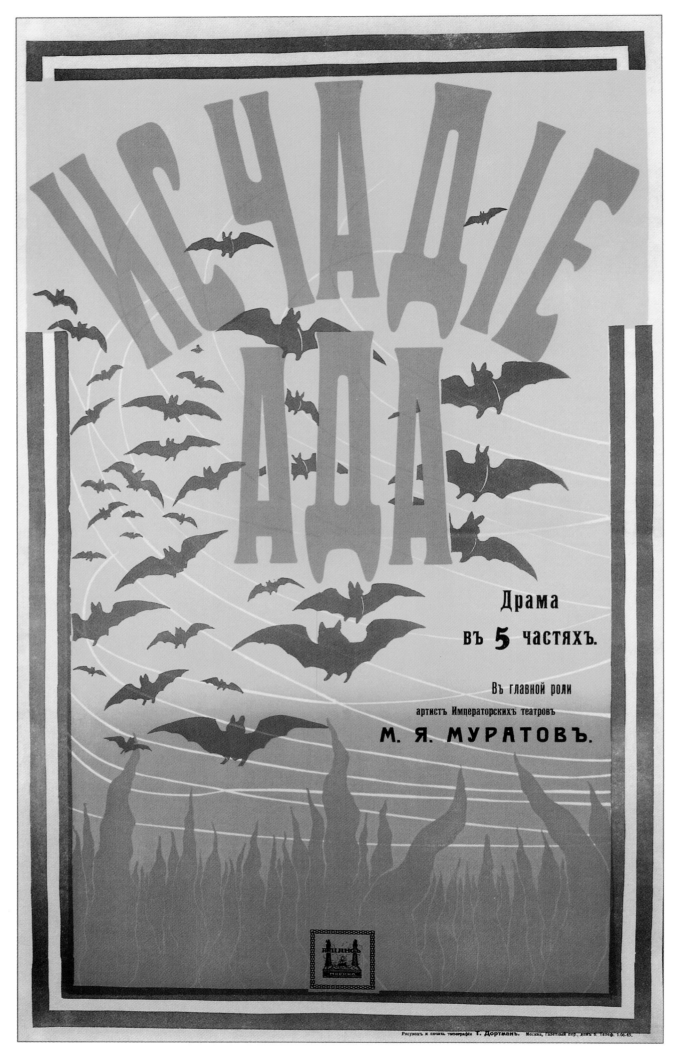

T. Dortman Spawn of the Devil • **T. Dortman** Un secuaz de Satán
T. Dortman Un suppôt de Satan • **T. Dortman** Höllenbrut

1916

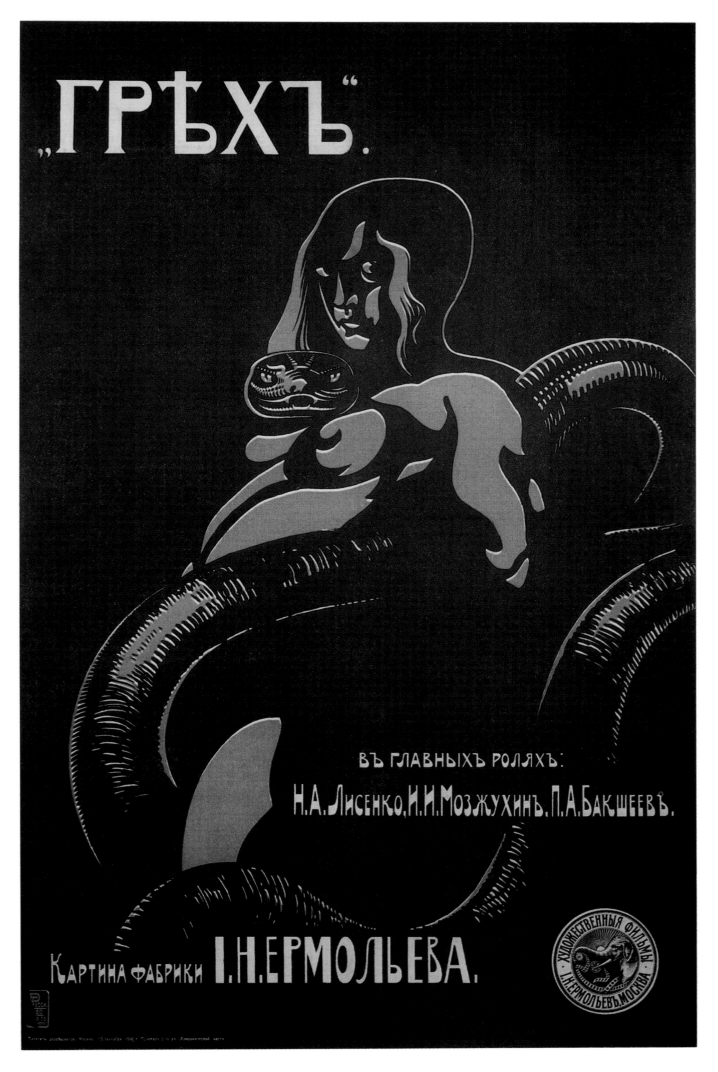

Anonymous Sin • Anónimo Pecado
Anonyme Le péché • Anonym Sünde
1916

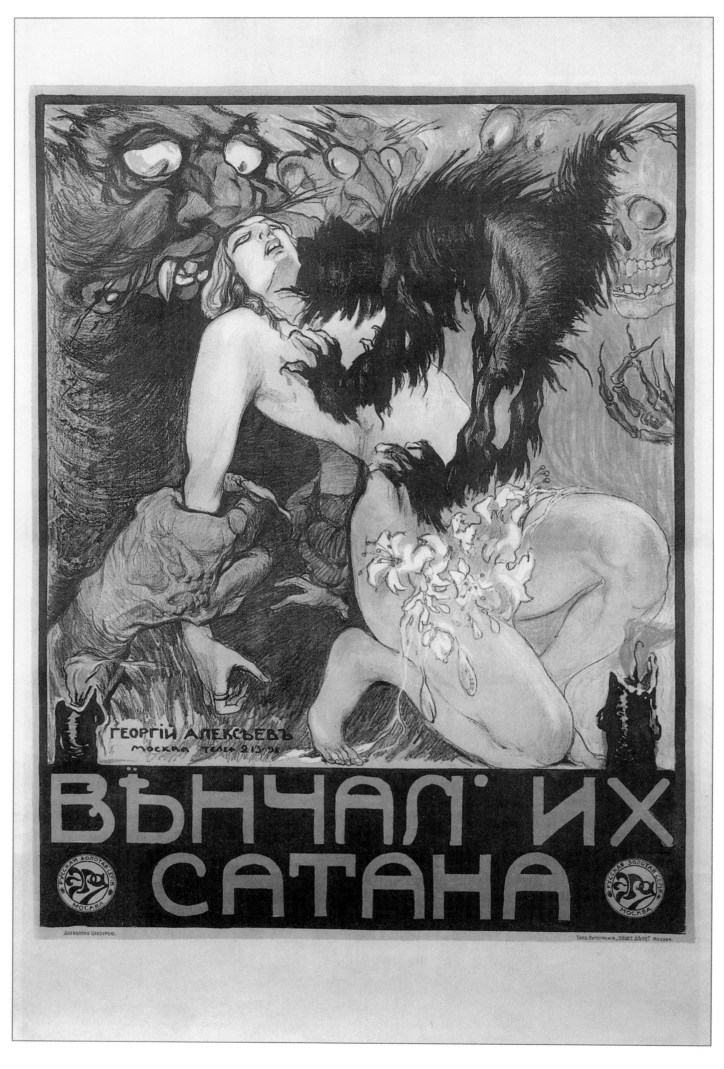

Georgi Alexeev Being Married by the Satan • **Gueorgui Alexéyev** Los coronó Satanás

Guéorgui Alexeiev Mariés par Satan • **Georgi Alexejew** Der Satan hat sie getraut

1917

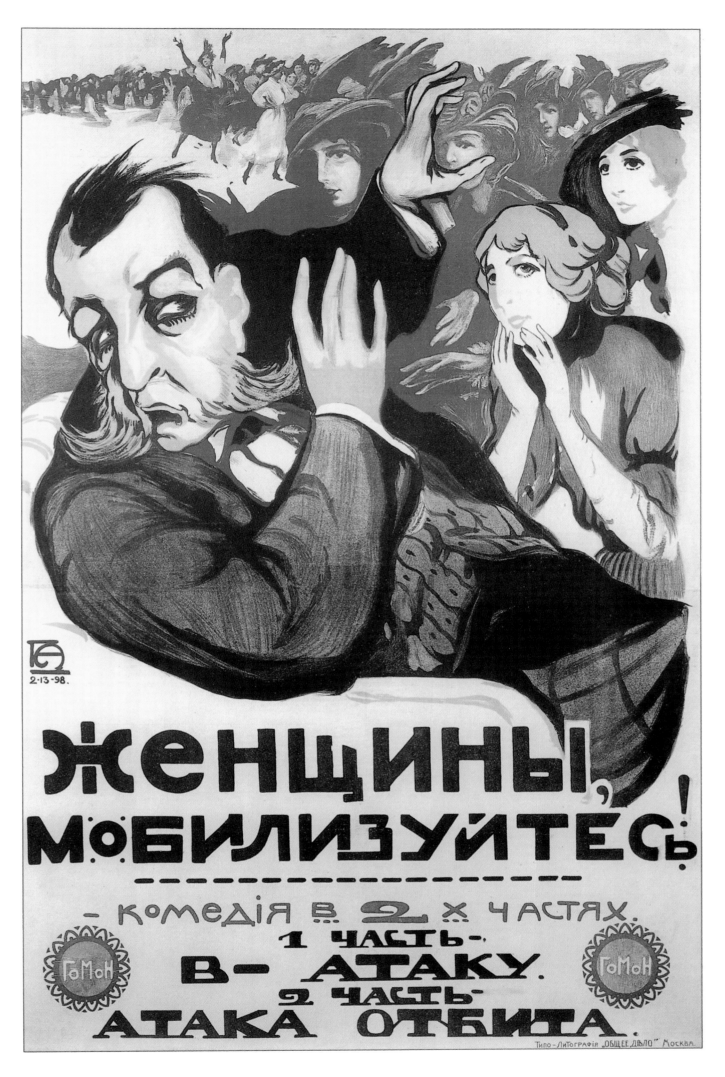

Georgi Alexeev Women, Mobilize! • Gueorgui Alexéyev Mujeres, ¡movilizaos!
Guéorgui Alexeiev Femmes, mobilisez-vous! • Georgi Alexejew Frauen, mobilisiert Euch!
1910s

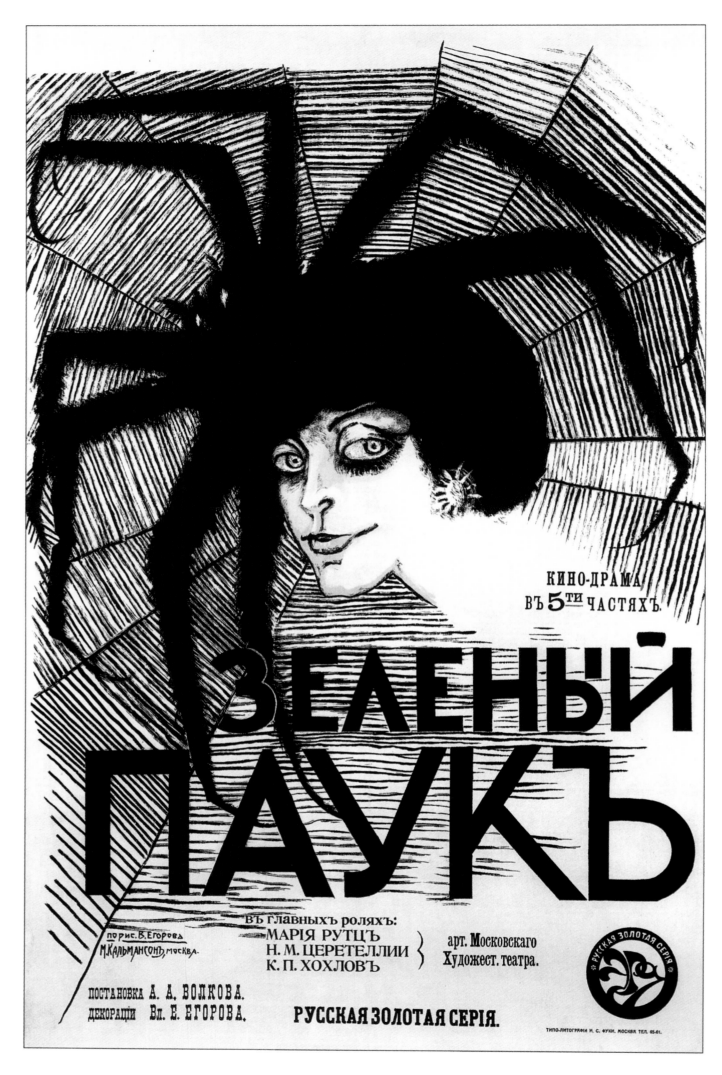

Vladimir Yegorov The Green Spider • Vladímir Yegórov La araña verde

Vladimir Yegorov L'araignée verte • Wladimir Jegorow Die grüne Spinne

1916

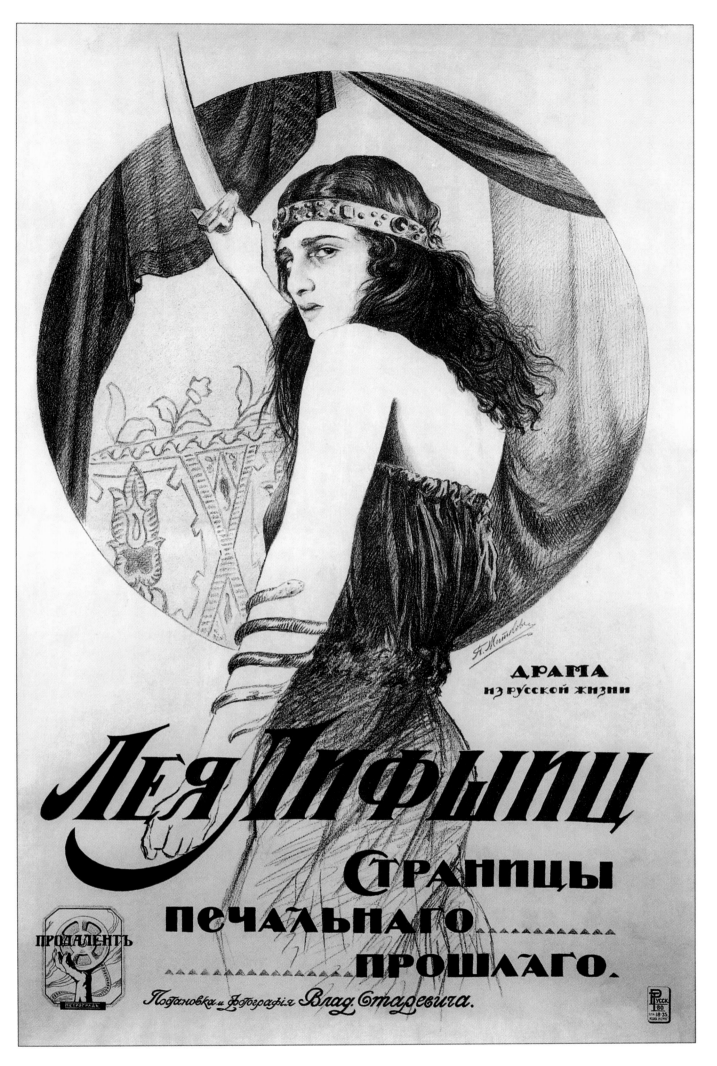

P. Zhitkov Lea Lifshitz • P. Zhítkov Lea Lifshitz

P. Jitkov Léa Lifshitz • P. Schitkow Lea Lifschitz

1917

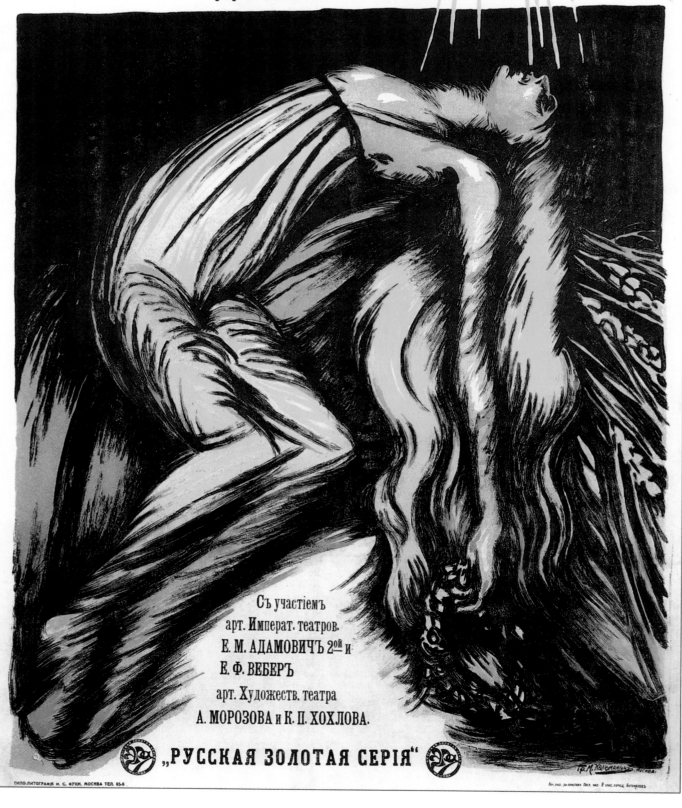

Mikhail Kalmanson The Reaped Sheaf in Love's Harvest • **Mijaíl Kálmanson** La gavilla segada en la cosecha de amor

Mikhaïl Kalmanson La gerbe récoltée dans le champ de l'amour • **Michail Kalmanson** Die abgemähte Garbe auf dem Erntefeld der Liebe

1917

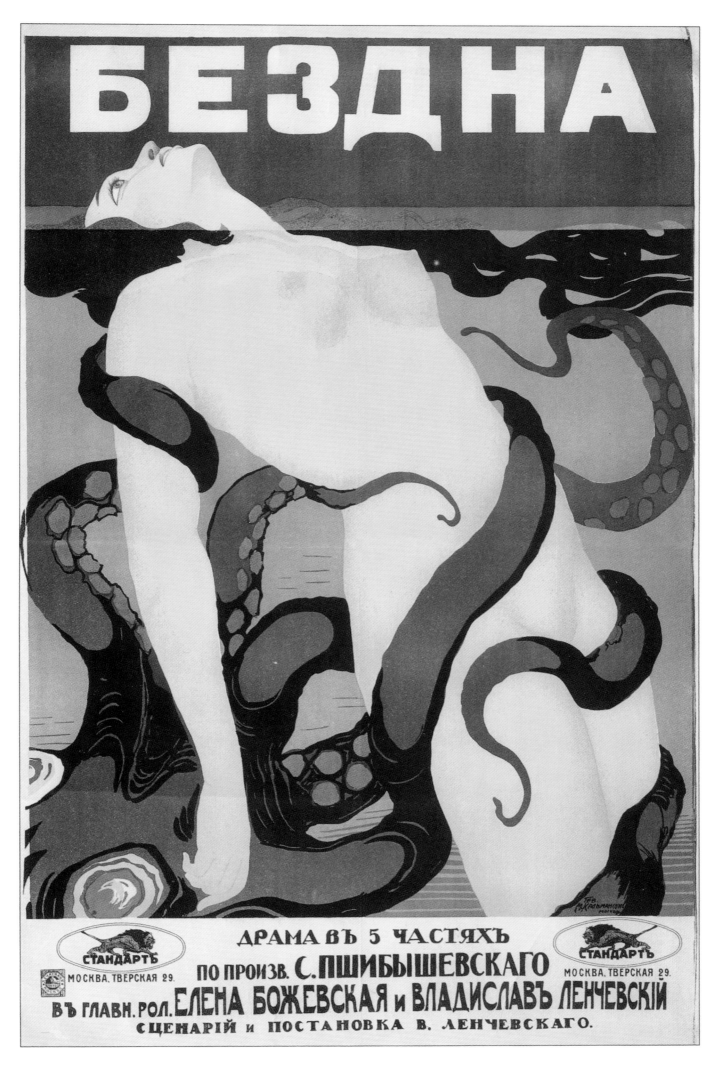

Mikhail Kalmanson The Abyss • Mijaíl Kálmanson El abismo

Mikhaïl Kalmanson L'abîme • Michail Kalmanson Der Abgrund

1917

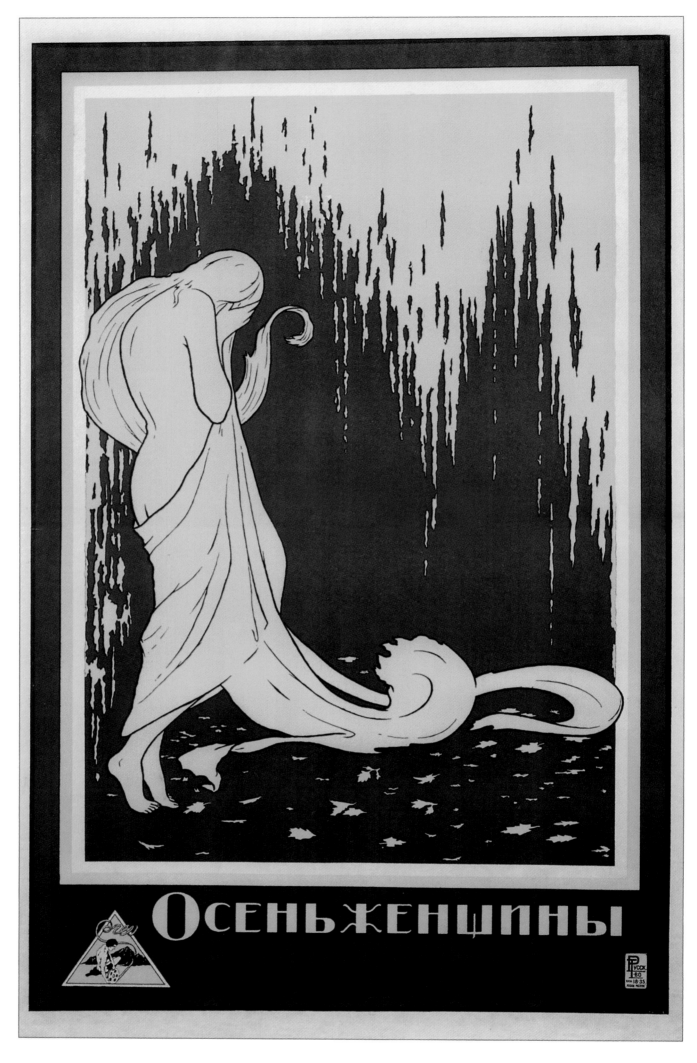

Anonymous A Woman's Autumn • Anónimo El otoño de una mujer
Anonyme L'automne d'une femme • Anonym Reife Jahre einer Frau
1917

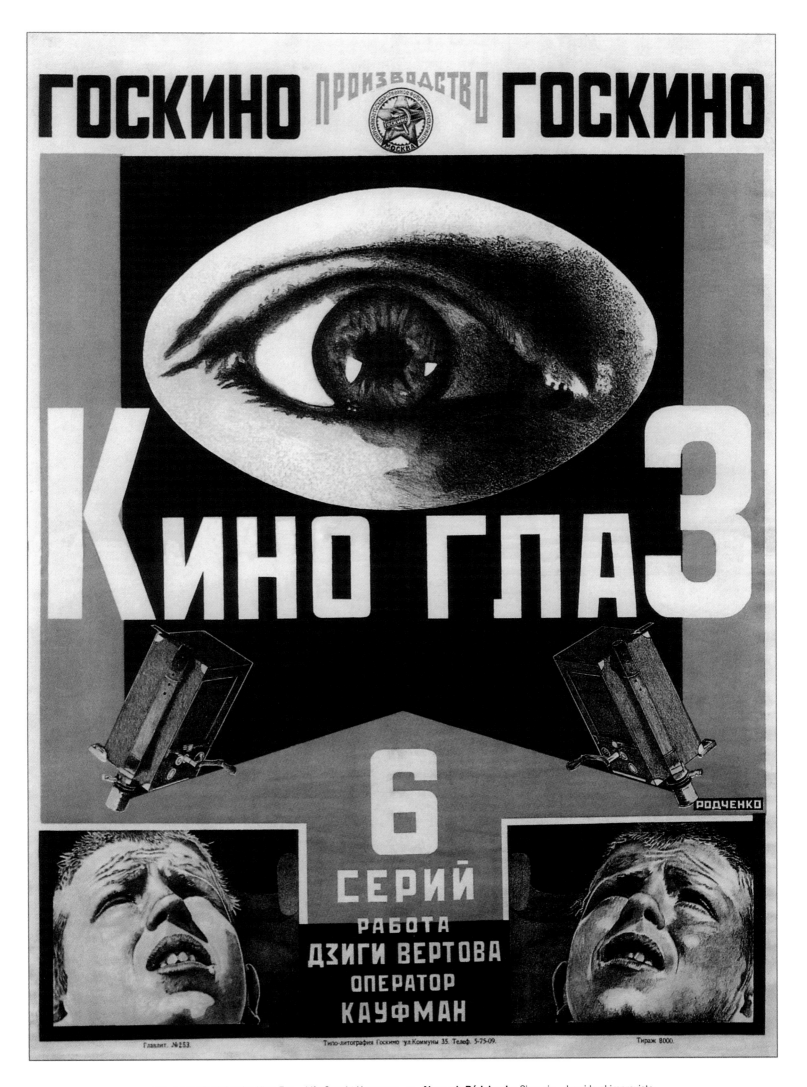

Alexander Rodchenko Kino-Eye – Life Caught Unawares • Alexandr Ródchenko Cine-ojo – La vida al improvisto
Alexandre Rodtchenko Ciné-Œil – La vie à l'improviste • Alexander Rodtschenko Kino-Auge

1924

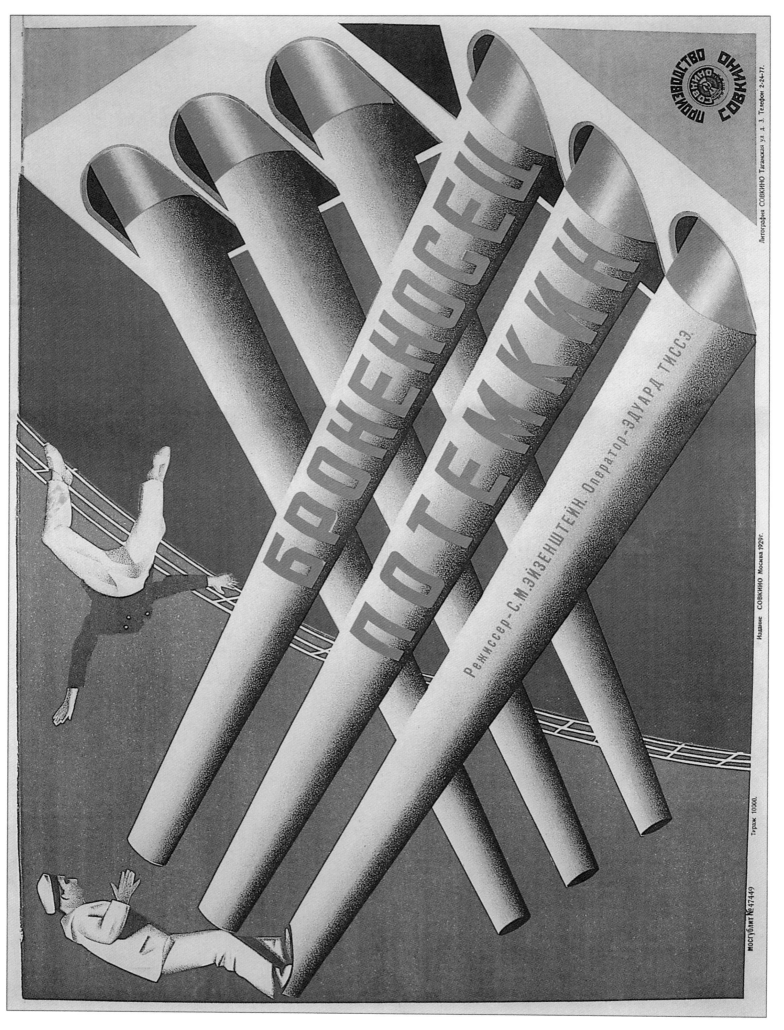

Georgi and Vladimir Stenberg Battleship Potemkin • Gueorgui y Vladimir Stenberg El acorazado Potemkin
Gueorgui et Vladimir Stenberg Le cuirassé Potemkine • Georgi und Wladimir Stenberg Panzerkreuzer Potemkin
1925

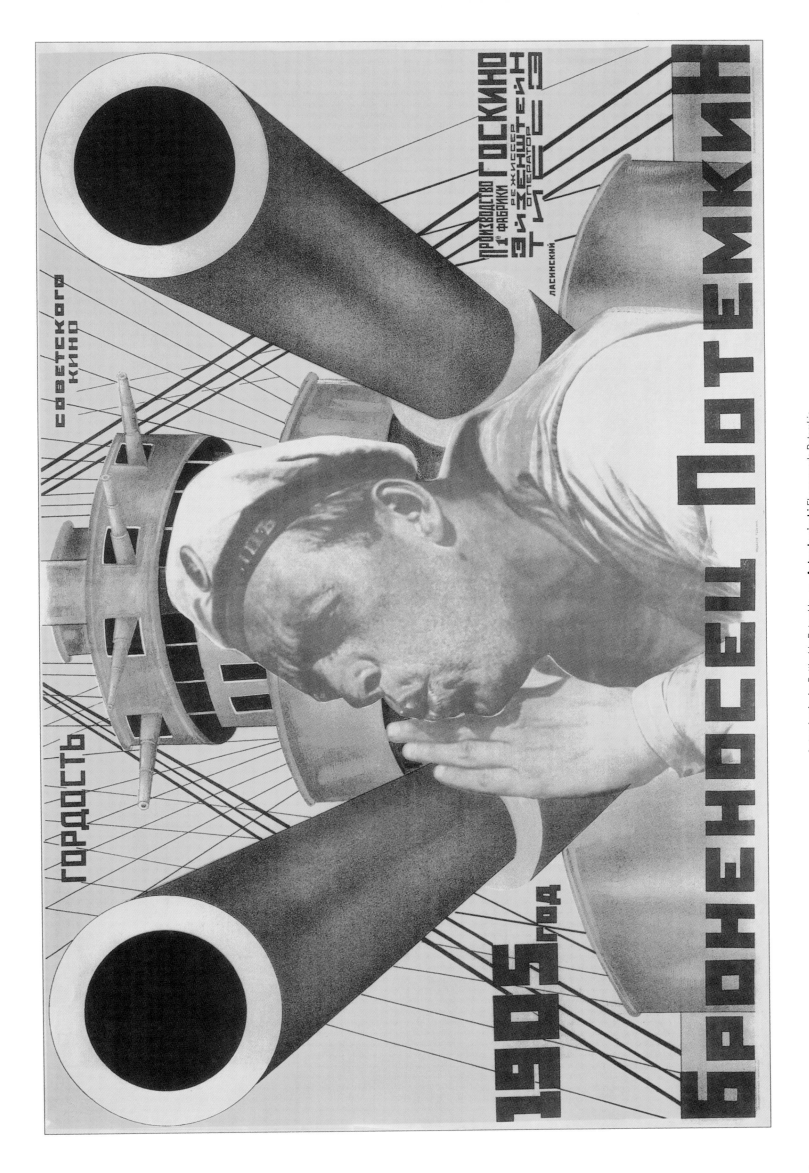

Anton Lavinsky Battleship Potemkin • Anton Lavinski El acorazado Potemkin
Anton Lavinski Le cuirassé Potemkine • Anton Lawinski Panzerkreuzer Potemkin
1926

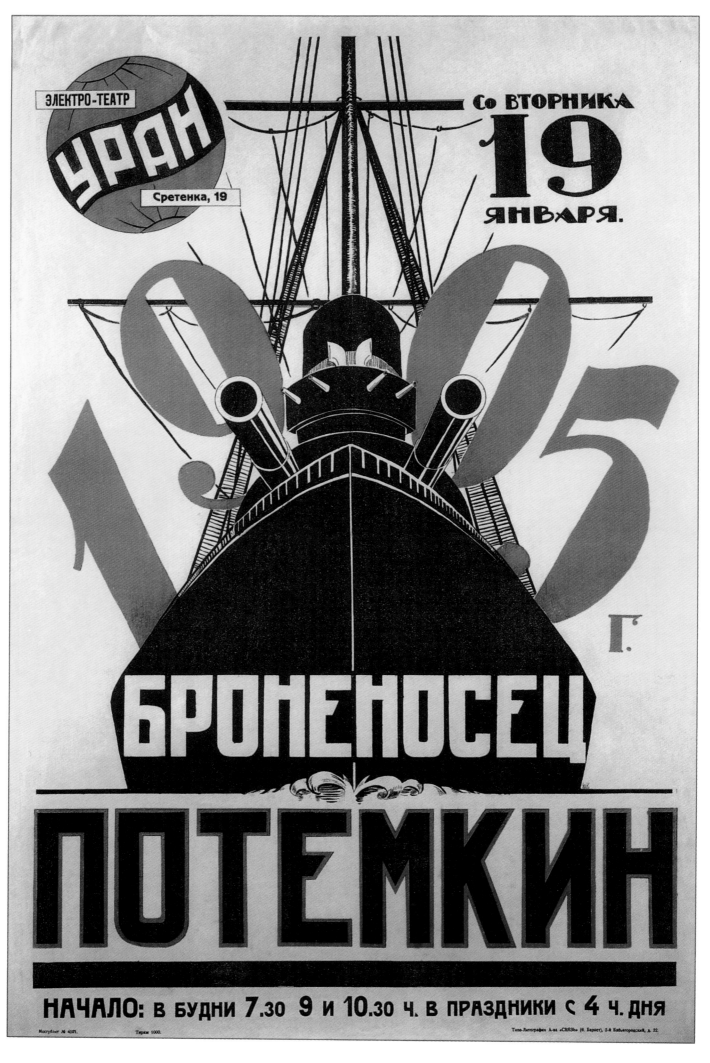

Anonymous Battleship Potemkin • Anónimo El acorazado Potemkin
Anonyme Le cuirassé Potemkine • Anonym Panzerkreuzer Potemkin
1926

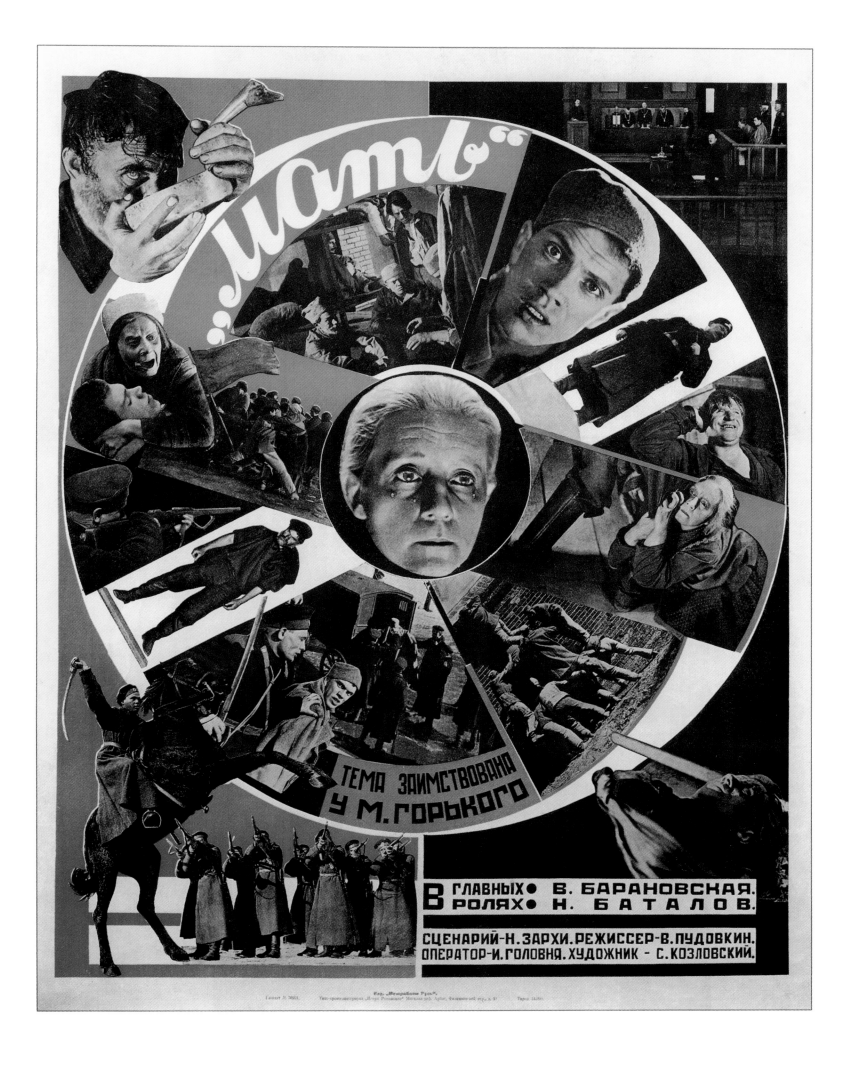

Anonymous Mother • Anónimo La madre
Anonyme La mère • Anonym Die Mutter
1926

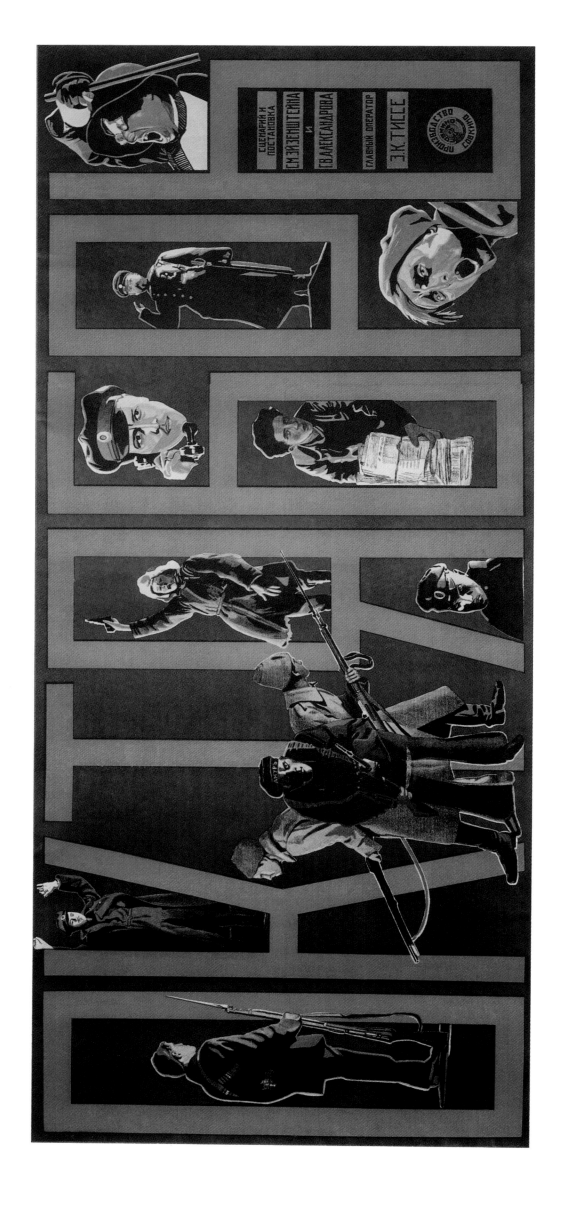

Anonymous October • **Anónimo** Octubre
Anonyme Octobre • **Anonym** Oktober
1927

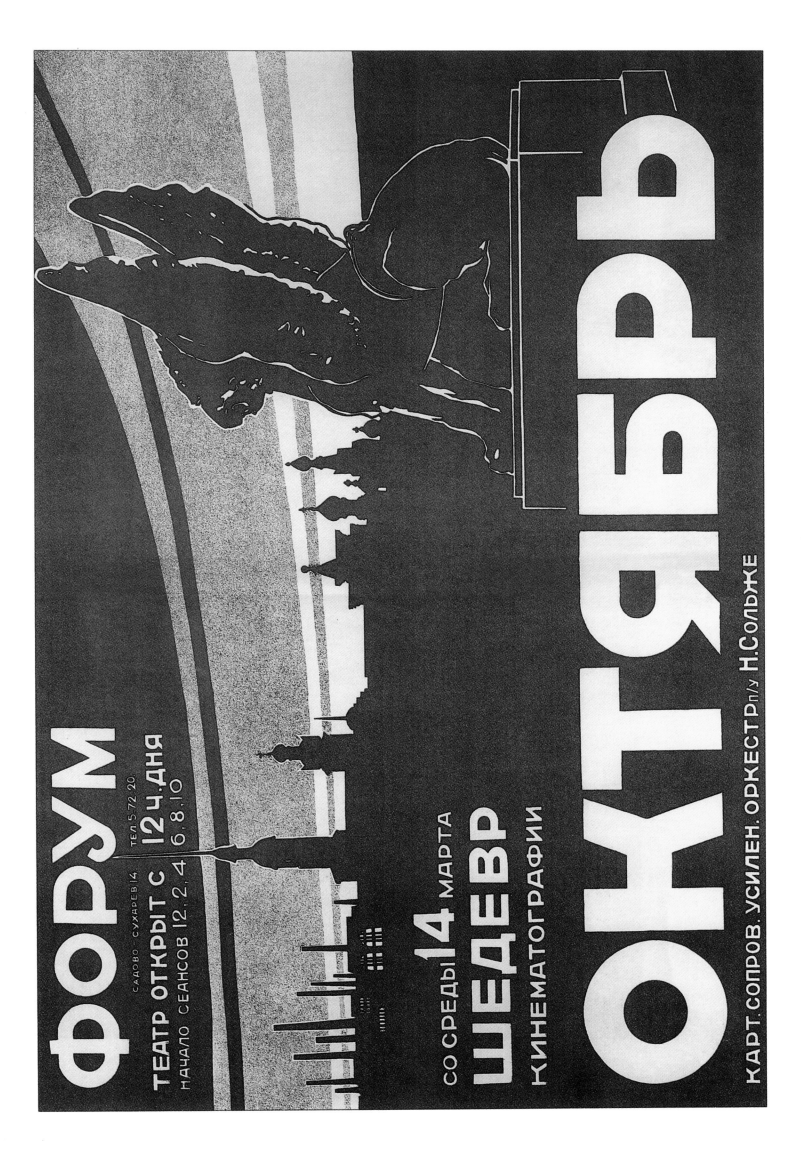

Anonymous October • **Anónimo** Octubre
Anonyme Octobre • **Anonym** Oktober

1927

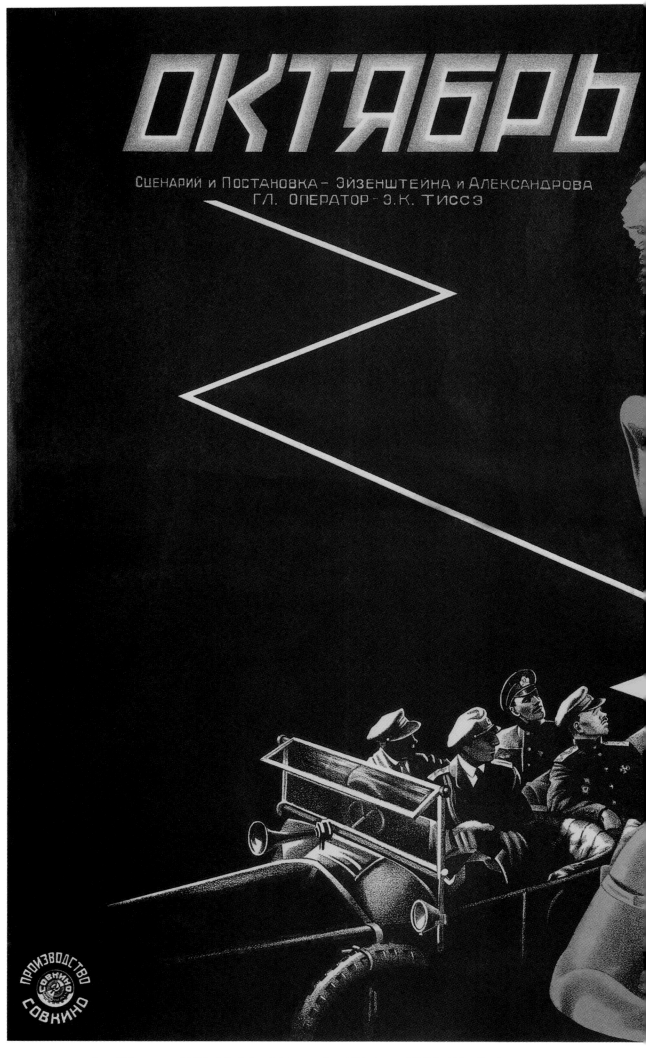

Leonid Voronov and Mikhail Evstafiev October • Leonid Vorónov y Mijaíl Evstáfiev Octubre
Léonid Voronov et Mikhaïl Evstafiev Octobre • Leonid Woronow und Michail Jewstafjew Oktober

1927

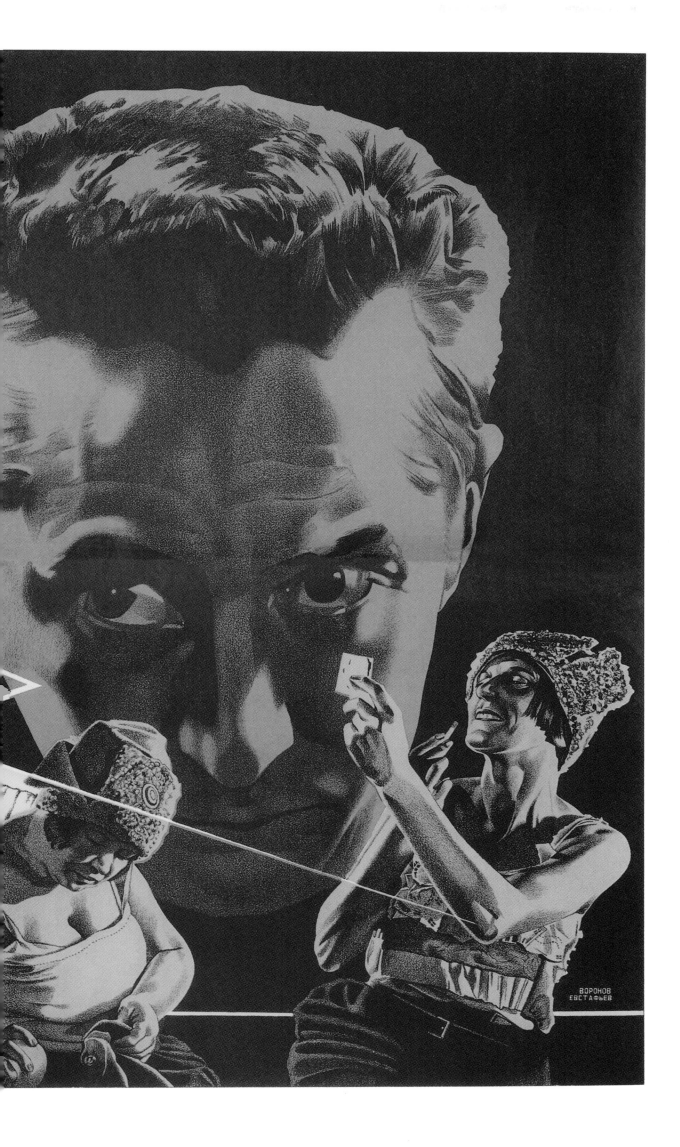

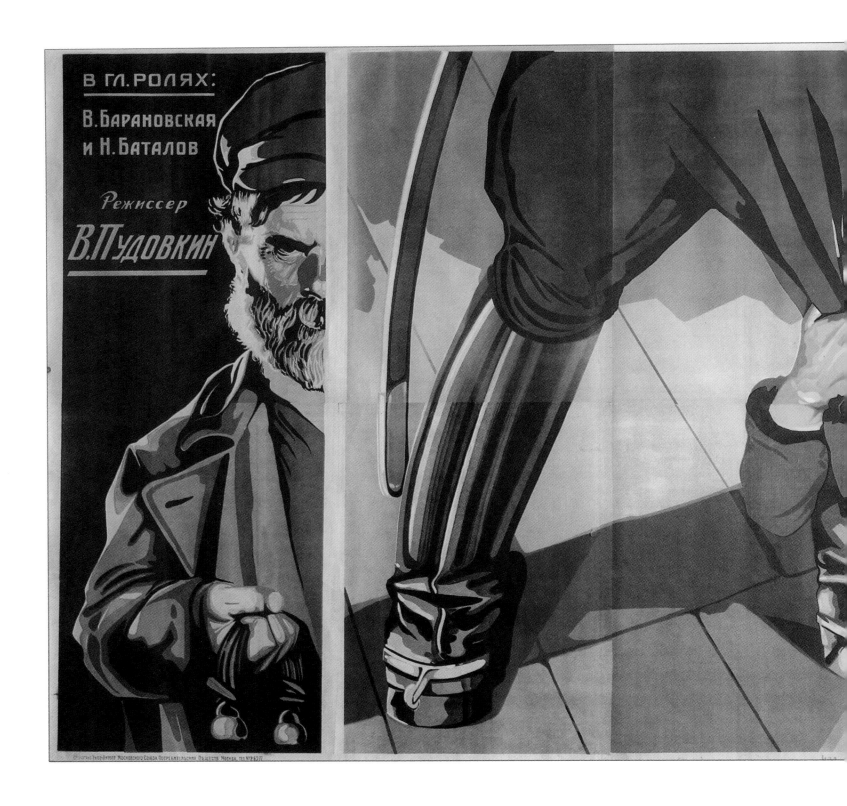

Izrail Bograd Mother • Israil Bograd La madre
Izraïl Bograd La mère • Israil Bograd Die Mutter
1926

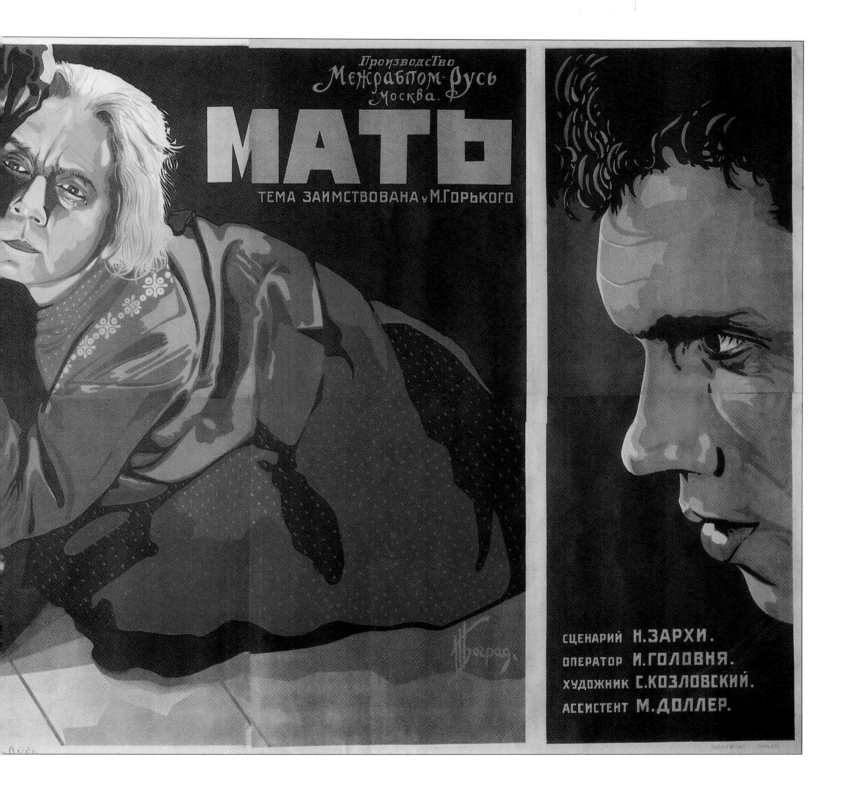

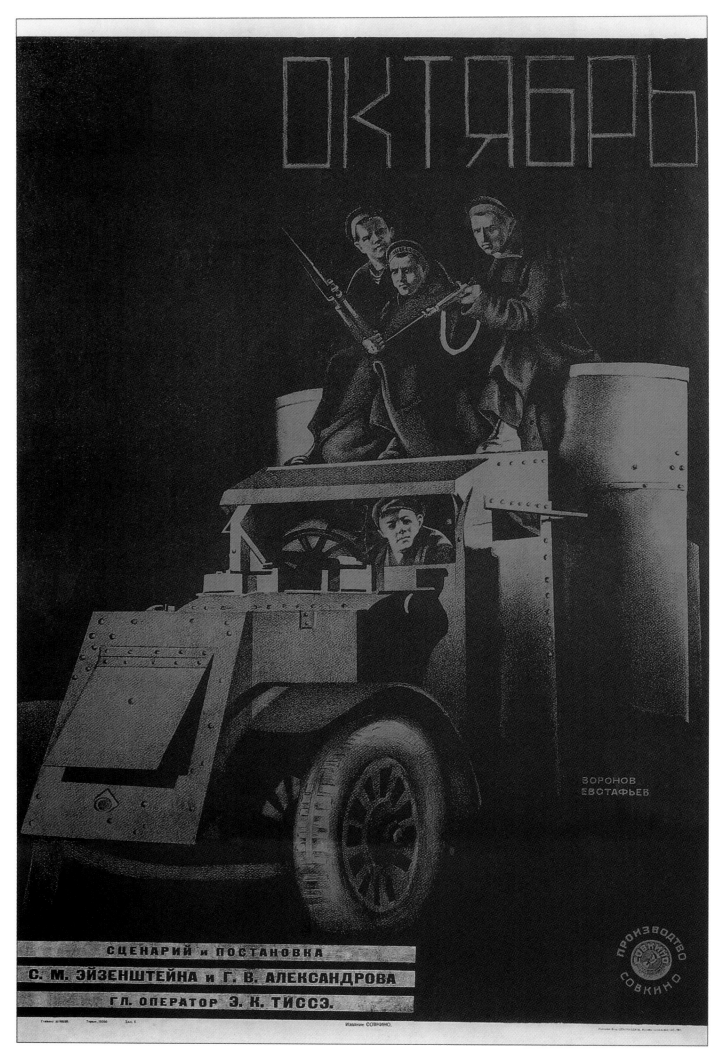

Leonid Voronov and Mikhail Evstafiev October • Leonid Vorónov y Mijaíl Evstáfiev Octubre
Léonid Voronov et Mikhaïl Evstafiev Octobre • Leonid Woronow und Michail Jewstafjew Oktober
1927

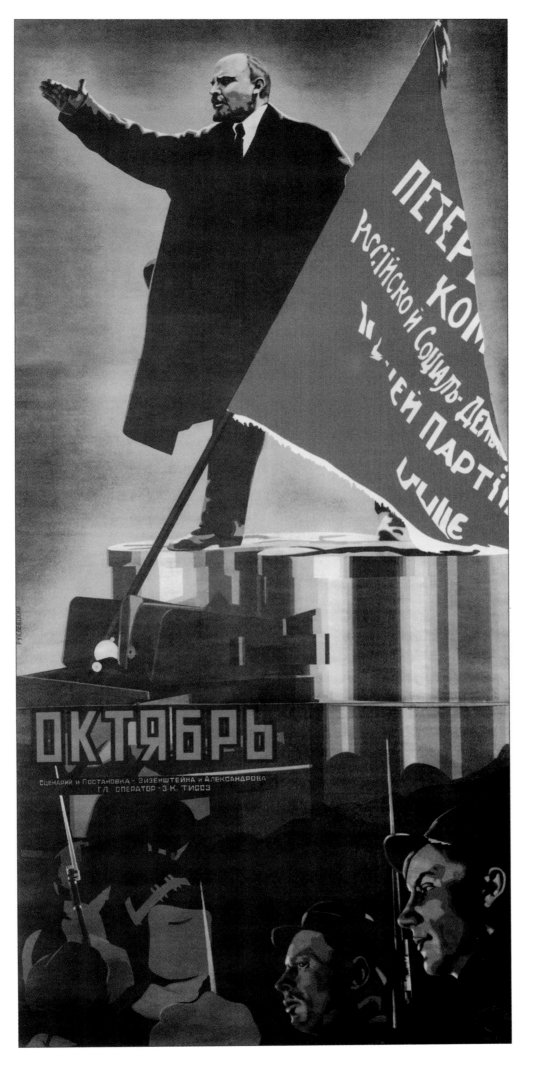

Yakov Ruklevsky October • **Yákov Ruklevski** Octubre
Yakov Rouklevski Octobre • **Jakow Ruklewski** Oktober

1927

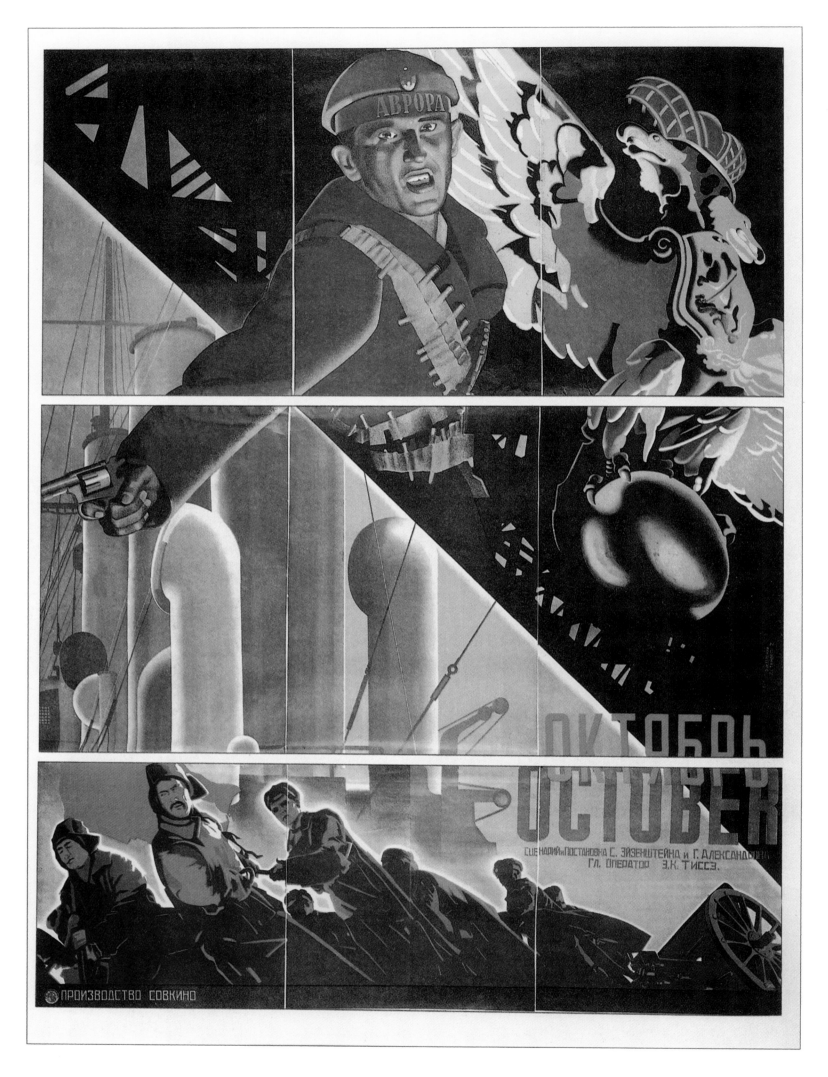

Georgi and Vladimir Stenberg, Yakov Ruklevsky October • Gueorgui y Vladímir Stenberg, Yákov Ruklevski Octubre
Guéorgui et Vladimir Stenberg, Yakov Rouklevski Octobre • Georgi und Wladimir Stenberg, Jakow Ruklewski Oktober
1927

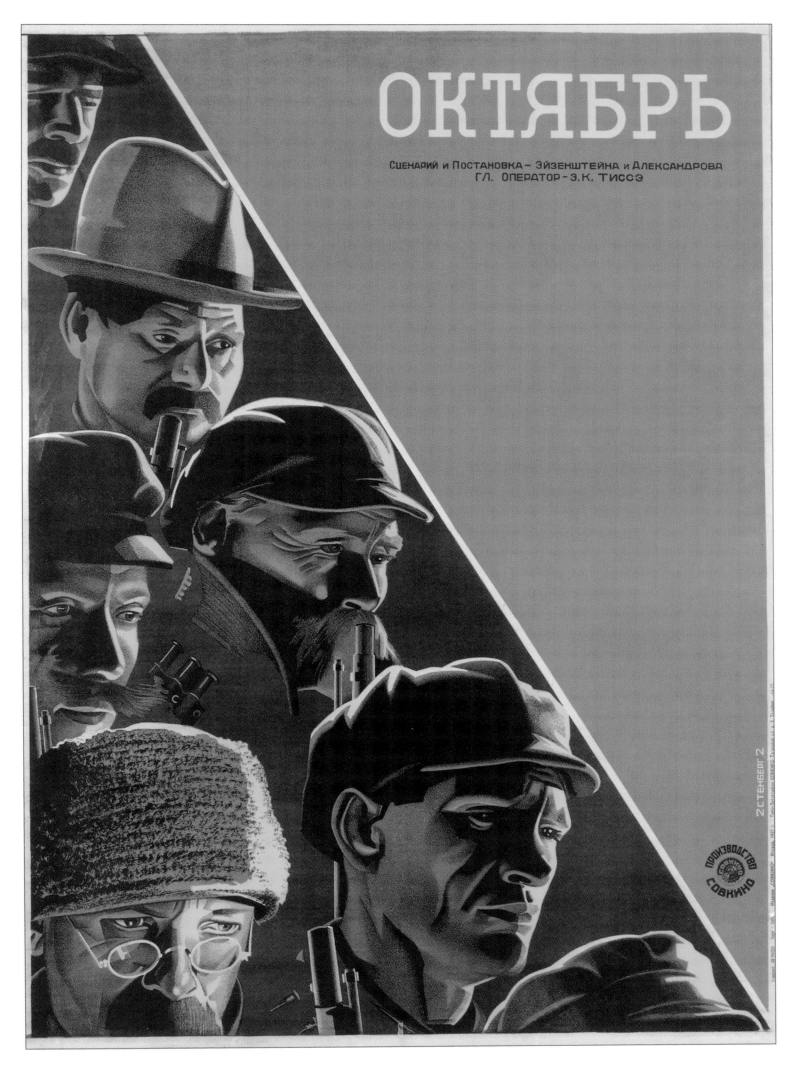

Georgi and Vladimir Stenberg October • Gueorgui y Vladímir Stenberg Octubre

Guéorgui et Vladimir Stenberg Octobre • Georgi und Wladimir Stenberg Oktober

1927

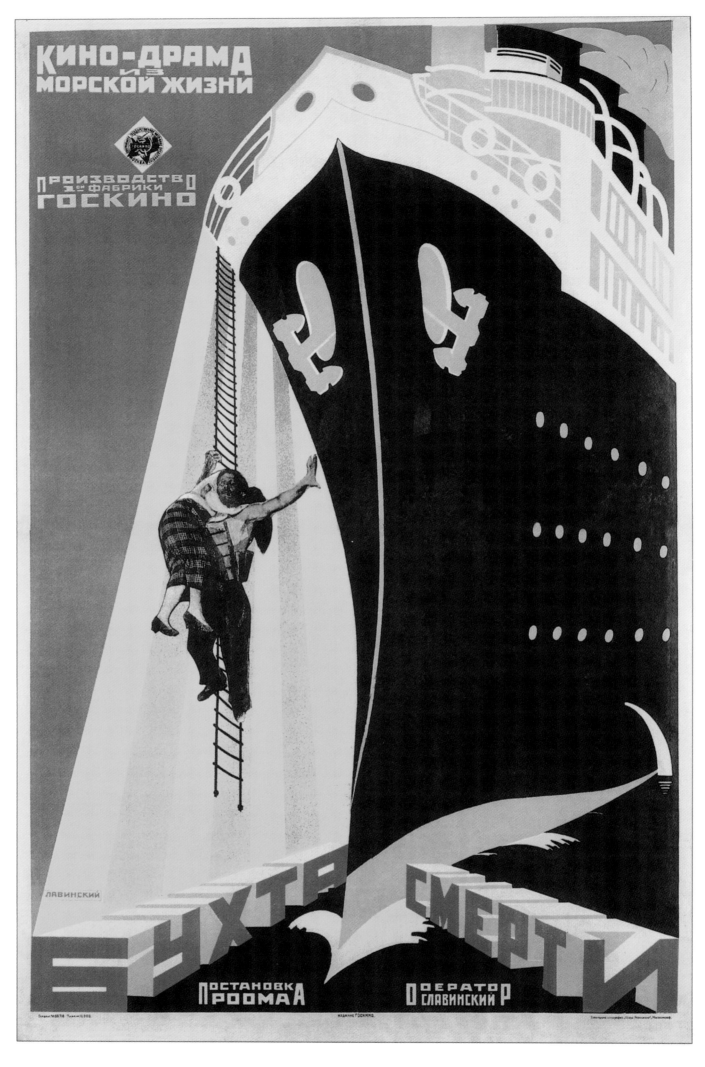

Anton Lavinsky Death Bay • Anton Lavinski La bahía de la muerte
Anton Lavinski La baie de la mort • Anton Lawinski Die Todesbucht

1926

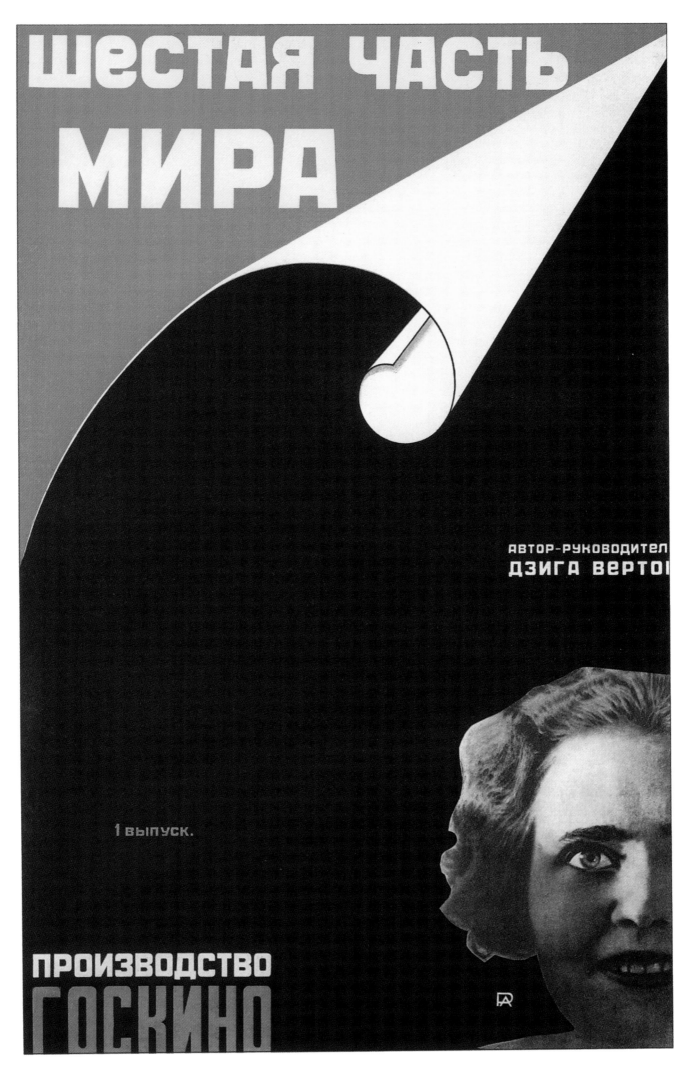

Alexander Rodchenko A Sixth of the World • Alexandr Ródchenko La sexta parte del mundo
Alexandre Rodtchenko La sixième partie du monde • Alexander Rodtschenko Ein Sechstel der Erde

1927

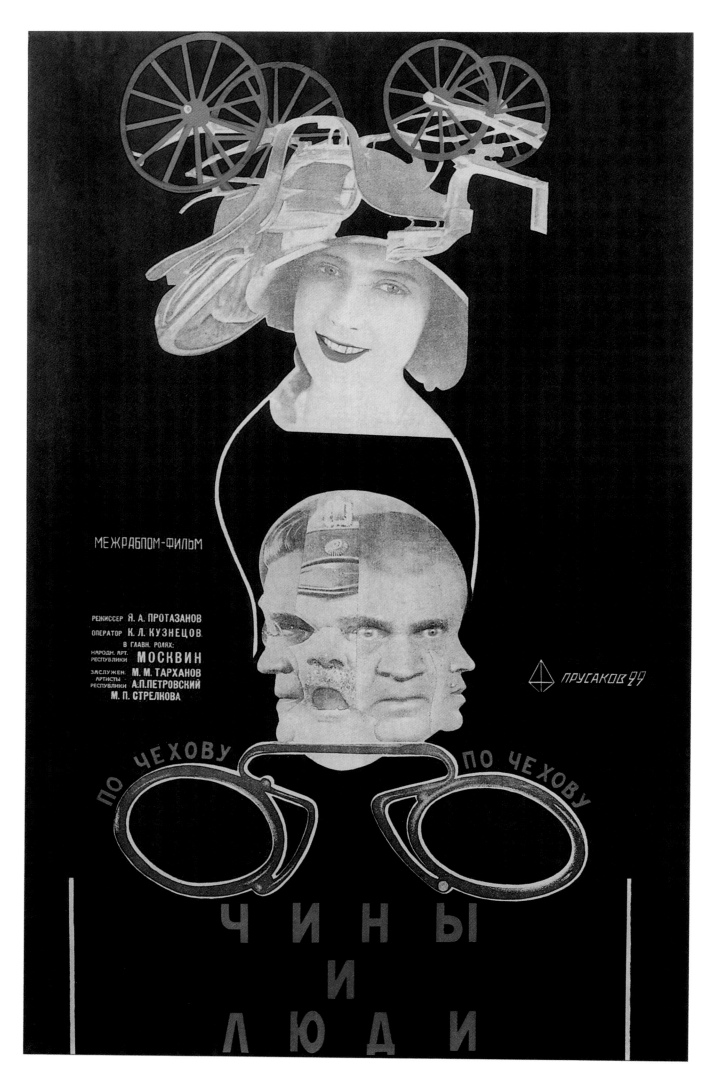

Nikolai Prusakov The Ranks and the People • Nikolai Prusákov Los funcionarios y la gente
Nicolas Prousakov Les tout-puissants et le peuple • Nikolai Prusakow Ränge und Menschen
1929

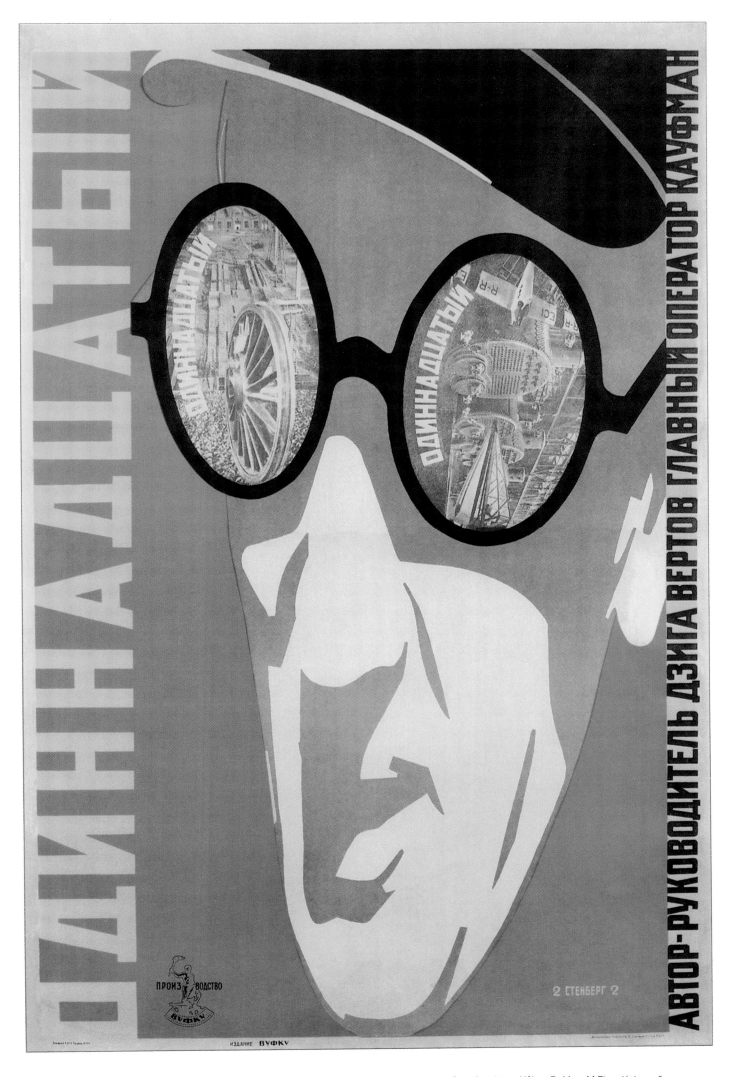

Georgi and Vladimir Stenberg, Yakov Ruklevsky The Eleventh Year • Gueorgui y Vladímir Stenberg, Yákov Ruklevski El undécimo año

Guéorgui et Vladimir Stenberg, Yakov Rouklevski La onzième année • Georgi und Wladimir Stenberg, Jakow Ruklewski Das elfte Jahr

1928

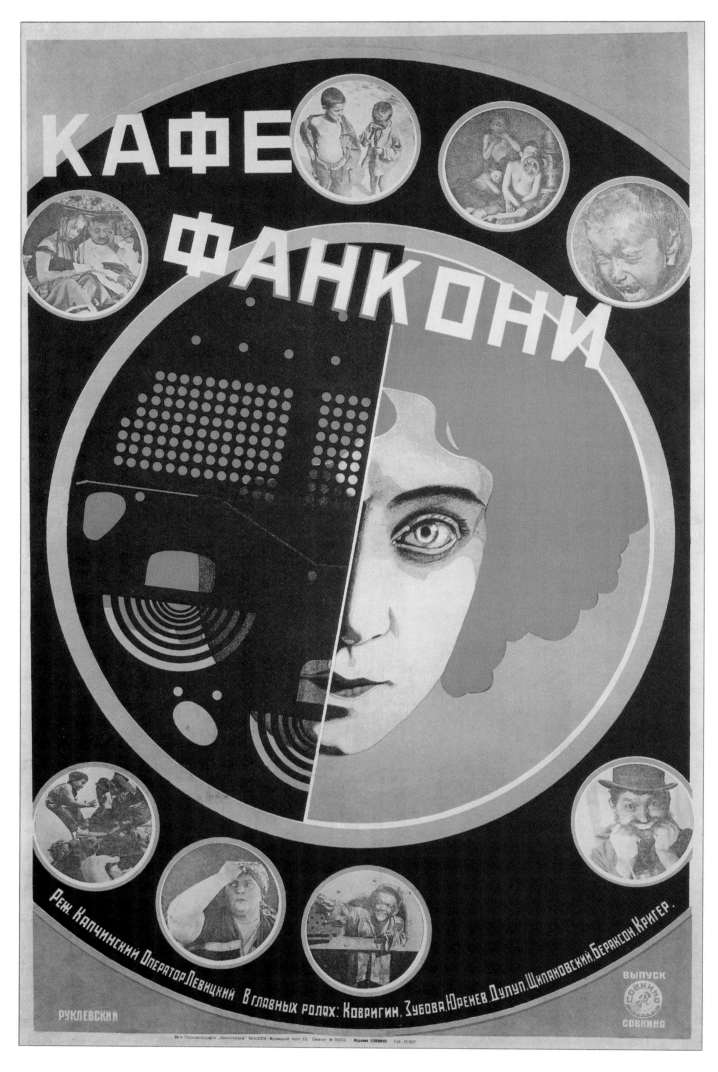

Yakov Ruklevsky Café Fanconi • Yákov Ruklevski Café Fanconi

Yakov Rouklevski Café Fanconi • Jakow Ruklewski Café Fanconi

1927

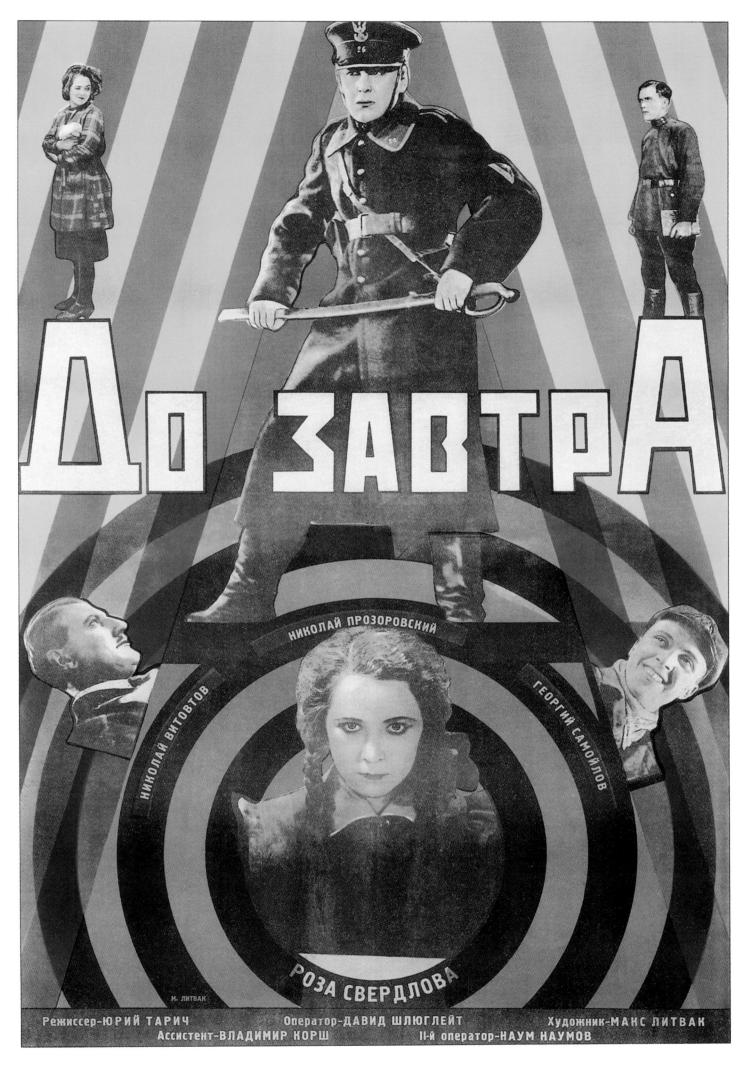

Max Litvak Until Tomorrow • Max Lítvak Hasta mañana
Max Litvak À demain • Max Litwak Bis morgen
1929

Grigori Borisov and Nikolai Prusakov The House on Trubnaya Square • Grigori Borisov y Nikolai Prusakov La casa de la plaza Trubnaya
Grigori Borisov und Nikolai Prusakow Das Haus am Trubnaja-Platz • Grigori Borisov et Nicolas Prousakov La maison de la place Troubnaia
1928

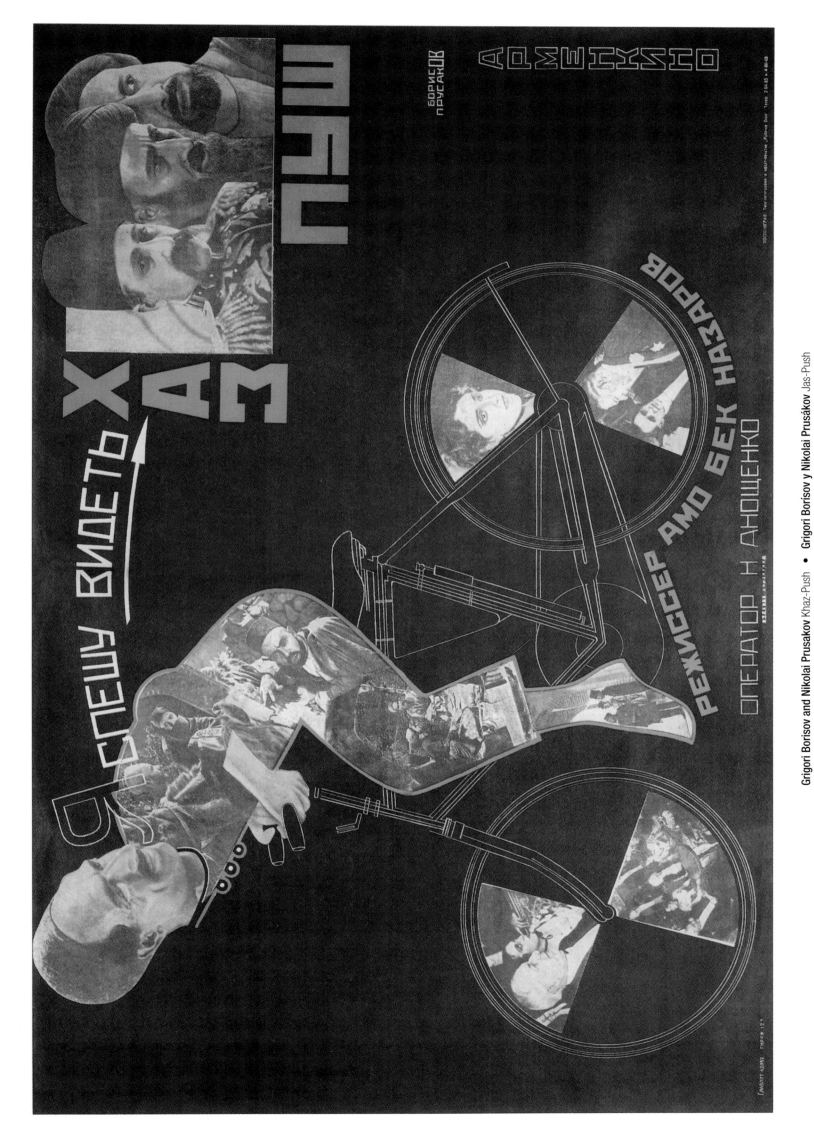

Grigori Borisov and Nikolai Prusakov Khaz-Push • Grigori Borisov y Nikolai Prusakov Jas-Push
Grigori Borisov et Nicolas Prousakov Khaz-Push • Grigori Borisov und Nikolai Prousakov Chaz-Pusch
1928

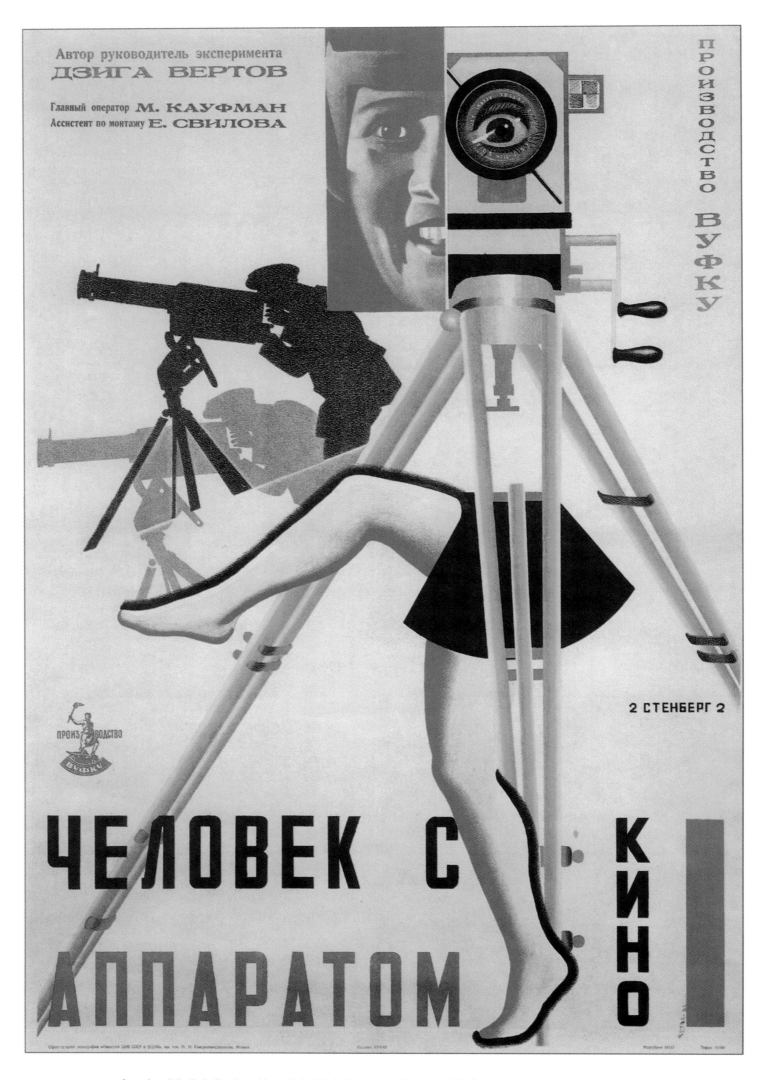

Georgi and Vladimir Stenberg Man with the Movie Camera • Gueorgui y Vladímir Stenberg El hombre con la cámara
Guéorgui et Vladimir Stenberg L'homme à la caméra • Georgi und Wladimir Stenberg Der Mann mit der Kamera
1929

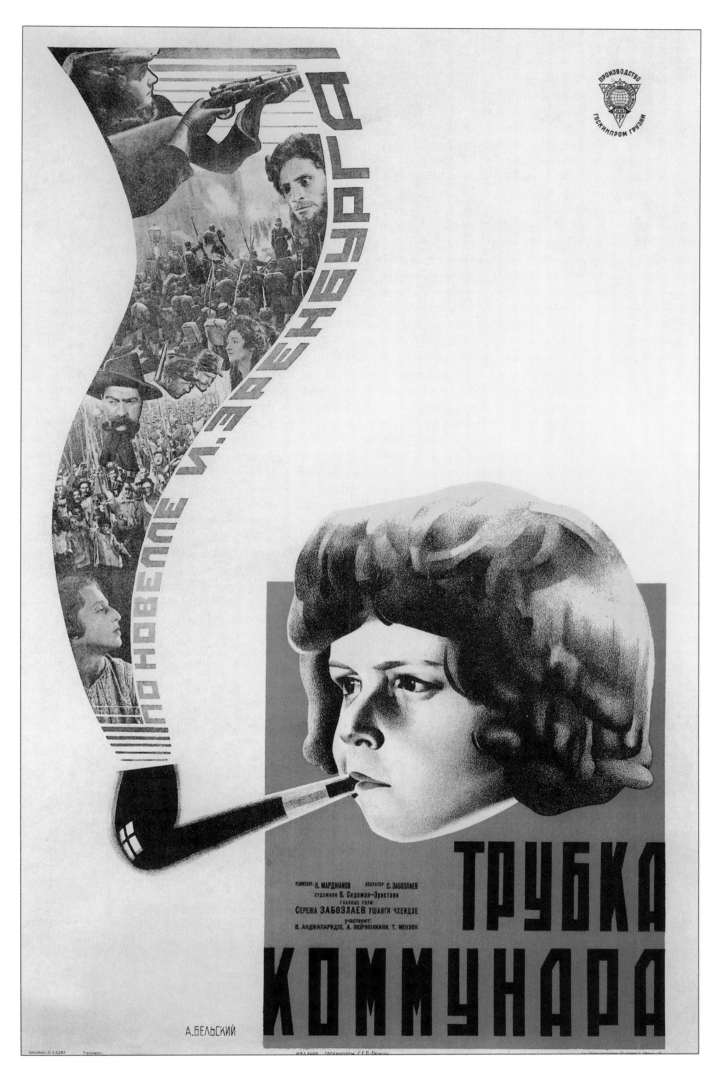

Anatoly Belsky The Communard's Pipe • **Anatoli Belski** La pipa del partidario de la Comuna
Anatoli Belski La pipe du communard • **Anatoli Belski** Die Pfeife des Kommunarden

1929

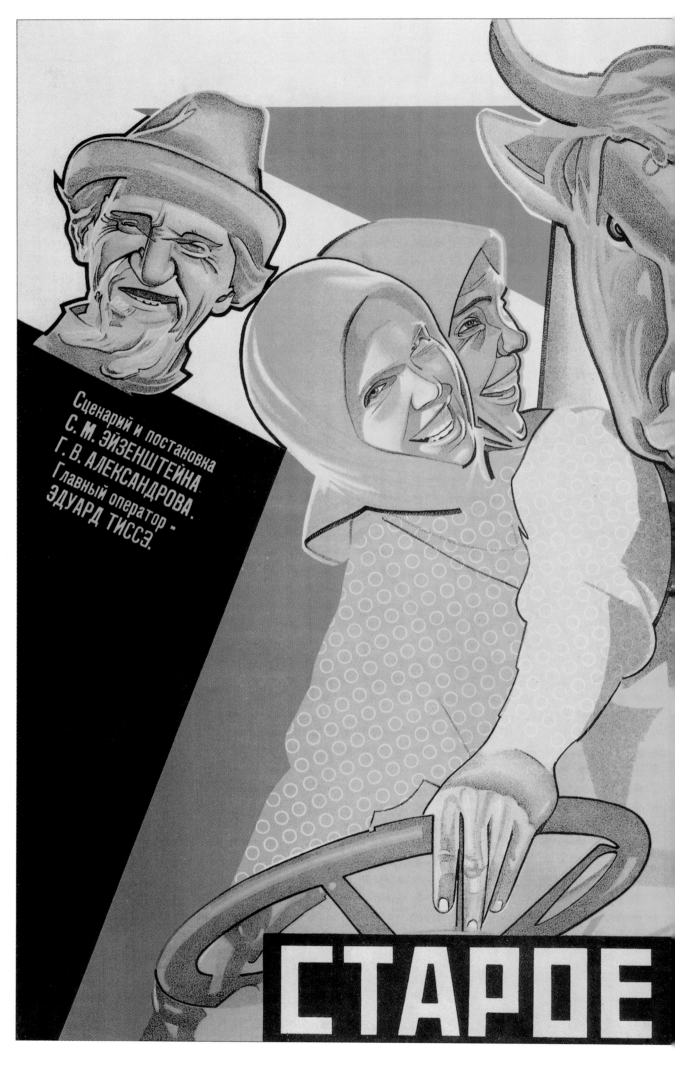

Nikolai Prusakov The General Line (Old and New) • Nikolai Prusákov La línea general (Lo viejo y lo nuevo)
Nicolas Prousakov La ligne générale (L'Ancien et le Nouveau) • Nikolai Prusakow Die Generallinie (Das Alte und das Neue)

1929

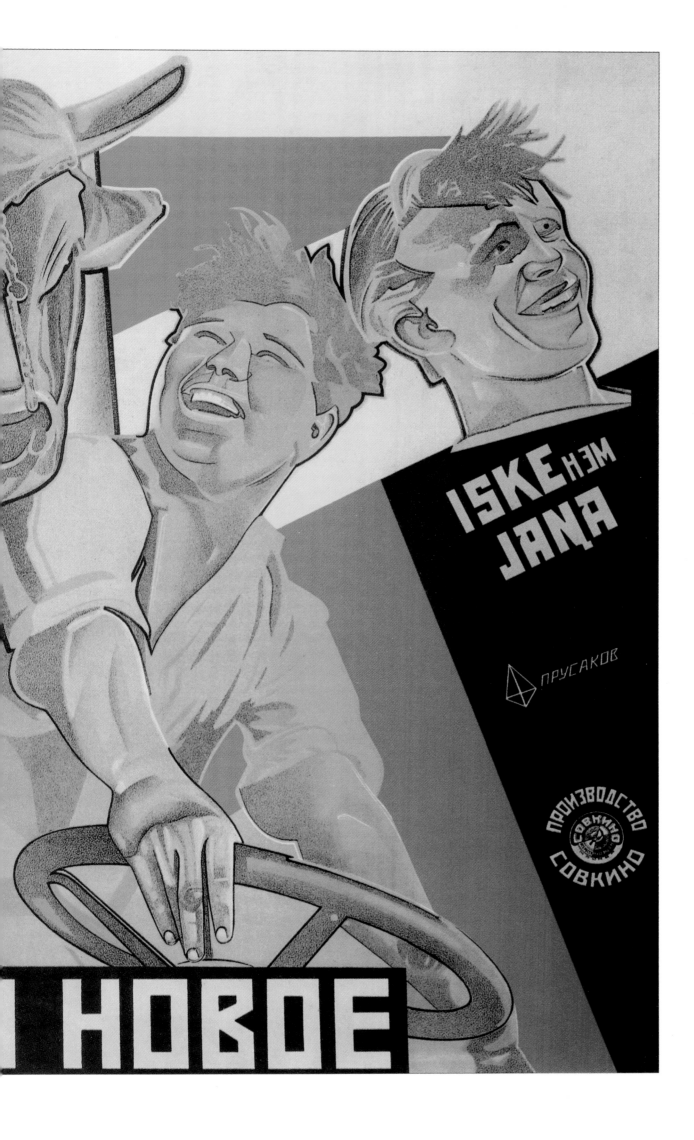

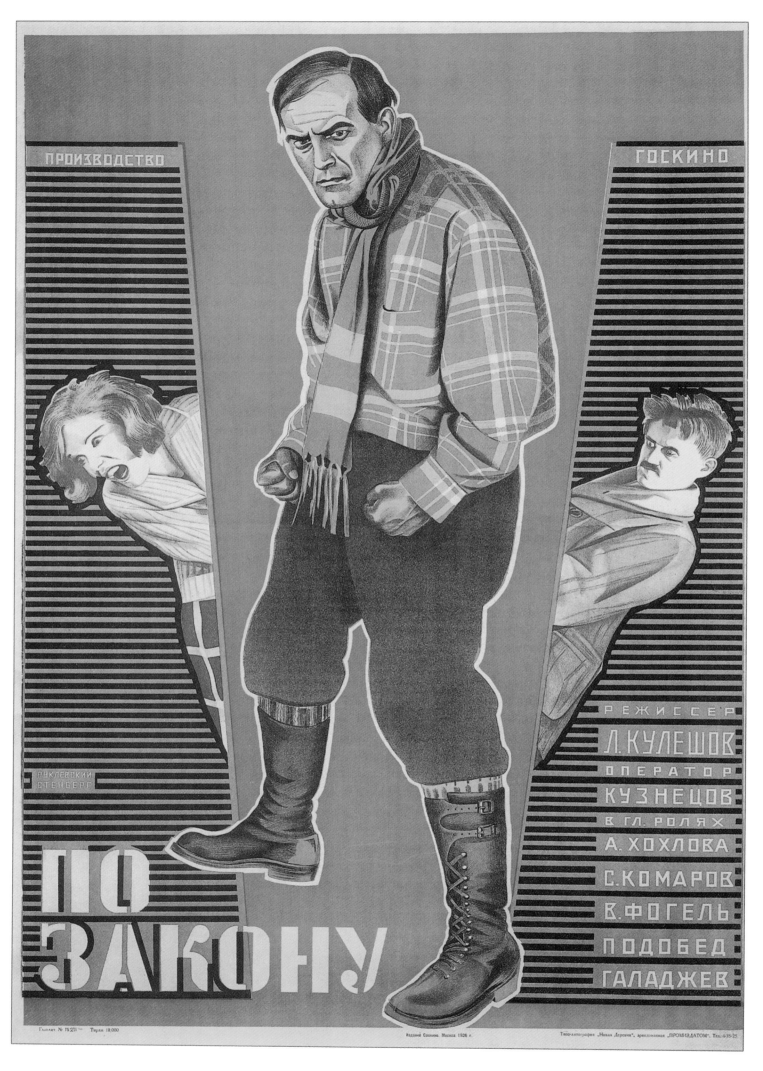

Georgi and Vladimir Stenberg, Yakov Ruklevsky By the Law • Gueorgui y Vladímir Stenberg, Yákov Ruklevski Por la ley
Guéorgui et Vladimir Stenberg, Yakov Rouklevski Selon la loi • Georgi und Wladimir Stenberg, Jakow Ruklewski Nach dem Gesetz

1926

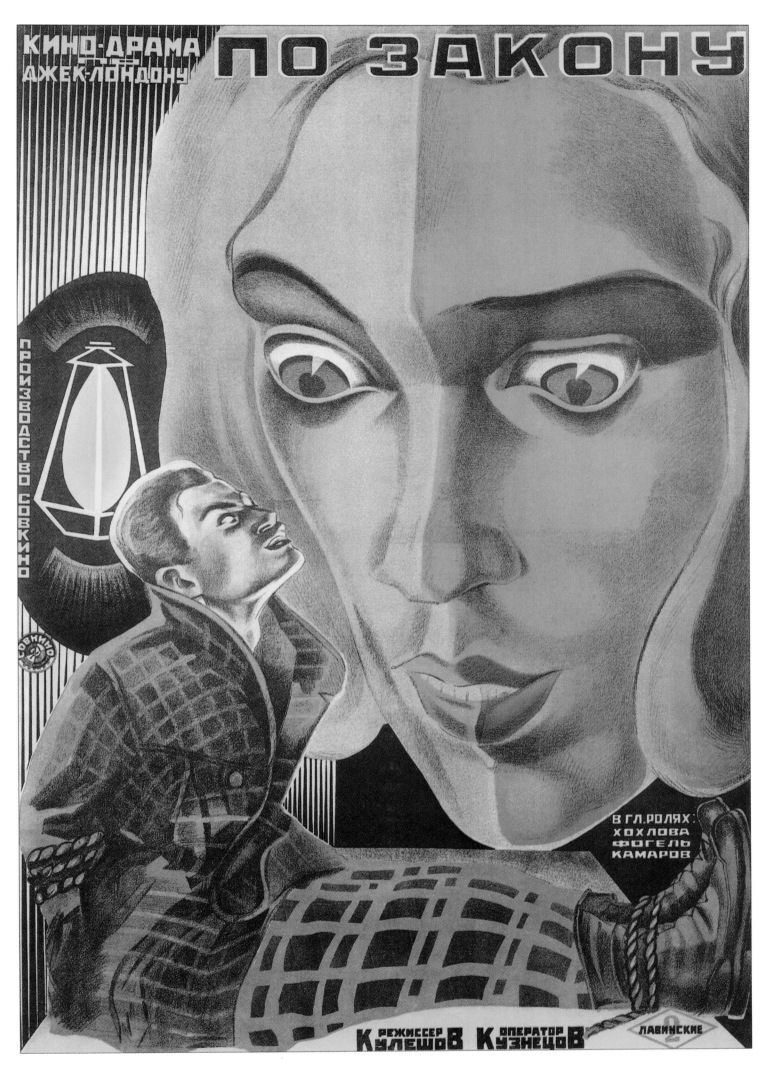

Anton Lavinsky By the Law • Anton Lavinski Por la ley

Anton Lavinski Selon la loi • Anton Lawinski Nach dem Gesetz

1926

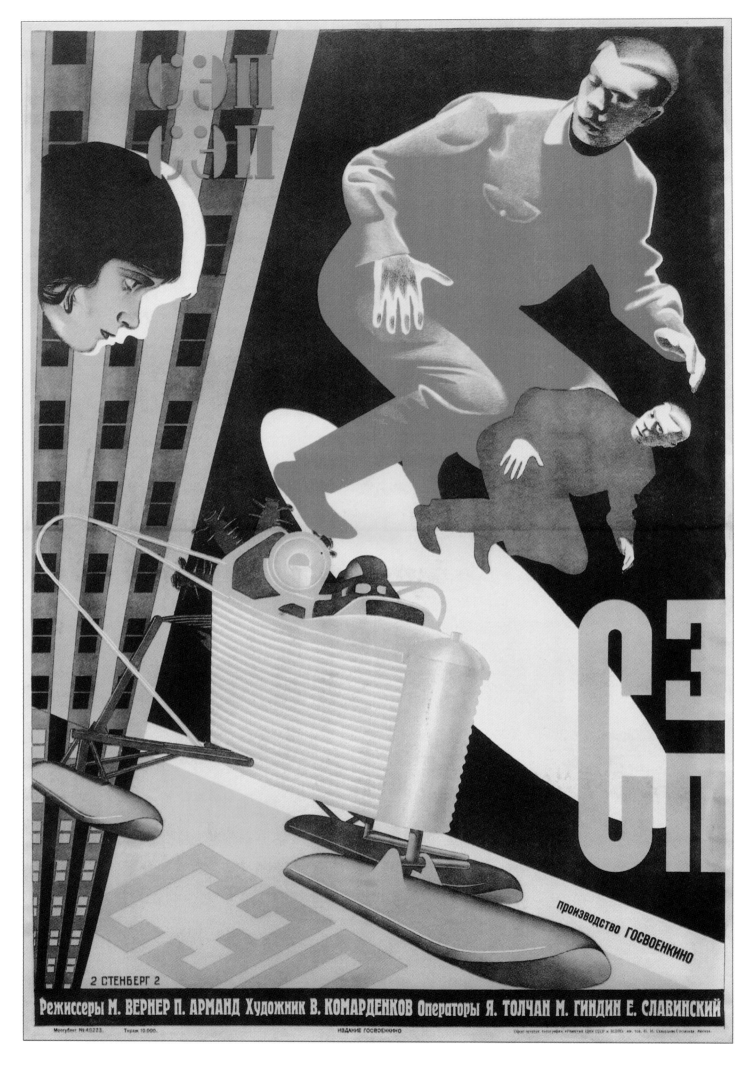

Georgi and Vladimir Stenberg SEP • Gueorgui y Vladímir Stenberg SEP

Guéorgui et Vladimir Stenberg SEP • Georgi und Wladimir Stenberg SEP

1929

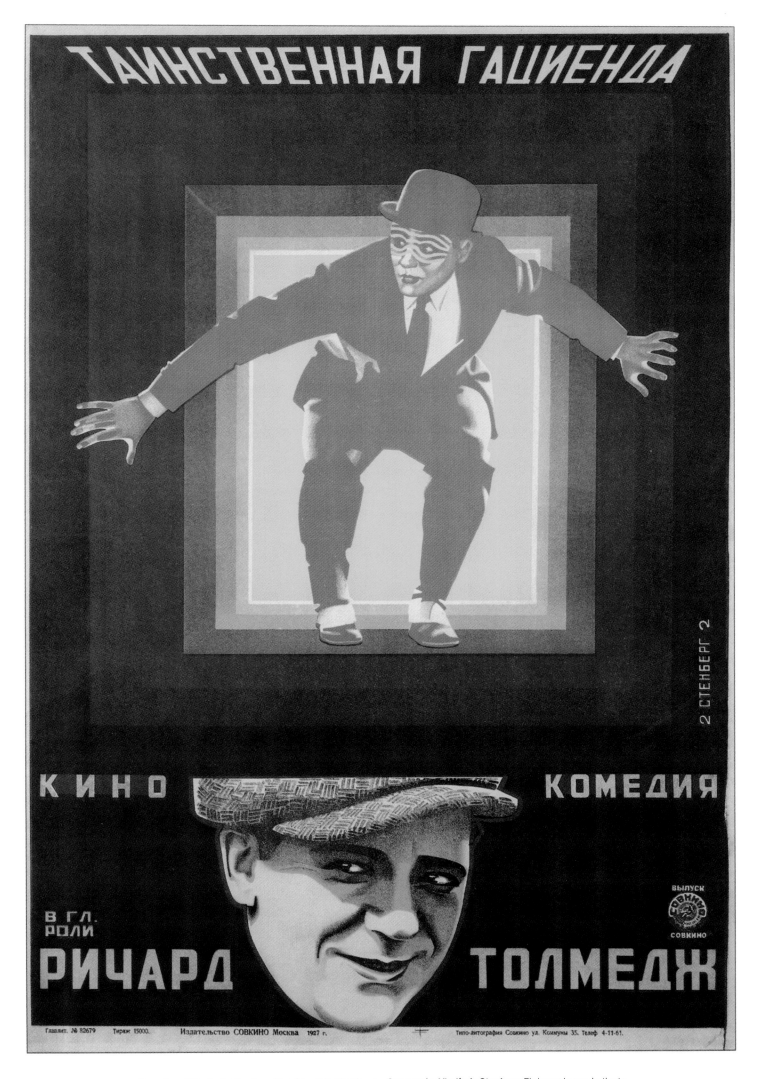

Georgi and Vladimir Stenberg The Secret Hacienda • Gueorgui y Vladímir Stenberg El demonio combatiente

Guéorgui et Vladimir Stenberg L'hacienda mystérieuse • Georgi und Wladimir Stenberg Die geheime Hazienda

1927

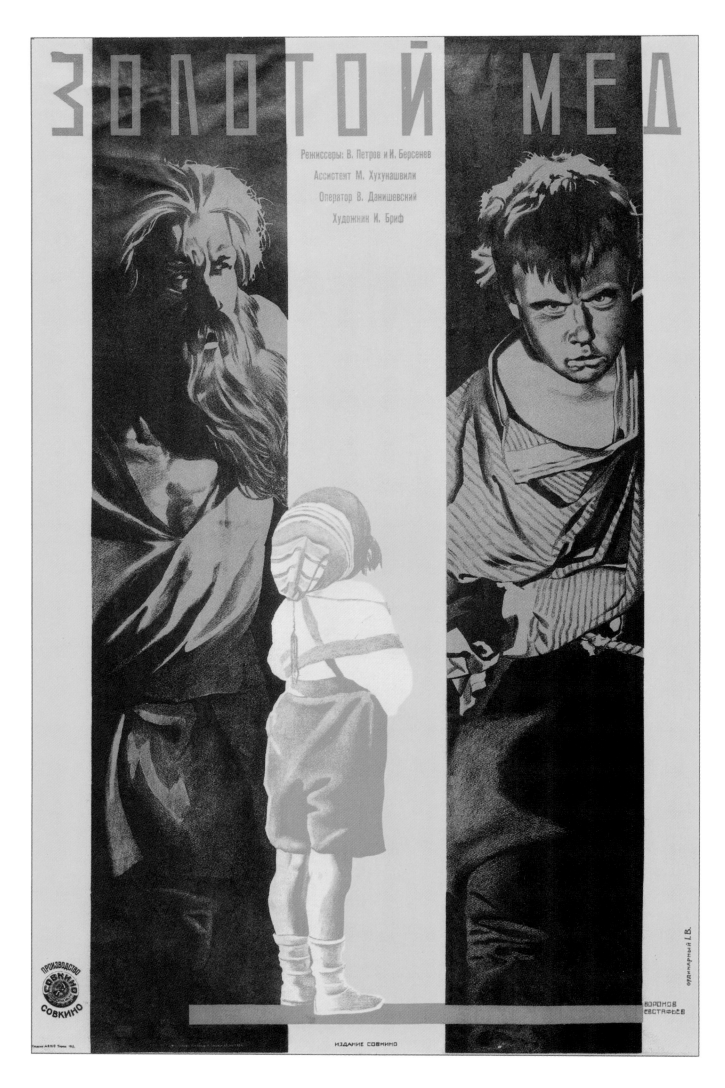

Leonid Voronov and Mikhail Evstafiev Golden Honey • Leonid Vorónov y Mijaíl Evstáfiev Luna de miel

Léonid Voronov et Mikhaïl Evstafiev Miel d'Or • Leonid Woronow und Michail Jewstafjew Goldener Honig

1928

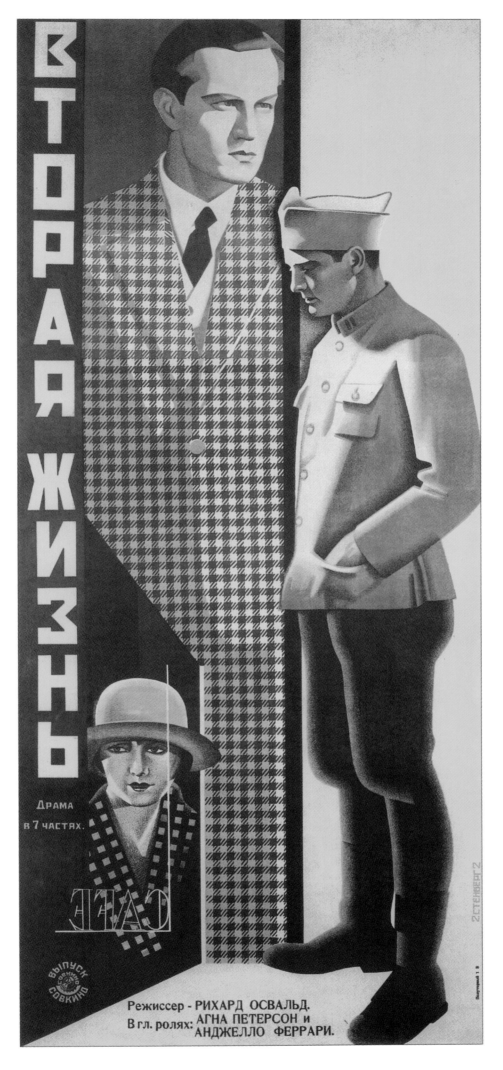

Georgi and Vladimir Stenberg The Second Life • Gueorgui y Vladímir Stenberg La segunda vida
Guéorgui et Vladimir Stenberg La seconde vie • Georgi und Wladimir Stenberg Das zweite Leben

1928

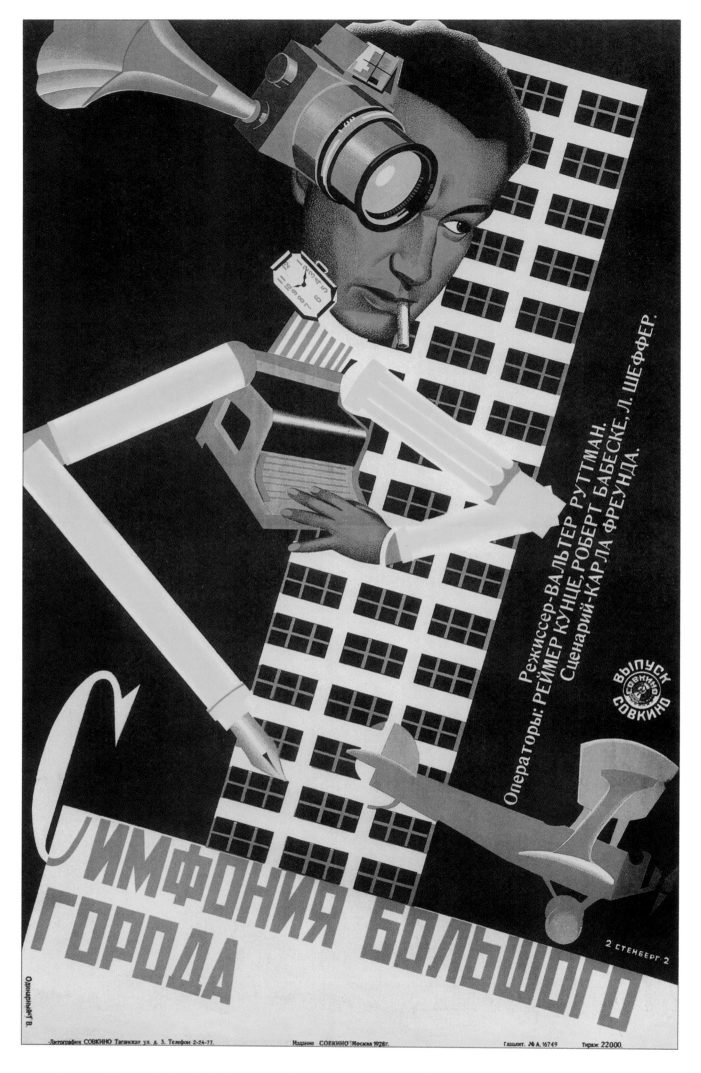

Georgi and Vladimir Stenberg Berlin: Symphony of a Great City • Gueorgui y Vladímir Stenberg Berlín: sinfonía de una gran ciudad
Guéorgui et Vladímir Stenberg Berlin: Symphonie d'une grande ville • Georgi und Wladimir Stenberg Berlin: Die Sinfonie der Großstadt

1928

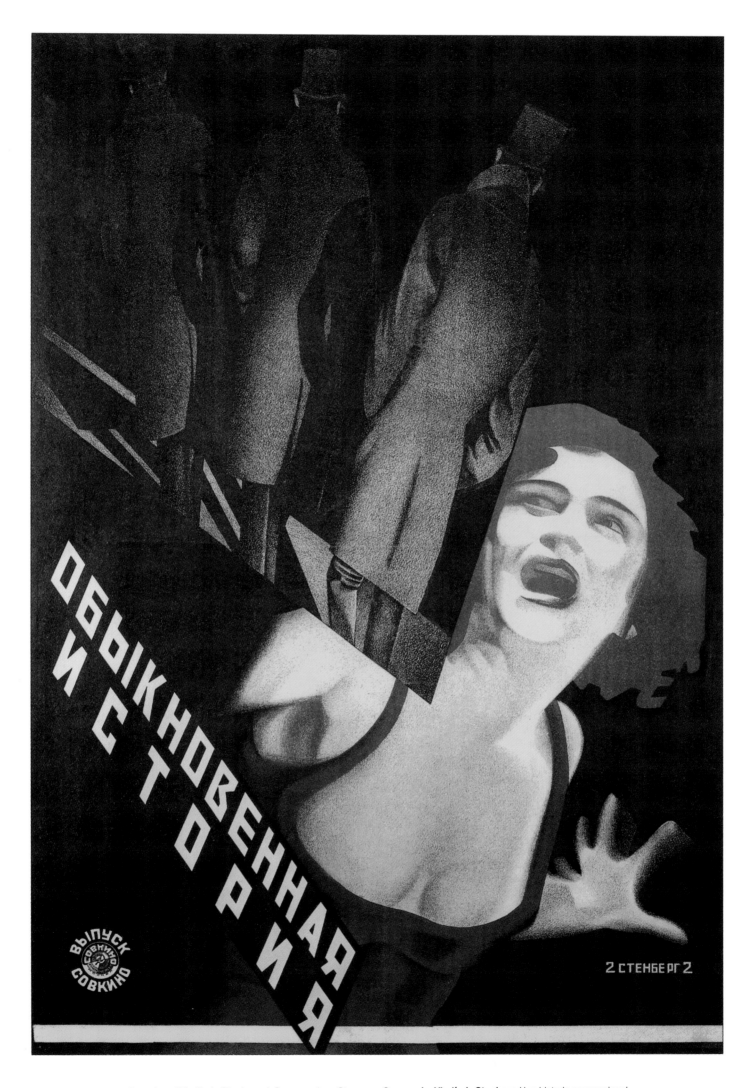

Georgi and Vladimir Stenberg A Commonplace Story • Gueorgui y Vladímir Stenberg Una historia convencional
Guéorgui et Vladimir Stenberg Une histoire ordinaire • Georgi und Wladimir Stenberg Eine gewöhnliche Geschichte

1927

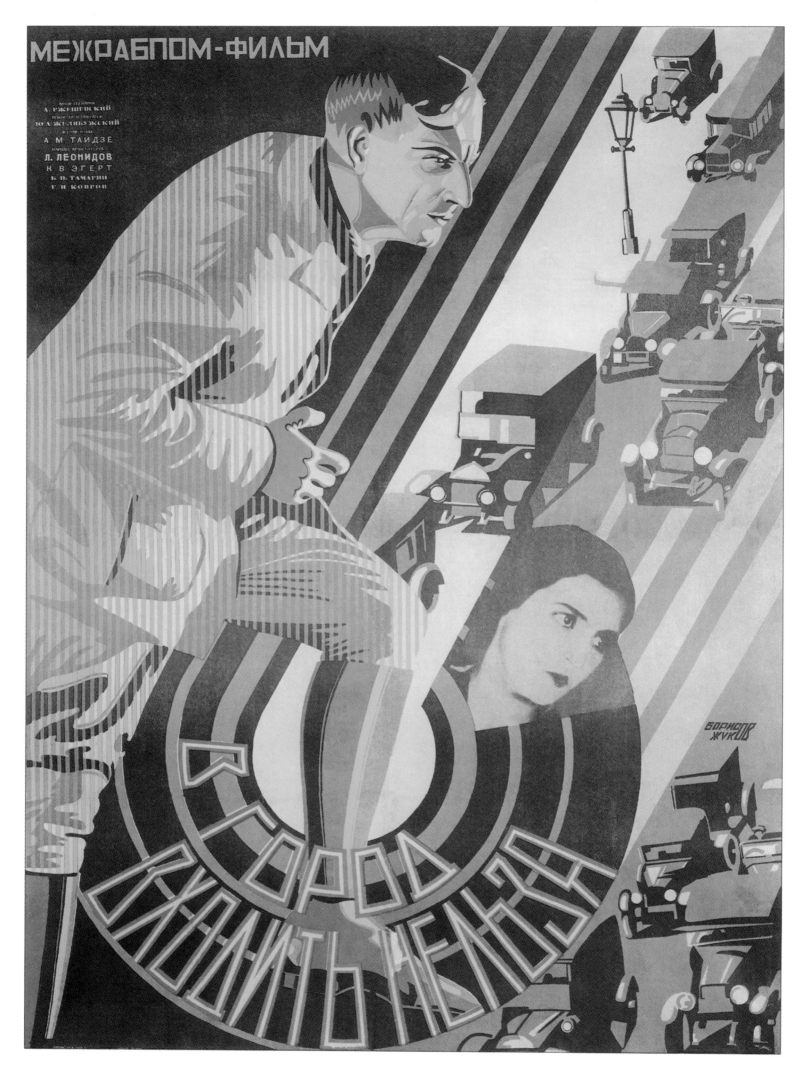

Grigori Borisov and Pyotr Zhukov No Entrance to the City • **Grigori Borísov y Piotr Zhúkov** Prohibido entrar en la ciudad
Grigori Borisov et Piotr Joukov La ville interdite • **Grigori Borisow und Pjotr Schukow** Betreten der Stadt verboten
1929

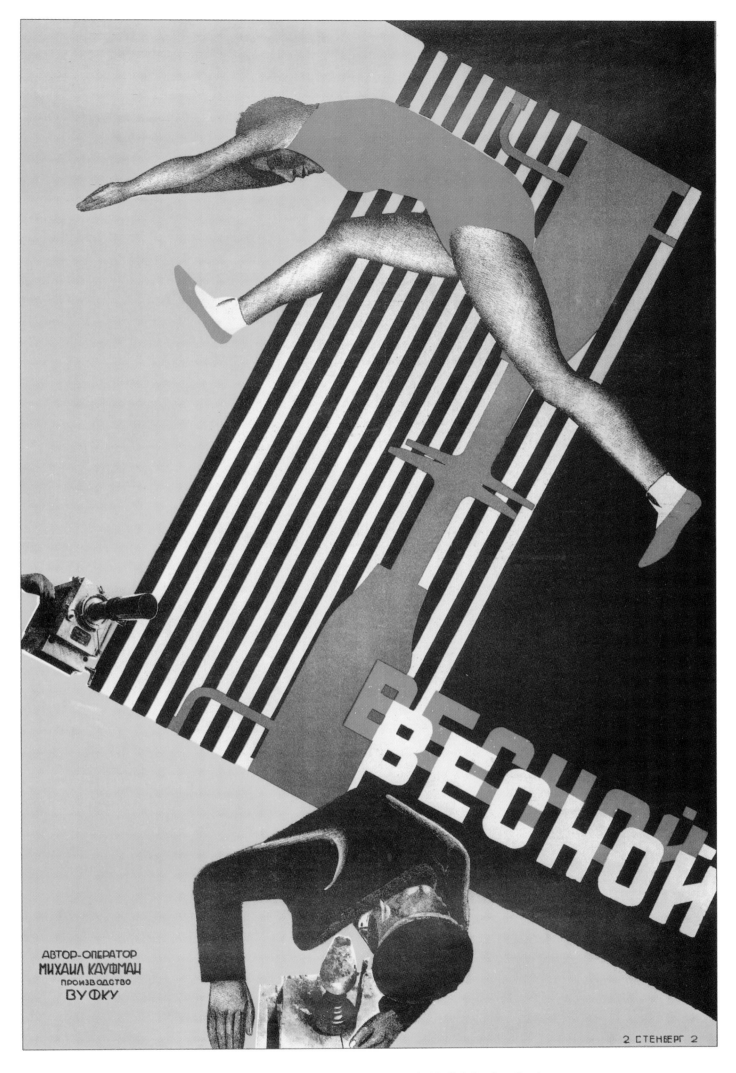

Georgi and Vladimir Stenberg In the Spring • Gueorgui y Vladímir Stenberg En primavera
Guéorgui et Vladimir Stenberg Au printemps • Georgi und Wladimir Stenberg Im Frühling

1929

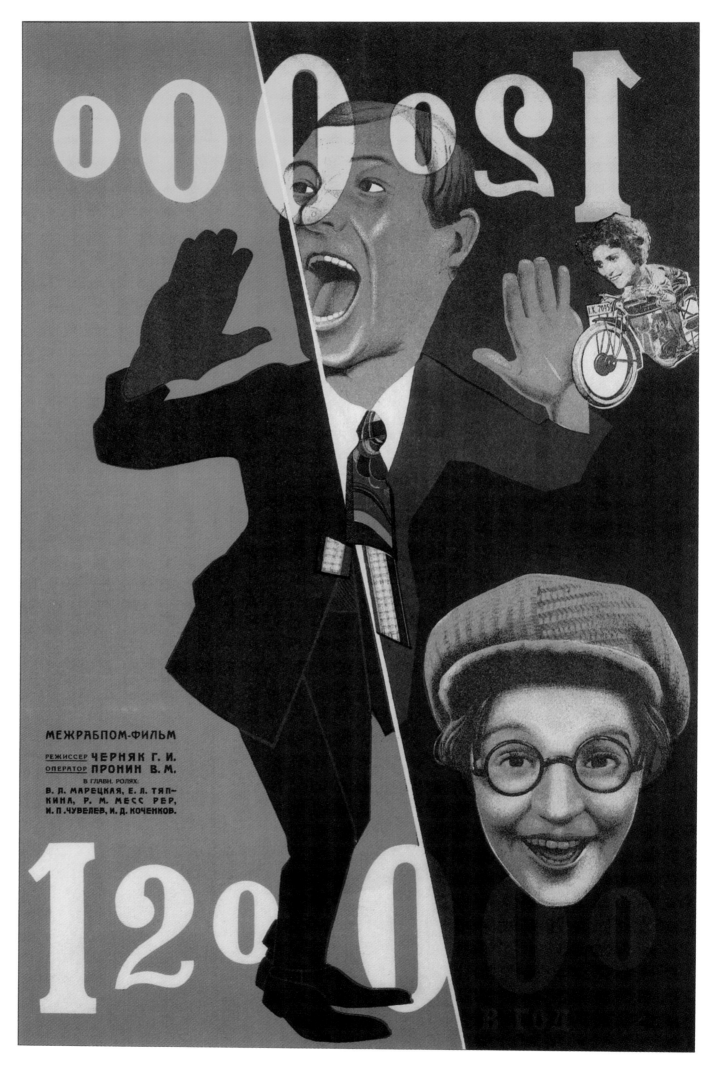

Iosif Gerasimovich 120 Thousand a Year • Yosif Guerasímovich 120.000 al año
Iosif Gerasimovich 120 000 par an • Iosif Gerasimowitsch 120 000 pro Jahr
1929

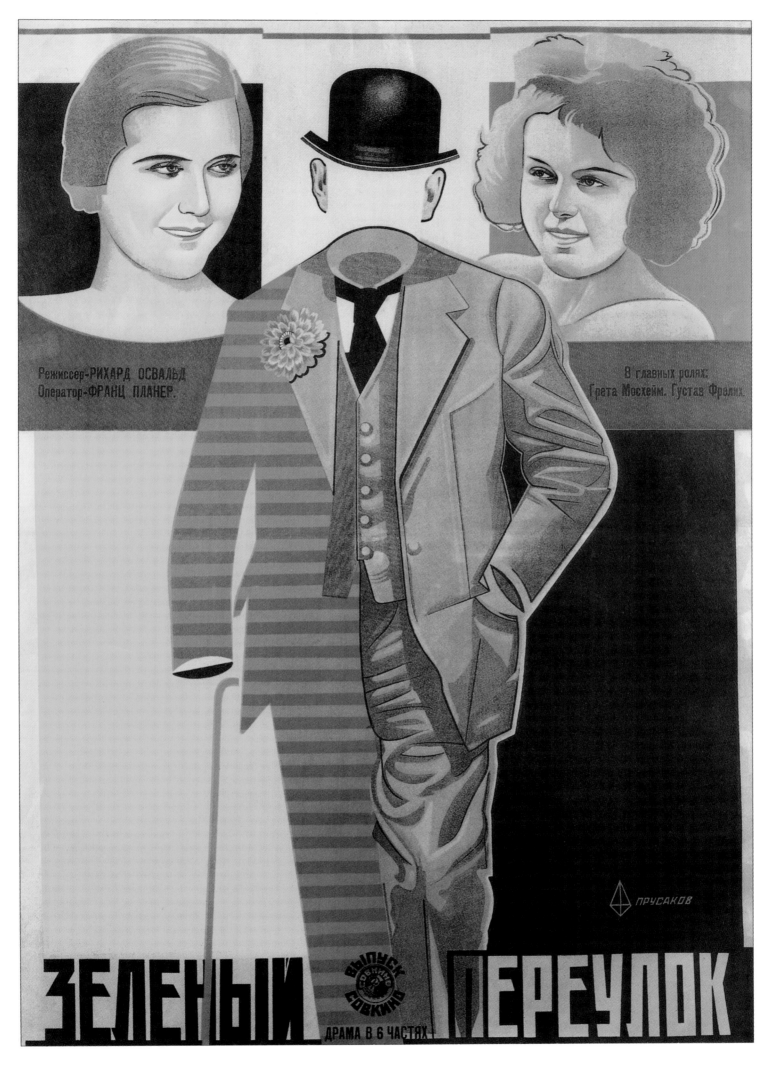

Режиссер-РИХАРД ОСВАЛЬД
Оператор-ФРАНЦ ПЛАНЕР.

В главных ролях:
Грета Мосхейм. Густав Фрелих.

ЗЕЛЕНЫЙ ПЕРЕУЛОК

ВЫПУСК СОВКИНО

ДРАМА В 6 ЧАСТЯХ

ПРУСАКОВ

Nikolai Prusakov The Green Alley • **Nikolai Prusákov** El callejón verde
Nicolas Prousakov La ruelle verte • **Nikolai Prusakow** Die grüne Gasse
1929

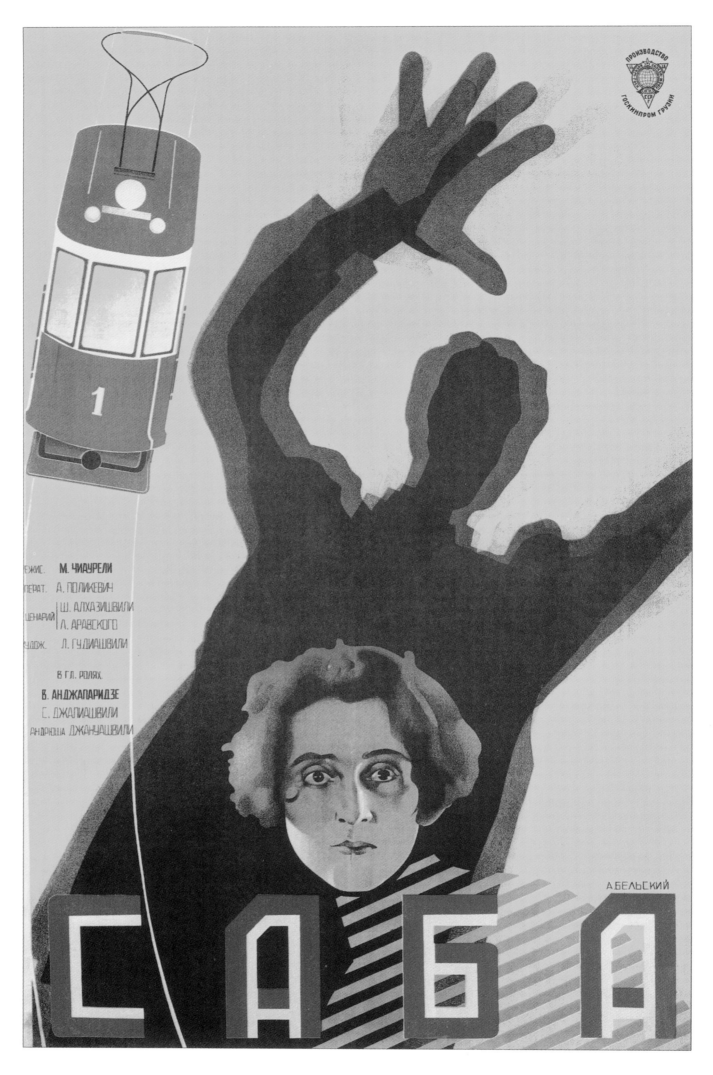

Anatoly Belsky Saba • Anatoli Belski Saba
Anatoli Belski Saba • Anatoli Belski Saba
1929

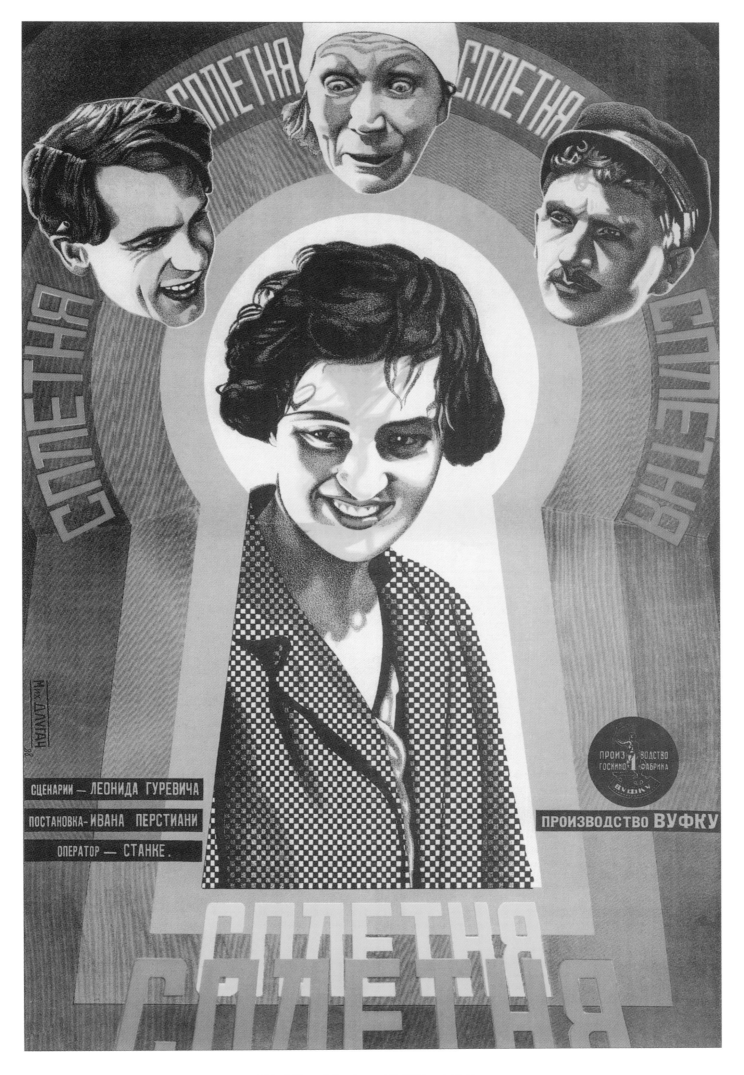

Mikhail Dlugach Gossip • Mijaíl Dlúgach El chisme
Mikhaïl Dlougatch Commérages • Michail Dlugatsch Klatsch
1928

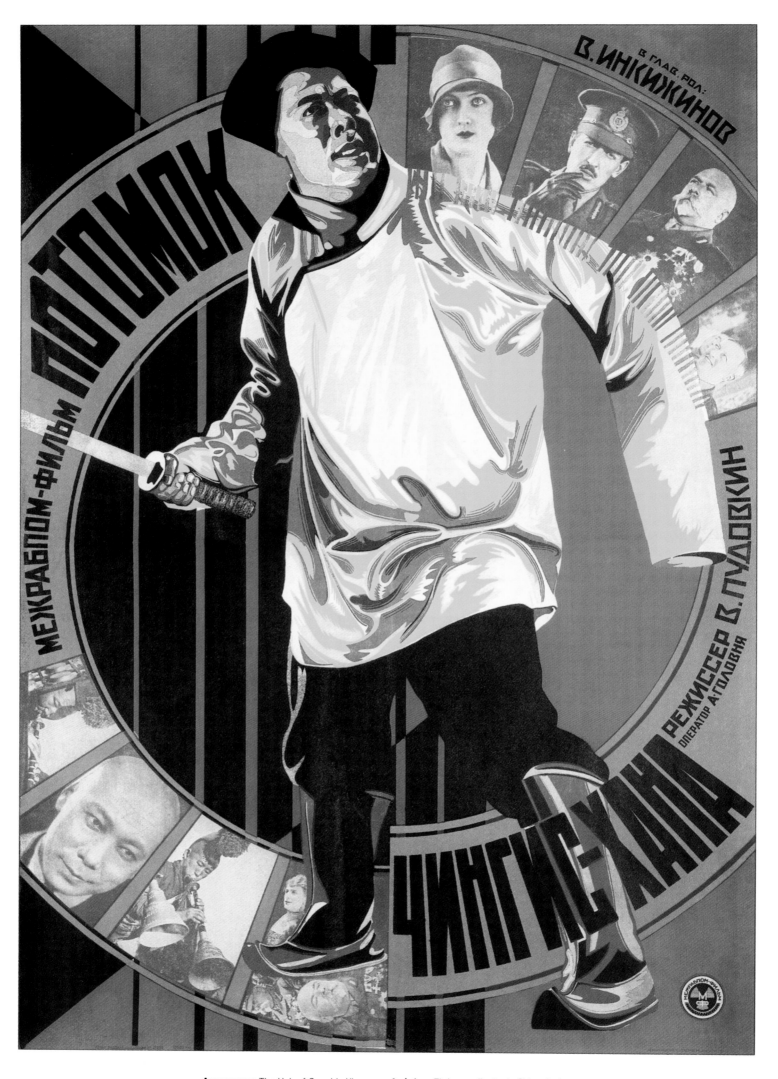

Anonymous The Heir of Genghis Khan • **Anónimo** El descendiente de Chinguis Jan
Anonyme Le descendant de Gengis Khan • **Anonym** Der Erbe von Dschingis Khan

1929

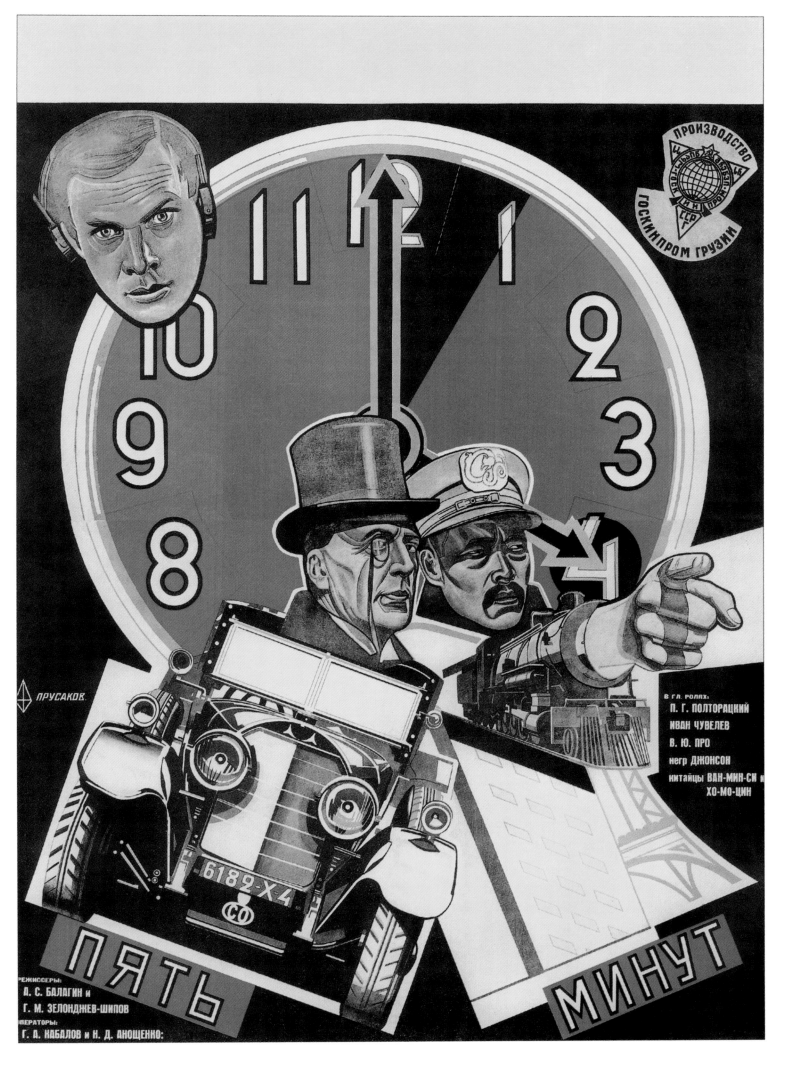

Nikolai Prusakov Five Minutes • Nikolai Prusákov Cinco minutos
Nicolas Prousakov Cinq minutes • Nikolai Prusakow Fünf Minuten
1929

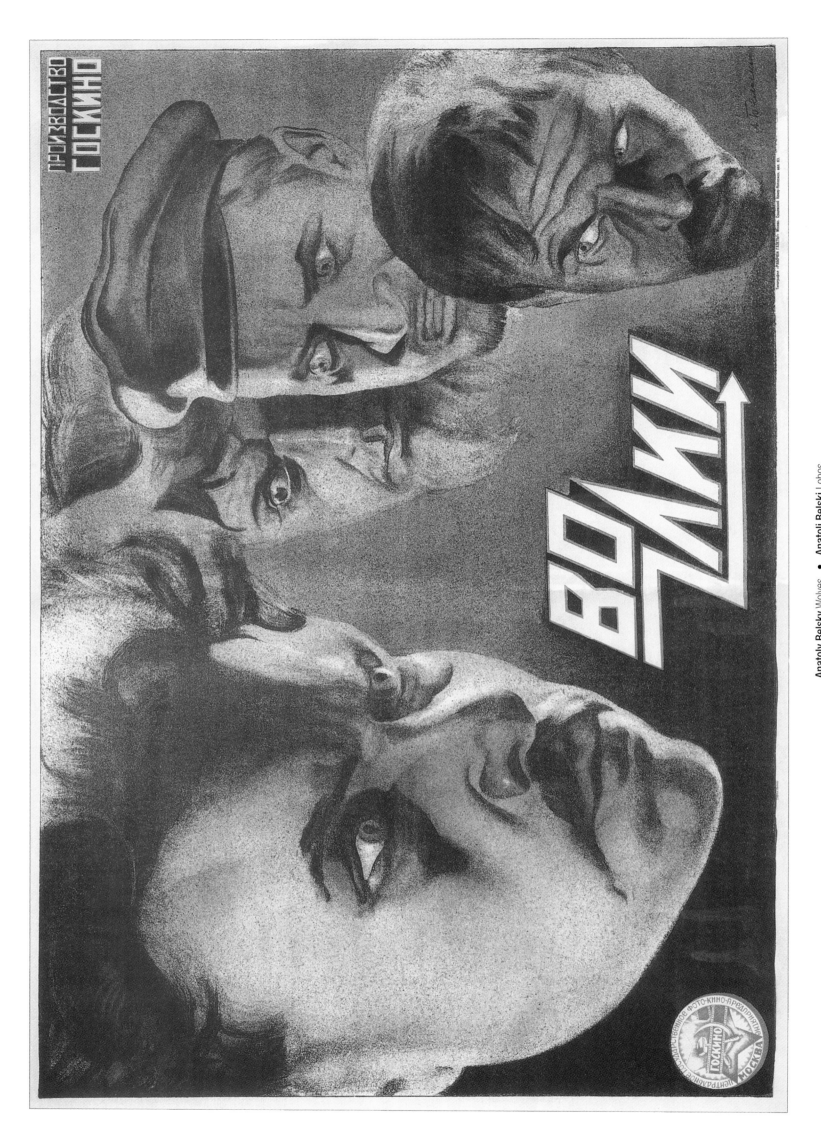

Anatoly Belsky Wolves • Anatoli Belski Lobos
Anatoli Belski Les loups • Anatoli Belski Wölfe
1925

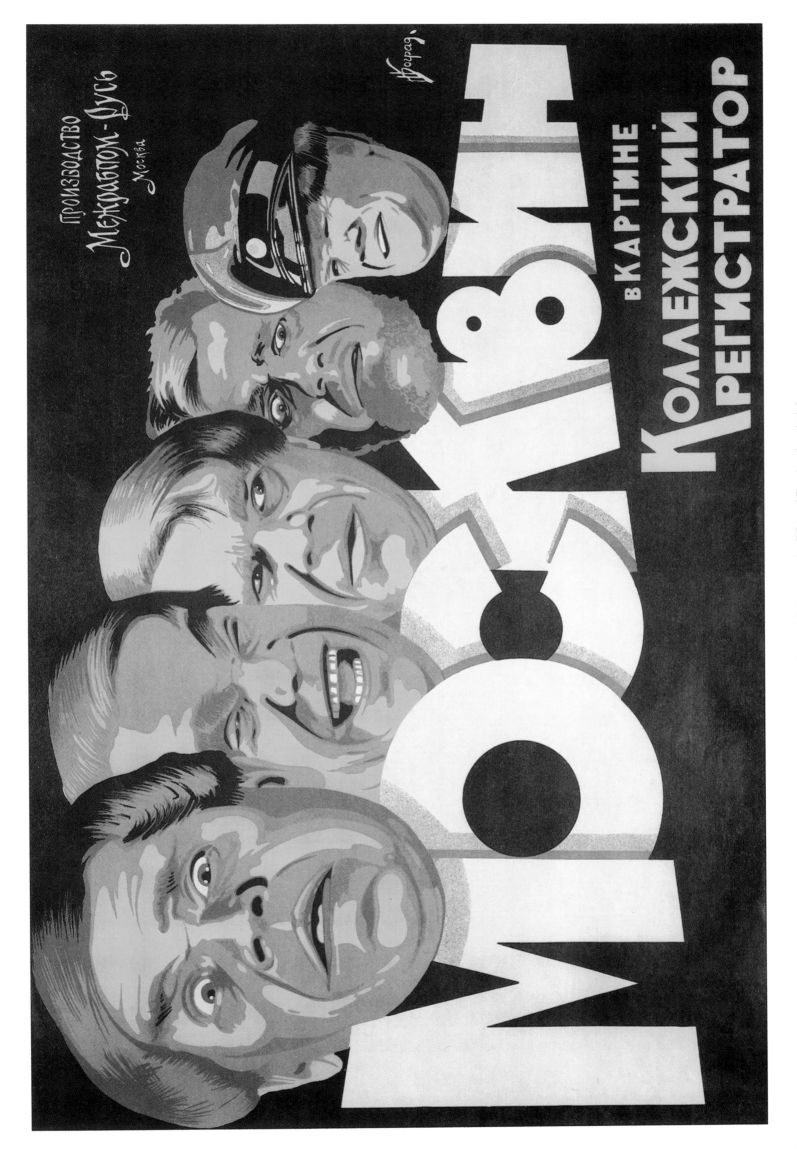

Izrail Bograd The Collegiate Registrar • **Israil Bograd** El registrador colegiado
Izraïl **Bograd** Le maître de poste • **Israil Bograd** Der Kollegienregistrator
1925

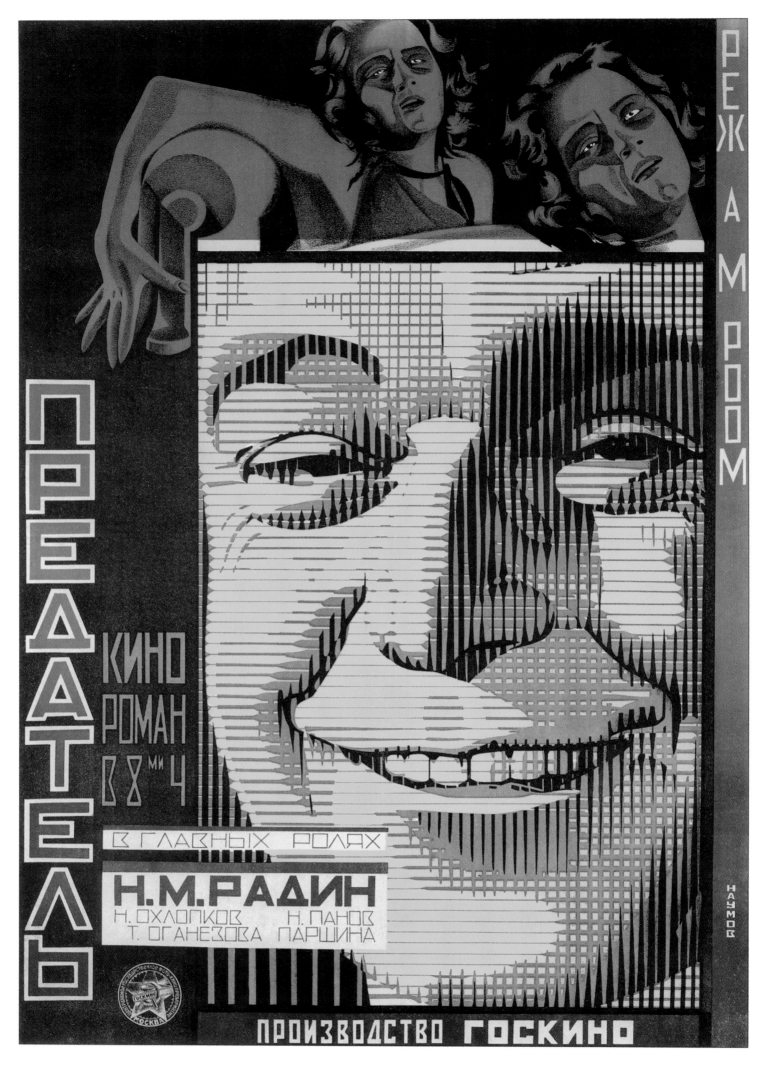

Alexander Naumov The Traitor • Alexandr Naumov El traidor
Alexandre Naoumov Le traître • Alexander Naumow Der Verräter
1926

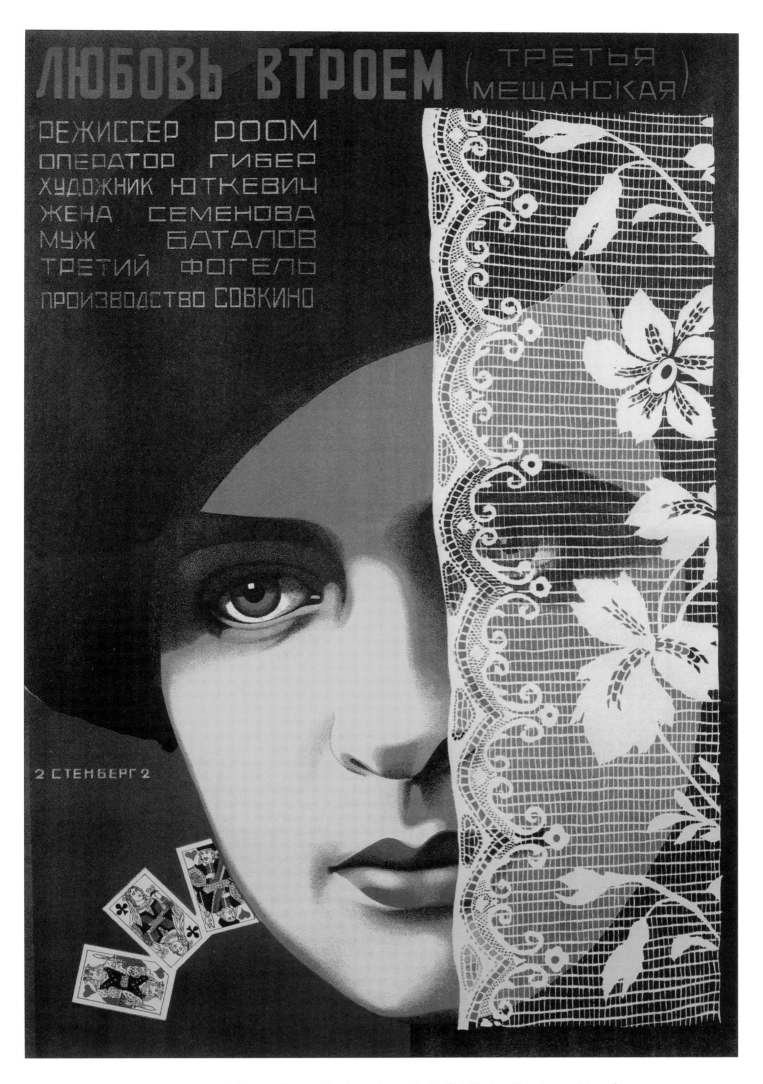

Georgi and Vladimir Stenberg The Love Triangle • Gueorgui y Vladímir Stenberg El tercio pequeñoburgués
Guéorgui et Vladimir Stenberg Trois dans un sous-sol • Georgi und Wladimir Stenberg Liebe zu dritt
1927

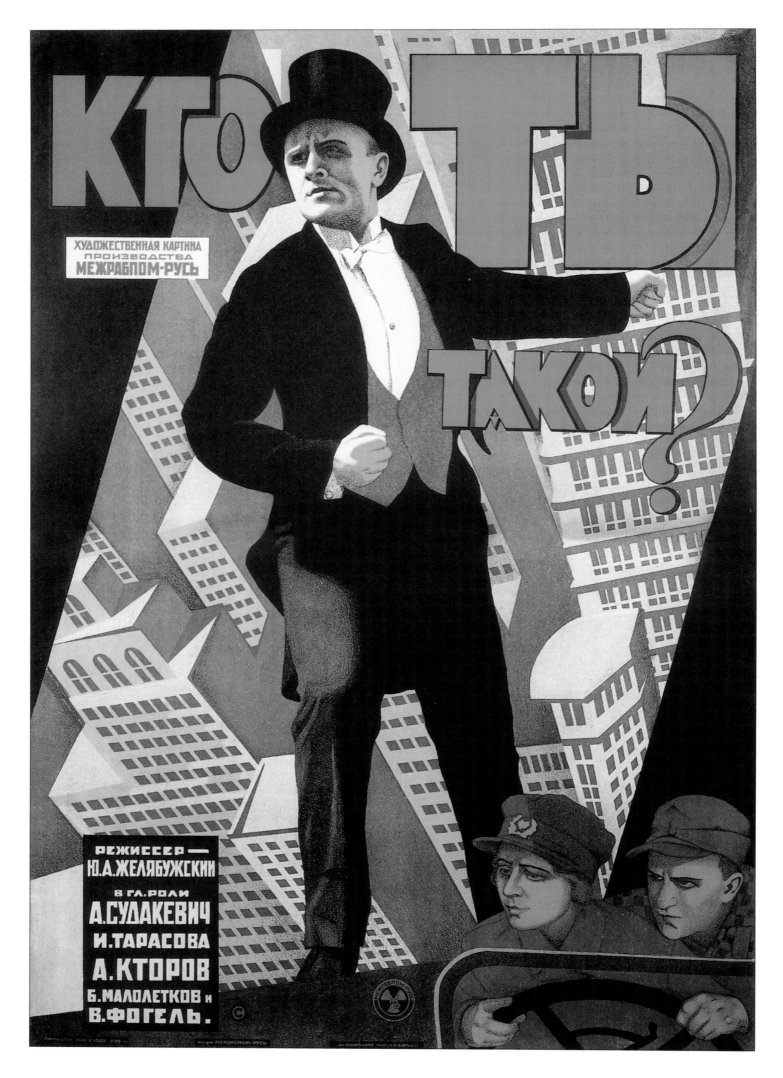

Semion Semionov-Menes Who Are You? • Semyón Semyónov-Menes ¿Tú quién eres?
Semion Semionov-Menes Qui es-tu ? • Semen Semenow-Menes Wer bist du?

1927

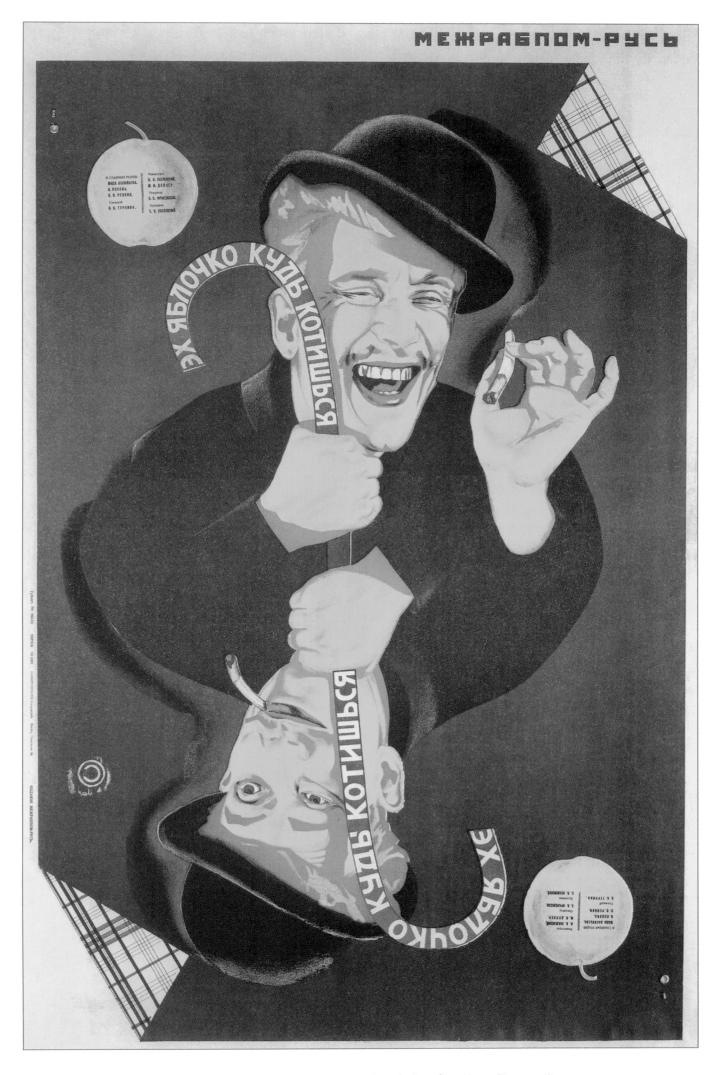

Semion Semionov-Menes Oh, Little Apple... • **Semyón Semyónov-Menes** Oh, manzanita...
Semion Semionov-Menes Ah, petite pomme... • **Semen Semenow-Menes** Ach, Äpfelchen...

1927

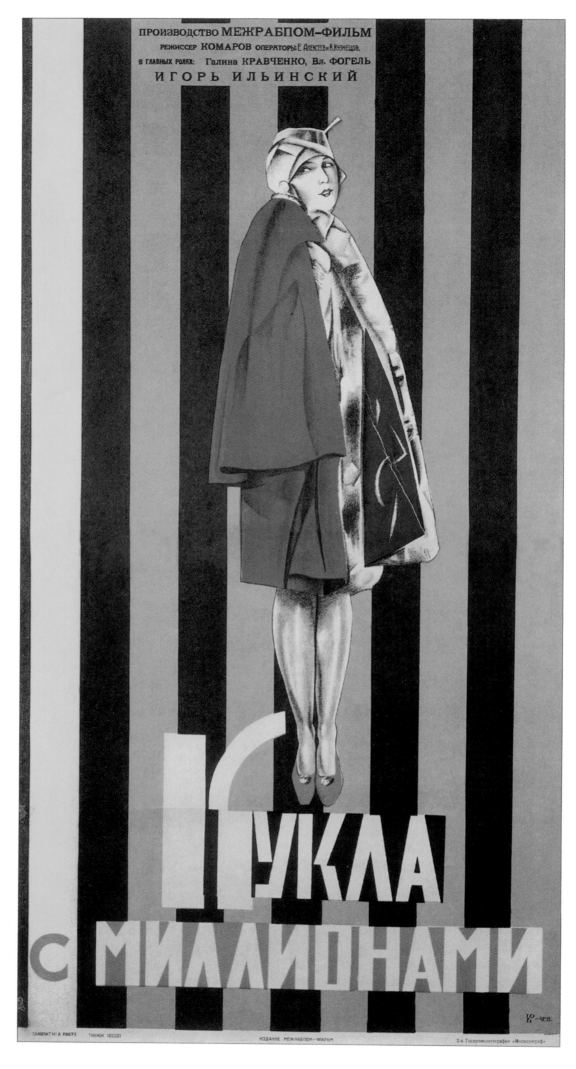

Isaak Rabichev The Doll with Millions • Isaak Rabíchev La muñeca de los millones
Isaac Rabichev La poupée aux millions • Isaak Rabitschew Die Puppe mit den Millionen
1928

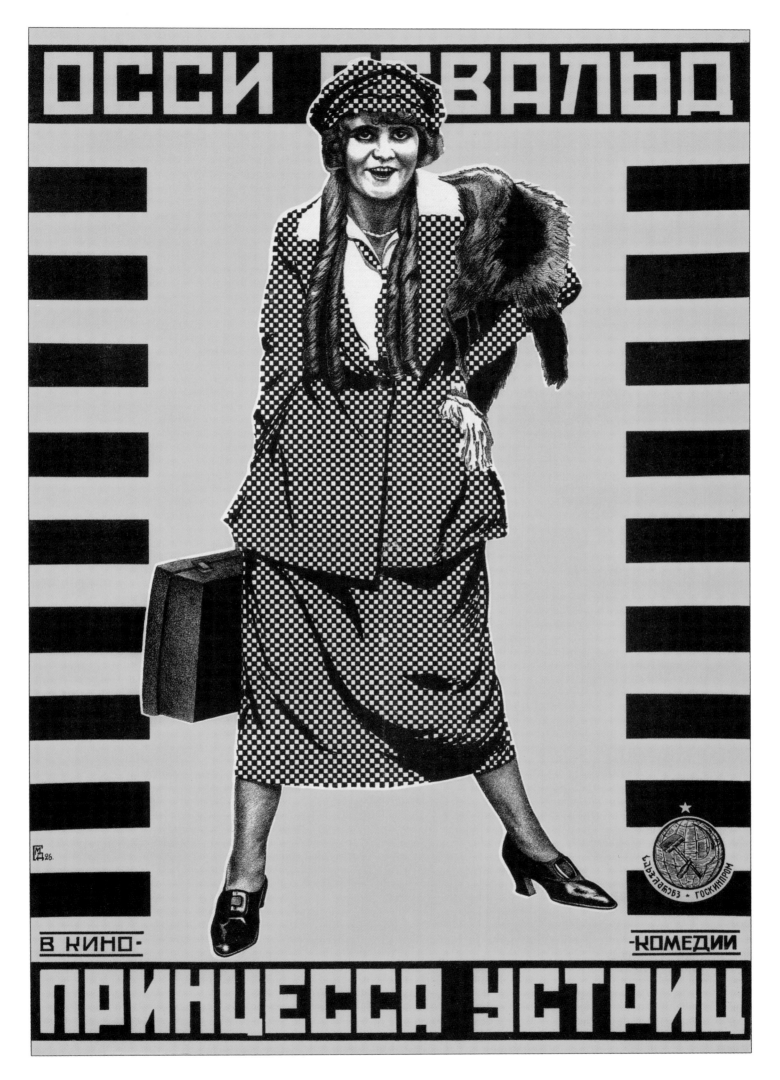

Mikhail Dlugach The Oyster Princess • Mijaíl Dlúgach La princesa de las ostras
Mikhaïl Dlougatch La princesse aux huîtres • Michail Dlugatsch Die Austernprinzessin

1926

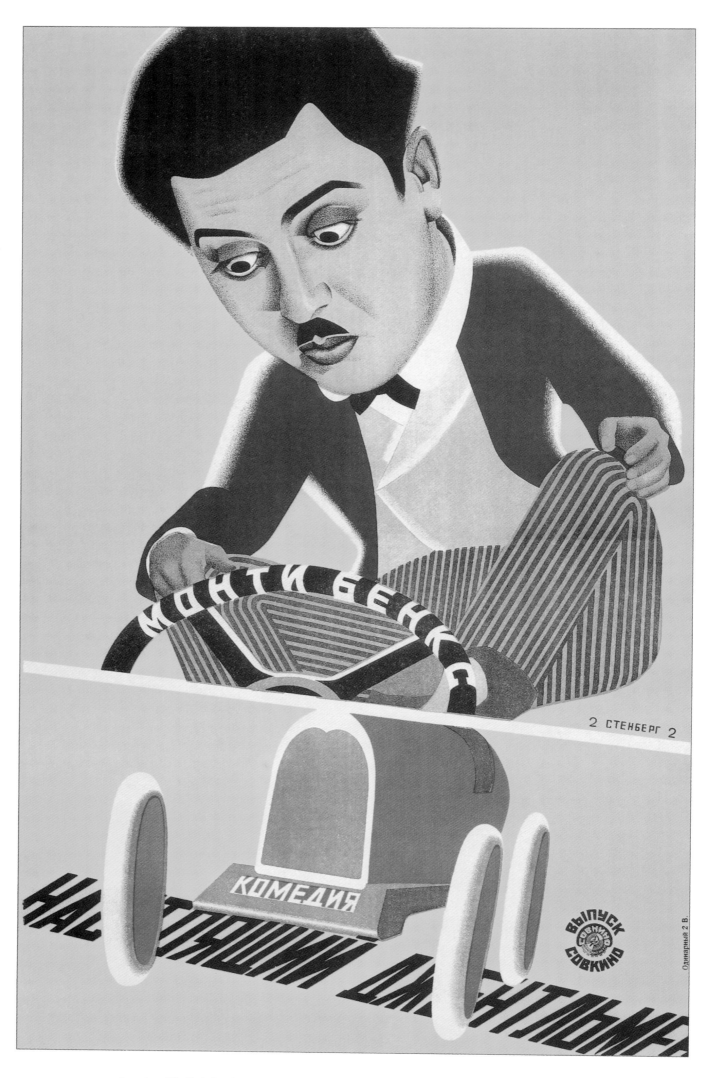

Georgi and Vladimir Stenberg A Real Gentleman • **Gueorgui y Vladímir Stenberg** Un auténtico caballero
Guéorgui et Vladimir Stenberg Un vrai gentleman • **Georgi und Wladimir Stenberg** Ein wahrer Gentleman
1928

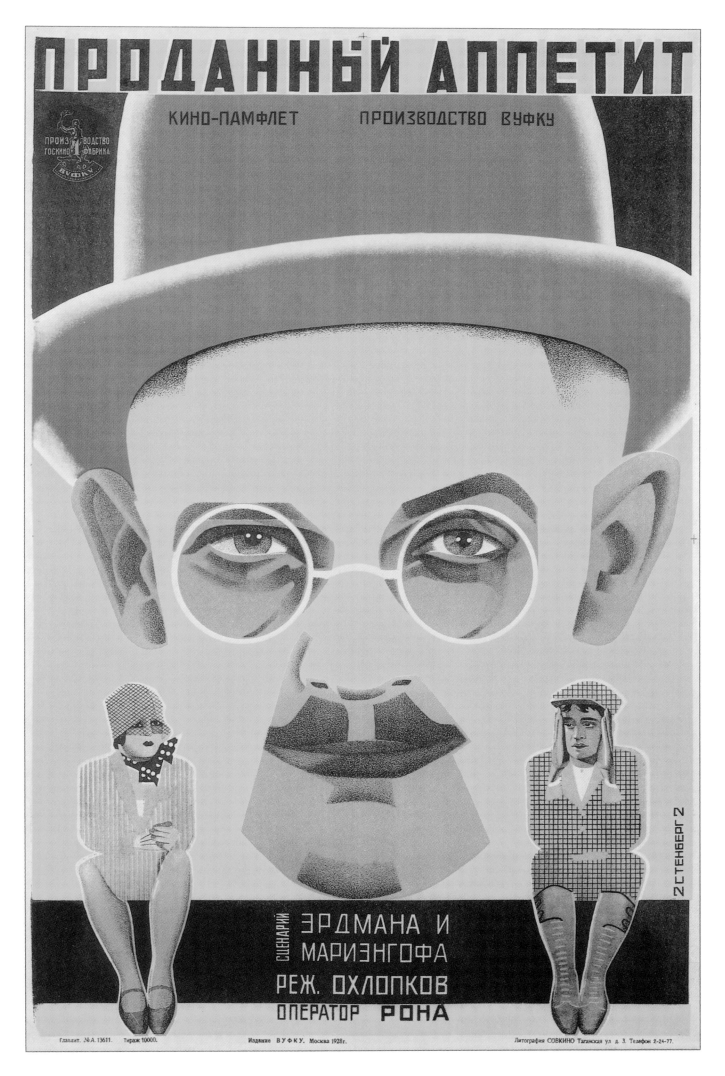

Georgi and Vladimir Stenberg The Sold Appetite • Gueorgui y Vladímir Stenberg El apetito vendido
Guéorgui et Vladimir Stenberg Appétit à vendre • Georgi und Wladimir Stenberg Der verkaufte Appetit
1928

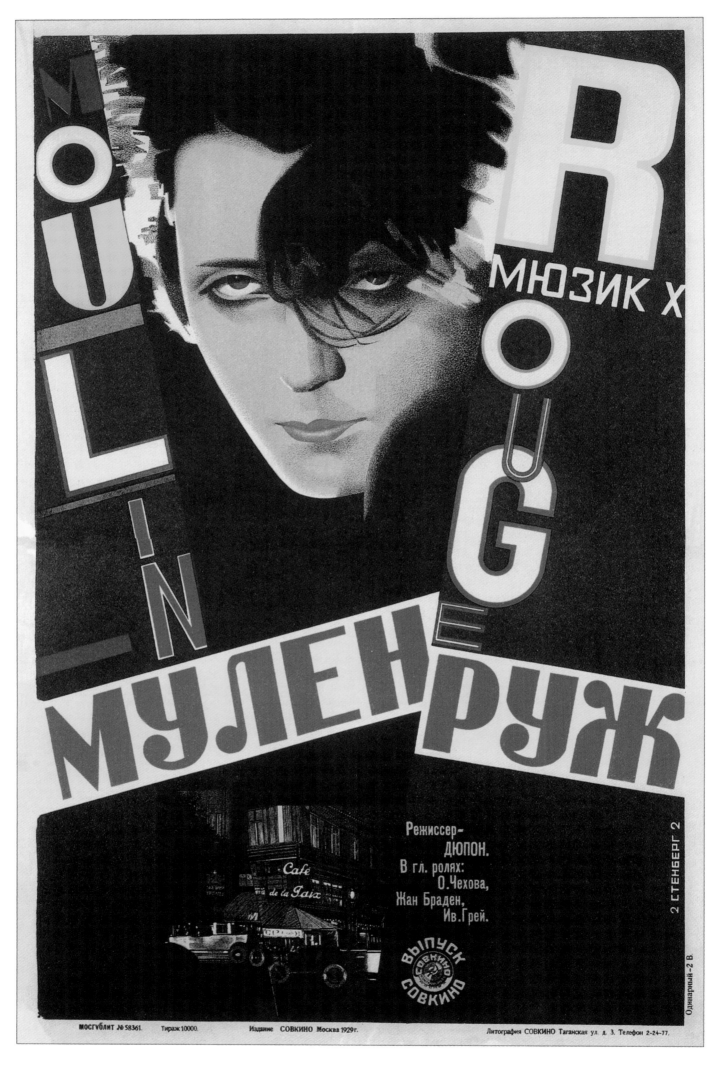

Georgi and Vladimir Stenberg Moulin Rouge • Gueorgui y Vladímir Stenberg Moulin Rouge
Guéorgui et Vladimir Stenberg Moulin Rouge • Georgi und Wladimir Stenberg Moulin Rouge

1929

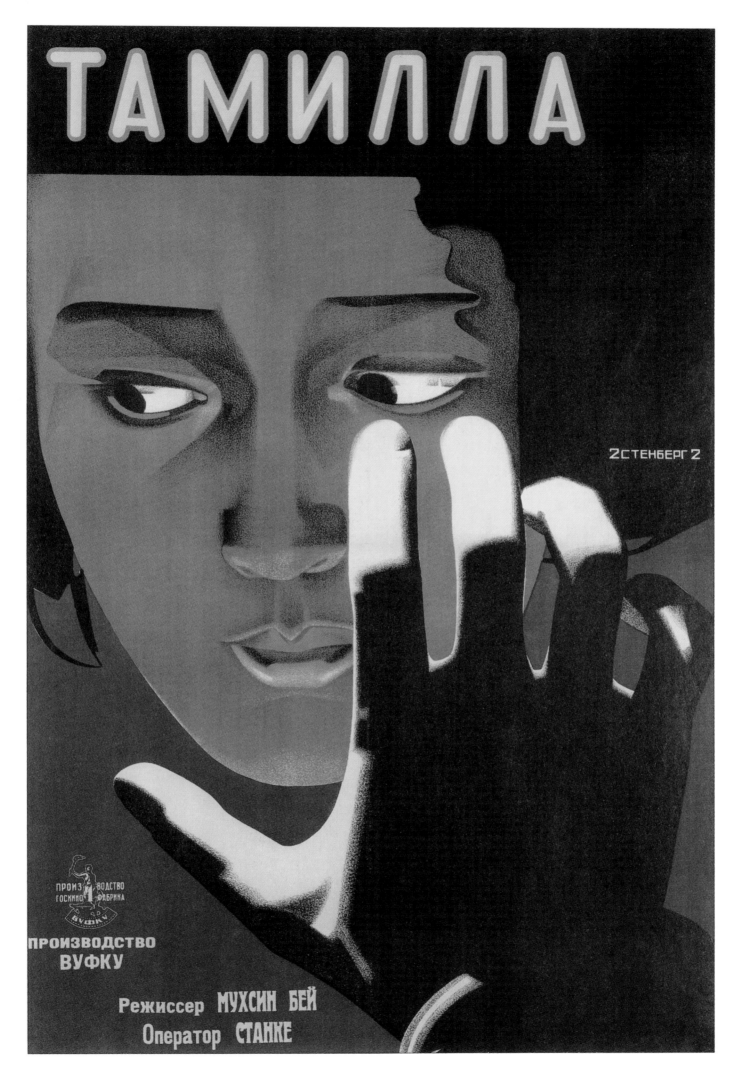

Georgi and Vladimir Stenberg Tamilla • Gueorgui y Vladímir Stenberg Tamilla
Guéorgui et Vladimir Stenberg Tamilla • Georgi und Wladimir Stenberg Tamilla
1928

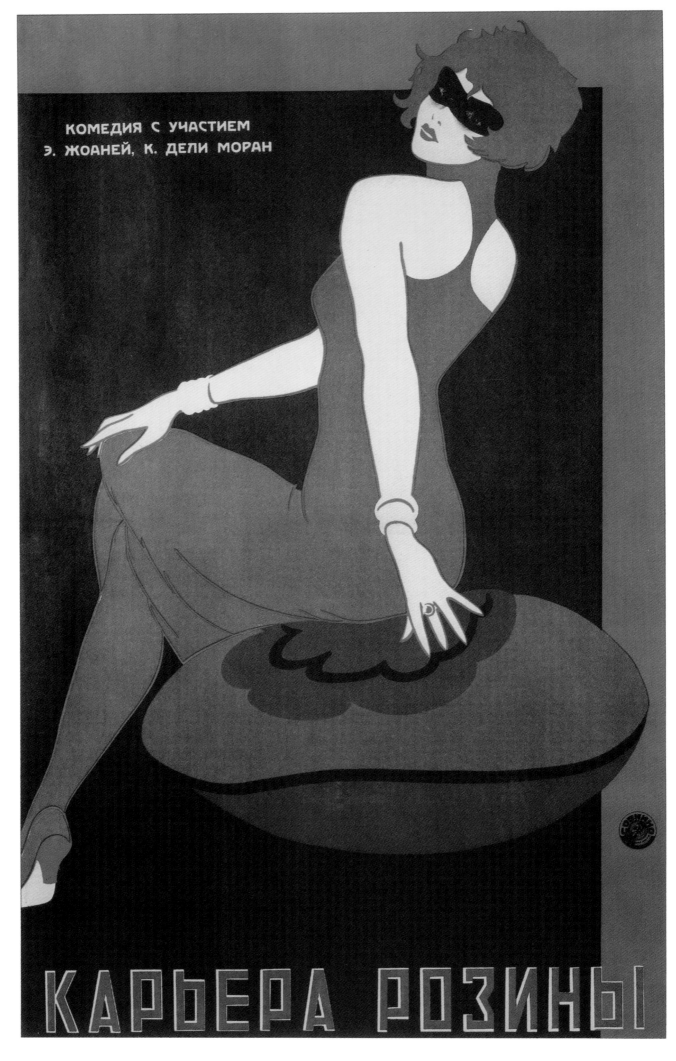

КОМЕДИЯ С УЧАСТИЕМ
Э. ЖОАНЕЙ, К. ДЕЛИ МОРАН

КАРЬЕРА РОЗИНЫ

Anonymous The Career of Rosine • Anónimo La boda de Rosine
Anonyme Le mariage de Rosine • Anonym Die Karriere von Rosine
1927

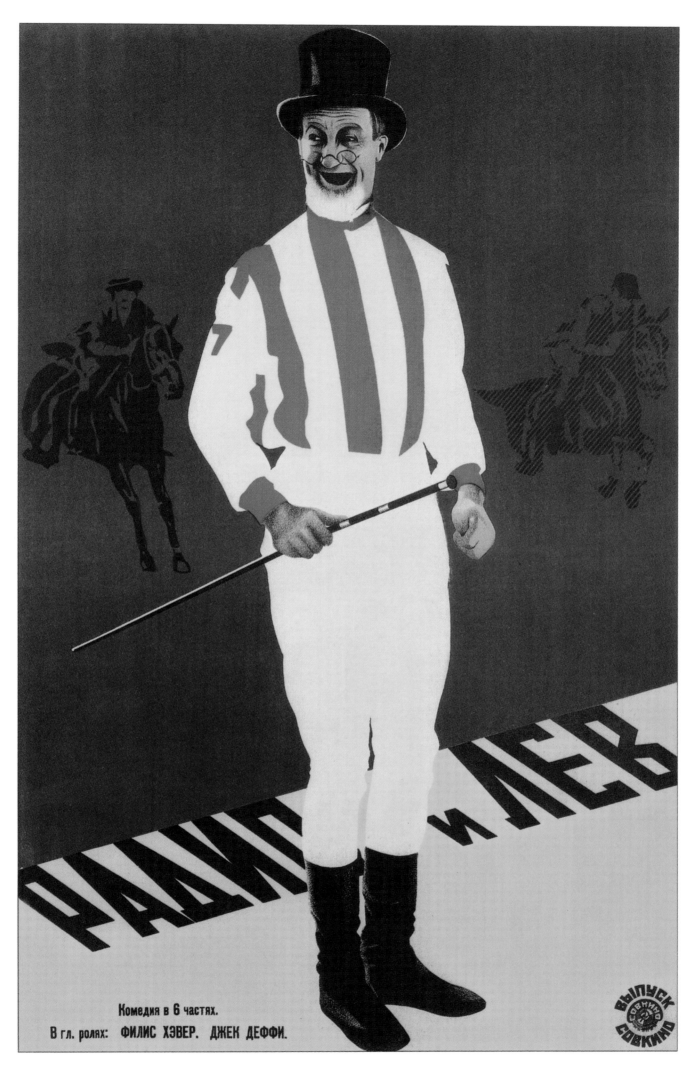

Anonymous Radio and the Lion • Anónimo La radio y el león
Anonyme La radio et le lion • Anonym Das Radio und der Löwe
1927

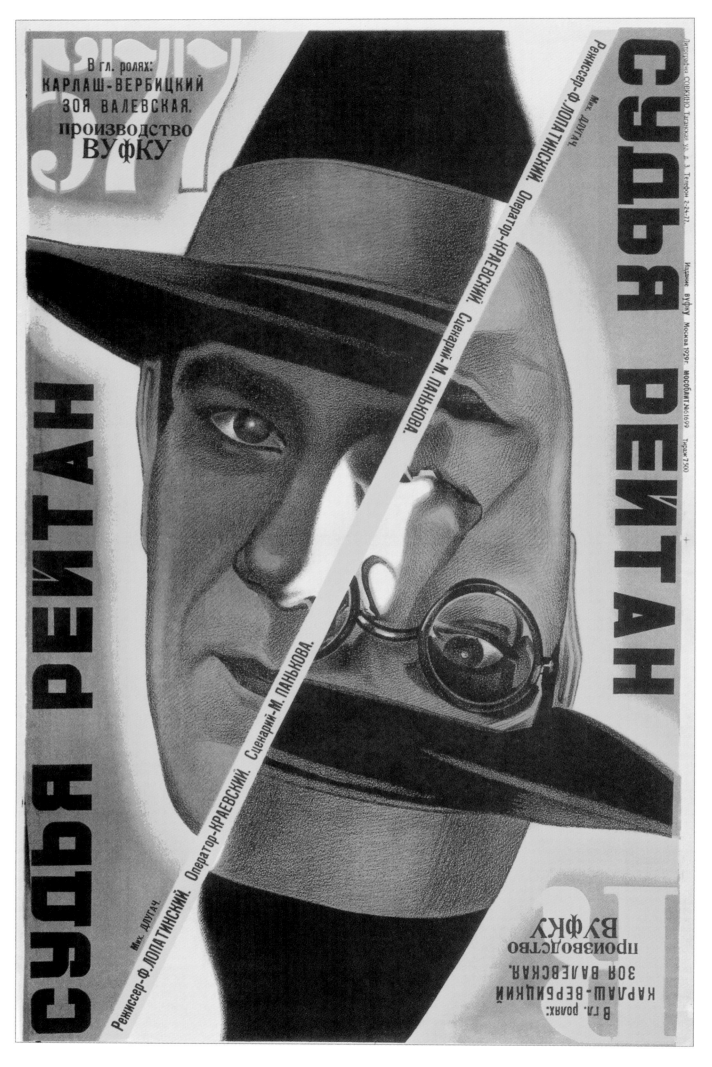

Mikhail Dlugach Judge Reitan • Mijaíl Dlúgach El juez Reitan
Mikhaïl Dlougatch Le juge Reitan • Michail Dlugatsch Richter Reitan

1929

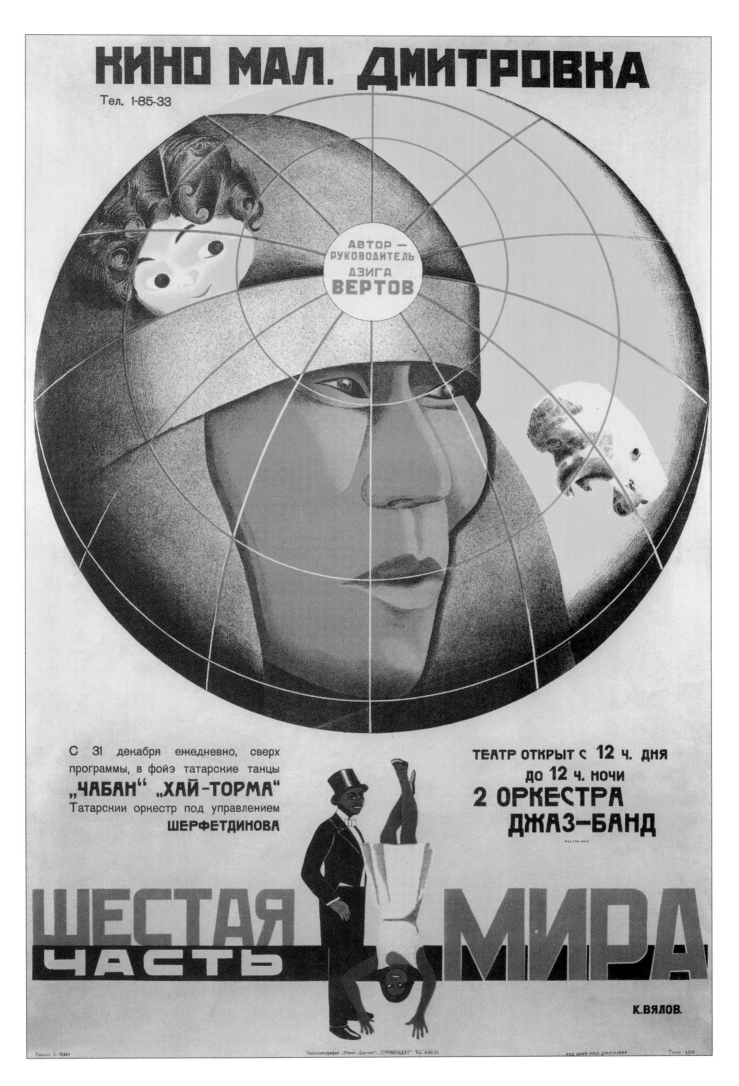

Konstantin Vialov A Sixth of the World • Konstantín Viálov La sexta parte del mundo
Constantin Vialov La sixième partie du monde • Konstantin Wjalow Ein Sechstel der Erde

1927

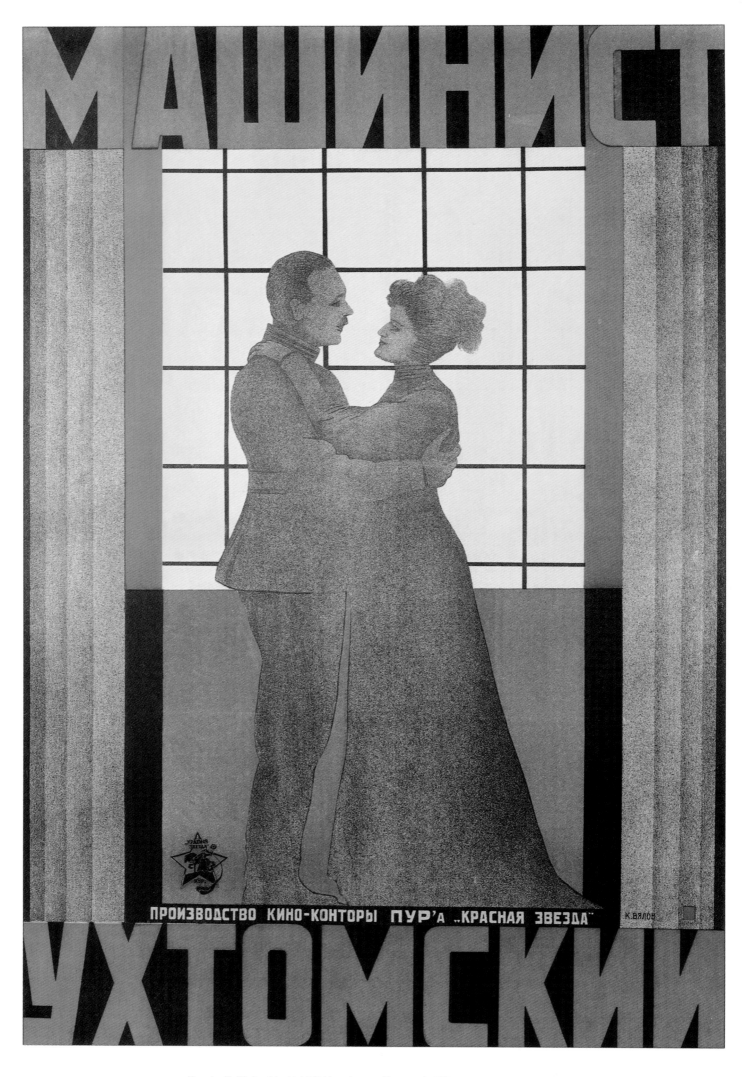

Konstantin Vialov Machinist Ukhtomsky • Konstantín Viálov El maquinista Ujtomski

Constantin Vialov Le machiniste Ukhtomsky • Konstantin Wjalow Maschinist Uchtomski

1926

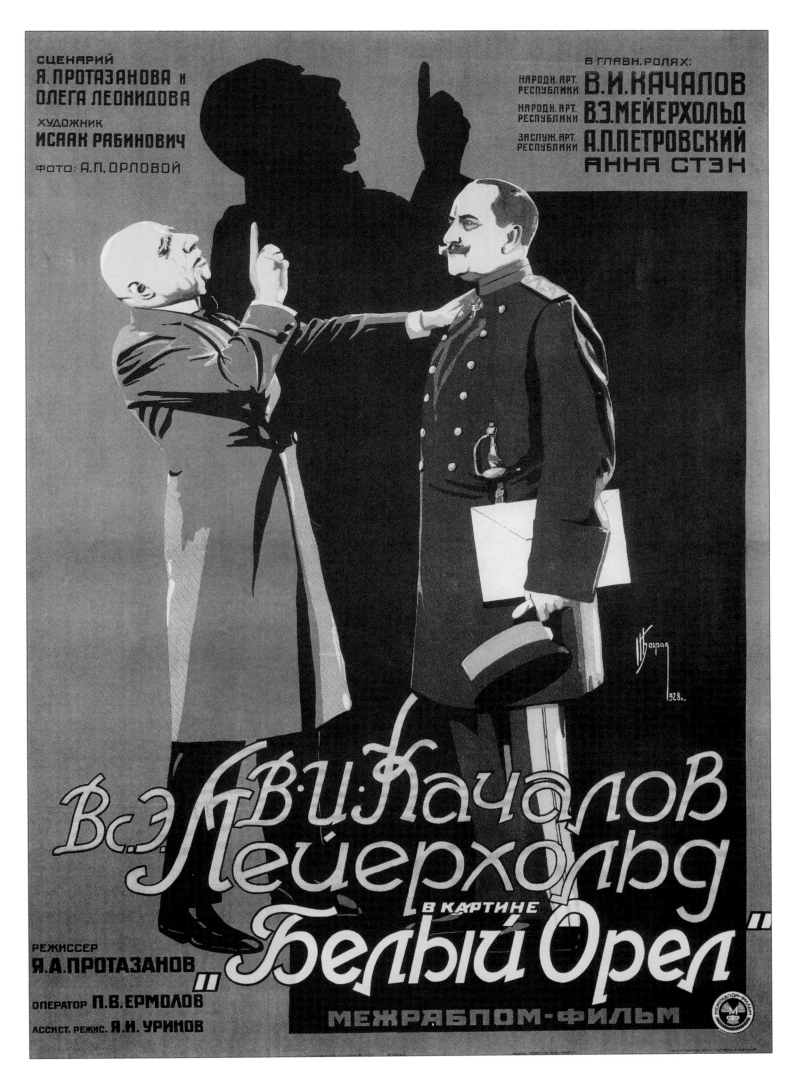

Izrail Bograd The White Eagle • Israil Bograd El águila blanca
Izraïl Bograd L'aigle blanc • Israil Bograd Der weiße Adler
1928

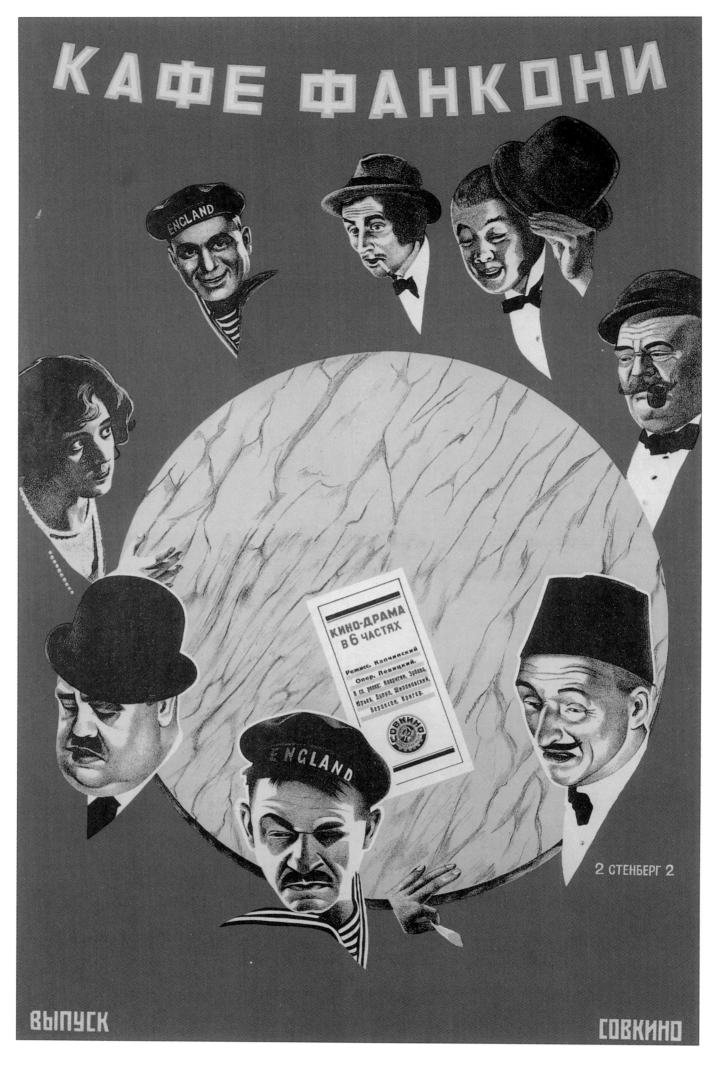

Georgi and Vladimir Stenberg Café Fanconi • Gueorgui y Vladímir Stenberg Café Fanconi
Guéorgui et Vladimir Stenberg Café Fanconi • Georgi und Wladimir Stenberg Café Fanconi
1927

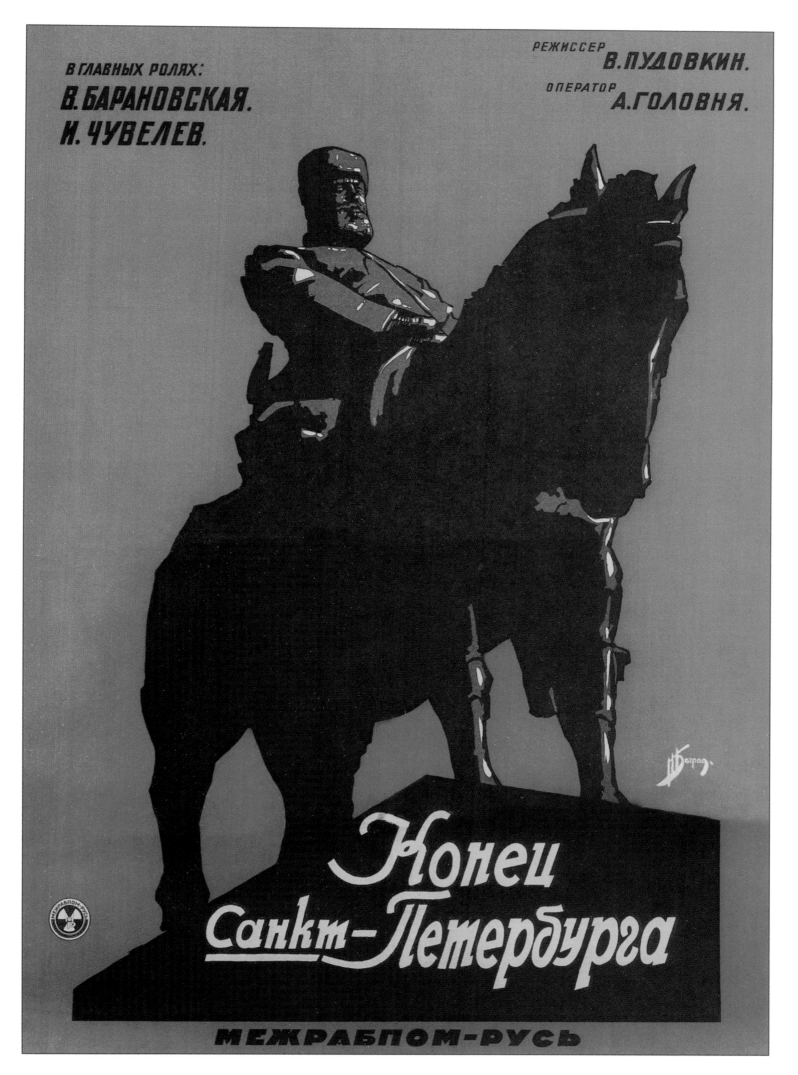

Izrail Bograd The End of St Petersburg • Israil Bograd El fin de San Petersburgo
Izraïl Bograd La fin de Saint-Pétersbourg • Israil Bograd Das Ende von St. Petersburg

1927

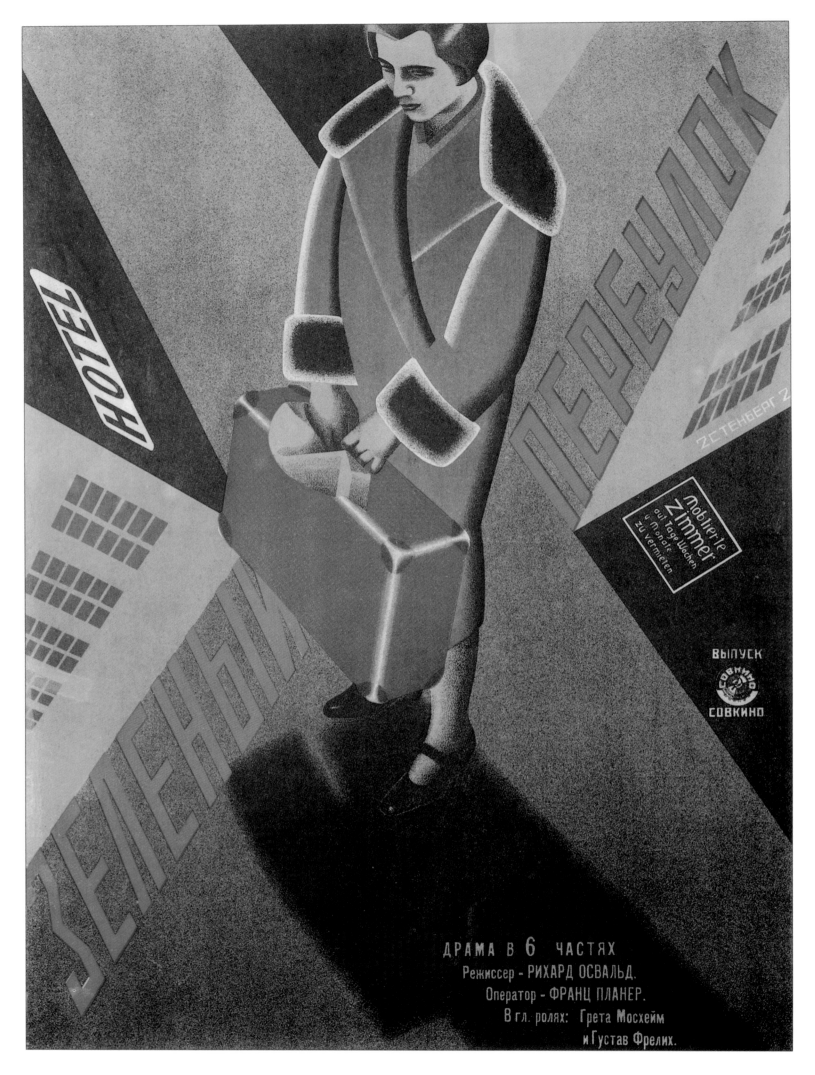

Georgi and Vladimir Stenberg The Green Alley • Gueorgui y Vladímir Stenberg El callejón verde
Guéorgui et Vladimir Stenberg La ruelle verte • Georgi und Wladimir Stenberg Die grüne Gasse
1929

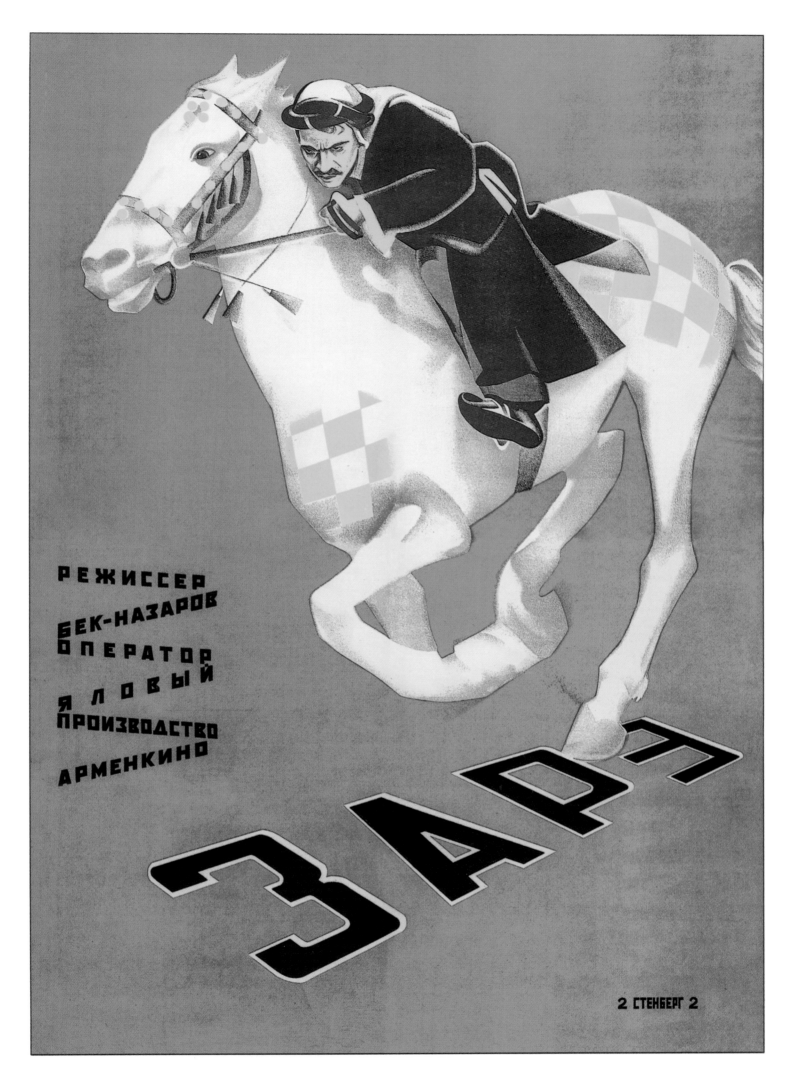

РЕЖИССЕР
БЕК-НАЗАРОВ
ОПЕРАТОР
ЯЛОВЫЙ
ПРОИЗВОДСТВО
АРМЕНКИНО

ЗАРЭ

2 СТЕНБЕРГ 2

Georgi and Vladimir Stenberg Zare • Gueorgui y Vladímir Stenberg Zare
Guéorgui et Vladimir Stenberg Zare • Georgi und Wladimir Stenberg Zare
1927

Georgi and Vladimir Stenberg Camilla • Gueorgui y Vladimir Stenberg Camilla
Guéorgui et Vladimir Stenberg Camilla • Georgi und Wladimir Stenberg Camilla
1928

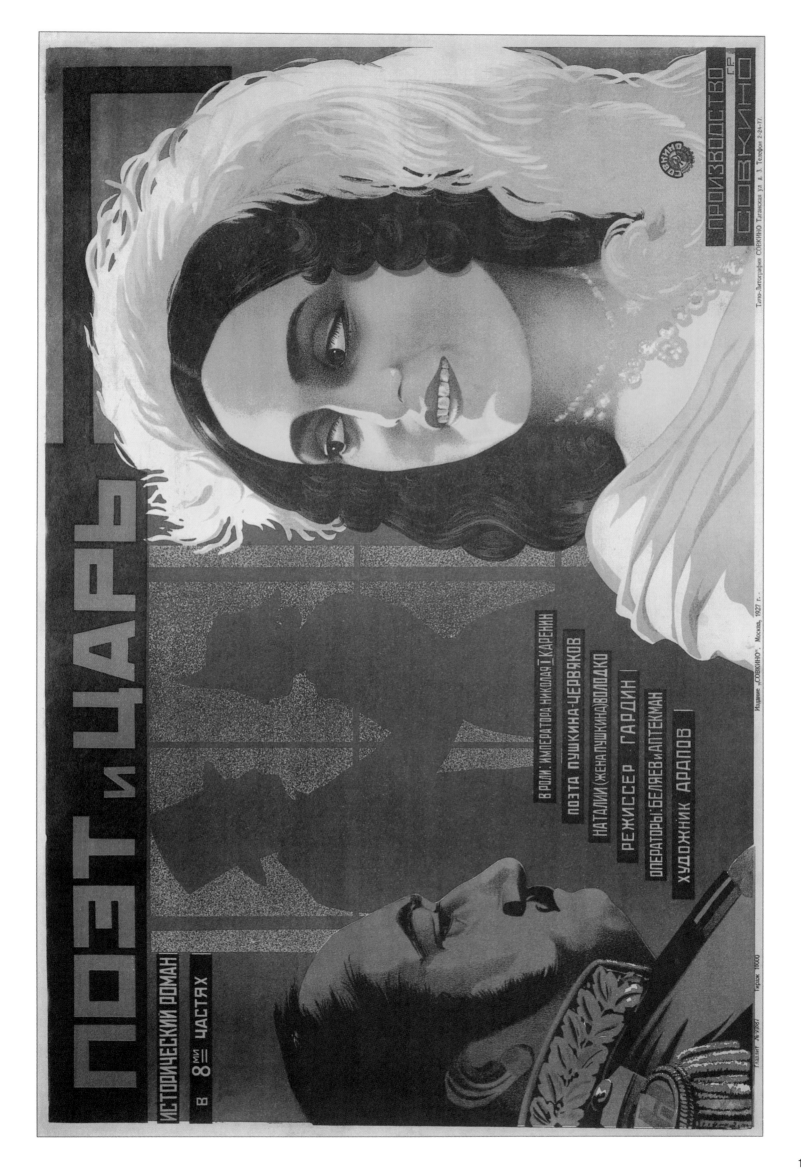

Grigori Rychkov The Poet and the Tsar • Grigori Richkov El poeta y el zar
Grigori Rychkov Le poète et le Tsar • Grigori Rytschkow Der Dichter und der Zar
1927

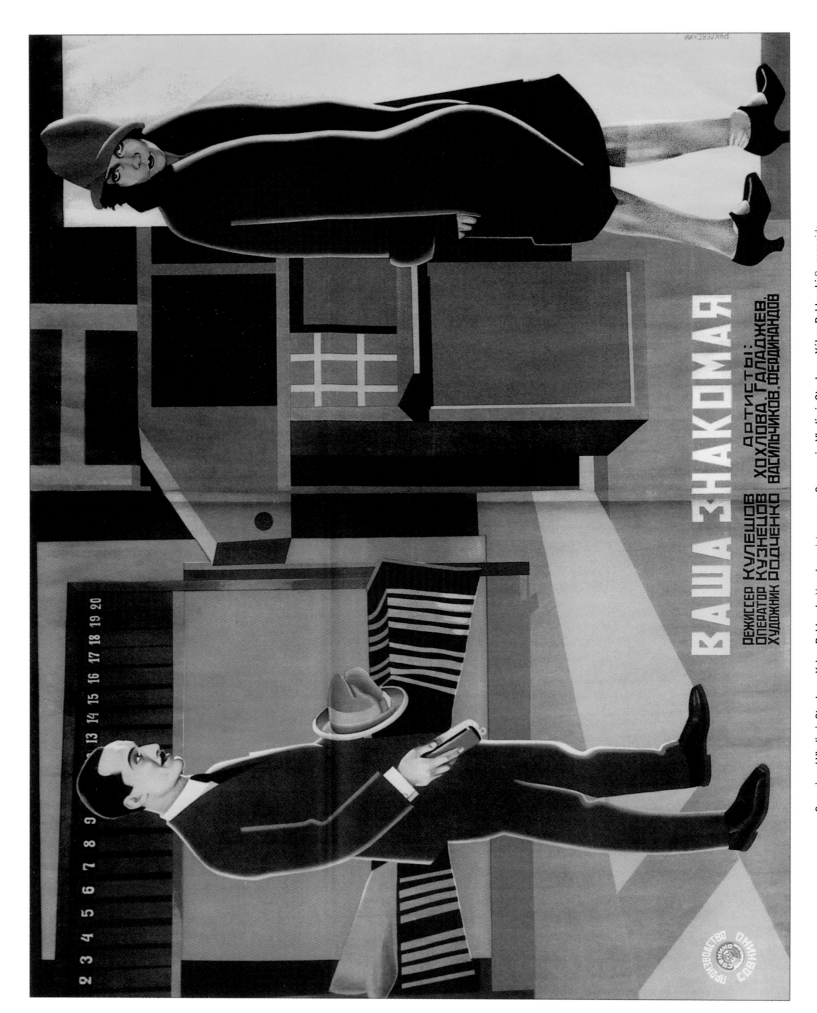

Georgi and Vladimir Stenberg, Yakov Ruklevsky Your Acquaintance • Gueorgui y Vladimir Stenberg, Yákov Ruklevski Su conocida
Guéorgui et Vladimir Stenberg, Yakov Rouklevski Votre connaissance • Georgi und Wladimir Stenberg, Jakow Ruklewski Ihre Bekannte
1927

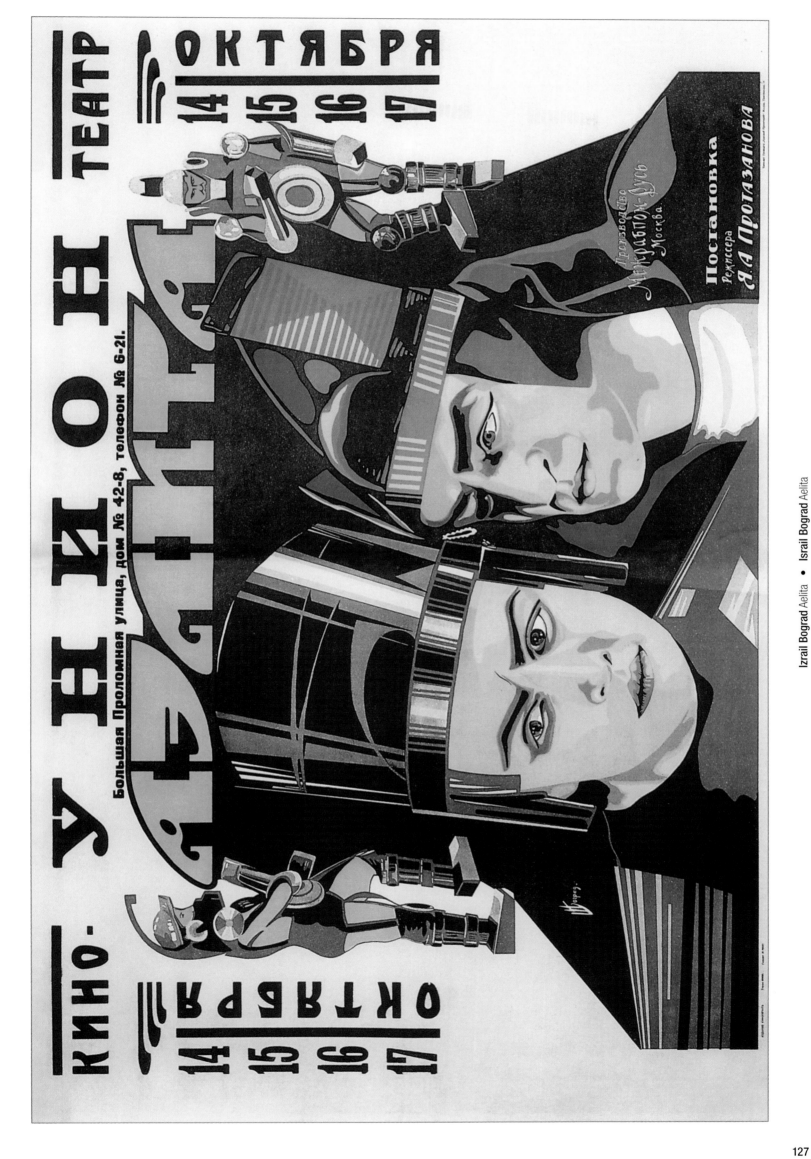

Izrail Bograd Aelita • Israil Bograd Aelita
Izraïl Bograd Aelita • Israil Bograd Aelita
1929

ПРОЦЕСС О ТРЕХ МИЛЛИОНАХ

РЕЖ. ПРОТАЗАНОВ · ПРОИЗВ.
МЕЖРАБПОМ РУСЬ

2 СТЕНБЕРГ 2

Georgi and Vladimir Stenberg The Three Million Trial • Gueorgui y Vladimir Stenberg El proceso de los tres millones
Guéorgui et Vladimir Stenberg Le procès des trois millions • Georgi und Wladimir Stenberg Der Drei-Millionen-Prozess
1926

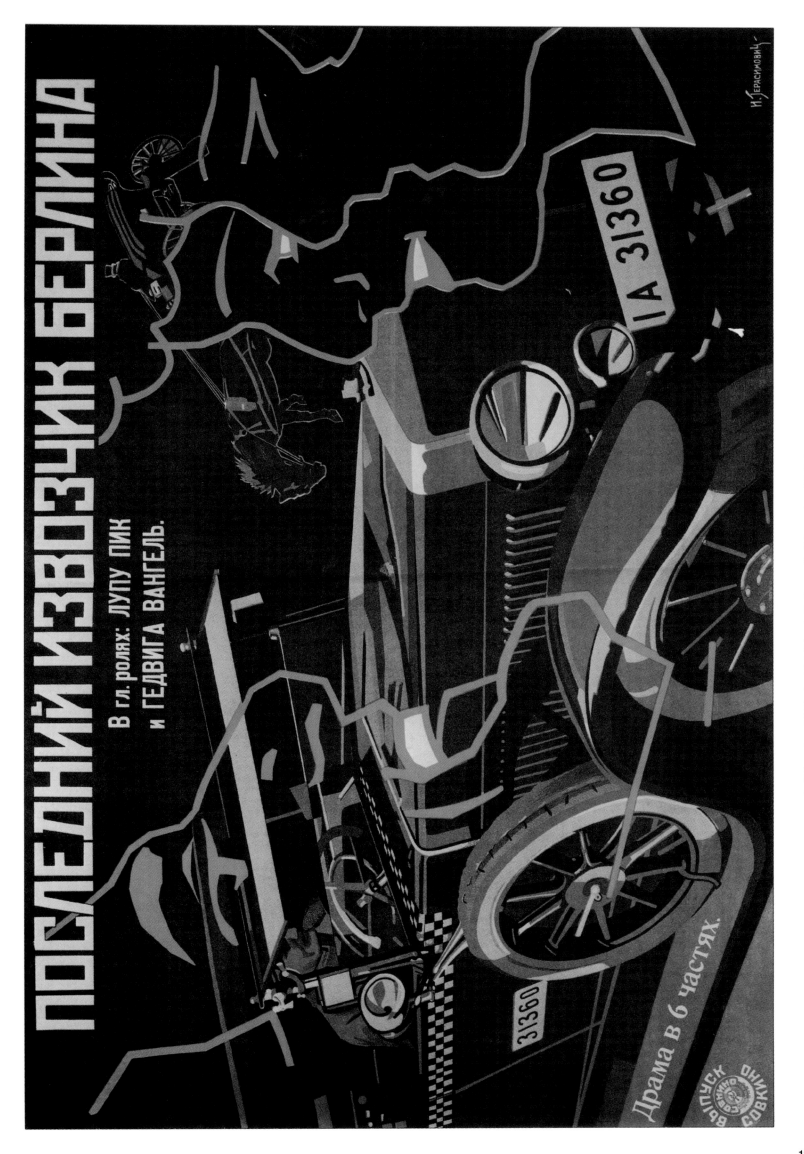

Iosif Gerasimovich The Last Cab Driver in Berlin • Yosif Guerasimovich El último cochero de Berlin
Iosif Gerasimovich Le dernier cocher de Berlin • Iosif Gerasimowitsch Der letzte Droschkenfahrer von Berlin
1928

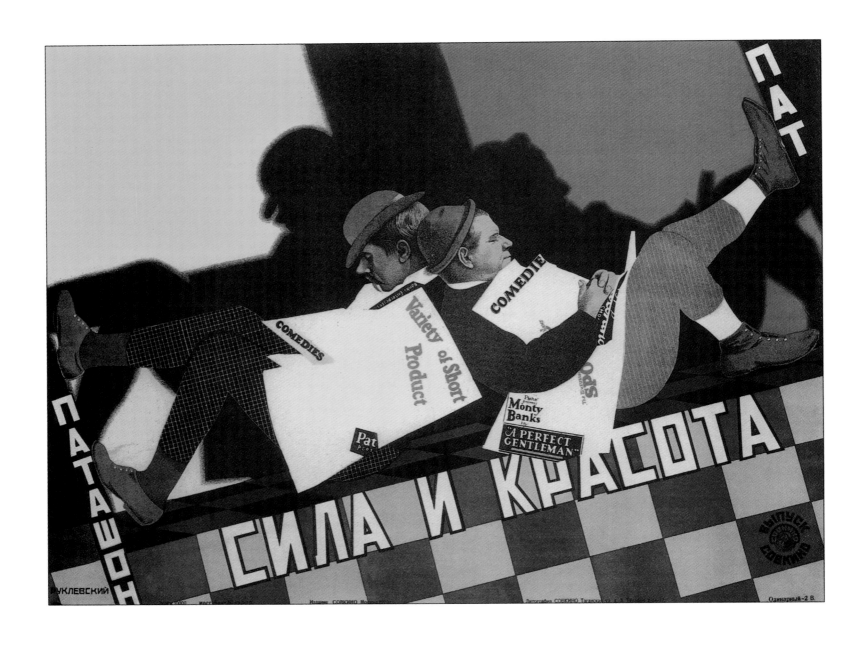

Yakov Ruklevsky Strength and Beauty • **Yákov Ruklevski** Fuerza y belleza
Yakov Rouklevski La force et la beauté • **Jakow Ruklewski** Kraft und Schönheit
1929

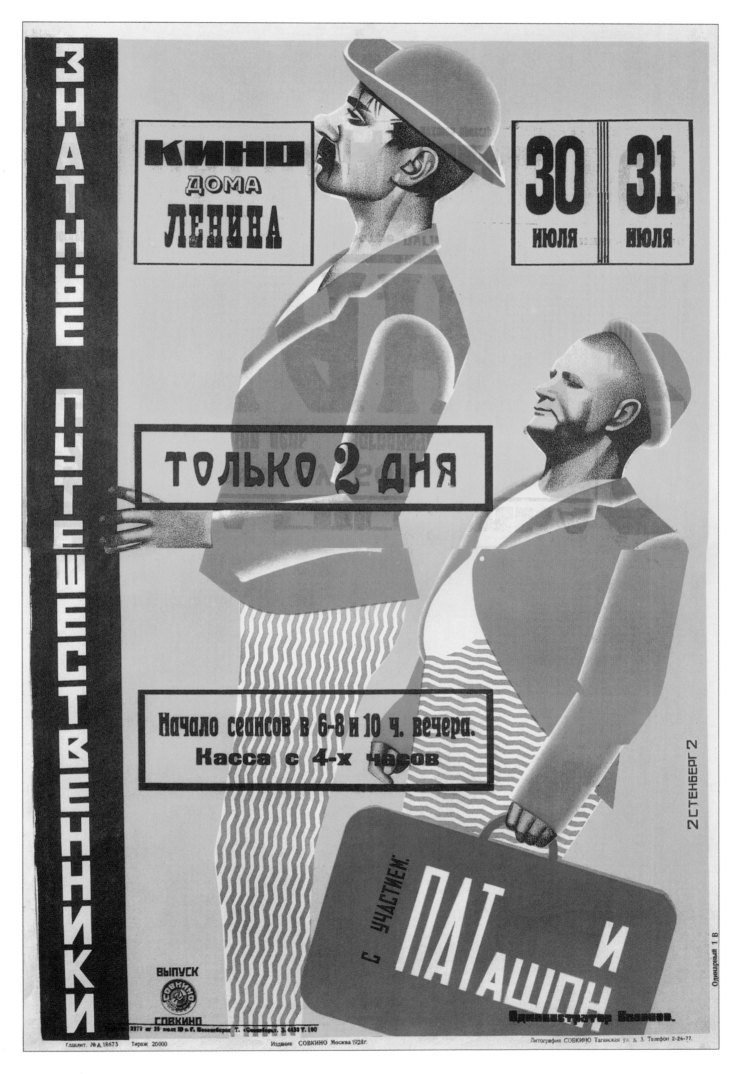

Georgi and Vladimir Stenberg Distinguished Travellers • Gueorgui y Vladímir Stenberg Viajeros distinguidos
Guéorgui et Vladimir Stenberg Des voyageurs de marque • Georgi und Wladimir Stenberg Vornehme Reisende
1928

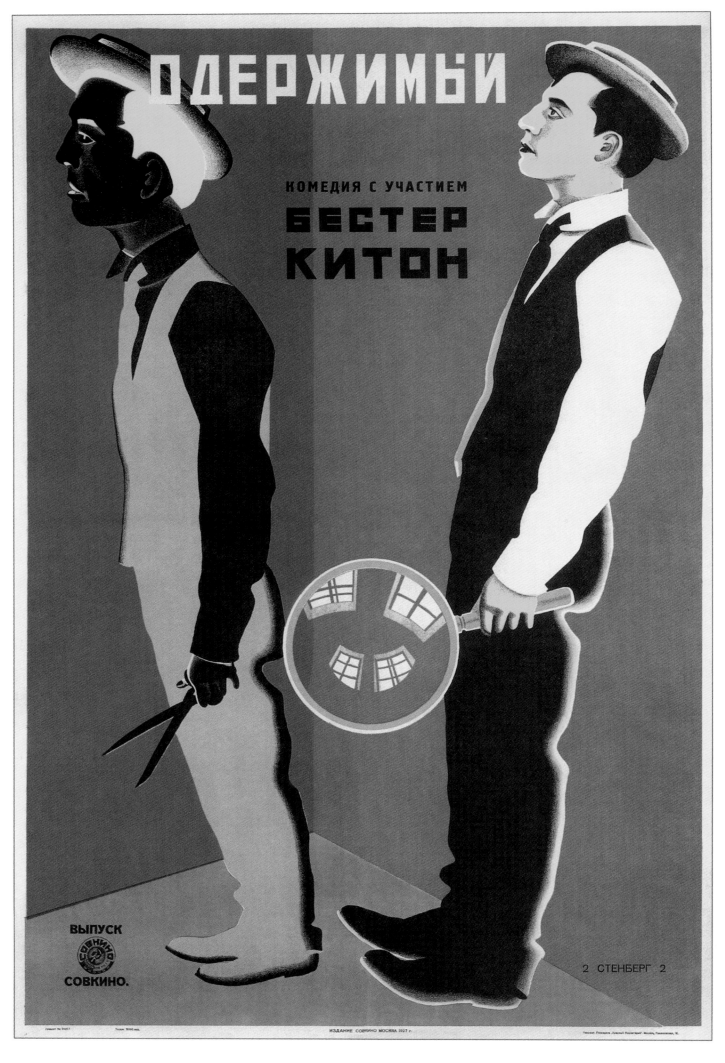

Georgi and Vladimir Stenberg Overcome • Gueorgui y Vladímir Stenberg Poseídos
Guéorgui et Vladimir Stenberg Le possédé • Georgi und Wladimir Stenberg Besessen
1927

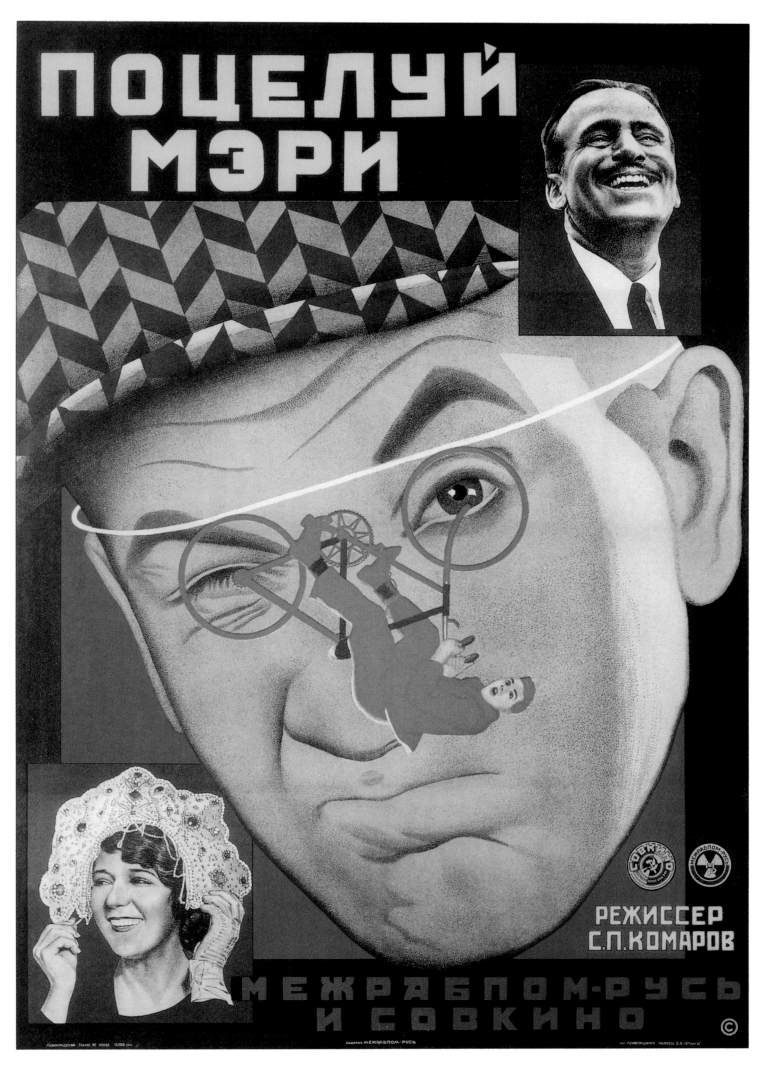

Semion Semionov-Menes Mary's Kiss • Semyón Semyónov-Menes El beso de Mary

Semion Semionov-Menes Le baiser de Mary • Semen Semenow-Menes Der Kuss von Mary

1927

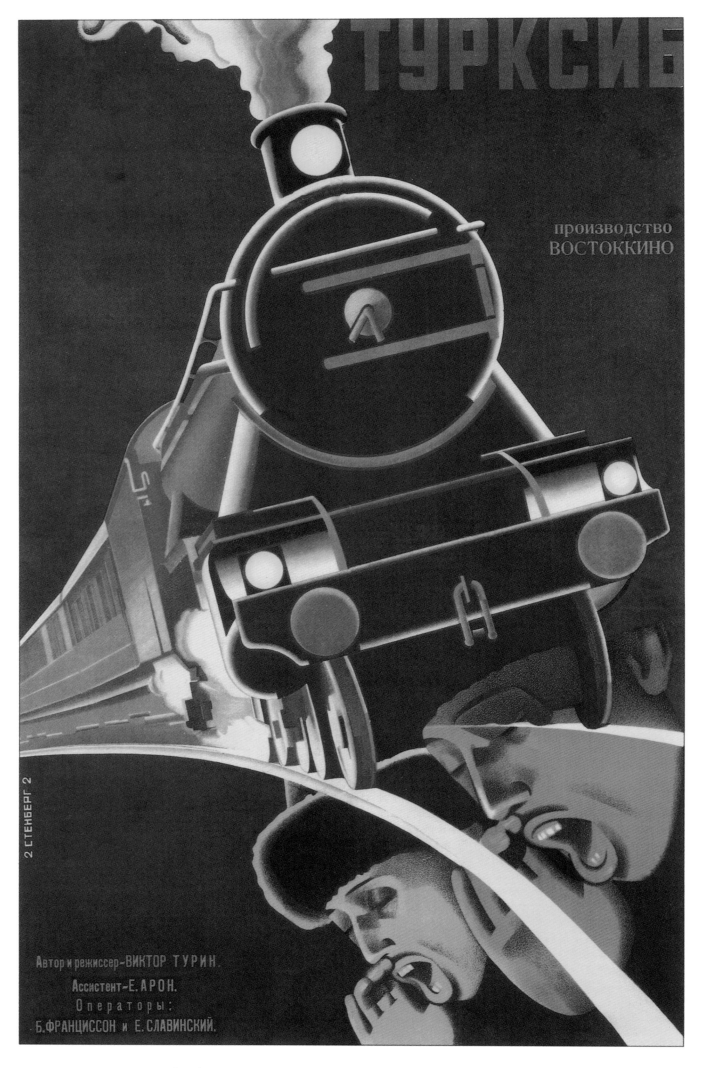

Georgi and Vladimir Stenberg Turksib • Gueorgui y Vladimir Stenberg Turksib
Guéorgui et Vladimir Stenberg Le Turksib • Georgi und Wladimir Stenberg Turksib
1929

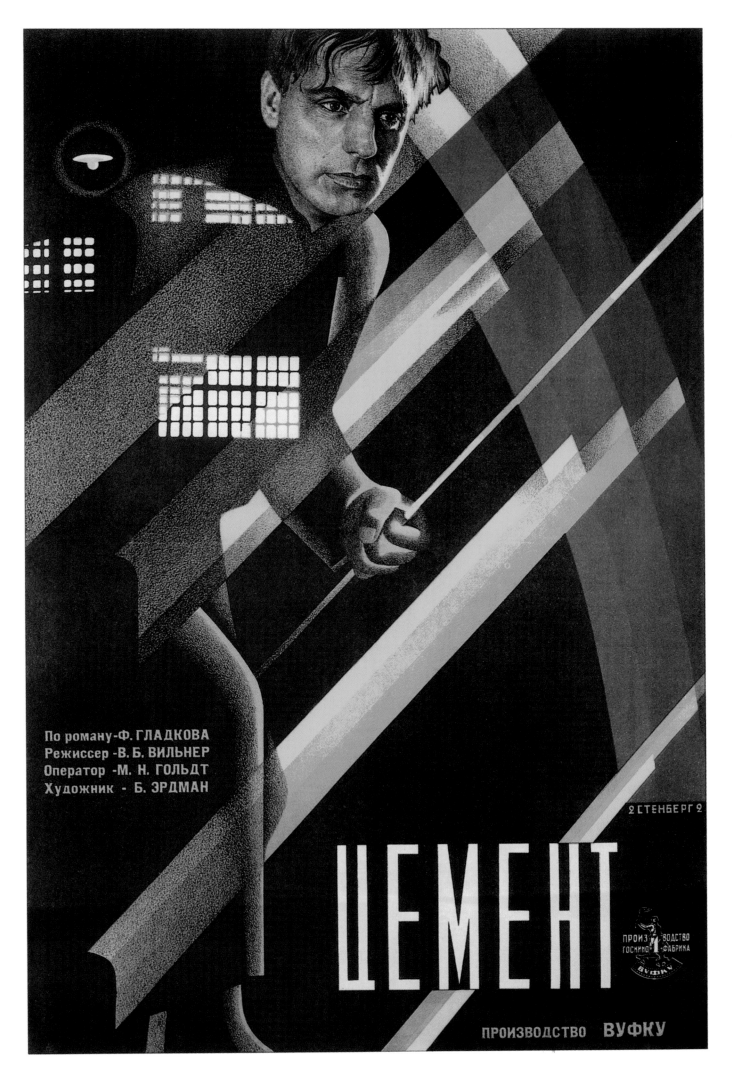

Georgi and Vladimir Stenberg Cement • Gueorgui y Vladímir Stenberg Cemento
Guéorgui et Vladimir Stenberg Le ciment • Georgi und Wladimir Stenberg Zement
1928

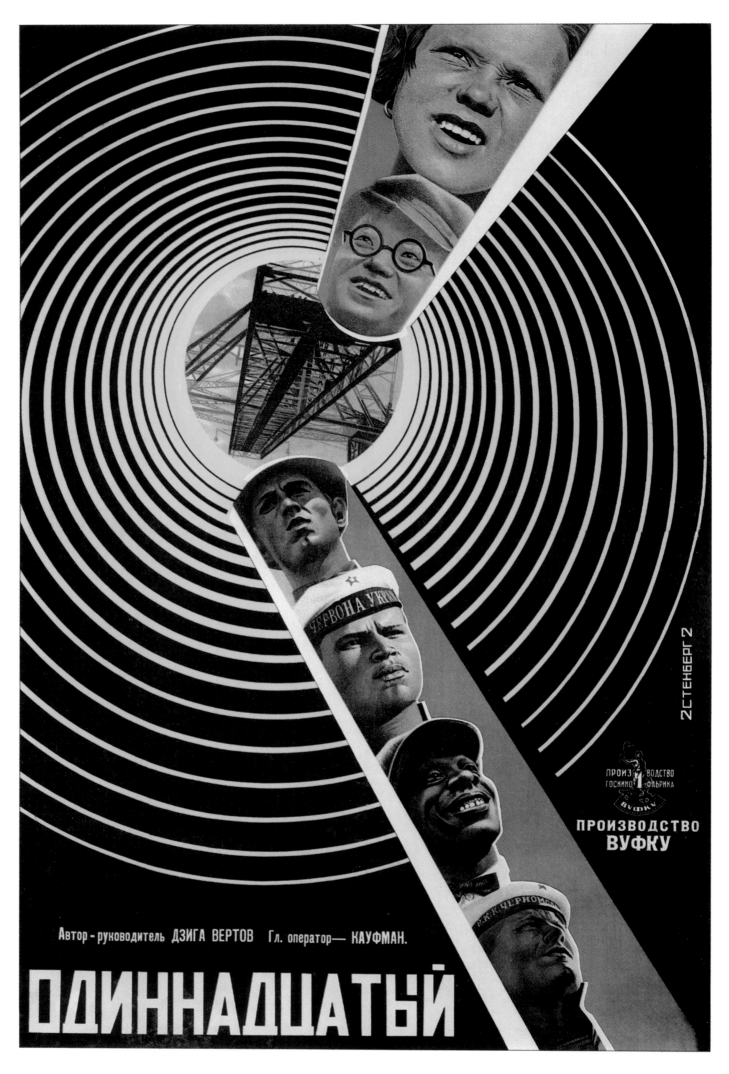

Georgi and Vladimir Stenberg The Eleventh Year • Gueorgui y Vladímir Stenberg El undécimo año
Guéorgui et Vladimir Stenberg La onzième année • Georgi und Wladimir Stenberg Das elfte Jahr
1928

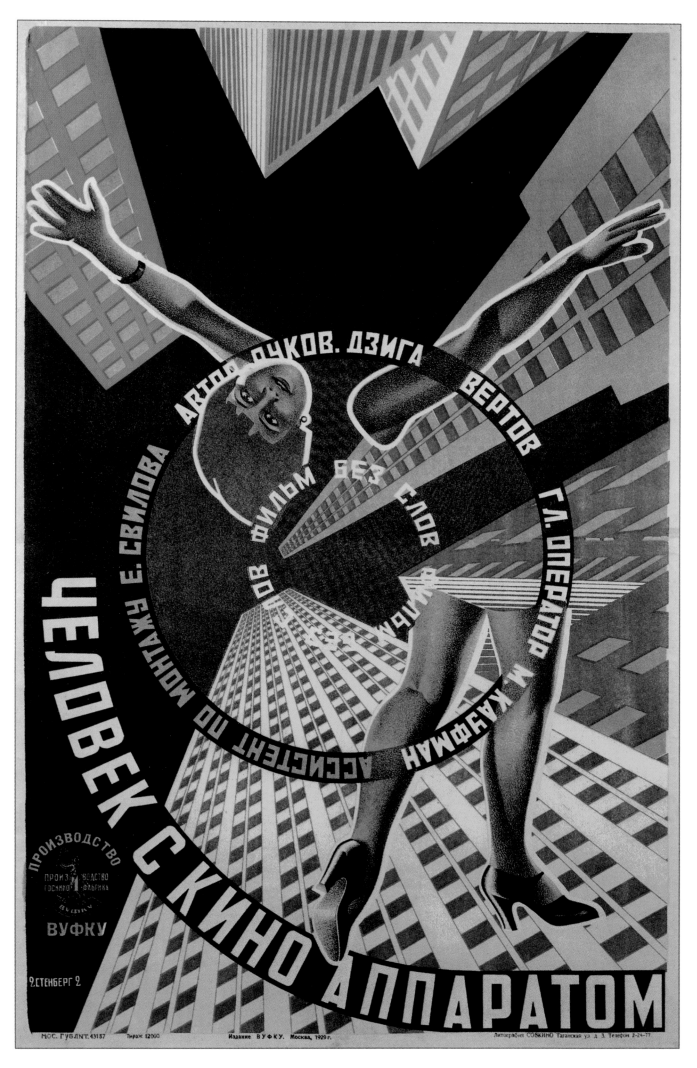

Georgi and Vladimir Stenberg Man with the Movie Camera • Gueorgui y Vladímir Stenberg El hombre con la cámara
Guéorgui et Vladimir Stenberg L'homme à la caméra • Georgi und Wladimir Stenberg Der Mann mit der Kamera
1929

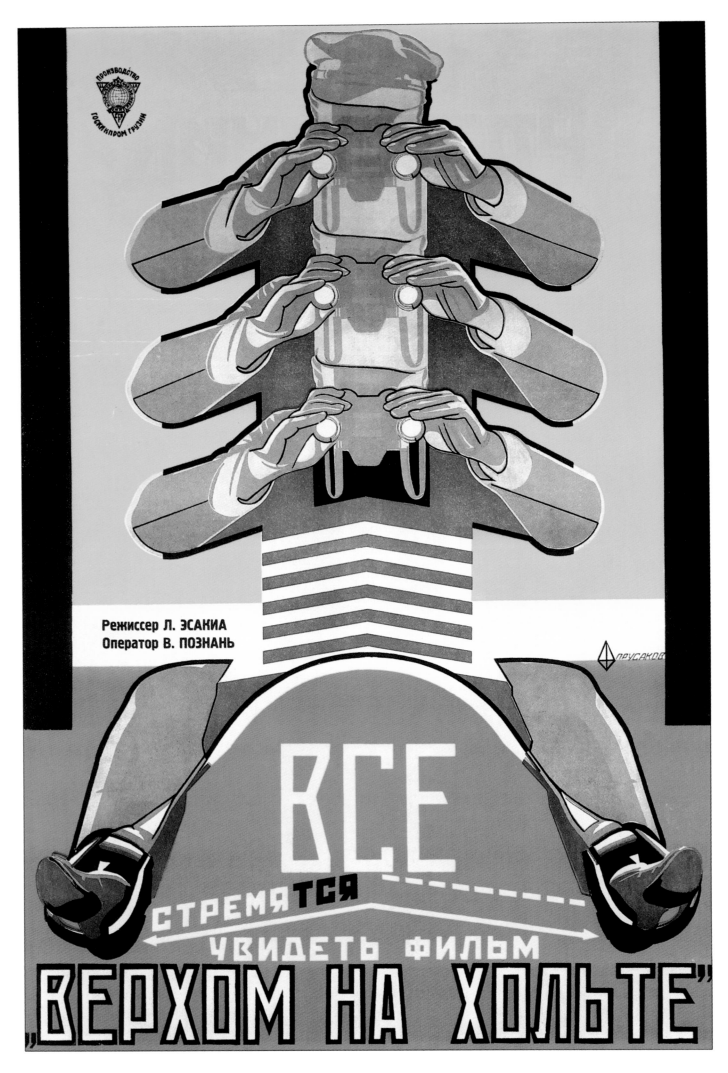

Nikolai Prusakov Up on Kholt • Nikolai Prusákov Encima del Jolt
Nicolas Prousakov A cheval sur le Holt • Nikolai Prusakow Auf dem Cholt
1929

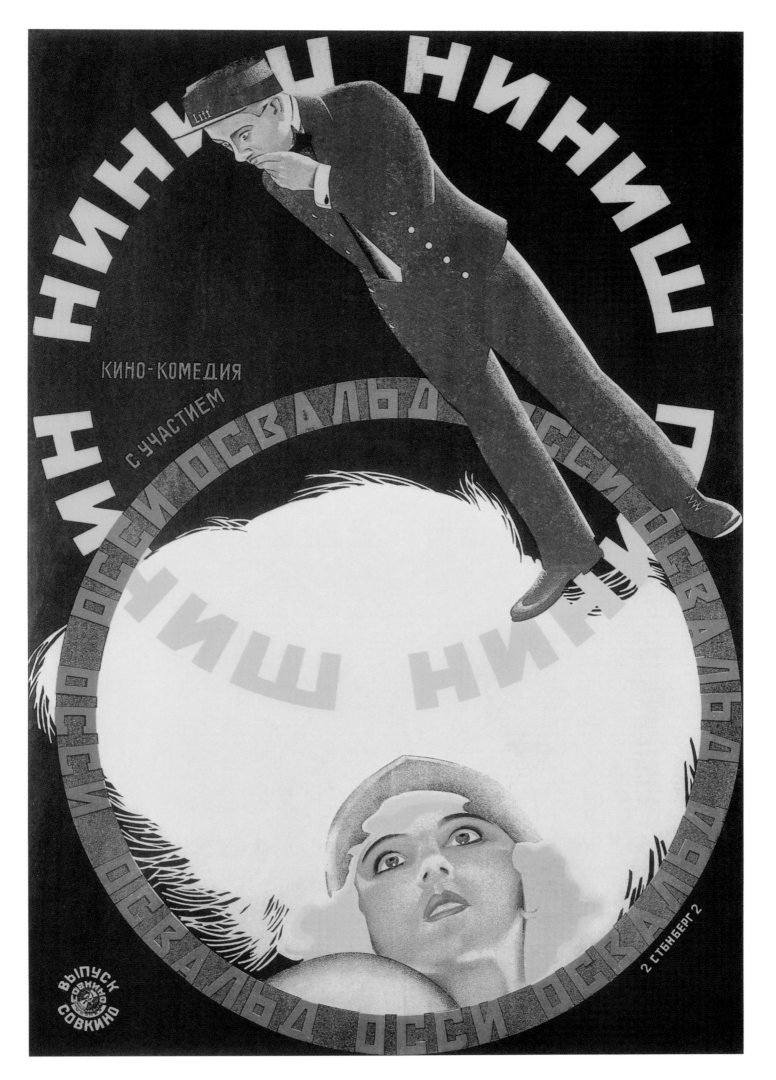

Georgi and Vladimir Stenberg Niniche • Gueorgui y Vladímir Stenberg Niniche
Guéorgui et Vladimir Stenberg Niniche • Georgi und Wladimir Stenberg Niniche

1927

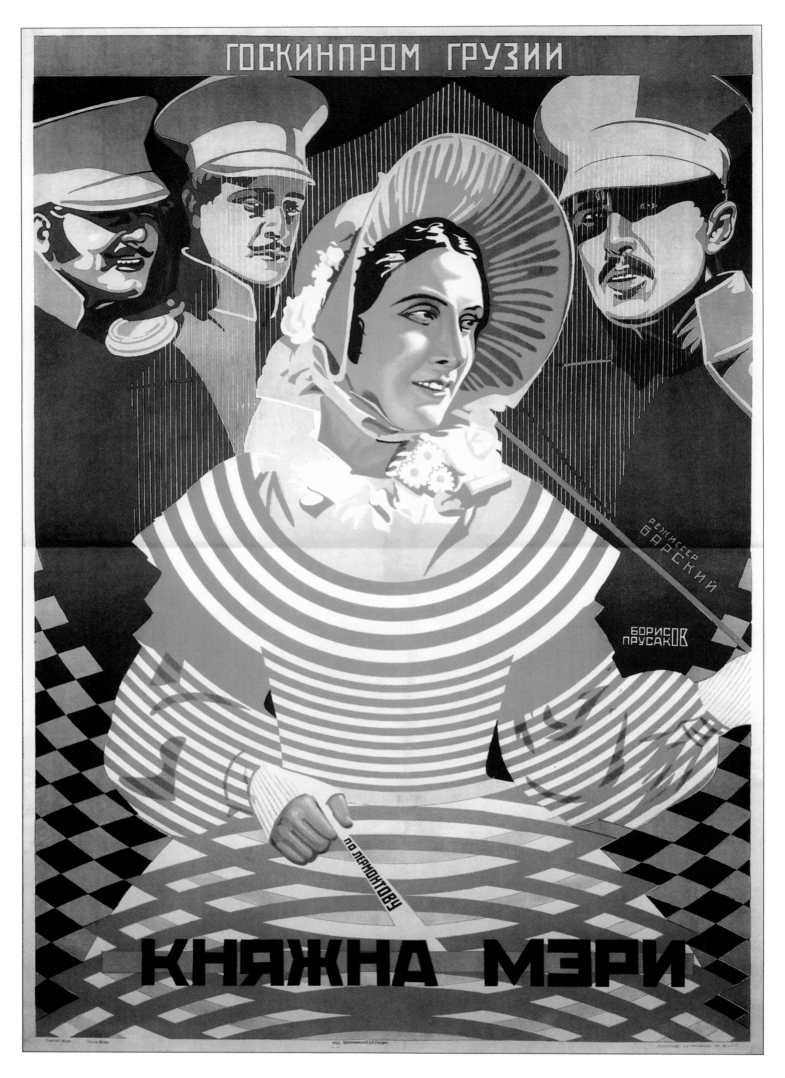

Grigori Borisov and Nikolai Prusakov Princess Mary • Grigori Borísov y Nikolai Prusákov Princesa Mary

Grigori Borisov et Nicolas Prousakov La princesse Mary • Grigori Borisow und Nikolai Prusakow Fürstentochter Mary

1927

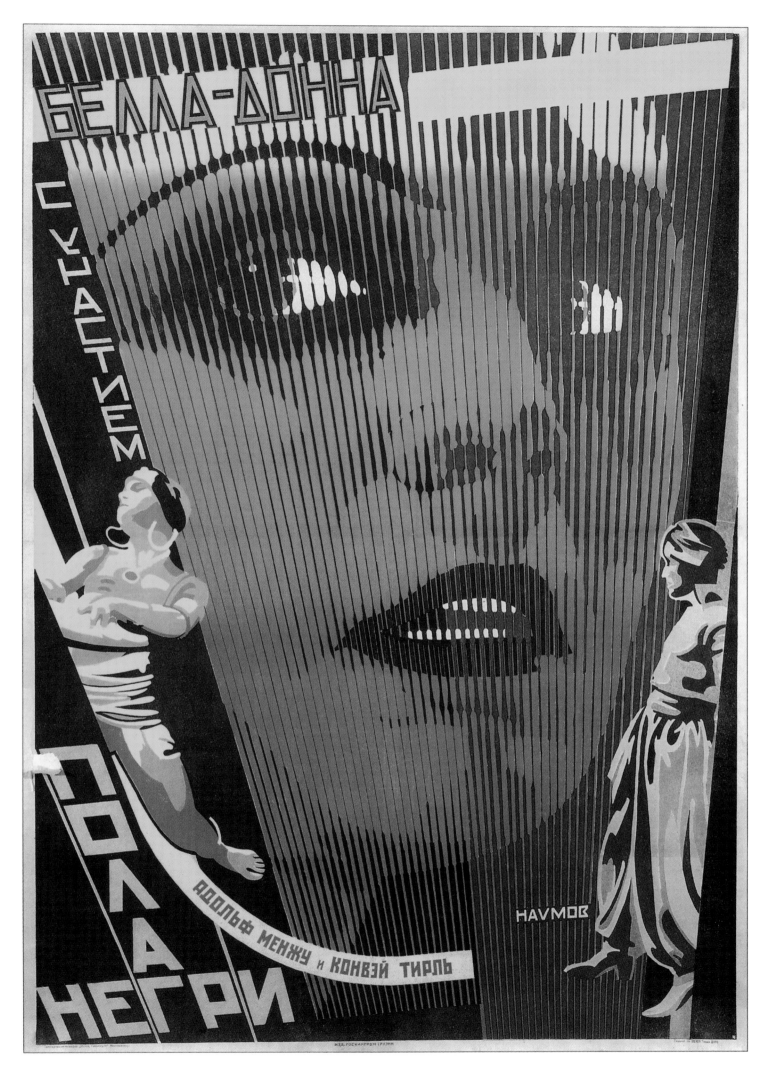

Alexander **Naumov** Bella Donna • Alexandr **Naumov** Bella Donna
Alexandre **Naoumov** Bella Donna • Alexander **Naumow** Bella Donna

1927

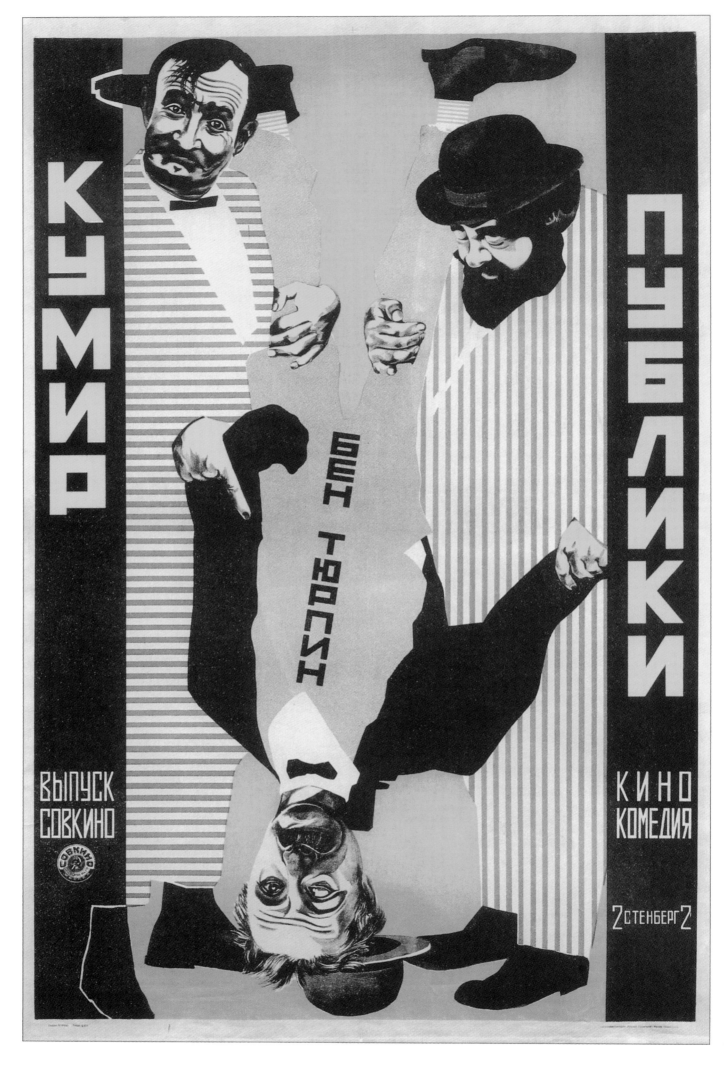

Georgi and Vladimir Stenberg Idol of the Public • Gueorgui y Vladímir Stenberg El ídolo del público
Guéorgui et Vladimir Stenberg L'idole du public • Georgi und Wladimir Stenberg Der Publikumsliebling
1925

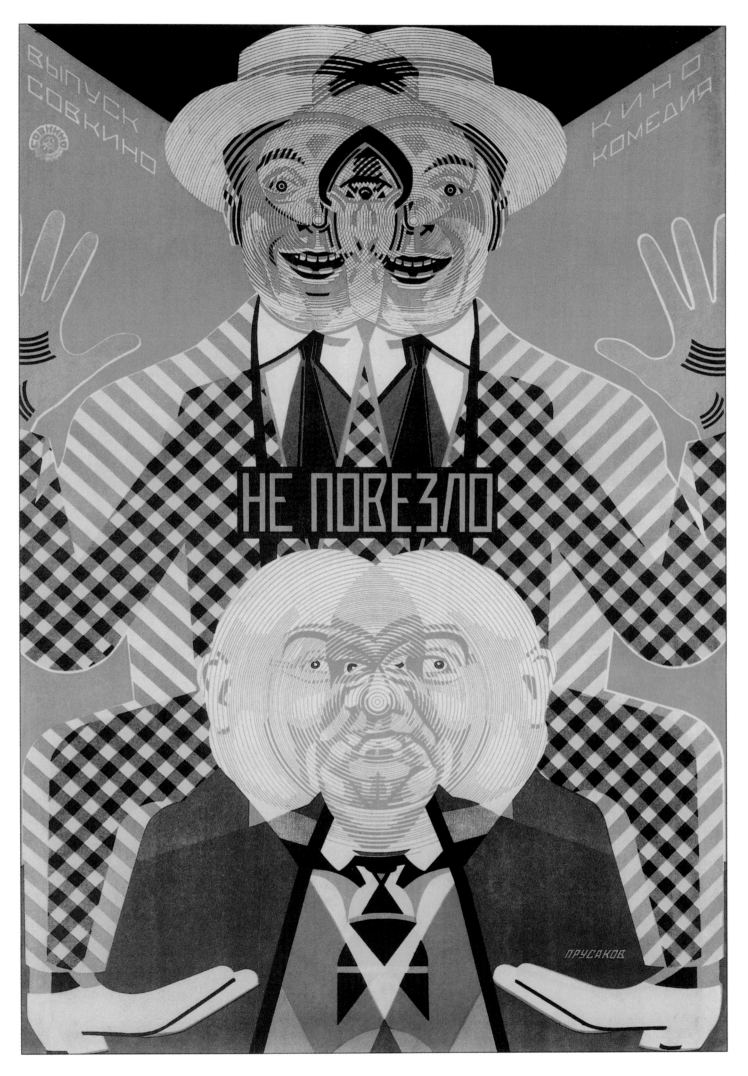

Nikolai Prusakov No Luck • Nikolai Prusákov Mala suerte
Nicolas Prousakov Pas de chance • Nikolai Prusakow Pech gehabt
1927

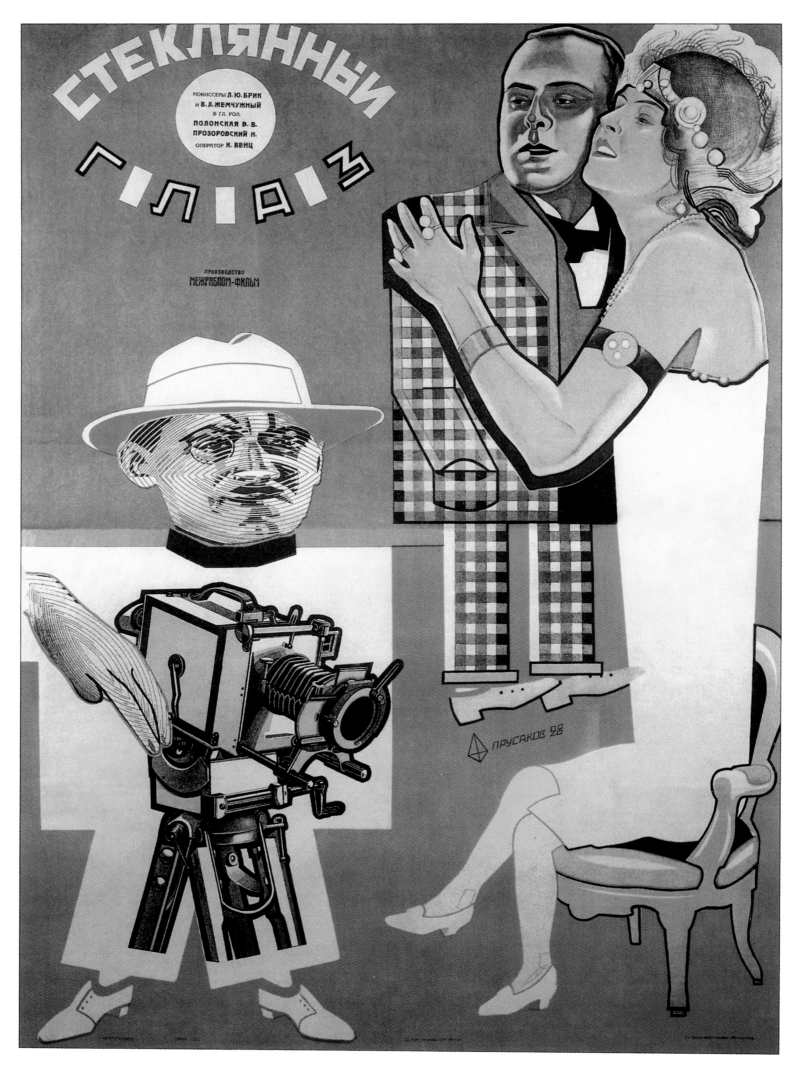

Nikolai Prusakov The Glass Eye • Nikolai Prusákov El ojo de cristal
Nicolas Prousakov L'œil de verre • Nikolai Prusakow Das Glasauge
1929

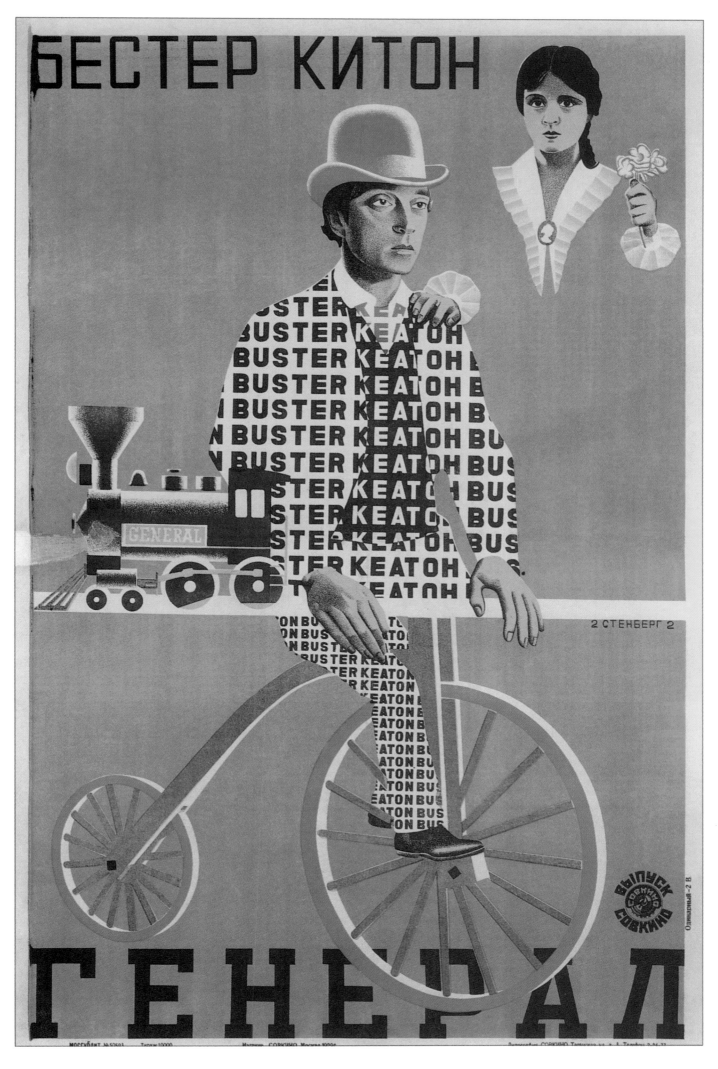

Georgi and Vladimir Stenberg The General • **Gueorgui y Vladímir Stenberg** La General
Guéorgui et Vladimir Stenberg Le mécano de la Générale • **Georgi und Wladimir Stenberg** Der General

1929

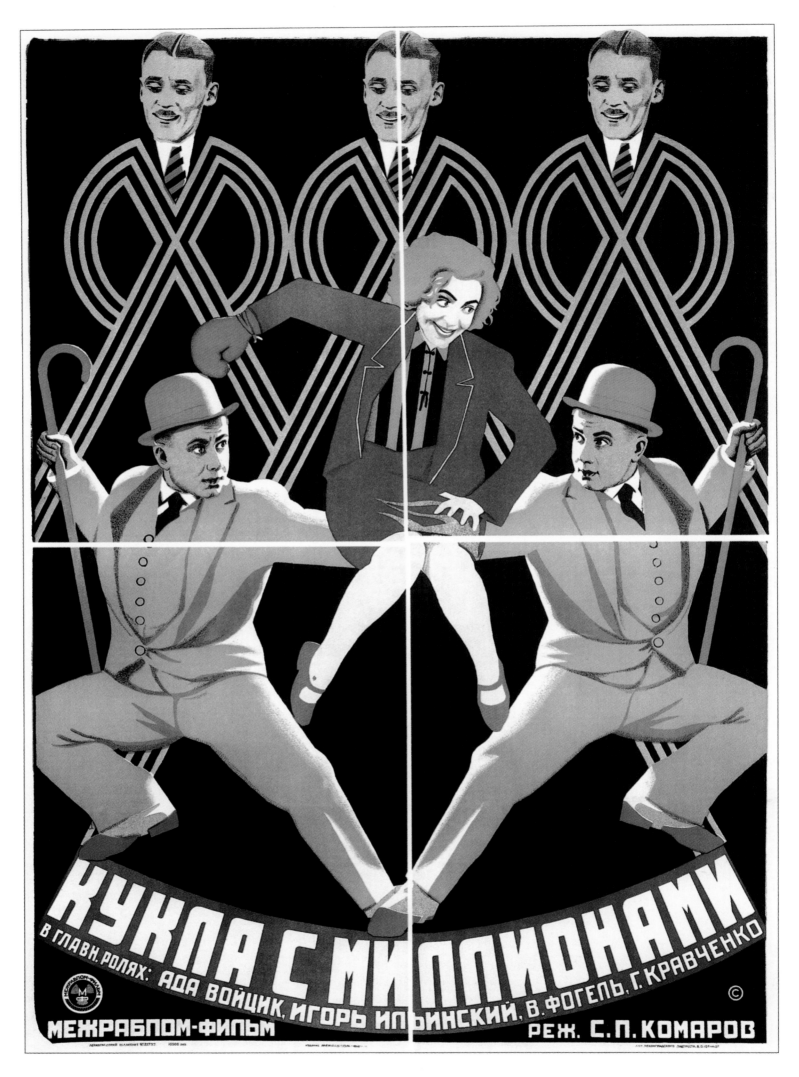

Semion Semionov-Menes The Doll with Millions • Semyón Semyónov-Menes La muñeca de los millones
Semion Semionov-Menes La poupée aux millions • Semen Semenow-Menes Die Puppe mit den Millionen
1928

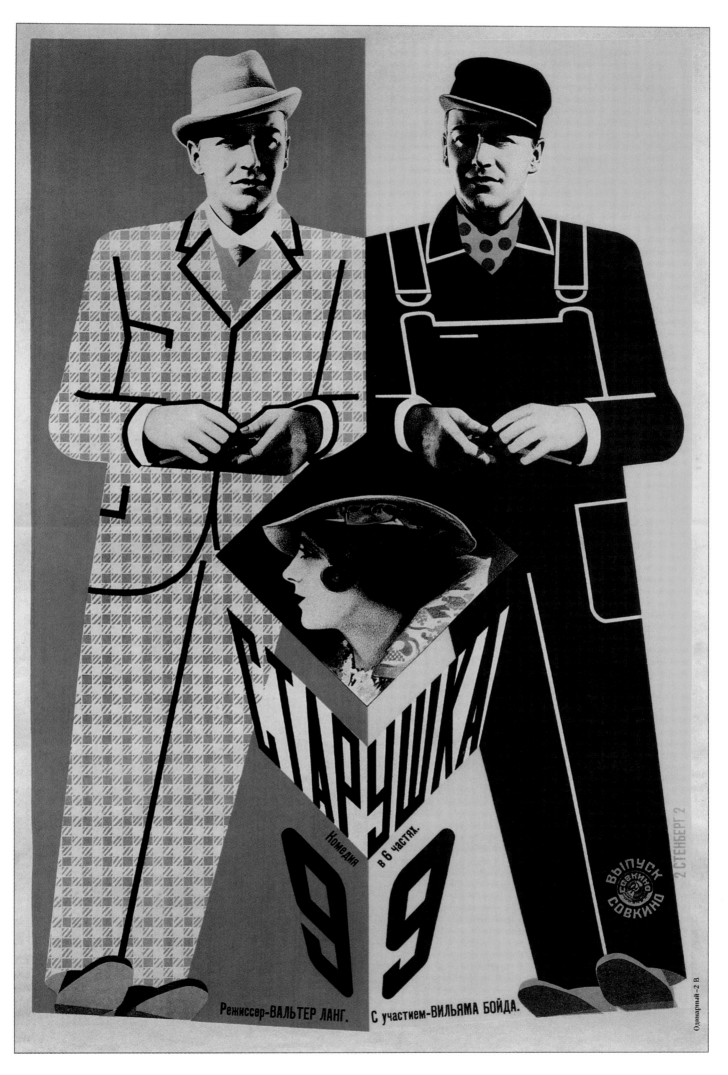

Georgi and Vladimir Stenberg Old Number 99 • Gueorgui y Vladímir Stenberg La antigua 99
Guéorgui et Vladimir Stenberg La vieille 99 • Georgi und Wladimir Stenberg Die alte Nr. 99
1929

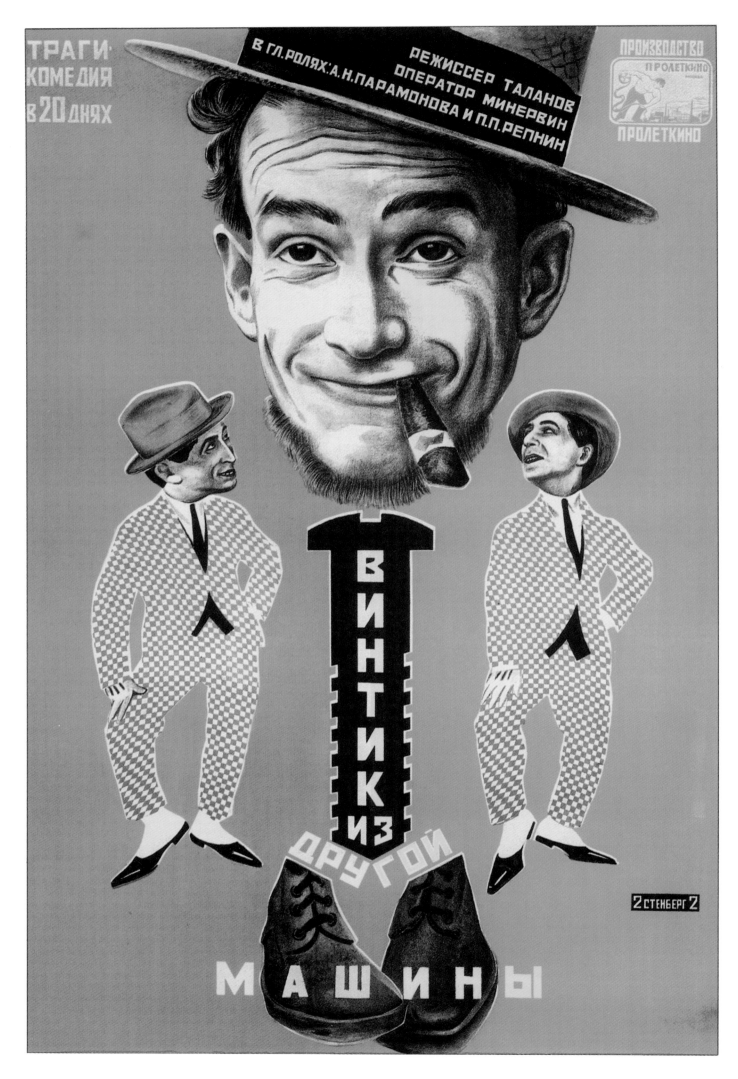

Georgi and Vladimir Stenberg The Screw from Another Machine • Gueorgui y Vladimír Stenberg El tornillo de otra máquina
Guéorgui et Vladimir Stenberg La vis d'une autre machine • Georgi und Wladimir Stenberg Die Schraube von einer anderen Maschine
1926

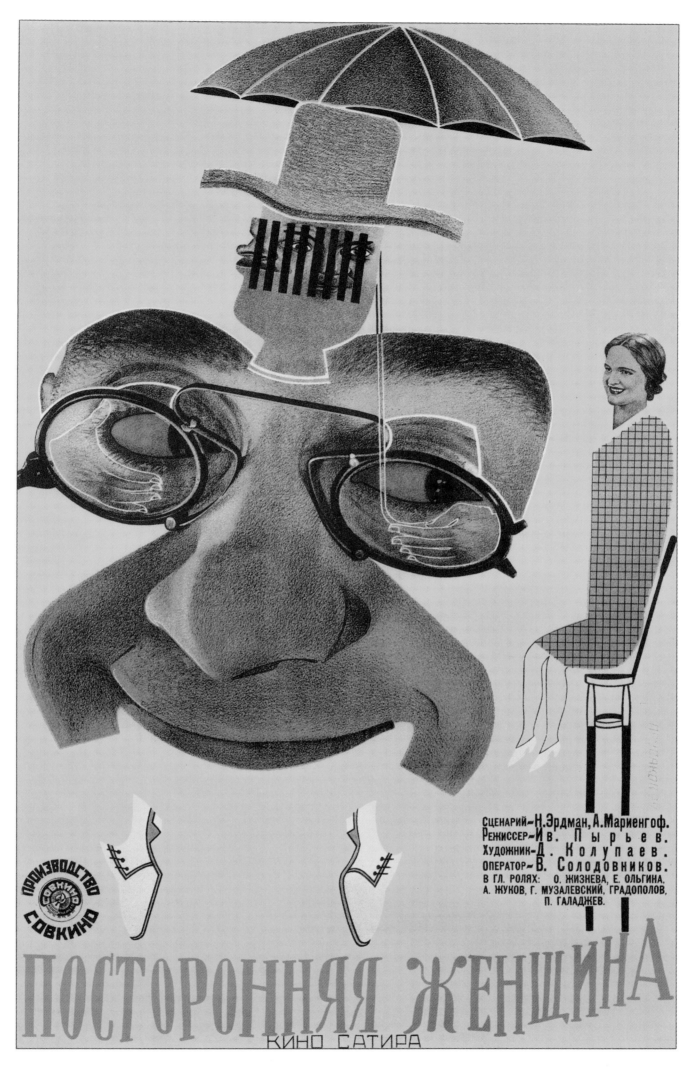

Nikolai Prusakov Strange Woman • Nikolai Prusákov Extraña mujer
Nicolas Prousakov Une autre femme • Nikolai Prusakow Die fremde Frau

1929

Georgi and Vladimir Stenberg Six Girls Seeking Shelter • **Gueorgui y Vladimir Stenberg** Seis chicas buscan refugio
Guéorgui et Vladimir Stenberg Six jeunes filles en quête d'un refuge • **Georgi und Wladimir Stenberg** Sechs Mädchen suchen Nachtquartier
1928

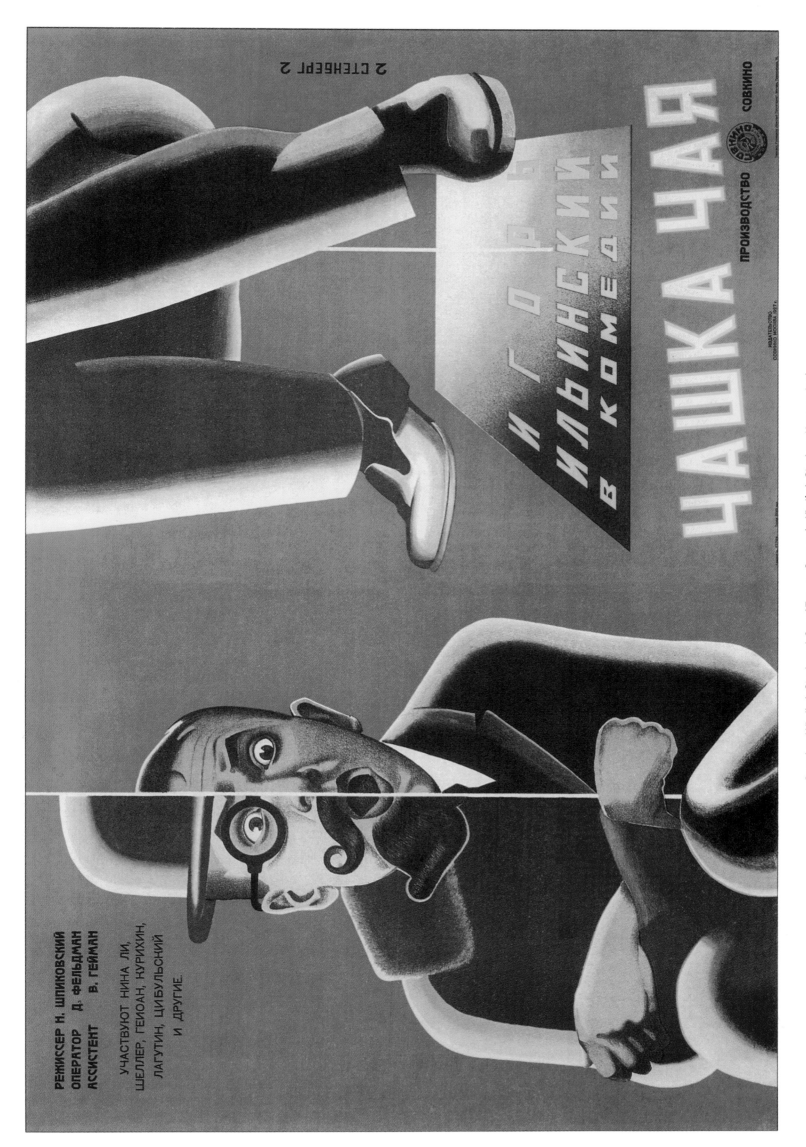

Georgi and Vladimir Stenberg A Cup of Tea • Gueorgui y Vladimir Stenberg Una taza de té
Guéorgui et Vladimir Stenberg Une tasse de thé • Georgi und Wladimir Stenberg Eine Tasse Tee
1927

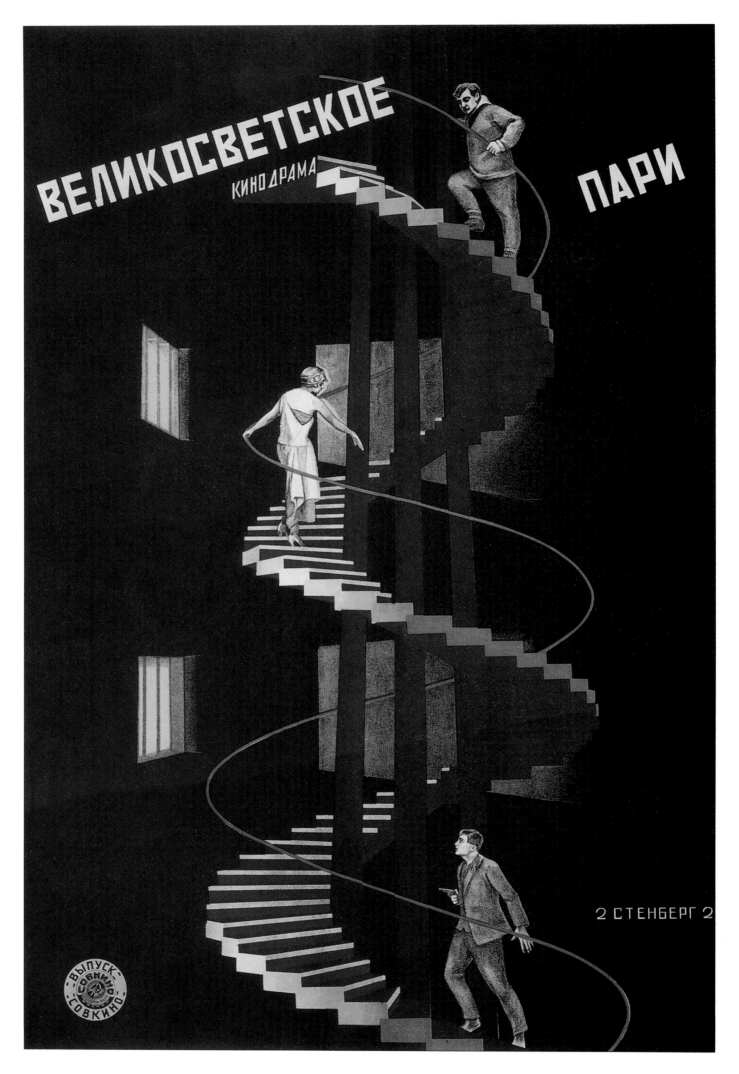

Georgi and Vladimir Stenberg High Society Wager • Gueorgui y Vladímir Stenberg Una apuesta mundana
Guéorgui et Vladimir Stenberg Un pari mondain • Georgi und Wladimir Stenberg Eine Wette in feinen Kreisen
1927

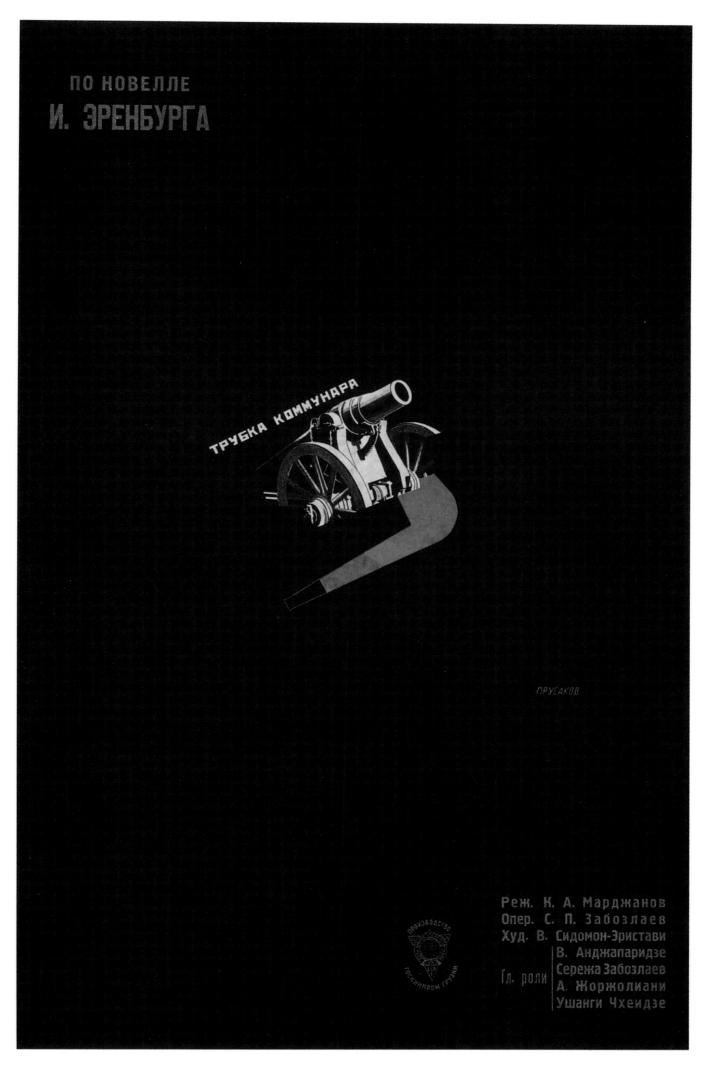

ПО НОВЕЛЛЕ
И. ЭРЕНБУРГА

ТРУБКА КОММУНАРА

ПРУСАКОВ

Реж. К. А. Марджанов
Опер. С. П. Забозлаев
Худ. В. Сидомон-Эристави
В. Анджапаридзе
Сережа Забозлаев
Гл. роли А. Жоржолиани
Ушанги Чхеидзе

Nikolai Prusakov The Communard's Pipe • **Nikolai Prusákov** La pipa del partidario de la Comuna
Nicolas Prousakov La pipe du communard • **Nikolai Prusakow** Die Pfeife des Kommunarden
1929

Georgi and Vladimir Stenberg The Pencil • Gueorgui y Vladímir Stenberg El lápiz
Guéorgui et Vladimir Stenberg Le crayon • Georgi und Wladimir Stenberg Der Bleistift
1928

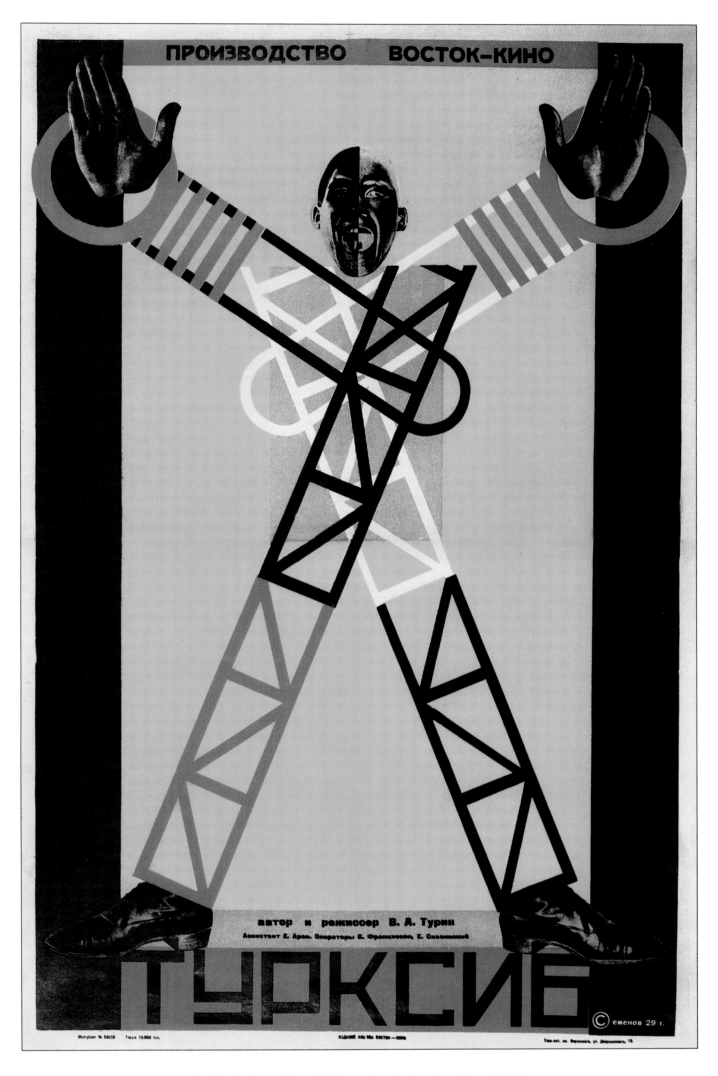

Semion Semionov-Menes Turksib • Semyón Semyónov-Menes Turksib

Semion Semionov-Menes Le Turksib • Semen Semenow-Menes Turksib

1929

Anonymous Toguyi Island • **Anónimo** La isla de Toguyi
Anonyme L'île de Toguyi • **Anonym** Die Toguji-Insel
1929

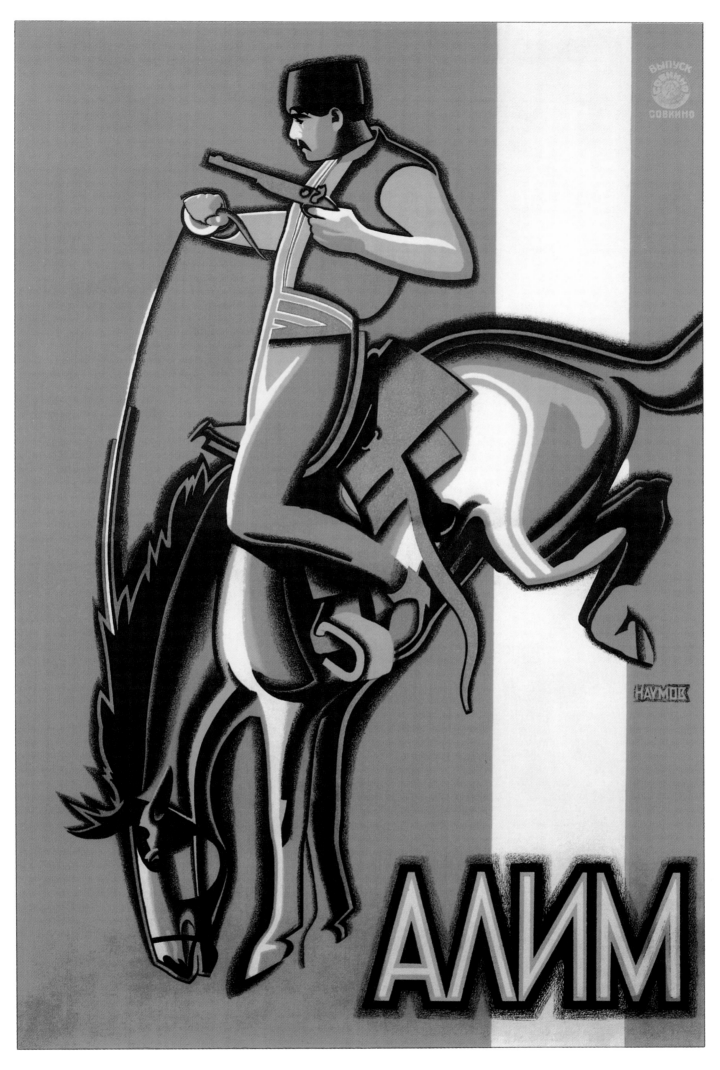

Alexander Naumov Alim • Alexandr Naumov Alim

Alexandre Naoumov Alim • Alexander Naumow Alim

1926

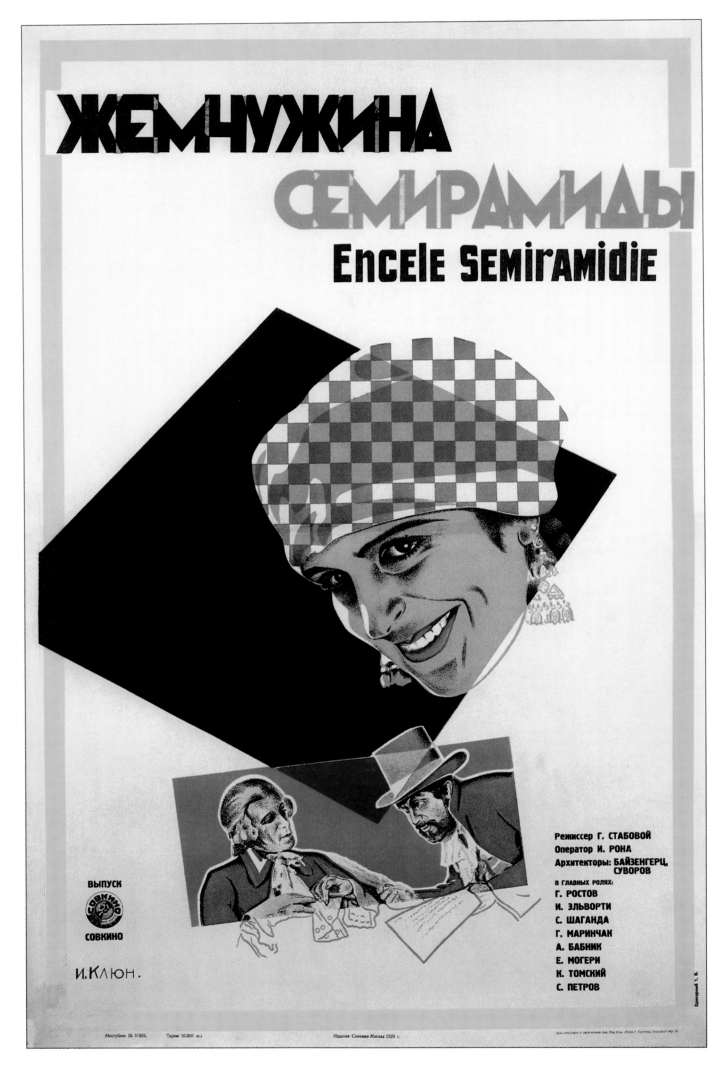

Ivan Kliun Semiramida's Pearl • Iván Kliun La perla de Semíramis

Ivan Klioun La perle de Sémiramis • Iwan Kljun Die Perle von Semiramis

1929

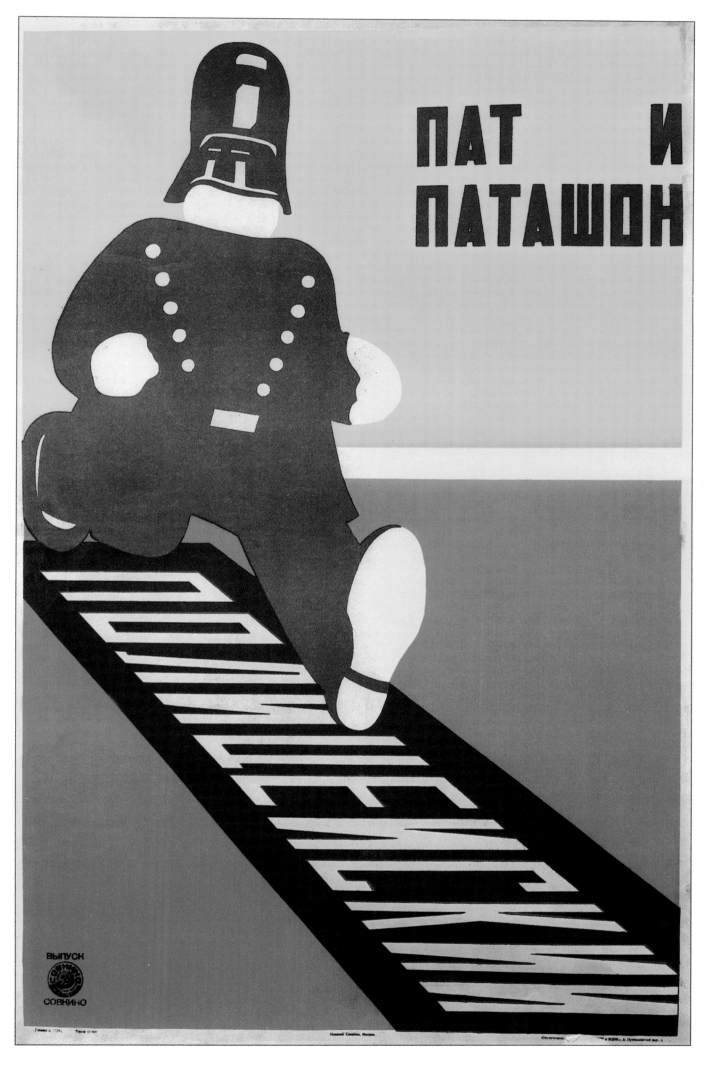

Georgi and Vladimir Stenberg The Policeman • Gueorgui y Vladímir Stenberg El policía
Guéorgui et Vladimir Stenberg Le policier • Georgi und Wladimir Stenberg Der Polizist
1928

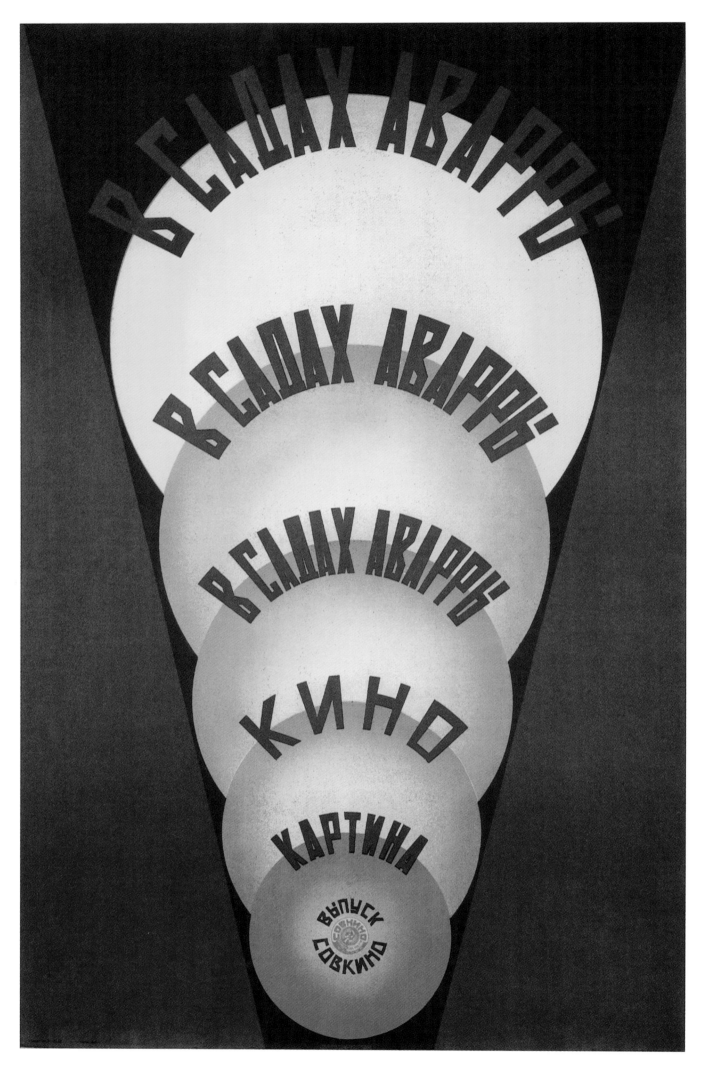

Anonymous In the Gardens of Avarra • Anónimo En los jardines de Murcia
Anonyme Aux jardins de Murcie • Anonym In den Gärten von Avarra
1926

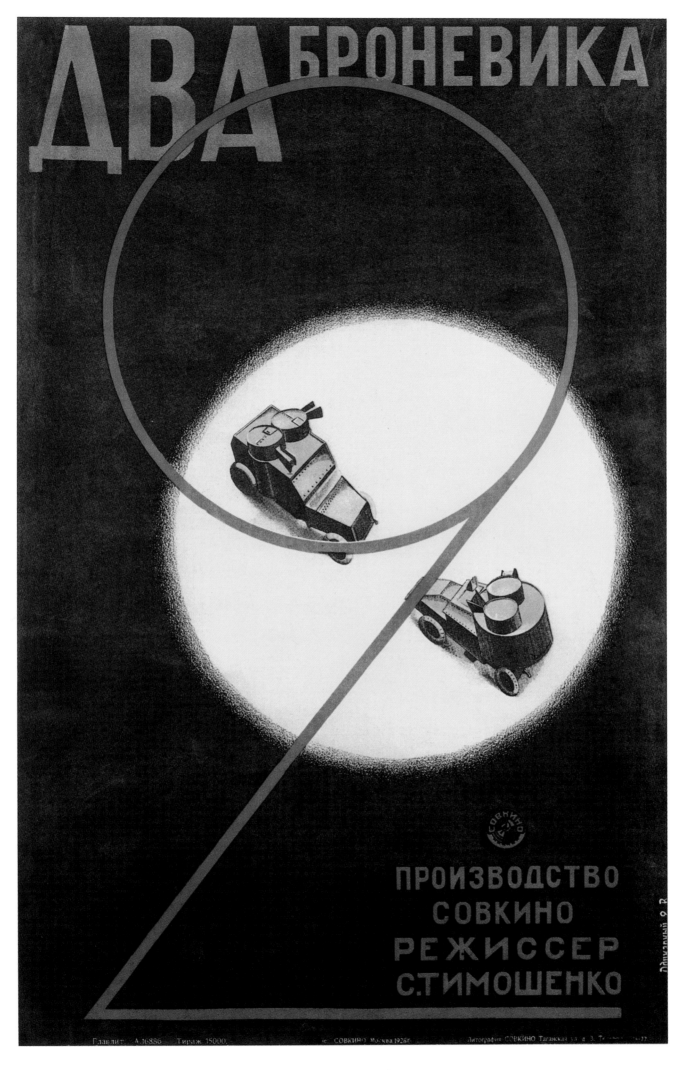

Anonymous Two Armoured Cars • Anónimo Dos blindados
Anonyme Deux blindés • Anonym Zwei Panzerwagen
1928

Vladimir Kabak Miss Mend • **Vladimir Kabak** Miss Mend
Vladimir Kabak Miss Mend • **Vladimir Kaabak** Miss Mend
1926

НУ ХА МА

ХАНУМА

В ГЛАВНЫХ РОЛЯХ.
ТАМАРА БОЛКВАДЗЕ
КОТЭ МИКАБЕРИДЗЕ
ЧЕРКЕЗИШВИЛИ

РЕЖИССЕРА.ЦУЦУНАВА
ПРОИЗВОДСТВО ГОСКИНПРОМА ГРУЗИИ
ОПЕРАТОР ЭНГЕЛЬС

К.ВЯЛОВ
ИЗД. СОВКИНО

Konstantin Vialov Khanuma • **Konstantin Vialov** Januma
Constantin Vialov Khanouma • **Konstantin Wjalow** Hanuma
1927

163

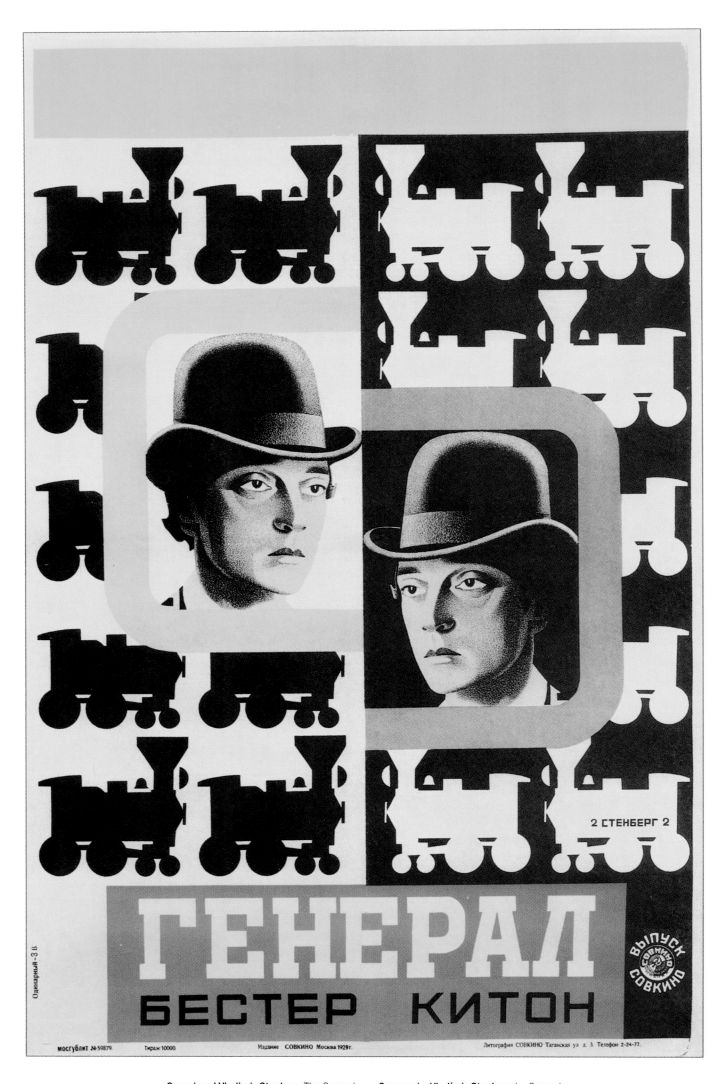

Georgi and Vladimir Stenberg The General • Gueorgui y Vladímir Stenberg La General

Guéorgui et Vladimir Stenberg Le mécano de la Générale • Georgi und Wladimir Stenberg Der General

1929

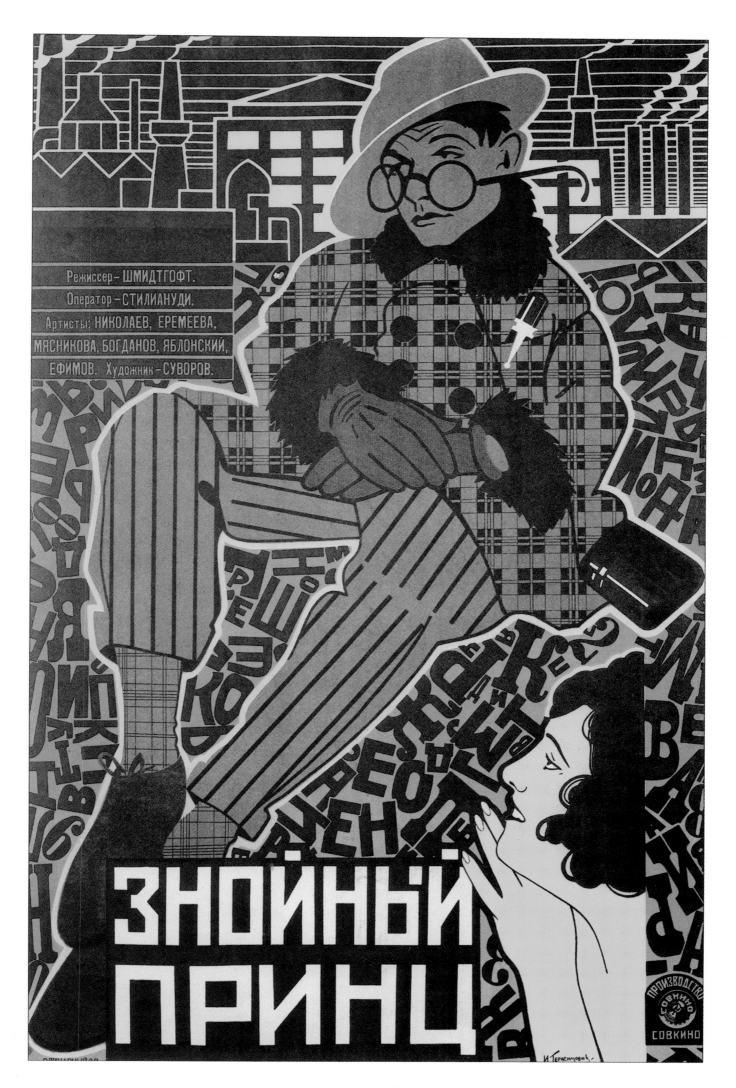

Iosif Gerasimovich The Passionate Prince • Yosif Guerasímovich El príncipe apasionado

Iosif Gerasimovich Le prince ardent • Iosif Gerasimowitsch Der leidenschaftliche Prinz

1928

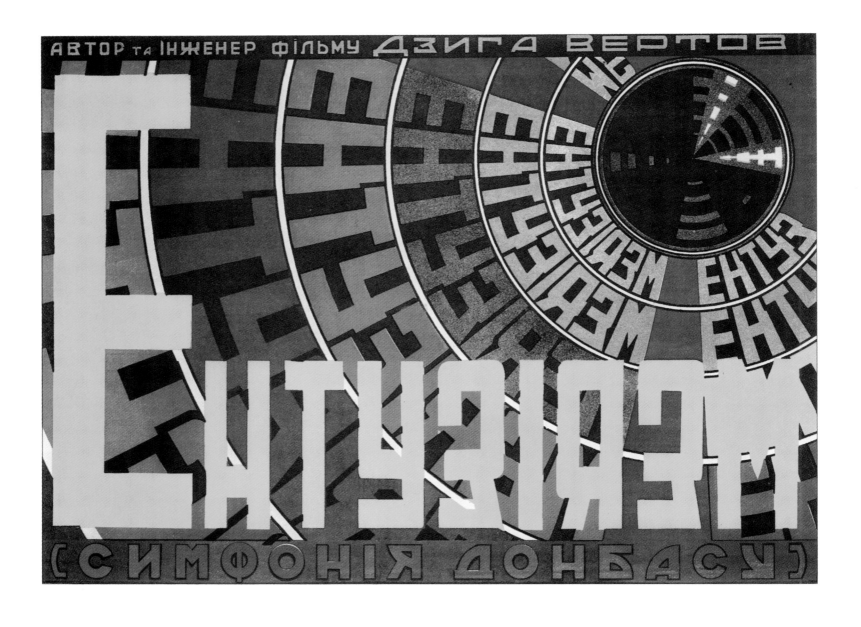

Anonymous Enthusiasm: Symphony of the Donbas • Anónimo Entusiasmo: sinfonía del Donbass
Anonyme Enthousiasme: La symphonie du Donbass • Anonym Enthusiasmus: Die Donbass-Sinfonie

1931

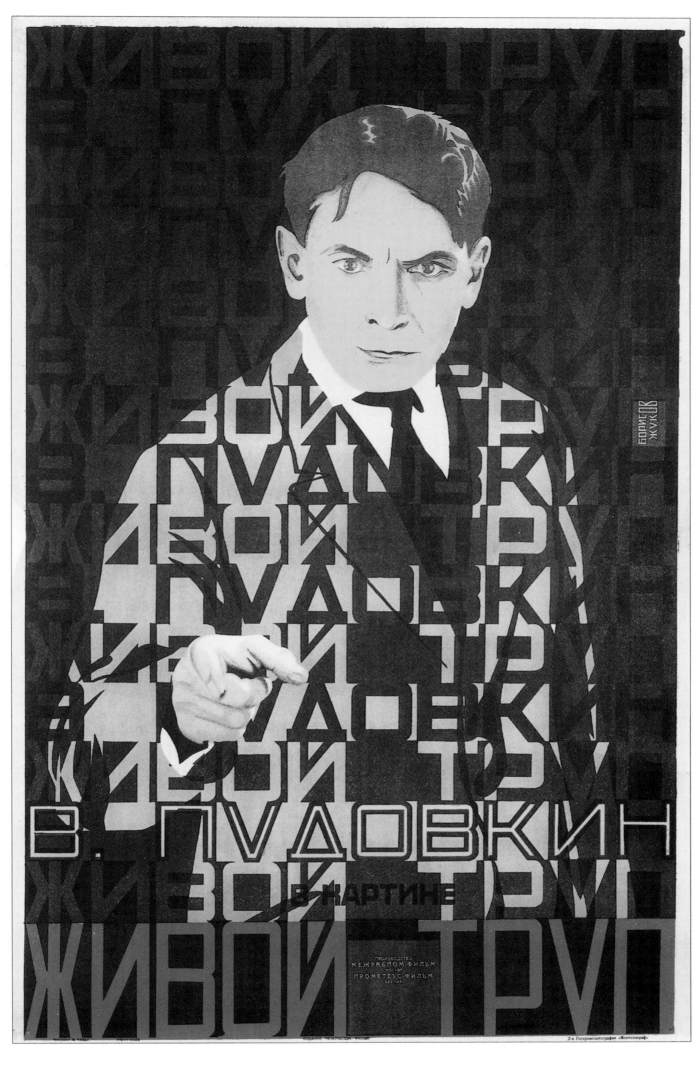

Grigori Borisov and Pyotr Zhukov The Living Corpse • **Grigori Borísov y Piotr Zhúkov** El cadáver vivo

Grigori Borisov et Piotr Joukov Le cadavre vivant • **Grigori Borisow und Pjotr Schukow** Der lebende Leichnam

1929

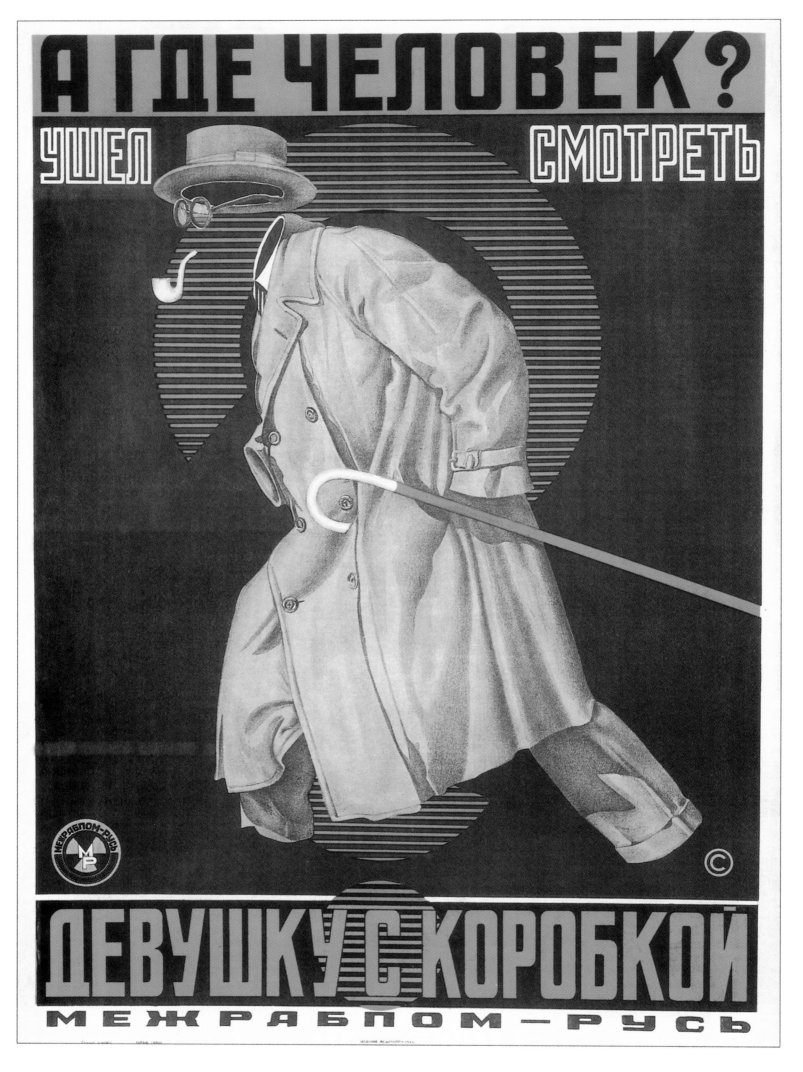

Semion Semionov-Menes The Girl with the Hat-Box • Semyón Semyónov-Menes La chica de la sombrerera
Semion Semionov-Menes La jeune fille au carton à chapeau • Semen Semenow-Menes Das Mädchen mit der Hutschachtel

1927

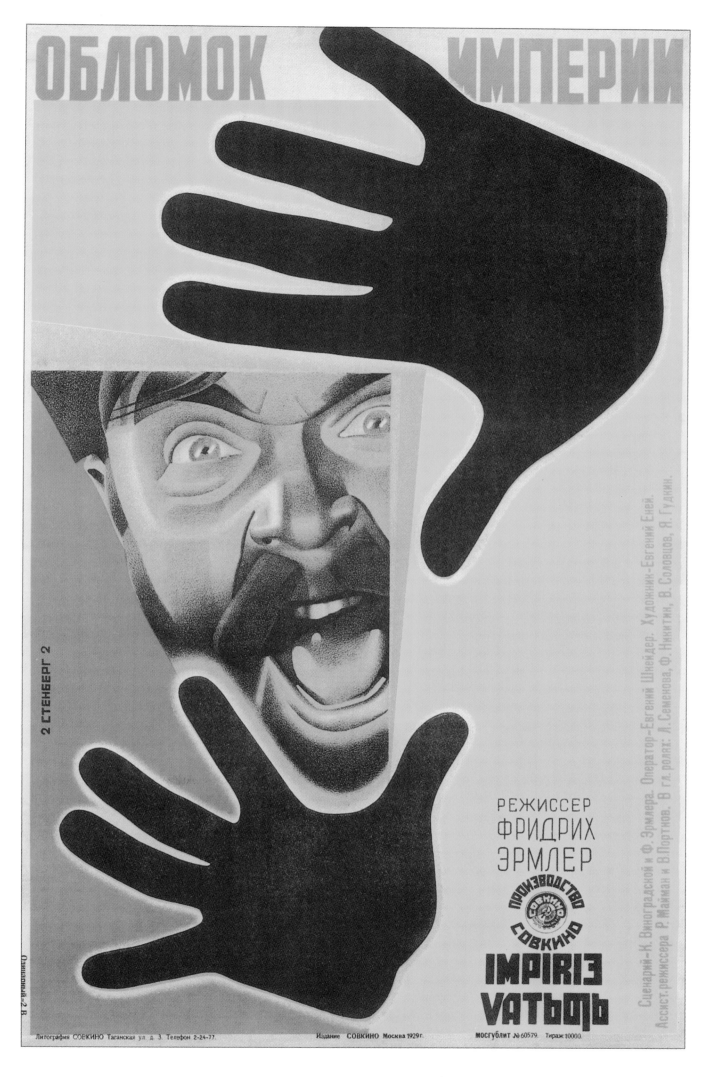

Georgi and Vladimir Stenberg Fragment of an Empire • Gueorgui y Vladímir Stenberg Un pedazo del imperio
Guéorgui et Vladimir Stenberg Un débris de l'Empire • Georgi und Wladimir Stenberg Trümmer eines Imperiums

1929

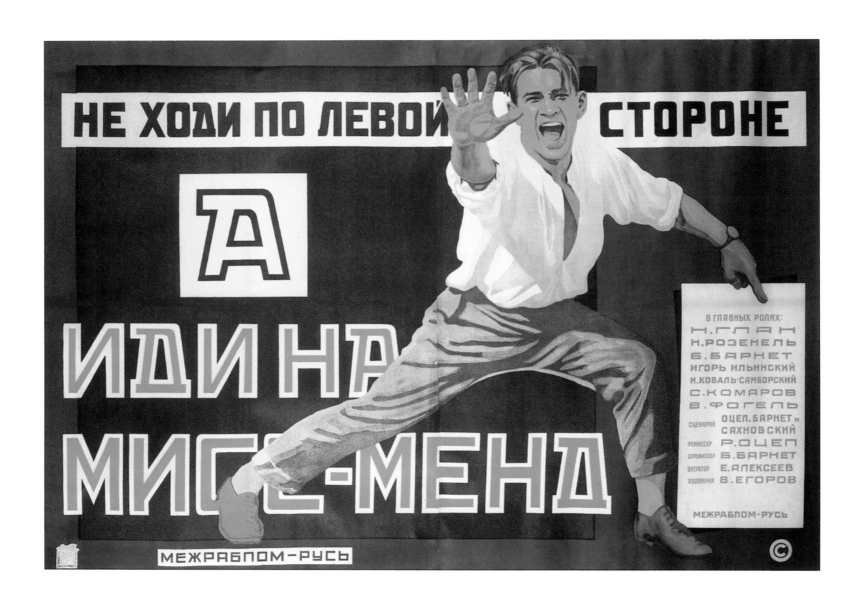

Semion Semionov-Menes Miss Mend • Semyón Semyónov-Menes Miss Mend
Semion Semionov-Menes Miss Mend • Semen Semenow-Menes Miss Mend

1927

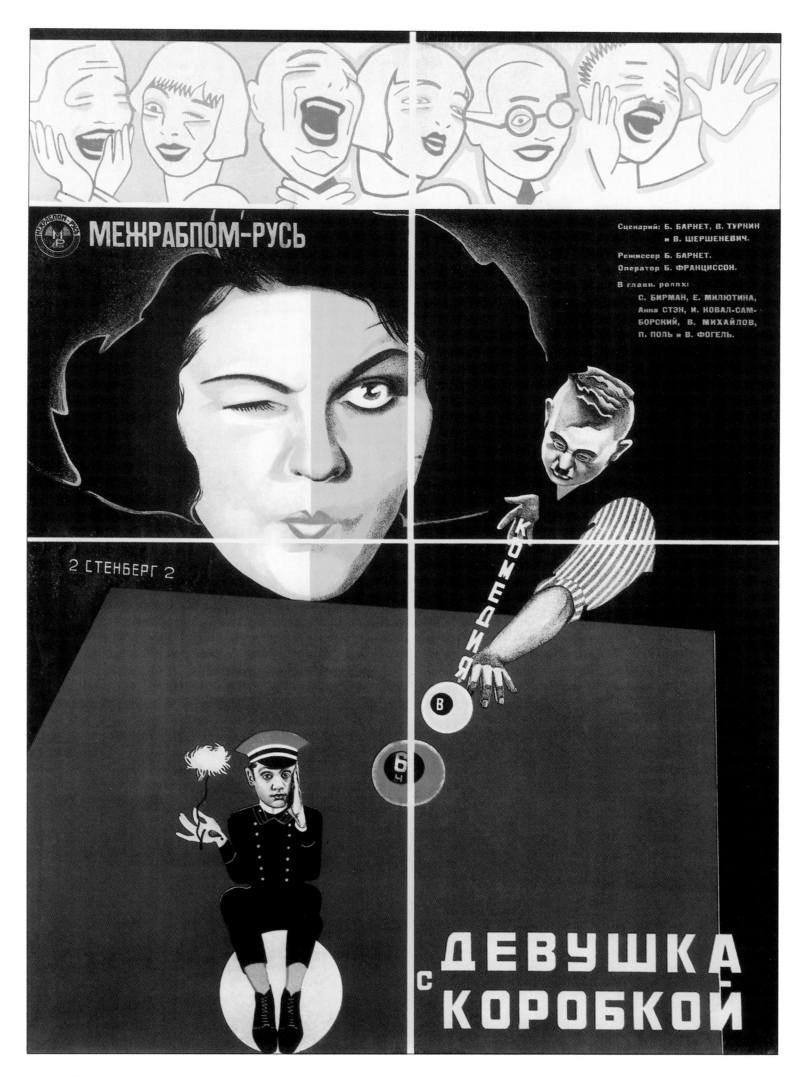

Georgi and Vladimir Stenberg The Girl with the Hat-Box • Gueorgui y Vladímir Stenberg La chica de la sombrerera
Guéorgui et Vladimir Stenberg La jeune fille au carton à chapeau • Georgi und Wladimir Stenberg Das Mädchen mit der Hutschachtel
1927

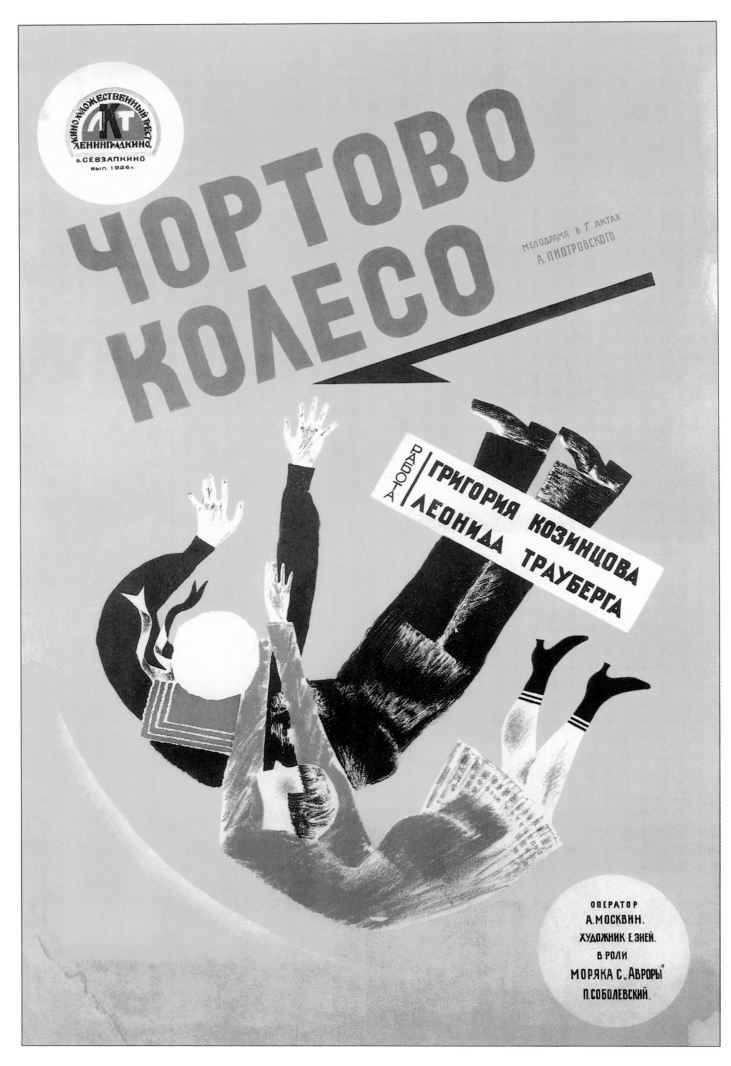

Nikolai Tyrsa The Devil's Wheel • **Nikolai Tirsa** La rueda del diablo
Nicolas Tyrsa La roue du diable • **Nikolai Tyrsa** Das Teufelsrad
1926

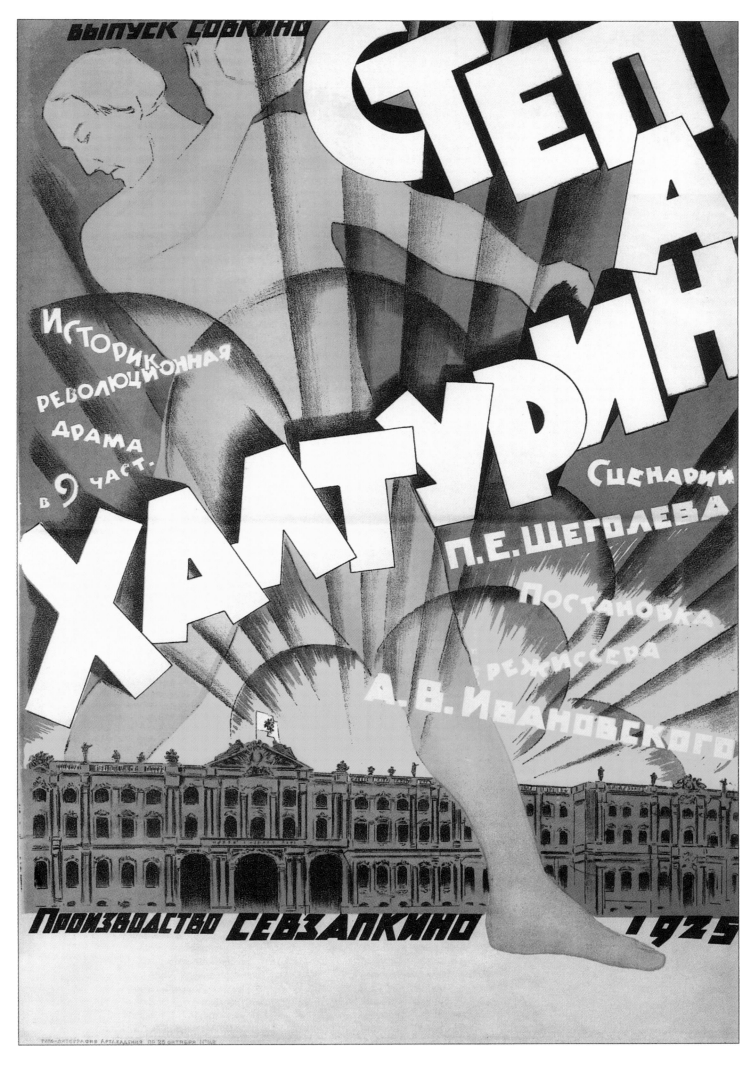

Anonymous Stepan Khalturin • Anónimo Stepán Jalturin
Anonyme Stepane Khaltourine • Anonym Stepan Chalturin
1925

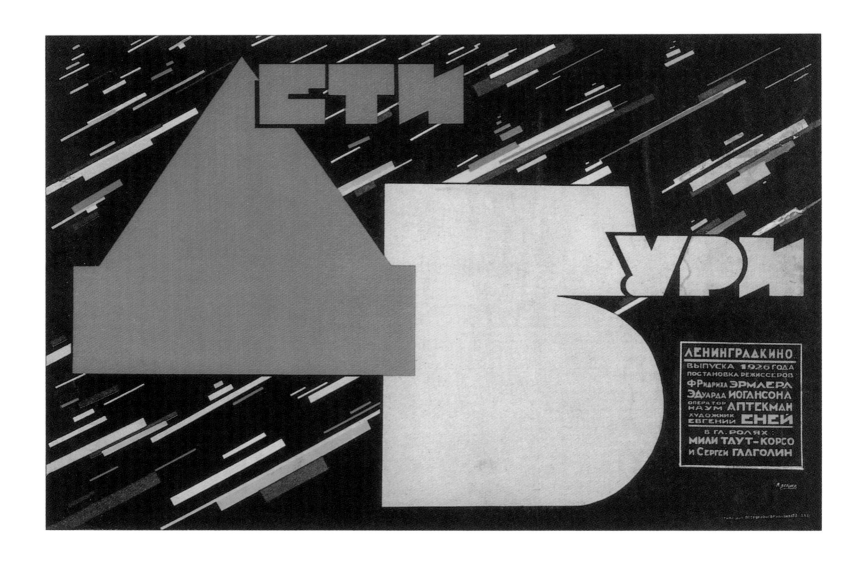

Mikhail Veksler Children of the Storm • **Mijaíl Veksler** Los hijos de la tormenta
Mikhaïl Veksler Les enfants de la tempête • **Michail Weksler** Die Kinder des Sturms
1926

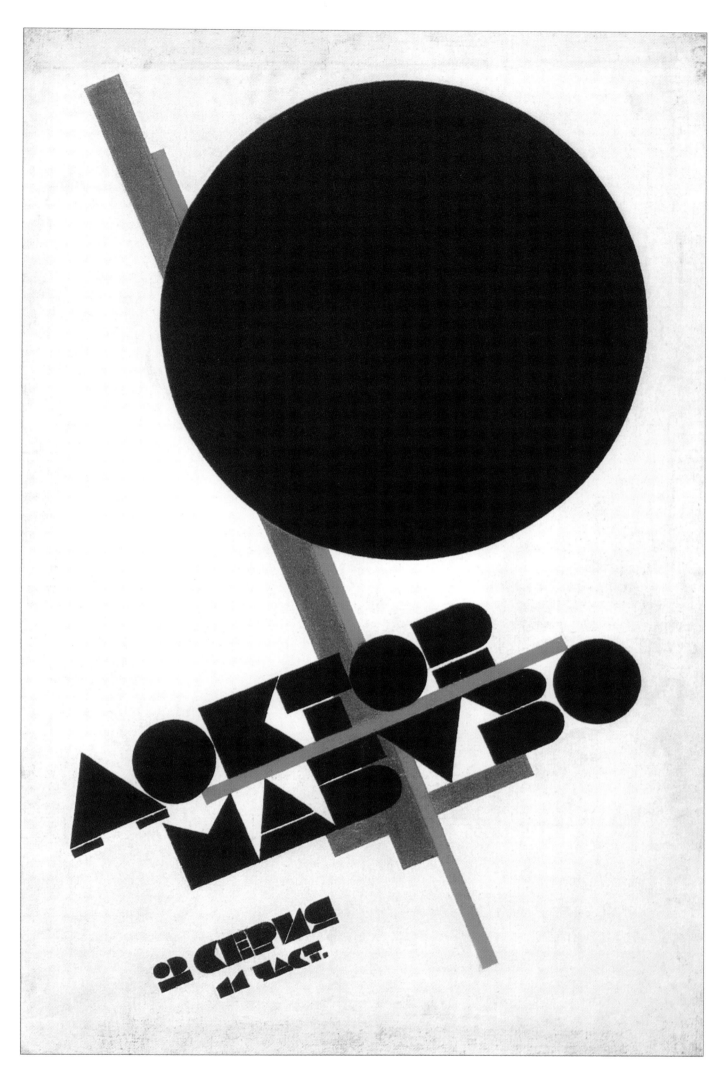

Kazimir **Malevich** Doctor Mabuse • **Kasimir Malévich** El doctor Mabuse
Kazimir Malevitch Docteur Mabuse • **Kasimir Malewitsch** Doktor Mabuse
1922–1927

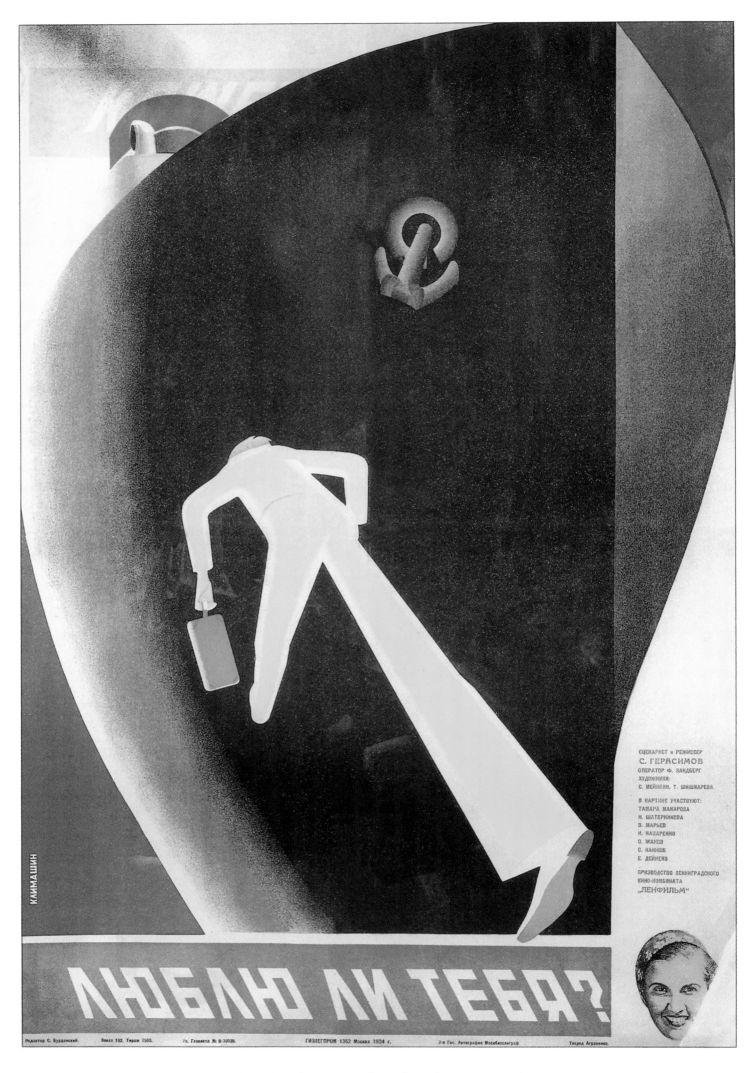

Viktor Klimashin Do I Love You? • Viktor Klimashin ¿Te quiero?
Victor Klimachine Si je t'aime? • Viktor Klimaschin Ob ich dich liebe?
1934

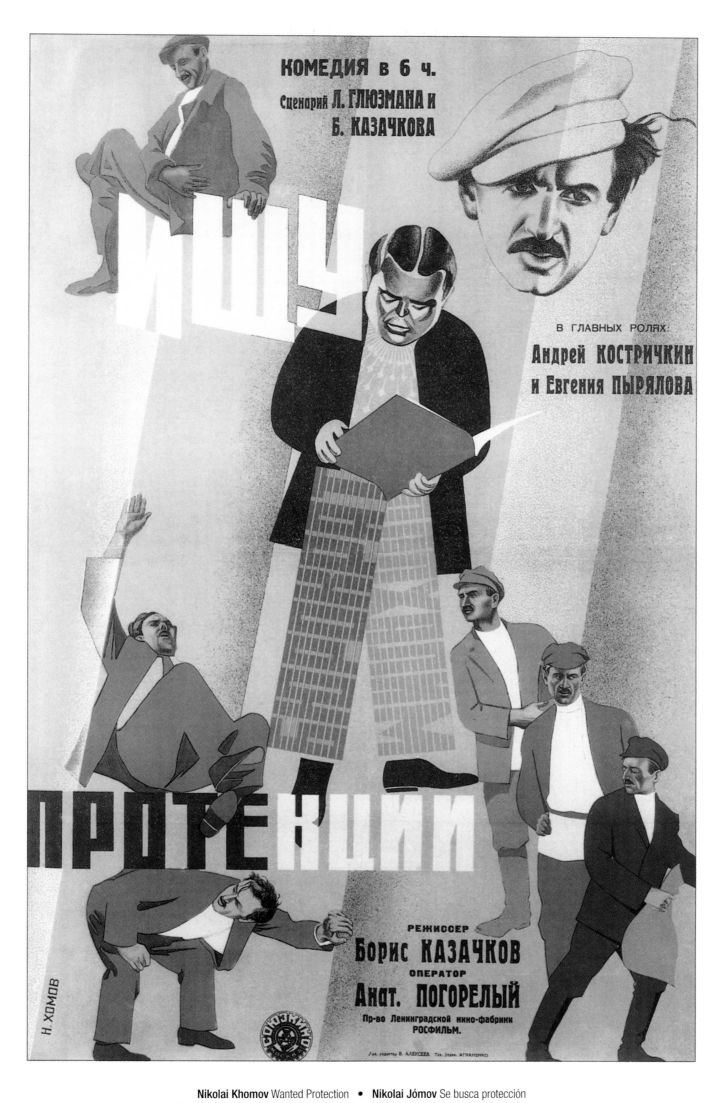

Nikolai Khomov Wanted Protection • Nikolai Jómov Se busca protección
Nicolas Khomov En quête de protection • Nikolai Chomow Suche nach Protektion
1933

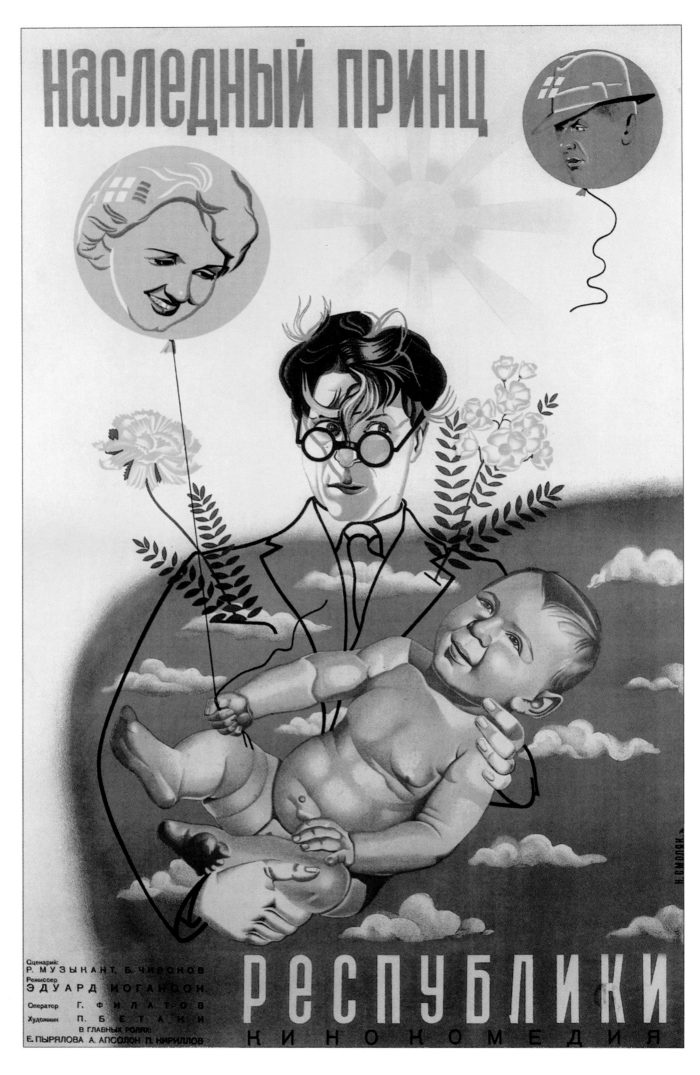

Nikolai Smoliak Crown Prince of the Republic • Nikolai Smóliak El príncipe heredero de la República
Nicolas Smoliak Prince héritier de la République • Nikolai Smoljak Kronprinz der Republik

1934

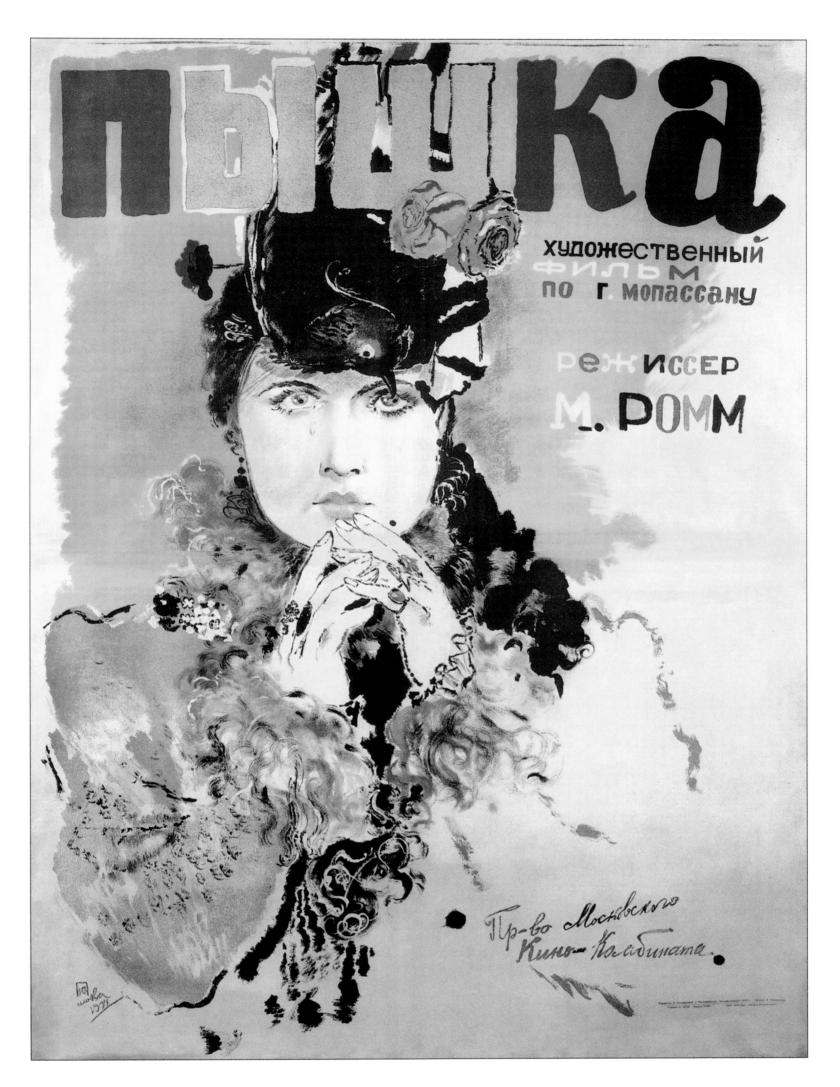

Yuri Pimenov Boule de Suif • **Yuri Piménov** Bola de sebo
Youri Pimenov Boule de Suif • **Juri Pimenow** Fettklößchen

1935

Artists' Biographies

ALEXEEV, Georgi Dmitrievich
(1881 – 1951)
Alexeev graduated from the Moscow School of Painting, Sculpture and Architecture as a sculptor and graphic designer. His teachers included S. Korovin and V. A. Serov. From 1905 on he participated in exhibitions with the Cooperative for Touring Artistic Exhibitions. From 1916 he worked as one of the first professional poster artists, creating posters for both films and propaganda, such as for the First World War. From 1921 to 1922 he collaborated on the "ROSTA Windows". His sculptures include busts of Marx, Lenin and other leaders of the Revolution.

APSIT (APSITIS), Alexander Petrovich
(1880 – 1944)
Born in Riga, Apsit studied in L. E. Dmitriev-Kavkassky's studio in St. Petersburg. From 1902 he worked as a book illustrator for Russian literature and drew caricatures for various magazines. He created film poster art and war posters during the First World War, while after the October Revolution he counted among the leading Soviet political poster artists. He fled to Latvia at the end of 1920. In 1939 he moved to Germany. Banned in the 1930s in the USSR, he was not rehabilitated as an artist until the 1960s.

ASATUROV (ASATURI), Paul K.
There is no biographical information available for Asaturov; he is known only for some cartoons for satirical magazines from the time of the first Russian revolution (1905 – 1907) as well as film posters from the early days of Russian cinema.

BELSKY, Anatoly Pavlovich
(1896 – 1970)
After training at the Stroganov School of Applied Art (1908 – 1917) and Moscow's VKHUTEMAS (Higher Art and Technical Studios, 1919 – 1921) Belsky worked as a set designer for Moscow's Variété Theatre, the circus and theatre and designed the interiors of pavilions for Soviet and international exhibitions. From the mid-1920s he also created film posters that made him one of the leading poster artists in the Soviet Union. After 1958 he devoted himself to landscape painting.

BOGRAD, Izrail Davidovich
(1899 – 1938)
After attending art school in Rostov-on-Don, Bograd worked as a designer and poster artist. Beginning in the 1920s, with his posters for the Soviet film company MEZHRABPOM-RUS (or MEZHRABPOMFILM after 1928), he became one of the leading artists for cinema advertising in the USSR. In the 1930s he also designed other advertising posters. He was arrested in 1938, and probably died that year.

BORISOV, Grigori Ilyich
(1899 – 1942)
Borisov studied in Moscow at the Stroganov School of Applied Art and the VKHUTEMAS (1924). He was a member of the Society of Young Artists (OBMOKhU) and worked as a film poster artist, often collaborating with colleagues Pyotr Zhukov, Alexander Naumov and Nikolai Prusakov. Under El Lissitzky's leadership, in 1928 he participated in the design of the Soviet pavilion at the International Press Exhibition in Cologne, and led one of the Proletkult workshops (Ministry of Culture).

DLUGACH, Mikhail Oskarovich
(1893 – 1989)
After studies at the Kiev Art School (1905 – 1917) Dlugach moved to Moscow in 1922 and concentrated on the design mainly of film posters but also books, medals and company signs. In 1924 he worked as one of the leading film poster artists for the SOVKINO state film production studio. In 1926 he joined the Association of Artists of the Revolution (AKhR). From 1932 to 1933 he was a member of the Union of Revolutionary Poster Workers (ORRP). Dlugach also designed exhibition pavilions, including one for the Soviet pavilion at the 1958 Brussels World's Fair. In the 1950s he concentrated mainly on agitprop and circus posters.

DORTMAN, T.
Aside from a few film posters by the artist dating from before the October Revolution, nothing more is known about Dortman and his work.

EVSTAFIEV, Mikhail Ilyich
(1896 – 1939)
Evstafiev studied at Moscow's VKHUTEMAS workshops and worked as a film poster artist, mainly with Leonid Voronov.

GERASIMOVICH, Iosif Vasilyevich
(1893 – 1986)
He received his education in the studios of I. Mashkov (1915 – 1916), K. F. Yuon (1922) and A. E. Arkhipov. Between 1920 and 1950 he worked mainly as a poster artist for the cinema and took part in national and international exhibitions. From 1926 to 1932 he was a member of the Association of Artists of the Revolution (AKhR); in 1927 he was awarded an honorary certificate at the International Exhibition of Decorative Arts in Monza.

KABAK, Vladimir Mikhailovich
(1888 – 1938)
Born in Kiev, Kabak graduated from the Academy of Arts in St. Petersburg. After participating in the civil war, he worked from the 1920s on in Moscow as an advertising and film poster artist, also designing some posters on social issues and book covers. In 1933 he was banned from exhibiting, and in 1938 became a victim of the so-called Stalinist purges.

KALMANSON, Mikhail Sergeyevich
Kalmanson owned a graphics firm in Moscow and created a series of film posters in the 1910s.

KHOMOV, Nikolai Mikhailovich
(1903 – 1973)
Ukrainian graphic artist Khomov graduated from the Artistic-Industrial College in Mariupol. From 1926 he worked steadily as a film poster artist and later for REKLAM FILM; in 1928 he finished his studies at the VKHUTEIN Institute in Moscow. He also participated in the design of the pavilions for the All-Union Agricultural Exhibition (VSKhV).

KLIMASHIN, Viktor Semionovich
(1912 – 1960)
Klimashin studied at the technical school in Saratov from 1928 to 1933. In the early 1930s he began to work as a poster artist, mainly political works but also advertising and film posters. After 1937 he also created book illustrations and drawings for various magazines. During World War II he created posters for the front, and in the 1950s he worked as designer of the Soviet exhibition pavilions in Bombay and Beijing. He also wrote a series of articles on the visual arts.

KLIUN (KLIUNKOV), Ivan Vasilyevich
(1873 – 1943)
Born in Ukraine, Kliun left his homeland in 1892 and studied in Warsaw until 1896 at the art school of the Society for Promotion of the Arts. After moving to Moscow he resumed his studies in 1898, including in the private artist's studios of V. Fischer and I. Mashkov. During his studies with F. I. Rerberg (1903 – 1906) he became acquainted with Malevich and the Suprematism movement. He participated in the great avant-garde exhibitions of 1915 – 1916 in Moscow and St. Petersburg as a visual artist and sculptor, and from 1918 he worked as a teacher and director in state cultural agencies and art institutions such as the VKHUTEMAS school. In the 1920s he created a few film posters.

LAVINSKY, Anton Mikhailovich
(1893 – 1968)
After completing his architecture studies at the Technical School in Baku, Lavinsky moved to St. Petersburg in 1914 where he continued his studies at the Free Artists' Studios and, in 1918 – 1919, at the SVOMAS art school. He participated in the implementation of Lenin's plan for monumental propaganda and worked as a sculptor (Karl Marx sculpture in Krasnoye Selo, 1918), architect and book designer. In the 1920s some film posters appeared, including the famous one for Eisenstein's *Battleship Potemkin*. From 1920 to 1926 he taught sculpture at the VKHUTEMAS in Moscow, working together with Mayakovsky on the "ROSTA Windows" and on the LEF journal.

LITVAK, Maxim Mikhailovich
(1898 – after 1943)
Born in Kiev, Litvak-Maksimov (pseudonym Max Litvak) worked from 1921 to 1923 at the "Novaja dama" Theatre in St. Petersburg and from 1923 to 1930 in the Leningrad Film Factory. He moved to Moscow in 1930 and created advertising, theatre and film posters in the following years, sometimes working with R. P. Feder (Fedor). In 1926 and 1932 he participated in film poster exhibitions in Moscow and was involved in the design of exhibition pavilions. He was arrested in 1938, but released later that year.

MALEVICH, Kazimir Severinovich
(1878 – 1935)
Malevich ranks among the most important artists of Russian modernism. His perception of art as pure, non-representational form exerted great influence over abstract painting in the early 20th century. He first studied at the art school in his native Kiev, then at the Moscow School of Painting, Sculpture and Architecture and in F. I. Rerberg's private studio. In 1907 he participated in the 14th exhibition of the Union of Moscow Artists, along with artists such as Wassily Kandinsky, and was a member of avant-garde artists' associations. Until 1913 he championed Cubo-Futurism as the only legitimate modern art movement and also exhibited abroad. He then developed the purely abstract art of Suprematism, explaining it theoretically in writings such as "From Cubism and Futurism to Suprematism. The New Realism in Painting" (1915). His numerous artistic activities included porcelain painting and stage design, but he mainly concentrated on educational and scholarly work as head of various studios in St. Petersburg, Moscow and Vitebsk. He wrote four books on cinematic art and during his trip to Germany in 1927, for an exhibition at the van Diemen gallery, also authored a film book with illustrations. From 1923 Malevich was head of the Institute for Artistic Culture (after 1925, GINKhUK) in Leningrad, but had to leave the post in 1926 because his avant-garde art no longer conformed to the state's artistic taste. In 1929 he also lost his post at the State Institute for Art History, which was closed shortly thereafter. He was only allowed to work two weeks out of the month at the Art Institute in Kiev. The exhibition of his works at Moscow's Tretyakov Gallery was negatively received by the critics, and the subsequent presentation in Kiev was closed shortly after its opening. In 1930 Malevich was arrested and interrogated. In 1932 he was appointed director of a research laboratory at the Russian Museum in Leningrad, where he worked until his death in 1935. His works were not shown again until 1988 in a major retrospective in St. Petersburg.

MOSIAGIN, Pyotr

He created the poster for the film *Stenka Razin* in 1914, published in Yaroslavl. There is no other evidence of the artist's life or work.

NAUMOV, Alexander Ilyich

(1899 – 1928)

Naumov studied in Moscow from 1909 to 1917 at the state Stroganov School of Applied Art and at the VKHUTEMAS; he was a member of the Society of Young Artists (OBMOKhU) and the "October" group. From 1921 to 1928 he worked as a stage designer at Moscow theatres including the Bolshoi. He also designed books for the SIF publishing house. He ranked among the leading film poster artists in the 1920s and also worked with Nikolai Prusakov, Grigori Borisov and Pyotr Zhukov.

PIMENOV, Yuri (Georgi) Ivanovich

(1903 – 1977)

Painter, stage designer and graphic artist Pimenov, a graduate of the VKHUTEMAS in Moscow (1920 – 1925), was one of the founding members in 1923 of the Society of Easel Painters (OST). From 1928 to 1931 he was a member of the Union of Revolutionary Poster Artists. At first working as an illustrator for various Russian magazines, he also worked from the 1930s to the 1960s as a film poster artist. He also designed costumes and sets for more than thirty productions in Moscow theatres. During World War II he was jointly responsible for organization and design of the "ROSTA Windows". Pimenov's work includes genre paintings, portraits and still lifes, while from the 1930s his work was defined by official "Socialist Realism". He earned several state awards for his art (USSR State Prize 1947 and 1950; Lenin Prize, 1967) and was the author of several books.

PRUSAKOV, Nikolai Petrovich

(1900 – 1952)

After his education at the Stroganov School (1911– 1920) and the VKHUTEMAS (1918 – 1924) in Moscow, Prusakov was one of the founding members of the Society of Young Artists (OBMOKhU). He designed political posters beginning in the 1920s, as well as film posters as a regular employee of the state film studios until 1941, sometimes with Grigori Borisov, Alexander Naumov and Pyotr Zhukov. He participated in the "ROSTA Windows", created oil paintings and monumental murals (Young Pioneer Palace in Moscow) and contributed to the design of the Soviet pavilions at international exhibitions (Cologne, Helsinki, Prague, Paris etc.). Prusakov was also a sought-after artist in various Moscow theatres as a stage and set designer. In 1944 he assumed a teaching position in glass design at the Moscow Institute for the Decorative and Applied Arts (MIDIPI).

RABICHEV, Isaak Benyevich

(1896 – 1957)

After his studies at the Kiev School of Arts and the VKHUTE-MAS in Moscow, Rabichev designed agitprop trains during the civil war and worked at various magazines in the 1920s. He also created film and propaganda posters and worked as a stage and set designer at theatres in Moscow, Odessa, Kharkov and Minsk.

RODCHENKO, Alexander Mikhailovich

(1891 – 1956)

Rodchenko is one of the great Russian avant-garde artists of the 20th century. He forged new paths in the fields of painting, sculpture, collage, photography and design (book and magazine design, advertising and posters) and also had international success in the early 1920s. Towards the end of the decade he came into conflict with Stalinism and the new official conception of art. The art world remained closed to him for the last twenty years

of his life and he fell into obscurity. After visiting the art school in Kazan as an observer, where he also met his future wife Varvara Stepanova in 1914, he continued his studies for two years at Moscow's Stroganov School. During his tenure as professor at the VKHUTEMAS and VKHUTEIN schools (1920 – 1930) and while working at INKhUK (Institute for Artistic Culture) he was occupied with designing exhibitions (e.g. for the 1925 International Art Déco Exhibition in Paris), as well as books, clothing, dishes, furniture and magazines (e.g. as an employee of LEF journal). His dedication to photography, characterised by unusual and breathtaking perspectives, led him to use photos as an innovative expressive device in books and posters. His use of photomontage, including for a book by the poet Mayakovsky as well as in posters, made Rodchenko a pioneer of this technique. He also worked as a stage and film designer. During the 1920s he worked for SOVKINO and designed some film posters.

RUKLEVSKY, Yakov Timofeevich

(1894 – 1965)

Born in Smolensk, Ruklevsky was educated in private studios between 1906 and 1915. In 1924 he moved to Moscow and until 1930 led the advertising department of SOVKINO. Ruklevsky began his artistic career with advertising on cinema façades, but soon came out with the first of a series of political posters. During the 1920s he acquired an outstanding reputation as a film poster artist, not least because of his frequent collaboration with the Stenberg brothers. From 1925 on he took part in Soviet and international exhibitions, and in 1927 received an honorary certificate at the International Exhibition in Monza.

RYCHKOV, Grigori Nikolayevich

(1885 – 1972)

Rychkov graduated from the Stroganov School of Applied Art in Moscow (1911), and then taught there himself before taking a teaching position at the VKHUTEMAS (watercolour, drawing, composition, interior design). He concentrated mainly on painting, graphics and wood sculpture, but also worked often in the 1920s as a film poster artist. In 1927 he was honoured at the International Exhibition in Monza.

SEMIONOV-MENES, Semion Abramovich

(1895 – 1972)

Born in Belarus, Semionov-Menes studied at the Kharkov Art School (Ukraine) from 1915 to 1918. He participated from 1919 to 1925 in the production of the Ukrainian "ROSTA Windows" and collaborated on the design of agitprop trains and ships. From 1925 on he lived in Moscow, where he worked as a stage designer among other things. He contributed to the design of national and international exhibitions including in Paris (1925), New York (1926) and Monza (1927). In the 1920s he was one of the most prominent representatives of film poster art. During the 1950s and 1960s he designed the interiors of pavilions for Soviet exhibitions.

SMOLIAK, Nikolai Petrovich

(1910 – 1963)

After finishing his studies at the College of Art in Samara (formerly Kuybyshev), Smoliak continued his education in 1929 in D. N. Kardovsky's studio in Moscow. He worked mainly as a poster artist, creating cinema posters from 1932 for the GLAVKINOPROKAT production company. During World War II he designed "TASS Windows" in Moscow and Chelyabinsk. In the 1940s he participated in various exhibitions and worked on export advertising for the All-Union Chamber of Commerce; from 1949 he mainly designed political posters, and in the 1960s participated in the USSR Artists' Association "Agitposter" studio.

STENBERG, Vladimir Avgustovich

(1899 – 1982)

STENBERG, Georgi Avgustovich

(1900 – 1933)

The Stenberg brothers produced film posters for almost all of their nation's great directors and were without a doubt the most important poster artists of their time. Their extensive creative work includes the design of streets and squares in Moscow for official celebrations, as well as work as stage designers (from 1922 to 1932 they were at Moscow's Kamerny Theatre), painters and designers (including for the SIF publishing house). They studied together in their native Moscow at the Stroganov School of Applied Art in the metalworking, enamel and ceramics painting, and theatre design departments (1912 – 1917), later studying monumental painting, sculpture, architecture and graphic arts at the SVOMAS (1917 – 1920). From 1919 to 1923 they belonged to OBMOKhU and participated in national and international exhibitions. After Vladimir Stenberg in 1915 had made scenery for performances in a film studio, the brothers' first film posters appeared for SOVKINO in 1924. The brothers always worked together until Georgi's accidental death in 1933. As co-founders and leading representatives of Constructivism, they were among the most influential artists of the Soviet avant-garde, for example popularising the innovative use of the cinematic montage principle in poster art. In 1927 they received an honorary certificate at the International Exhibition in Monza. After his brother's death, Vladimir continued alone in his work in the theatre, as a poster artist and a set and costume designer. In 1941 he was appointed as director of the Mayakovsky museum, and in 1949 as chief artist for the Moscow City Design Trust (MOSGOROFORMLENIE). He was arrested in 1952 but rehabilitated one year later.

TALDYKIN, Alexander Alexeevich

(1896 – 1965)

After studying at the VKHUTEMAS in Moscow, Taldykin worked as a stage designer for productions in various opera houses and theatres including Moscow, Lugansk, Vladivostok, Bryansk and Smolensk. He designed some film posters before the Revolution.

TYRSA, Nikolai Andreevich

(1887 – 1942)

The Armenian-born Tyrsa studied architecture from 1905 to 1909 at the Imperial Academy of Arts (IAKh) in St. Petersburg, and then at E. Zvantseva's School for Drawing and Painting. In 1917 he was one of the founding members of the Freedom for the Arts Association; from 1918 to 1922 he himself taught as a professor at the State Free Art Studios in St. Petersburg. In the 1920s and 1930s the painter and graphic artist, renowned for his watercolours and drawings, worked for various magazines and also illustrated children's books. From 1924 to 1942 he taught at the Institute for Civil Engineers, and from 1939 to 1942 he worked in the "Militant Pencil" studio of the Leningrad Artists' Union. He participated in national and international exhibitions from 1914 on and also worked in applied arts (glass art).

VEKSLER, Mikhail Solomonovich

(1898 – 1959)

After studying with Kazimir Malevich at the art school in his native Vitebsk, Veksler worked as a painter and graphic artist, and from the 1920s as a poster artist.

VIALOV, Konstantin Alexandrovich

(1900 – 1976)

After his studies in Moscow at the Stroganov School of Applied Art (1914 – 1917) and at the VKHUTEMAS, Vialov was one of the leading avant-garde artists of Suprematism and Constructivism as a painter, graphic artist and

sculptor. In the 1920s and 1930s he exhibited his works at international exhibitions including Paris, Berlin and New York. He worked as a poster artist and book illustrator, for newspapers and magazines, and designed theatre sets. His later works adhered to the state "Socialist Realist" style.

VORONOV, Leonid Alexandrovich
(1899 – 1938)
Voronov was a graphic artist, and his work as a poster artist was mainly for film advertising, on which he often worked with Mikhail Evstafiev. At the end of the 1920s he illustrated books for the SIF publishing house.

YEGOROV, Vladimir Yevgenievich
(1878 – 1960)
After Yegorov graduated from the Stroganov School of Applied Art in Moscow, he worked from 1906 to 1911 as a set designer at the Moscow Art Theatre. But he is best known as one of the pioneers of Russian film scenery and designed for more than 90 films, including *Mother* and *Miss Mend*. Many of his film posters date from before the Revolution.

ZHITKOV, P.
Zhitkov worked in Moscow and is known as one of the few professional poster artists of the pre-revolutionary cinema. His film posters date from the period between 1912 and 1916.

ZHUKOV, Pyotr Ilyich
(1898 – 1970)
Zhukov was educated in Moscow as a scenery and stage artist at the Stroganov School of Applied Art and at the VKHUTEMAS. In the 1920s he was one of the best known representatives of Soviet film posters. As an exhibition artist he was involved in important projects in Moscow (e.g. ZPKO, Gorky Central Park of Culture and Leisure), and abroad (including in Cologne and Philadelphia). He was also responsible for festival decorations for Moscow's streets and squares and worked as a stage designer.

Abbreviations
AKhR: Association of Artists of the Revolution (1928 – 1932)
AKhRR: Association of Artists of Revolutionary Russia (1922 – 1928)
ARMENKINO: United Armenian Film Studios
BELGOSKINO: Film Studios of the Byelorussian Soviet Socialist Republic
GLAVKINOPROKAT: Main film distributor of the USSR
GOSKINO: Soviet State Committee for Cinematography (1922 – 1924)
INKhUK: Institute for Artistic Culture, Moscow
MEZHRABPOM-RUS: Soviet film company (founded 1924, continued as MEZHRABPOMFILM from 1928 to 1936)
OBMOKhU: Society of Young Artists
ORRP: Union of Revolutionary Poster Workers
OST: Society of Easel Painters
PRESSA: 1928 International Press Exhibition in Cologne (duration 6 months; 1500 exhibitors from 48 countries)
ROSFILM: Moscow Film Studios (founded in 1932)
ROSTA Windows: Soviet propaganda posters created by the ROSTA Telegraph Agency, which later became TASS
SIF: Semilia i Fabrika, state publishing house
SOVKINO: Soviet Cinema state film production studio, from 1934 known as LENFILM
SVOMAS: Free State Art Studios
UKRAINFILM: Ukraine Film Studios
VKHUTEIN: Higher Art and Technical Institute (1927 – 1930, dissolved in 1930)
VKHUTEMAS: Higher Art and Technical Studios (1920 – 1927) in Moscow
VSKhV: All-Union Agricultural Exhibition, established in 1939 in Moscow to showcase the Soviet planned economy
VUFKU: All-Ukrainian Photo and Film Studios (founded 1924)

Biografías de los artistas

ALEXÉYEV, Gueorgui Dmítriyevich
(1881–1951)
Alexéyev realizó sus estudios de escultor y grafista en la Escuela de Pintura, Escultura y Arquitectura de Moscú. Sus profesores fueron, entre otros, S. Korovin y V. A. Sérov. Desde 1905 participó en exposiciones de la Cooperativa de Exposiciones Itinerantes. A partir de 1916 se convirtió en uno de los primeros cartelistas profesionales y creó, además de carteles cinematográficos, otros de propaganda, por ejemplo en relación con la Primera Guerra Mundial. Entre 1921 y 1922 colaboró en las «ventanas ROSTA». Entre sus obras escultóricas se incluyen bustos de Marx, Lenin y otros dirigentes revolucionarios.

APSIT (APSITIS), Alexandr Petróvich
(1880–1944)
Nacido en Riga, Apsit se formó en el estudio de L. E. Dmítriyev-Kavkaski en San Petersburgo. A partir de 1902 trabajó de ilustrador de libros de literatura rusa y de caricaturista para diversas revistas. Durante la Primera Guerra Mundial creó carteles cinematográficos y propagandísticos, y se convirtió en uno de los artistas más destacados del cartelismo político después de la Revolución de Octubre. A finales de 1920 huyó a Letonia y en 1939 se trasladó a Alemania. Caído en desgracia en la URSS durante la década de 1930, no fue restituido como artista hasta treinta años después.

ASATÚROV (ASATURI), Paul K.
De Asatúrov, cuyos datos biográficos se desconocen, solo se conservan algunas caricaturas publicadas en revistas satíricas de la época de la primera revolución rusa (1905–1907) y carteles sobre películas de los comienzos del cine ruso.

BELSKI, Anatoli Pávlovich
(1896–1970)
Después de estudiar en la Escuela Stróganov de Artes Aplicadas (1908–1917) y en los Talleres Superiores Artístico-Técnicos VJUTEMAS (1919–1921) de Moscú, Belski trabajó de escenógrafo para el teatro de variedades, el circo y otros teatros de Moscú, así como de decorador de pabellones para exposiciones soviéticas e internacionales. Además, desde mediados de la década de 1920 se dedicó a crear carteles cinematográficos, convirtiéndose en uno de los cartelistas más destacados de la Unión Soviética. A partir de 1958 se dedicó a la pintura paisajística.

BOGRAD, Israil Davídovich
(1899–1938)
Bograd trabajó, una vez terminados sus estudios en una escuela de arte de Róstov del Don, de decorador y cartelista. En la década de 1920 se convirtió, con los carteles que creó para la compañía cinematográfica soviética MESHRABPOM-RUS (denominada a partir de 1928 MESHRABPOMFILM), en uno de los artistas más destacados de la publicidad cinematográfica de la URSS. En la década de 1930 también diseñó carteles publicitarios en general. En 1938 fue detenido y, supuestamente, murió ese mismo año.

BORÍSOV, Grigori Ilíich
(1899–1942)
Borísov estudió en la Escuela Stróganov de Artes Aplicadas y en los VJUTEMAS de Moscú (1924). Ingresó en la Asociación de Jóvenes Artistas (OBMUJU) y trabajó de cartelista cinematográfico, a menudo en colaboración con Piotr Zhúkov, Alexandr Naumov y Nikolai Prusákov. En 1928 participó, bajo la dirección de El Lisitski, en el diseño del pabellón soviético de la Exposición Internacional Pressa en Colonia y dirigió uno de los talleres del Proletkult (Ministerio de Cultura).

DLÚGACH, Mijaíl Oskárovich
(1893–1989)
Concluidos sus estudios en la Escuela de Arte de Kiev (1905–1917), Dlúgach se trasladó en 1922 a Moscú, donde se dedicó al diseño de libros, medallas y logotipos de empresas, pero principalmente al cartelismo cinematográfico. En 1924 fue contratado por el estudio estatal de producción SOVKINO como uno de sus principales cartelistas. En 1926 ingresó en la Asociación de Artistas de la Revolución (AJR) y entre 1932 y 1933 formó parte de la Asociación de Trabajadores del Cartel Revolucionario (ORRP). Dlúgach realizó además diseños de pabellones, entre otros el del pabellón soviético para la Exposición Universal de Bruselas de 1958. Durante la década de 1950 la mayor parte de su creación se centró en los carteles de agitación y circenses.

DORTMAN, T.
Aparte de algunos carteles cinematográficos del artista, creados antes de la Revolución de Octubre, no se conoce nada más de Dortman y su obra.

EVSTÁFIEV, Mijaíl Ilíich
(1896–1939)
Evstáfiev estudió en los talleres de arte moscovitas VJUTEMAS y trabajó de cartelista cinematográfico, principalmente en colaboración con Leonid Vorónov.

GUERASÍMOVICH, Yosif Vasílyevich
(1893–1986)
Se formó en los estudios de I. Máshkov (1915–1916), K. F. Yuon (1922) y A. E. Arjípov. Entre 1920 y 1950 trabajó sobre todo de cartelista para el cine y participó en exposiciones nacionales e internacionales. De 1926 a 1932 fue miembro de la Asociación de Artistas de la Revolución (AJR); en 1927 recibió un diploma de honor en la Exposición Internacional de Artes Decorativas de Monza.

JÓMOV, Nikolai Mijáilovich
(1903–1973)
El grafista ucraniano Jómov estudió en el Centro Artístico-Industrial de Mariupol. Desde 1926 se dedicó al cartelismo y más tarde trabajó para REKLAM-FILM; en 1928 concluyó sus estudios en el VJUTEIN de Moscú. Asimismo participó en el diseño del pabellón de la Exposición Agrícola de la Unión (VSHV).

KABAK, Vladímir Mijáilovich
(1888–1938)
Kabak, nacido en Kiev, estudió en la Academia de las Artes de San Petersburgo. Participó activamente en la guerra civil y en la década de 1920 trabajó en Moscú de cartelista publicitario y cinematográfico, aunque también diseñó algunos carteles sobre temas sociales y cubiertas de libros. En 1933 le prohibieron exponer y en 1938 murió víctima de las llamadas purgas estalinistas.

KÁLMANSON, Mijaíl Serguéyevich
Kálmanson era titular de una empresa de artes gráficas de Moscú y en la década de 1910 creó una serie de carteles cinematográficos.

KLIMASHIN, Víktor Semyónovich
(1912–1960)
Klimashin estudió de 1928 a 1933 en la Politécnica de Sarátov. A principios de la década de 1930 comenzó a diseñar carteles; fueron sobre todo trabajos de índole política, aunque también realizó carteles publicitarios y cinematográficos. A partir de 1937 también se dedicó a ilustrar libros y realizar dibujos para diversas revistas. Durante la Segunda Guerra Mundial diseñó carteles para el frente y en la década de 1950 trabajó de decorador de los pabellones soviéti-

cos para sendas exposiciones en Bombay y Pekín. Además, escribió una serie de artículos sobre las artes plásticas.

KLIUN (KLIÚNKOV), Iván Vasílyevich
(1873–1943)
Nacido en Ucrania, Kliun abandonó su país en 1892 y estudió hasta 1896 en Varsovia, en la Escuela de Arte de la Sociedad de Fomento de las Artes. Después de su traslado a Moscú, en 1898 reanudó sus estudios, entre otros en los estudios privados de V. Fischer e I. Máshkov. Durante su formación con F. I. Rerberg (1903–1906) conoció a Malévich y el suprematismo. Entre 1915 y 1916 participó como artista plástico y escultor en las grandes exposiciones de la vanguardia en Moscú y San Petersburgo; más tarde, a partir de 1918, trabajó de profesor y director de organismos culturales estatales e instituciones dedicadas al arte, como los VJUTEMAS. En la década de 1920 creó algunos carteles para películas.

LAVINSKI, Anton Mijáilovich
(1893–1968)
Después de licenciarse en arquitectura en el Instituto Técnico de Bakú, Lavinski se trasladó en 1914 a San Petersburgo, donde siguió estudiando en los Talleres Artísticos Libres y en 1918 y 1919 en la Escuela de Arte SVOMAS. Participó en la ejecución del plan de propaganda monumental de Lenin y trabajó de escultor (estatua de Carlos Marx en Krásnoye Seló, 1918), arquitecto y diseñador de libros. En la década de 1920 realizó asimismo varios carteles cinematográficos, entre ellos el famoso cartel de la película de Eisenstein *El acorazado Potemkin*. De 1920 a 1926 enseñó escultura en los VJUTEMAS de Moscú, colaboró con Mayakovski en las «ventanas ROSTA» y en la revista LEF.

LÍTVAK, Maxim Mijáilovich
(1898–después de 1943)
Lítvak-Maxímov (de nombre artístico Max Lítvak), nacido en Kiev, trabajó de 1921 a 1923 en el teatro Nóvaya Dama de San Petersburgo y de 1923 a 1930 en la fábrica de cine de Leningrado. En 1930 se trasladó a Moscú y creó en los años siguientes carteles publicitarios, para el teatro y el cine, parcialmente en colaboración con R. P. Feder (Fedor). En 1926 y 1932 participó en exposiciones de carteles cinematográficos en Moscú y en la decoración de pabellones expositivos. En 1938 fue detenido, pero fue puesto nuevamente en libertad ese mismo año.

MALÉVICH, Kasimir Severínovich
(1878–1935)
Malévich es uno de los principales exponentes del arte moderno ruso. Su idea del arte como pura forma estética ejerció una gran influencia en la pintura abstracta de comienzos del siglo XX. Estudió primero en la Escuela de Arte de su ciudad natal, Kiev, y posteriormente en Moscú, en la Escuela de Pintura, Escultura y Arquitectura y en el estudio privado de F. I. Rerberg. En 1907 participó, junto con artistas como Vasili Kandinsky, en la 14.ª exposición de la Asociación de Artistas de Moscú e ingresó en varias asociaciones de artistas de vanguardia. Hasta 1913 defendió el cubofuturismo como única orientación artística legítima moderna y expuso también en el extranjero. Después desarrolló el arte puramente abstracto del suprematismo, que fundamentó teóricamente con escritos como *Del cubismo al suprematismo: el nuevo realismo pictórico* (1915). Entre sus numerosas actividades artísticas figuran tanto la pintura sobre porcelana como la escenografía, pero sobre todo se dedicó, como director de diversos talleres artísticos de San Petersburgo, Moscú y Vitebsk, a labores pedagógicas y científicas. Escribió cuatro ensayos sobre el arte cinematográfico y durante un viaje a Alemania, con motivo de una exposición en 1927 en la galería Van Diemen, creó un libro sobre cine con ilustraciones. En

1923, Malévich pasó a dirigir el Instituto de Cultura Artística (que a partir de 1925 se denominó GINJUK) en Leningrado, aunque tuvo que dejar el puesto en 1926 porque su arte vanguardista dejó de corresponderse con el gusto estético oficial. En 1929 también perdió su puesto en el Instituto Estatal de Historia del Arte, que poco después cerró sus puertas. Pudo seguir trabajando en el Instituto del Arte de Kiev, pero solo durante dos semanas al mes. La exposición de sus obras en la galería Tretiákov de Moscú fue mal recibida por la crítica y su posterior presentación en Kiev fue clausurada poco después de la inauguración. En 1930, Malévich fue detenido e interrogado. En 1932 fue nombrado director de un laboratorio de investigación del Museo Ruso de Leningrado, donde trabajó hasta su muerte en 1935. Tan solo en 1988 volvieron a mostrarse sus obras en una gran retrospectiva en San Petersburgo.

MOSIAGUIN, Piotr
Creó el cartel sobre la película *Stenka Rasin* en 1914 que se publicó en la ciudad rusa de Yaroslavl. Aparte de esto no se sabe nada de la vida y la obra de este artista.

NAUMOV, Alexandr Ilíich
(1899–1928)
Naumov estudió de 1909 a 1917 en la Escuela Stróganov de Artes Aplicadas de Moscú y en los VJUTEMAS; fue miembro de la Asociación de Jóvenes Artistas (OBMUJU) y del grupo Oktyabr. Entre 1921 y 1928 trabajó de escenógrafo en teatros moscovitas, entre ellos el Bolshói. Además diseñó libros para la editorial SIF. Fue uno de los cartelistas cinematográficos más destacados de la década de 1920 y colaboró también con Nikolai Prusákov, Grigori Borísov y Piotr Zhúkov.

PIMÉNOV, Yuri (Gueorgui) Ivánovich
(1903–1977)
El pintor, escenógrafo y grafista Piménov, que estudió en los VJUTEMAS de Moscú (1920–1925), se encontraba entre los miembros fundadores de la Sociedad de Pintura de Caballete (OST) en 1923. Entre 1928 y 1931 perteneció a la Asociación de Artistas del Cartel Revolucionario. Después de trabajar de ilustrador para diversas revistas rusas, desde la década de 1930 hasta la de 1960 también se dedicó al cartelismo cinematográfico. Además, diseñó vestuarios y escenografías para más de treinta funciones de los teatros moscovitas. Durante la Segunda Guerra Mundial fue corresponsable de la organización y el diseño de las «ventanas ROSTA». La obra de Piménov abarca cuadros de género, retratos y bodegones, y se ajusta, a partir de la década de 1930, a los criterios del «realismo socialista» oficial. Obtuvo diversos galardones por su arte (Premio del Estado de la URSS de 1947 y 1950; Premio Lenin de 1967) y publicó varios libros.

PRUSÁKOV, Nikolai Petróvich
(1900–1952)
Después de estudiar en la Escuela Stróganov (1911–1920) y en los VJUTEMAS (1918–1924) en Moscú, Prusákov fue uno de los miembros fundadores de la Asociación de Jóvenes Artistas (OBMUJU). A partir de la década de 1920 se dedicó a diseñar carteles políticos y, como empleado fijo de las compañías cinematográficas estatales, también diseñó carteles para este sector hasta el año 1941, en parte junto con Grigori Borísov, Alexandr Naumov y Piotr Zhúkov. Participó en las «ventanas ROSTA», creó pinturas al óleo y murales monumentales (Casa de los Pioneros en Moscú), y colaboró en el diseño del pabellón soviético de varias exposiciones internacionales (Colonia, Helsinki, Praga, París, etc.). Prusákov también fue un solicitado artista como escenógrafo y creador de decorados en varios teatros moscovitas. A partir de 1944 se hizo cargo además de la asignatura de escultura en vidrio en el Instituto de Artes Decorativas y Aplicadas de Moscú (MIPIDI).

RABÍCHEV, Isaak Benyévich
(1896–1957)
Después de estudiar en la Escuela de Arte de Kiev y en los VJUTEMAS de Moscú, Rabíchev diseñó durante la guerra civil «trenes de agitación y propaganda» y colaboró en la década de 1920 en varias revistas. Además de diseñar carteles cinematográficos y propagandísticos, trabajó de escenógrafo y creador de decorados en teatros de Moscú, Odesa, Járkov y Minsk.

RÍCHKOV, Grigori Nikoláyevich
(1885–1972)
Ríchkov se licenció por la Escuela Stróganov de Artes Aplicadas de Moscú (1911), en la que acto seguido se puso a enseñar él mismo, antes de emprender su actividad docente en los VJUTEMAS (acuarela, dibujo, composición e interiorismo). Se dedicó sobre todo a la pintura, el grafismo y la escultura en madera, aunque en la década de 1920 también realizó muchos carteles para el cine. En 1927 fue galardonado en la Exposición Internacional de Monza.

RÓDCHENKO, Alexandr Mijáilovich
(1891–1956)
Ródchenko es uno de los grandes artistas de vanguardia rusos del siglo XX. Abrió nuevas vías en el ámbito de la pintura, la escultura, *el collage*, la fotografía y el diseño (de libros y revistas, publicidad y carteles), y cosechó éxitos a escala internacional en la primera mitad de la década de 1920. Sin embargo, hacia finales del decenio entró en conflicto con el estalinismo y la nueva orientación oficial del arte. Durante los últimos veinte años de su vida tuvo prohibido dedicarse al arte y cayó en el olvido. Después de acudir como oyente a la Escuela de Arte de Kasán, donde conoció en 1914 a la que más tarde sería su mujer, Várvara Stepánova, prosiguió sus estudios durante dos años en la Escuela Stróganov de Moscú. Durante su época de profesor en los VJUTEMAS y el VJUTEIN (1920 – 1930) y su actividad en el INJUK (Instituto de Cultura Artística), se consagró al diseño de exposiciones (como la Exposición Internacional de Art-déco en París en 1925), libros, ropa, vajilla, muebles y revistas (por ejemplo, como empleado de la revista LEF). Su dedicación a la fotografía, caracterizada por unas sensacionales perspectivas insólitas, le llevó a utilizar fotos como medio de expresión innovador en libros y carteles. El uso del fotomontaje, por ejemplo para un libro del poeta Mayakovski o en los carteles, convirtió a Ródchenko en un pionero de esta técnica. También hizo de escenógrafo y creador de decorados para películas. En la década de 1920 trabajó para SOVKINO y diseñó algunos carteles cinematográficos.

RUKLEVSKI, Yákov Timoféyevich
(1894–1965)
Ruklevski, nacido en Smolensk, se formó entre 1906 y 1915 en estudios de arte privados. En 1924 se trasladó a Moscú, donde dirigió hasta 1930 el departamento de SOVKINO encargado de la publicidad. Inició su carrera artística con la publicidad en fachadas de las salas de cine, pero muy pronto creó también los primeros de toda una serie de carteles políticos. Durante la década de 1920 había adquirido además un gran prestigio como cartelista cinematográfico, entre otras cosas gracias a su colaboración con los hermanos Stenberg. A partir de 1925 participó en exposiciones soviéticas e internacionales y en 1927 recibió un diploma de honor en la Exposición Internacional de Monza.

SEMYÓNOV-MENES, Semyón Abramóvich
(1895–1972)
Nacido en Bielorrusia, Semyónov-Menes estudió de 1915 a 1918 en la Escuela de Arte de Járkov (Ucrania). De 1919 a 1925 participó en la producción de las «ventanas ROSTA» ucranianas y colaboró en el diseño de trenes y barcos de agitación y propaganda. A partir de 1925 se instaló en Moscú, donde trabajó, entre otras cosas, de escenógrafo.

Participó en el diseño de exposiciones nacionales e internacionales, como las de París (1925), Nueva York (1926) y Monza (1927). Durante la década de 1920 fue uno de los representantes más destacados del cartelismo cinematográfico. En las décadas de 1950 y 1960 decoró pabellones para exposiciones soviéticas.

SMÓLIAK, Nikolai Petróvich
(1910–1963)
Concluidos sus estudios en la Escuela Técnico-Artística de Samara (antes Kuibíshev) en 1929, Smóliak siguió formándose en el estudio de D. N. Kardóvski en Moscú. Trabajó principalmente de cartelista y a partir de 1932 creó carteles para la productora de cine GLAVKINOPROKAT. Durante la Segunda Guerra Mundial diseñó «ventanas TASS» en Moscú y Chelyabinsk. En la década de 1940 participó en diversas exposiciones y trabajó para la Cámara de Comercio Federal en el departamento de publicidad para la exportación; a partir de 1949 su creación se centró en los carteles políticos y en la década de 1960 colaboró en el estudio Agitplakat de la Asociación de Artistas de la URSS.

STENBERG, Vladímir Avgústovich
(1899–1982)
STENBERG, Gueorgui Avgústovich
(1900–1933)
Los hermanos Stenberg crearon carteles para casi todos los grandes cineastas de su país y fueron sin duda los principales cartelistas artísticos de su época. Su vasta obra incluye además la decoración de plazas y calles moscovitas con motivo de celebraciones oficiales, su labor en la escenografía (de 1922 a 1932 estuvieron trabajando en el Teatro de Cámara de Moscú), así como la pintura y el diseño (para la editorial SIF, entre otras). Estudiaron juntos en su ciudad natal, Moscú, en la Escuela Stróganov de Artes Aplicadas, concretamente en las secciones de estampado de metales, pintura de esmalte y cerámica, y decorados teatrales (1912–1917), y más tarde, en los SVOMAS, en las de pintura monumental, escultura, arquitectura y grafismo (1917–1920). De 1919 a 1923 formaron parte de la OBMUJU y participaron en exposiciones nacionales e internacionales. Después de que Vladímir Stenberg hubiera realizado ya en 1915 decorados para funciones teatrales en un estudio cinematográfico, en 1924 aparecieron los primeros carteles para SOVKINO realizados por los dos hermanos, que siguieron trabajando juntos hasta la muerte en accidente de Gueorgui en 1933. Como cofundadores y destacados exponentes del constructivismo, figuraron entre los artistas más influyentes de la vanguardia soviética, y así, por ejemplo, el uso innovador del principio de montaje del cine en el cartelismo hizo escuela. En 1927 recibieron un diploma de honor en la Exposición Internacional de Monza. Tras la muerte de su hermano, Vladímir continuó trabajando en el teatro como cartelista, diseñador y creador de decorados en solitario. En 1941 fue nombrado director del Museo Mayakovski y, en 1949, director artístico del Consorcio para la Decoración Urbana de Moscú (MOSGOROFORMLENIE). En 1952 fue detenido, aunque lo rehabilitaron un año después.

TALDYKIN, Alexandr Alexéyevich
(1896–1965)
Después de estudiar en los VJUTEMAS de Moscú, Taldykin trabajó de escenógrafo y creó decorados para teatros de Moscú, Lugansk, Vladivostok, Bryansk, Smolensk, etc. También diseñó algunos carteles cinematográficos antes de la Revolución.

TIRSA, Nikolai Andréyevich
(1887–1942)
Originario de Armenia, Tirsa estudió arquitectura en la Academia Imperial de las Artes (IAJ) de San Petersburgo entre 1905 y 1909, y continuó su formación en la Escuela de Dibujo y Pintura de E. Svantseva. En 1917 fue uno de los miembros fundadores de la Asociación Libertad para el Arte. De 1918 a 1922 trabajó de profesor en los Talleres de Arte Libres del Estado en San Petersburgo. En las décadas de 1920 y 1930 el pintor, grafista y artista, apreciado por sus acuarelas y dibujos, trabajó para diversas revistas e ilustró libros infantiles. De 1924 a 1942 dio clases en el Instituto de Ingenieros Civiles, de 1939 a 1942 estuvo empleado en el taller «Lápiz combativo» de la Asociación de Artistas de Leningrado. A partir de 1914 participó en exposiciones nacionales e internacionales y también se dedicó a las artes aplicadas (vidrio).

VEKSLER, Mijaíl Solomónovich
(1898–1959)
Después de estudiar en la escuela de arte de su ciudad natal, Vitebsk, con Kasimir Malévich, Veksler trabajó de pintor y grafista, y desde la década de 1920 también de cartelista.

VIÁLOV, Konstantín Alexándrovich
(1900–1976)
Una vez concluidos sus estudios en la Escuela Stróganov de Artes Aplicadas (1914–1917) y en los VJUTEMAS de Moscú, el pintor, grafista y escultor Viálov pasó a formar parte de los artistas vanguardistas más destacados del supremacismo y del constructivismo. En las décadas de 1920 y 1930 exhibió sus obras en exposiciones internacionales, como las de París, Berlín y Nueva York. Trabajó de cartelista e ilustrador de libros, para periódicos y revistas y diseñó decorados teatrales. Su obra posterior se ajusta a los criterios de la orientación artística oficial del «realismo socialista».

VORÓNOV, Leonid Alexándrovich
(1899–1938)
Vorónov era grafista y como cartelista trabajó sobre todo en la publicidad para el cine, a menudo en colaboración con Mijaíl Evstáfiev. A finales de la década de 1920 ilustró libros para la editorial SIF.

YEGÓROV, Vladímir Yevguényevich
(1878–1960)
Concluidos los estudios en la Escuela Stróganov de Artes Aplicadas de Moscú, Yegórov trabajó de escenógrafo en el Teatro Artístico de Moscú entre 1906 y 1911. Sin embargo, fue uno de los pioneros del arte ruso en decorados cinematográficos y realizó los decorados de más de 90 películas, entre ellas *La madre* y *Miss Mend*. Muchos de sus carteles cinematográficos fueron creados antes de la Revolución.

ZHÍTKOV, P.
Zhítkov trabajó en Moscú y pasa por ser uno de los pocos cartelistas profesionales de la época del cine prerrevolucionario. Sus carteles cinematográficos abarcan los años 1912 a 1916.

ZHÚKOV, Piotr Ilíich
(1898–1970)
Zhúkov se formó como decorador y creador de decorados en la Escuela Stróganov de Artes Aplicadas y en los VJUTEMAS de Moscú. En la década de 1920 figuraba entre los representantes más conocidos del cartelismo cinematográfico soviético. Como diseñador de exposiciones participó en importantes proyectos en Moscú (por ejemplo, en el ZPKO, el «Parque Central de Cultura y Descanso») y en el extranjero (Colonia, Filadelfia, etc.). Además, fue responsable de las decoraciones festivas de las calles y plazas moscovitas y trabajó de escenógrafo.

Glosario
AJR: Asociación de Artistas de la Revolución (1928–1932)
AJRR: Asociación de Artistas de la Rusia Revolucionaria (1922–1928)
ARMENKINO: estudios de cine de Armenia
BELGOSKINO: estudios de cine de la República Socialista Soviética Bielorrussia
GLAVKINOPROKAT: principal distribuidora de cine de la URSS
GOSKINO: estudio de cine estatal soviético (1922–1924)
INJUK: Instituto de Cultura Artística, Moscú
MESHRABPOM-RUS: productora de cine soviética (fundada en 1924, de 1928 a 1936 se denominó MESHRABPOMFILM)
OBMUJU: Asociación de Jóvenes Artistas
ORRP: Asociación de Trabajadores del Cartel Revolucionario
OST: Sociedad de Pintura de Caballete
PRESSA: exposición internacional de prensa de Colonia de 1928 (duración: 6 meses; 1.500 expositores de 48 países)
ROSFILM: estudios de cine de Moscú (fundados en 1932)
Ventanas ROSTA: carteles de propaganda soviéticos de la agencia telegráfica ROSTA (después TASS)
SIF: Semilia i Fábrika, editorial estatal
SOVKINO: estudio de cine estatal soviético, que a partir de 1934 pasó a denominarse LENFILM
SVOMAS: talleres de arte libres del Estado
UKRAINFILM: estudios de cine de Ucrania
VJUTEIN: Instituto Superior Artístico-Técnico (1927–1930, cerrado en 1930)
VJUTEMAS: Talleres Superiores Artístico-Técnicos (1920–1927) de Moscú
VSHV: exposición agrícola de la URSS, celebrada en 1939 en Moscú para mostrar los logros de la economía planificada soviética
VUFKU: estudio de cine y fotografía de Ucrania (fundado en 1924)

Biographies des artistes

ALEXEIEV, Guéorgui Dmitrievitch
(1881 – 1951)

Alexeiev étudie la sculpture et le graphisme à l'École de peinture, de sculpture et d'architecture de Moscou. Il compte notamment S. Korovine et V. A. Serov parmi ses professeurs. À partir de 1905, il participe à des expositions avec l'association des expositions artistiques itinérantes. En 1916, il est l'un des premiers affichistes professionnels. Il crée principalement des affiches de films et de propagande, sur la Première Guerre mondiale entre autres. En 1921 – 1922, il prend part aux « Fenêtres ROSTA ». Parmi ses travaux de sculpture, on compte des bustes de Marx, de Lénine et d'autres chefs de la révolution.

APSIT (APSITIS), Alexandre Petrovitch
(1880 – 1944)

Né à Riga, Apsit étudie dans l'atelier de L.E. Dmitriev-Kavkaski à Saint-Pétersbourg. Dès 1902, il travaille comme illustrateur d'ouvrages de la littérature russe et dessine des caricatures pour différentes revues. Durant la Première Guerre mondiale, il réalise des affiches de films et de guerre, et après la révolution d'Octobre, il est considéré comme l'un des artistes éminents dans le domaine de l'affiche politique soviétique. Fin 1920, il s'enfuit en Lettonie, puis s'installe en Allemagne en 1939. Proscrit en URSS à partir des années 1930, il n'est réhabilité comme artiste que dans les années 1960.

ASATOUROV (ASATURI), Paul K.

Asatourov – il n'existe pas de données biographiques à son sujet – n'est connu que pour quelques caricatures réalisées pour des revues satiriques à l'époque de la première révolution russe (1905 – 1907) ainsi que pour ses affiches de films réalisées aux débuts du cinéma russe.

BELSKI, Anatoli Pavlovitch
(1896 – 1970)

Après une formation à l'École Stroganov d'arts appliqués (1908 – 1917) et aux Ateliers supérieurs d'art et de technique de Moscou VKHOUTEMAS (1919 – 1921), Belski travaille comme décorateur pour le music-hall de Moscou, le cirque ainsi que le théâtre et conçoit l'aménagement de pavillons lors d'expositions soviétiques et internationales. À partir du milieu des années 1920, il élabore également des affiches de films, qui feront de lui l'un des affichistes majeurs de l'Union soviétique. Il se consacre à la peinture de paysages à partir 1958.

BOGRAD, Izraïl Davidovitch
(1899 – 1938)

Après avoir fréquenté une école d'art à Rostov-sur-le-Don, Bograd travaille comme ensemblier et affichiste. À partir des années 1920, grâce à ses affiches réalisées pour la compagnie soviétique de films MESHRABPOM-RUS (devenue en 1928 MESHRABPOMFILM), il compte parmi les plus brillants artistes de publicité cinématographique. Dans les années 1930, il conçoit aussi des affiches purement publicitaires. Arrêté en 1938, il meurt probablement la même année.

BORISOV, Grigori Ilitch
(1899 – 1942)

Borisov étudie à l'École Stroganov d'arts appliqués et aux VKHOUTEMAS de Moscou (1924). Il est membre de l'Association des jeunes artistes (OBMOKHOU) et travaille comme affichiste, souvent avec ses collègues Piotr Joukov, Alexandre Naoumov et Nicolas Prousakov. Sous la direction d'El Lissitzky, il participe en 1928 à la conception du pavillon soviétique pour l'exposition internationale Pressa à Cologne et dirige l'un des ateliers du Proletkult (ministère de la Culture).

DLOUGATCH, Mikhaïl Oskarovitch
(1893 – 1989)

Après sa formation à l'École d'Art de Kiev (1905 – 1917), Dlougatch s'installe en 1922 à Moscou et se consacre à la décoration d'ouvrages, de médailles et d'enseignes et surtout aux affiches de films. En 1924, il est l'un des principaux affichistes de films du studio de production d'État, SOVKINO. En 1926, il entre à l'Association des artistes de la Révolution (AKhR). En 1932 – 1933, il est membre de l'Association des ouvriers de l'affiche révolutionnaire (ORRP). Dlougatch fabrique par ailleurs des maquettes pour les pavillons des expositions, dont celle du pavillon soviétique de l'Exposition universelle à Bruxelles en 1958. Dans les années 1950, il se consacre principalement aux affiches de propagande et de cirque.

DORTMAN, T.

Très peu d'informations sont disponibles sur l'œuvre et sur l'artiste, connu pour certaines affiches de films, conçues avant la révolution d'Octobre.

EVSTAFIEV, Mikhaïl Ilitch
(1896 – 1939)

Evstafiev étudie dans les ateliers d'art de Moscou VKHOUTEMAS, puis travaille comme affichiste, principalement en collaboration avec Léonid Voronov.

GERASIMOVICH, Iosif Vasilievitch
(1893 – 1986)

Artiste formé dans les ateliers d'I. Mashkov (1915 – 1916), K. F. Juon (1922) et A. E. Arkhipov. Entre 1920 et 1950, il travaille principalement comme affichiste pour le cinéma et participe à des expositions nationales et internationales. De 1926 à 1932, il est membre de l'Association des artistes de la Révolution (AKhR). En 1927, un diplôme honorifique lui est décerné lors de l'Exposition Internationale des Arts décoratifs à Monza.

JITKOV, P.

Jitkov a travaillé à Moscou. Ses travaux réalisés entre 1912 et 1916 lui valent d'être considéré comme l'un des rares affichistes professionnels de l'époque du cinéma prérévolutionnaire.

JOUKOV, Piotr Ilitch
(1898 – 1970)

Joukov suit sa formation en décoration et aménagement à l'École Stroganov d'arts appliqués et aux VKHOUTEMAS de Moscou. Dans les années 1920, il est l'un des représentants les plus connus de l'affiche de film soviétique. Il participe à des projets importants en tant qu'artiste exposant à Moscou (par ex. au « ZPKO », le « Parc Central de la Culture et du Repos »), mais aussi à l'étranger (notamment à Cologne et Philadelphie). Il est par ailleurs responsable des décorations de fête des rues et des places de Moscou et crée aussi des décors de théâtre.

KABAK, Vladimir Mikhaïlovitch
(1888 – 1938)

Né à Kiev, Kabak étudie à l'Académie des beaux-arts de Saint-Pétersbourg. Après avoir pris part à la guerre civile, il travaille à Moscou, dès les années 1920, comme affichiste, principalement pour le cinéma et le secteur de la publicité. Toutefois, il dessine aussi des affiches à thème social ainsi que des jaquettes de livres. À partir de 1933, il est interdit d'exposition et victime en 1938 des épurations staliniennes.

KALMANSON, Mikhaïl Sergejevitch

Kalmanson, propriétaire d'une entreprise de graphisme à Moscou, est l'auteur de nombreuses affiches de films dans les années 1910.

KHOMOV, Nicolas Mikhaïlovitch
(1903 – 1973)

Le graphiste ukrainien Khomov étudie à l'Académie d'art et d'industrie de Marioupol. À partir de 1926, il travaille régulièrement comme affichiste de cinéma pour la société REKLAM-FILM. En 1928, il termine ses études au VKHOUTEIN de Moscou. Il participe aussi à l'aménagement des pavillons de l'Exposition agricole de l'union (VSKHV).

KLIMACHINE, Victor Semionovitch
(1912 – 1960)

Klimachine étudie de 1928 à 1933 au laboratoire technique de Saratov, commençant à travailler comme affichiste au début des années 1930. Il réalise essentiellement des œuvres politiques, mais aussi des affiches publicitaires et cinématographiques. Dès 1937, il illustre des ouvrages et dessine pour diverses revues. Durant la Seconde Guerre mondiale, il crée des affiches pour le front, et dans les années 1950, il travaille comme ensemblier pour les pavillons soviétiques des expositions de Bombay et de Pékin. Il a par ailleurs rédigé une série d'articles sur les arts plastiques.

KLIOUN (KLIOUNKOV), Ivan Vasilievitch
(1873 – 1943)

Originaire d'Ukraine, il quitte son pays en 1892 et étudie jusqu'en 1896 à Varsovie à l'École artistique de la société de promotion des arts. Après s'être installé à Moscou, il reprend ses études, notamment dans les studios privés de V. Fischer et I. Mashkov. Durant ses études chez F. I. Rerberg (1903 – 1906), il fait la connaissance de Malevitch et du suprématisme. En 1915 – 1916, il prend part comme artiste et sculpteur aux grandes expositions d'avant-garde à Moscou et à Saint-Pétersbourg. Il enseigne à partir de 1918, puis dirige les services culturels d'État et des instituts artistiques comme les VKHOUTEMAS.

LAVINSKI, Anton Mikhaïlovitch
(1893 – 1968)

Après avoir terminé sa formation en architecture à l'Institut technique de Bakou, Lavinski part en 1914 pour Saint-Pétersbourg, où il poursuit ses études dans les ateliers d'artistes indépendants et aux SVOMAS (Ateliers libres) en 1918 – 1919. Il participe à la réalisation du plan de Lénine sur la propagande monumentale et travaille comme sculpteur (sculpture de Karl Marx à Krasnoe Selo, 1918), architecte et illustrateur. Dans les années 1920, il réalise aussi quelques affiches de films, parmi lesquelles celle du film d'Eisenstein Le cuirassé Potemkine, qui deviendra célèbre. De 1920 à 1926, il enseigne la sculpture aux VKHOUTEMAS de Moscou. Il travaille également avec Maïakovski sur les « Fenêtres ROSTA » et collabore à la revue LEF.

LITVAK, Maxime Mikhaïlovitch
(1898 – après 1943)

Originaire de Kiev, Litvak-Maksimov (connu sous le nom de Max Litvak) travaille de 1921 à 1923 au théâtre Novaja dama de Saint-Pétersbourg et à la fabrique de films de Léningrad entre 1923 et 1930. En 1930, il part pour Moscou et crée au cours des années suivantes des affiches publicitaires, de théâtre et de cinéma, certaines en collaboration avec R. P. Feder (Fedor). En 1926 et 1932, il participe aux expositions d'affiches cinématographiques à Moscou et à l'aménagement des pavillons d'exposition. Il est arrêté en 1938, mais libéré la même année.

MALEVITCH, Kazimir Severinovitch
(1878 – 1935)

Malevitch est l'un des artistes les plus éminents de l'art moderne russe. Sa conception de l'art comme une forme pure et sans objet, exerce une influence importante sur la peinture abstraite du début du 20ème siècle. Il étudie d'abord à l'École des beaux-arts de Kiev, sa ville natale, puis à Moscou à l'École de peinture, de sculpture et d'ar-

chitecture et dans l'atelier privé de F. I. Rerberg. En 1907, il participe, avec des artistes comme Vassili Kandinsky, à la 14ème exposition de l'Union des peintres moscovites. Il est membre d'associations d'artistes d'avant-garde. Jusqu'en 1913, il représente le cubo-futurisme comme seule tendance légitime moderne et expose aussi à l'étranger. Il développe ensuite l'art purement abstrait du suprématisme, qu'il justifie dans des écrits comme *Du cubisme au suprématisme. Le nouveau réalisme pictural* (1915). Parmi ses nombreuses activités artistiques, figurent la peinture sur porcelaine ainsi que la décoration de théâtre, mais il se consacre principalement à ses travaux pédagogiques et de recherche, en tant que directeur de différents ateliers d'artistes de Saint-Pétersbourg, de Moscou et de Vitebsk. Il rédige quatre écrits sur l'art cinématographique et élabore, durant son voyage en Allemagne en 1927, un ouvrage illustré sur le cinéma, à l'occasion d'une exposition dans la galerie de Van Diemen. À partir de 1923, Malevitch dirige l'Institut de culture artistique (à partir de 1925, GINKhOUK) de Léningrad. Poste qu'il se voit contraint de quitter en 1926 parce que son art avant-gardiste ne correspond plus aux conceptions artistiques de l'État. En 1929, il perd aussi son poste à l'Institut national d'histoire de l'art, dont les portes ferment peu après. Il reçoit l'autorisation de travailler à l'Institut artistique de Kiev, mais seulement deux semaines par mois. L'exposition de ses œuvres à la Galerie Tretiakov de Moscou est mal accueillie par la critique, celle qui suit à Kiev est annulée peu après son inauguration. Malevitch est arrêté en 1930 et interrogé. En 1932, il est nommé directeur du laboratoire de recherche du musée russe à Léningrad, où il travaille jusqu'à sa mort en 1935. Il faudra attendre 1988 pour voir ses œuvres réunies dans une grande rétrospective à Saint-Pétersbourg.

MOSIAGINE, Piotr

Auteur en 1914 de l'affiche du film *Stenka Razine*, éditée dans la ville russe de Yaroslavl. Aucune autre information n'est disponible sur la vie ou l'œuvre de l'artiste.

NAOUMOV, Alexandre Ilitch
(1899 – 1928)

Naoumov étudie à Moscou entre 1909 et 1917 à l'École Stroganov d'arts appliqués et aux VKHOUTEMAS. Il est membre de l'Association des jeunes artistes (OBMOKHOU) et du groupe Octobre (Oktjabr). Entre 1921 et 1928, il travaille comme décorateur dans des théâtres moscovites, notamment au théâtre du Bolchoï. Il illustre également des ouvrages pour les éditions SIF. Il fait partie des affichistes de premier plan des années 1920 et travaille aussi avec Nicolas Prousakov, Grigori Borisov et Piotr Joukov.

PIMENOV, Youri (Guéorgui) Ivanovitch
(1903 – 1977)

Le peintre, décorateur et graphiste Pimenov, diplômé des VKHOUTEMAS à Moscou (1920 – 1925), fait partie en 1923 des membres fondateurs de la Société des peintres de chevalet (OST). De 1928 à 1931, il est membre de l'Association des artistes de l'affiche révolutionnaire. D'abord illustrateur pour différentes revues russes, il travaille ensuite comme affichiste pour l'industrie cinématographique des années 1930 à 1960. Il conçoit également des costumes et des décors pour plus de trente œuvres présentées dans des théâtres moscovites. Durant la Seconde Guerre mondiale, il est responsable de l'organisation et de la conception des « Fenêtres ROSTA ». L'œuvre de Pimenov s'étend des tableaux de genre et des portraits aux natures mortes. À partir des années 1930, son œuvre est qualifiée de « réalisme socialiste » officiel. Il reçoit différentes distinctions nationales pour son art (prix national de l'URSS en 1947 et en 1950, prix Lénine en 1967) et signe plusieurs ouvrages.

PROUSAKOV, Nicolas Petrovitch
(1900 – 1952)

Après ses études à l'École Stroganov (1911 – 1920) et aux VKHOUTEMAS (1918 – 1924) à Moscou, Prousakov fait partie des membres fondateurs de l'Association des jeunes artistes (OBMOKHOU). À partir des années 1920, il dessine des affiches politiques et crée des affiches de films jusqu'en 1941 comme employé permanent des sociétés cinématographiques, parfois en collaboration avec Grigori Borisov, Alexandre Naoumov et Piotr Joukov. Il participe aux « Fenêtres ROSTA » et réalise des peintures à l'huile et des fresques murales monumentales (Maison des Pionniers à Moscou). Il participe également à la conception des pavillons soviétiques lors d'expositions internationales (Cologne, Helsinki, Prague et Paris notamment). Prousakov est également prisé comme décorateur dans différents théâtres de Moscou. En 1944, il enseigne par ailleurs la décoration du verre à l'Institut moscovite des arts décoratifs et appliqués (MIPIDI).

RABICHEV, Isaac Benjevitch
(1896 – 1957)

Après ses études à l'École des arts de Kiev et aux VKHOUTEMAS de Moscou, Rabichev aménage des trains de propagande durant la guerre civile et collabore à différentes revues dans les années 1920. En outre, il conçoit des affiches de cinéma et de propagande et travaille comme décorateur dans les théâtres de Moscou, d'Odessa, de Kharkov et de Minsk.

RODTCHENKO, Alexandre Mikhaïlovitch
(1891 – 1956)

Rodtchenko est l'un des grands artistes russes d'avant-garde du 20ème siècle. Il ouvre de nouvelles voies dans les domaines de la peinture, de la sculpture, du collage, de la photographie et du design (décoration d'ouvrages et de revues, publicité et affiches) et rencontre un succès international au début des années 1920. Vers la fin de la décennie, il entre toutefois en conflit avec le stalinisme et la nouvelle conception officielle de l'art. Durant les vingt dernières années de sa vie, le monde de l'art lui ferme ses portes et il tombe dans l'oubli. Après avoir fréquenté l'école d'art de Kazan en auditeur libre, où il fait la connaissance en 1914 de sa future épouse Varvara Stepanova, il poursuit ses études durant deux ans à l'École Stroganov de Moscou. Durant la période où il enseigne aux VKHOUTEMAS ou au VKHOUTEIN (1920 – 1930) et à l'INKhOUK (Institut de la culture artistique), il se consacre à la décoration d'expositions (par exemple l'Exposition Internationale des Arts Décoratifs Industriels Modernes à Paris, 1925), d'ouvrages, de vêtements, de vaisselle, de mobilier et de revues (il collabore par exemple à la revue LEF). Son intérêt pour la photographie, caractérisée par des perspectives inhabituelles et vertigineuses, l'amène à utiliser des photos comme moyen d'expression novateur dans des ouvrages et des affiches. Rodtchenko est pionnier dans l'utilisation de photomontages, notamment pour un ouvrage du poète Maïakovski, mais aussi pour des affiches. Il dessine aussi des décors de cinéma. Durant les années 1920, il est employé par SOVKINO et réalise quelques affiches de films.

ROUKLEVSKI, Yakov Timofeïevitch
(1894 – 1965)

Originaire de Smolensk, Rouklevski se forme entre 1906 et 1915 dans des ateliers privés d'artistes. En 1924, il s'installe à Moscou et dirige jusqu'en 1930 le service publicitaire de SOVKINO. Rouklevski débute sa carrière artistique en faisant de la publicité sur les façades des cinémas, mais, très vite, il réalise ses premières affiches politiques d'une longue série. Dans les années 1920, sa réputation en tant qu'affichiste est excellente, notamment grâce à sa collaboration fréquente avec les frères Stenberg. À partir de 1925, il participe aux expositions soviétiques et internationales et

reçoit en 1927 un diplôme honorifique lors de l'Exposition Internationale de Monza.

RYCHKOV, Grigori Nikolaïevitch
(1885 – 1972)

Rychkov étudie à l'École Stroganov d'arts appliqués à Moscou (1911), où il enseigne par la suite avant de devenir professeur aux VKHOUTEMAS (aquarelle, dessin, composition, architecture d'intérieur). Il se consacre surtout à la peinture, au graphisme et à la sculpture sur bois, mais travaille aussi dans les années 1920 comme affichiste pour l'industrie du cinéma. En 1927, il reçoit une distinction lors de l'Exposition Internationale de Monza.

SEMIONOV-MENES, Semion Abramovitch
(1895 – 1972)

Originaire de Biélorussie, Semionov-Menes étudie de 1915 à 1918 à l'École des beaux-arts de Kharkov (Ukraine). De 1919 à 1925, il participe à la production des « Fenêtres ROSTA » ukrainiennes et collabore à la conception des trains et des bateaux de propagande. À partir de 1925, il vit à Moscou, où il travaille notamment comme décorateur de théâtre. Il participe à l'aménagement d'expositions nationales et internationales, notamment à Paris (1925), à New York (1926) et à Monza (1927). Dans les années 1920, il est l'un des représentants les plus éminents de l'art de l'affiche de cinéma. Au cours des années 1950 et 1960, il aménage les pavillons d'expositions soviétiques.

SMOLIAK, Nicolas Petrovitch
(1910 – 1963)

Après avoir achevé ses études à l'École des beaux-arts de Samara (ex Kouibichev) en 1929, Smoliak poursuit sa formation dans l'atelier de D. N. Kardovski à Moscou. Il travaille surtout comme affichiste et crée, à partir de 1932, des affiches pour la société de production cinématographique GLAVKINOPROKAT. Durant la Seconde Guerre mondiale, il conçoit des « Fenêtres TASS » à Moscou et à Tchéliabinsk. Dans les années 1940, il participe à différentes expositions et travaille à la Chambre de Commerce All-Union de l'URSS dans la publicité d'exportation. À partir de 1949, il dessine principalement des affiches politiques et participe, dans les années 1960, à l'atelier « Agitplakat » de l'Union des artistes de l'URSS.

STENBERG, Vladimir Avgustovitch
(1899 – 1982)
STENBERG, Guéorgui Avgustovitch
(1900 – 1933)

Les frères Stenberg ont réalisé des affiches pour presque tous les grands réalisateurs de leur pays et sont sans aucun doute les plus brillants affichistes de leur époque. Leurs œuvres variées recouvrent par ailleurs l'aménagement de places et de rues de Moscou lors de fêtes officielles. Ils travaillent également comme décorateurs de théâtre (de 1922 à 1932 au Théâtre de Chambre de Moscou), peintres et dessinateurs (notamment pour les éditions SIF). Ils étudient ensemble la gravure sur métal, la peinture sur émail et la céramique ainsi que la conception de décors de théâtre à Moscou, leur ville natale, à l'École Stroganov d'arts appliqués (1912 – 1917), puis aux SVOMAS où ils se consacrent à la peinture monumentale, la sculpture, l'architecture et le graphisme (1917 – 1920). De 1919 à 1923, ils font partie de l'OBMOKHOU et participent aux expositions nationales et internationales. Vladimir Stenberg réalise dès 1915 des décorations pour des représentations dans un atelier du film, puis les deux frères créent en 1924 les premières affiches pour SOVKINO. Ils travaillent ensemble jusqu'à la mort accidentelle de Guéorgui en 1933. Cofondateurs et représentants majeurs du constructivisme, ils comptent parmi les artistes les plus influents de l'avant-garde soviétique. Leur utilisation novatrice du principe de montage

filmique dans l'art de l'affiche fait école. En 1927, ils reçoivent un diplôme honorifique lors de l'Exposition Internationale de Monza. Après la mort de son frère, Vladimir poursuit seul son travail d'affichiste, de dessinateur et de décorateur de théâtre. En 1941, il est nommé directeur du musée Maïakovski. En 1949, il est directeur artistique du trust MOSGOROFORMLENIE (aménagement urbain de Moscou). Arrêté en 1952, il est réhabilité un an plus tard.

TALDYKINE, Alexandre Alexeïevitch
(1896 – 1965)
Après ses études aux VKHOUTEMAS de Moscou, Taldykine travaille comme décorateur de théâtre et réalise les décors de nombreux opéras et pièces de théâtre, notamment à Moscou, à Lougansk, à Vladivostok, à Briansk et à Smolensk. Avant la révolution, il dessine encore quelques affiches de films.

TYRSA, Nicolas Andreïevitch
(1887 – 1942)
Originaire d'Arménie, Tyrsa étudie l'architecture de 1905 à 1909 à l'Académie impériale des arts (IAKH) de Saint-Pétersbourg, puis à l'école de dessin et de peinture d'E. Zvantseva. En 1917, il fait partie des membres fondateurs de l'association Liberté pour l'art. Entre 1918 et 1922, il est professeur aux ateliers artistiques d'État de Saint-Pétersbourg. Dans les années 1920 et 1930, le peintre, graphiste et artiste apprécié pour ses aquarelles et ses dessins, travaille pour diverses revues et illustre des ouvrages pour enfants. Entre 1924 et 1942, il enseigne à l'Institut des ingénieurs civils. De 1939 à 1942, il travaille dans l'atelier « Le crayon combatif » de l'Association artistique de Léningrad. À partir de 1914, il participe aux expositions nationales et internationales et se consacre aux arts décoratifs (art du verre).

VEKSLER, Mikhaïl Solomonovitch
(1898 – 1959)
Après des études à l'École des beaux-arts de Vitebsk, sa ville natale, chez Kazimir Malevitch, Veksler travaille comme peintre et graphiste puis, à partir des années 1920, également comme affichiste.

VIALOV, Constantin Alexandrovitch
(1900 – 1976)
Après avoir suivi une formation à l'École Stroganov d'arts appliqués (1914 – 1917) et aux VKHOUTEMAS de Moscou, Vialov fait partie des principaux artistes d'avant-garde du suprématisme et du constructivisme, en tant que peintre, graphiste et sculpteur. Dans les années 1920 et 1930, il présente ses œuvres lors d'expositions internationales, notamment à Paris, à Berlin et à New York. Il travaille comme affichiste et illustrateur, pour des journaux et des revues, et crée des décors de théâtre. Ses œuvres tardives suivent la tendance artistique nationale du « réalisme socialiste ».

VORONOV, Léonid Alexandrovitch
(1899 – 1938)
Voronov, graphiste de formation, travaille comme affichiste, en particulier pour la publicité cinématographique, souvent en collaboration avec Mikhaïl Evstafiev. À la fin des années 1920, il illustre des ouvrages pour les éditions SIF.

YEGOROV, Vladimir Jevgenievitch
(1878 – 1960)
Après avoir étudié à l'École Stroganov d'arts appliqués de Moscou, Yegorov est engagé comme décorateur au Théâtre artistique de la ville, de 1906 à 1911. Toutefois, il est surtout reconnu comme l'un des précurseurs en matière de décors pour le cinéma russe. Il a, en effet, réalisé les décors de plus de 90 films, parmi lesquels *La mère* et *Miss Mend*. Nombre de ses affiches ont été réalisées avant la révolution.

Abréviations
AKhR : Association des artistes de la Révolution (1928 – 1932)
AKhRR : Association des artistes de la Russie révolutionnaire (1922 – 1928)
ARMENKINO : Studios arméniens réunis
BELGOSKINO : Studios de la République socialiste soviétique de Biélorussie
GLAVKINOPROKAT : Principal distributeur de films en URSS
GOSKINO : Studio de cinéma d'État soviétique (1922 – 1924)
INKhOUK : Institut de la culture artistique de Moscou
MESHRABPOM-RUS : Société cinématographique soviétique (fondée en 1924, devenue MESHRABPOMFILM de 1928 à 1936)
OBMOKHOU : Association des jeunes artistes
ORRP : Association des ouvriers de l'affiche révolutionnaire
OST : Société des peintres de chevalet
PRESSA : Exposition Internationale de Presse à Cologne en 1928 (Durée : 6 mois; 1500 exposants de 48 pays)
ROSFILM : Studios cinématographiques moscovites (fondés en 1932)
Fenêtres ROSTA : Affiches de propagande soviétiques de l'agence télégraphique ROSTA (qui deviendra TASS)
SIF : Semilia i Fabrika, éditions d'État
SOVKINO : Le « Cinéma soviétique » est un studio de cinéma, qui s'est appelé Lenfilm à partir de 1934
SVOMAS : Ateliers libres d'État
UKRAINFILM : Studios cinématographiques d'Ukraine
VKHOUTEIN : Institut supérieur d'art et de technique (1927 – 1930, dissout en 1930)
VKHOUTEMAS : Ateliers supérieurs d'art et de technique (1920 – 1927) à Moscou
VSKHV : Exposition agricole de l'union, une vitrine de l'économie planifiée soviétique installée à Moscou en 1939
VUFKU : Studios de films et de photos de toute l'Ukraine (fondés en 1924)

Künstlerbiografien

ALEXEJEW, Georgi Dmitrijewitsch
(1881 – 1951)
Alexejew absolvierte eine Ausbildung als Bildhauer und Grafiker an der Moskauer Schule für Malerei, Bildhauerei und Architektur. Seine Lehrer waren u. a. S. Korowin und W. A. Serow. Seit 1905 nahm er an Ausstellungen der Genossenschaft für künstlerische Wanderausstellungen teil. Er arbeitete ab 1916 als einer der ersten professionellen Plakatkünstler und schuf neben Film- auch Propagandaplakate, z. B. zum Ersten Weltkrieg. 1921 – 1922 wirkte er an den „ROSTA-Fenstern" mit. Zu seinen bildhauerischen Arbeiten gehören Büsten von Marx, Lenin und anderen Führern der Revolution.

APSIT (APSITIS), Alexander Petrowitsch
(1880 – 1944)
Der in Riga geborene Apsit studierte im Atelier von L. E. Dmitrijew-Kawkasski in St. Petersburg. Ab 1902 arbeitete er als Buchillustrator russischer Literatur und entwarf Karikaturen für verschiedene Zeitschriften. Während des Ersten Weltkrieges schuf er Film- und Kriegsplakate, nach der Oktoberrevolution zählte er zu den führenden Künstlern des sowjetischen politischen Plakats. Ende 1920 flüchtete er nach Lettland, 1939 siedelte er nach Deutschland über. Ab den 1930er Jahren in der UdSSR verfemt, wurde er erst in den 1960er Jahren als Künstler rehabilitiert.

ASATUROW (ASATURI), Paul K.
Asaturow, über den keine biografischen Angaben vorliegen, ist lediglich durch einige Karikaturen für satirische Zeitschriften aus der Zeit der ersten russischen Revolution (1905 – 1907) sowie Filmplakate aus den Anfängen des russischen Kinos bekannt.

BELSKI, Anatoli Pawlowitsch
(1896 – 1970)
Nach einer Ausbildung an der Stroganow-Schule für angewandte Kunst (1908 – 1917) und an der staatlichen Moskauer Kunsthochschule WChUTEMAS (1919 – 1921) war Belski als Bühnenbildner für das Moskauer Varieté, den Zirkus sowie das Theater tätig und konzipierte die Ausstattung von Pavillons auf sowjetischen und internationalen Ausstellungen. Darüber hinaus schuf er ab Mitte der 1920er Jahre Filmplakate, die ihn zu einem der führenden Plakatkünstler in der Sowjetunion machten. Ab 1958 widmete er sich der Landschaftsmalerei.

BOGRAD, Israil Dawidowitsch
(1899 – 1938)
Bograd war nach dem Besuch einer Kunstschule in Rostow am Don als Ausstatter und Plakatkünstler aktiv. Seit den 1920er Jahren wurde er mit seinen Plakaten für die sowjetische Filmgesellschaft MESCHRABPOM-RUS (bzw. ab 1928 MESCHRABPOMFILM) zu einem der führenden Künstler für Kinowerbung in der UdSSR. In den 1930er Jahren gestaltete er auch reine Werbeplakate. 1938 wurde er verhaftet und verstarb vermutlich im selben Jahr.

BORISOW, Grigori Iljitsch
(1899 – 1942)
Borisow studierte an der Stroganow-Schule für angewandte Kunst und den WChUTEMAS in Moskau (1924). Er wurde Mitglied in der Vereinigung junger Künstler (OBMUChU) und arbeitete als Filmplakatkünstler, oft gemeinsam mit den Kollegen Pjotr Schukow, Alexander Naumow und Nikolai Prusakow. Er beteiligte sich 1928 unter der Leitung von El Lissitzky an der Konzeption für den sowjetischen Pavillon der internationalen Pressa-Ausstellung in Köln und leitete eine der Werkstätten des Proletkult (Kulturministerium).

CHOMOW, Nikolai Michailowitsch

(1903 – 1973)

Der ukrainische Grafiker Chomow absolvierte die Künstlerisch-industrielle Lehranstalt in Mariupol. Seit 1926 arbeitete er ständig als Filmplakatkünstler und war später für REKLAM-FILM tätig; 1928 beendete er sein Studium am WChUTEIN in Moskau. Er beteiligte sich ferner an der Gestaltung der Pavillons für die All-Unions-Landwirtschaftsausstellung (WSChW).

DLUGATSCH, Michail Oskarowitsch

(1893 – 1989)

Nach dem Studium an der Kiewer Kunstschule (1905 – 1917) zog Dlugatsch 1922 nach Moskau und widmete sich dort neben der Gestaltung von Büchern, Medaillen und Firmenschildern vorwiegend dem Filmplakat. 1924 wurde er als einer der führenden Filmplakatkünstler für das staatliche Produktionsstudio SOWKINO tätig. 1926 trat er in die Assoziation der Künstler der Revolution (AChR) ein, 1932 – 1933 war er Mitglied in der Vereinigung der Arbeiter des revolutionären Plakats (ORRP). Dlugatsch fertigte außerdem Entwürfe für Ausstellungspavillons, darunter auch für den sowjetischen Pavillon auf der Weltausstellung in Brüssel 1958. In den 1950er Jahren konzentrierte er sich überwiegend auf Agitations- und Zirkusplakate.

DORTMAN, T.

Abgesehen von einigen Filmplakaten des Künstlers, die noch vor der Oktoberrevolution entstanden sind, ist über Dortman und sein Werk nichts weiter bekannt.

GERASIMOWITSCH, Iosif Wasiljewitsch

(1893 – 1986)

Er erhielt seine Ausbildung in den Ateliers von I. Maschkow (1915 – 1916), K. F. Juon (1922) und A. E. Archipow. Zwischen 1920 und 1950 arbeitete er vor allem als Plakatkünstler für das Kino und nahm an nationalen und internationalen Ausstellungen teil. Von 1926 – 1932 war er Mitglied der Assoziation der Künstler der Revolution (AChR); 1927 wurde ihm eine Ehrenurkunde auf der Internationalen Ausstellung der dekorativen Künste in Monza verliehen.

JEGOROW, Wladimir Jewgenjewitsch

(1878 – 1960)

Nachdem Jegorow die Stroganow-Schule für angewandte Kunst in Moskau absolviert hatte, erhielt er von 1906 bis 1911 ein Engagement als Bühnenbildner am Moskauer Künstler-Theater. Er gilt aber vor allem als einer der Wegbereiter der russischen Filmdekorationskunst und stattete mehr als 90 Filme aus, darunter *Die Mutter* und *Miss Mend*. Eine ganze Reihe seiner Filmplakate entstanden noch vor der Revolution.

JEWSTAFJEW, Michail Iljitsch

(1896 – 1939)

Jewstafjew studierte an den Moskauer Kunstwerkstätten WChUTEMAS und arbeitete als Filmplakatkünstler vorwiegend mit Leonid Woronow zusammen.

KAABAK, Wladimir Michailowitsch

(1888 – 1938)

Der in Kiew geborene Kaabak absolvierte die Akademie der Künste in St. Petersburg. Nach seiner Teilnahme am Bürgerkrieg arbeitete er ab den 1920er Jahren in Moskau als Werbe- und Filmplakatkünstler, er entwarf aber auch einige Plakate zu sozialen Themen und Buchumschläge. Er erhielt nach 1933 Ausstellungsverbot und wurde 1938 Opfer der sog. stalinistischen Säuberungen.

KALMANSON, Michail Sergejewitsch

Kalmanson war Inhaber eines grafischen Betriebs in Moskau und schuf in den 1910er Jahren eine Reihe Filmplakate.

KLIMASCHIN, Viktor Semjonowitsch

(1912 – 1960)

Klimaschin studierte von 1928 – 1933 am Technikum in Saratow. Anfang der 1930er Jahre begann er seine Tätigkeit als Plakatkünstler; es entstanden überwiegend politische Arbeiten, aber auch Werbe- und Filmplakate. Seit 1937 schuf er zudem Buchillustrationen und Zeichnungen für verschiedene Zeitschriften. Im Zweiten Weltkrieg entwarf er Frontplakate und in den 1950er Jahren war er als Ausstatter sowjetischer Ausstellungspavillons in Bombay und Peking tätig. Außerdem schrieb er eine Reihe von Artikeln zur bildenden Kunst.

KLJUN (KLJUNKOW), Iwan Wasiljewitsch

(1873 – 1943)

Der geborene Ukrainer verließ 1892 seine Heimat und studierte bis 1896 in Warschau an der Kunstschule der Gesellschaft für Förderung der Künste. Nach seinem Umzug nach Moskau nahm er seine Studien 1898 wieder auf, u. a. in den privaten Künstlerstudios von W. Fischer und I. Maschkow. Während seines Studiums bei F. I. Rerberg (1903 – 1906) lernte er Malewitsch und den Suprematismus kennen. Als bildender Künstler und Bildhauer nahm er 1915 – 1916 an den großen Avantgarde-Ausstellungen in Moskau und St. Petersburg teil und war ab 1918 als Lehrer bzw. Leiter in staatlichen Kulturbehörden und Kunstinstitutionen wie den WChUTEMAS tätig. In den 1920er Jahren entstanden einige Filmplakate.

LAWINSKI, Anton Michailowitsch

(1893 – 1968)

Nach dem Abschluss seines Architekturstudiums an der Technischen Lehranstalt in Baku zog Lawinski 1914 nach St. Petersburg, wo er seine Studien an den Freien Künstler-Werkstätten und 1918 – 1919 an der Kunstschule SWOMAS fortsetzte. Er beteiligte sich an der Umsetzung von Lenins Plan zur Monumentalpropaganda und war als Bildhauer (Karl-Marx-Skulptur in Krasnoe Selo, 1918), Architekt sowie Buchgestalter aktiv. In den 1920er Jahren entstanden auch einige Kinoplakate, darunter das berühmte zu Eisensteins *Panzerkreuzer Potemkin*. 1920 – 1926 lehrte er Bildhauerei an den WChUTEMAS in Moskau, arbeitete zusammen mit Majakowski an den „ROSTA-Fenstern" und an der Zeitschrift LEF mit.

LITWAK, Maxim Michailowitsch

(1898 – nach 1943)

Der in Kiew geborene Litwak-Maksimow (Pseudonym: Max Litwak) arbeitete von 1921 – 1923 am Theater „Novaja dama" in St. Petersburg und von 1923 – 1930 in der Leningrader Filmfabrik. 1930 zog er nach Moskau und schuf in den folgenden Jahren Werbe-, Theater- und Filmplakate, die er teilweise auch mit R. P. Feder (Fedor) realisierte. 1926 und 1932 nahm er an Filmplakat-Ausstellungen in Moskau teil und war an der Gestaltung von Ausstellungspavillons beteiligt. 1938 wurde er verhaftet, aber noch im selben Jahr wieder freigelassen.

MALEWITSCH, Kasimir Sewerinowitsch

(1878 – 1935)

Malewitsch zählt zu den wichtigsten Künstlern der russischen Moderne. Seine Auffassung von der Kunst als reiner, gegenstandsloser Form übte großen Einfluss auf die abstrakte Malerei im frühen 20. Jahrhundert aus. Er studierte zunächst an der Kunstschule in seiner Heimatstadt Kiew, dann in Moskau an der Schule für Malerei, Bildhauerei und Architektur und im privaten Atelier von F. I. Rerberg. 1907 nahm er mit Künstlern wie Wassili Kandinsky an der 14. Ausstellung des Verbandes der Moskauer Künstler teil und war Mitglied von Avantgarde-Künstlervereinigungen. Bis 1913 vertrat er den Kubofuturismus als einzig legitime moderne Kunstrichtung und stellte auch im Ausland aus. Danach entwickelte er die rein abstrakte Kunst des Supre-

matismus, den er auch theoretisch in Schriften wie „Vom Kubismus bis zum Suprematismus. Der neue Realismus der Malerei" (1915) begründete. Zu seinen zahlreichen künstlerischen Aktivitäten gehörten die Porzellanmalerei ebenso wie die Bühnenbildgestaltung, vor allem aber widmete er sich als Leiter verschiedener Künstlerwerkstätten in St. Petersburg, Moskau und Witebsk der pädagogischen und wissenschaftlichen Arbeit. Er verfasste vier Schriften zur Filmkunst und schuf während seiner Reise nach Deutschland 1927 anlässlich einer Ausstellung in der Galerie van Diemen ein Filmbuch mit Illustrationen. Ab 1923 war Malewitsch Leiter des Instituts für künstlerische Kultur (ab 1925 GINChUK) in Leningrad, musste den Posten jedoch bereits 1926 wieder verlassen, weil seine avantgardistische Kunst nicht mehr dem staatlichen Kunstgeschmack entsprach. 1929 verlor er auch seinen Posten am Staatlichen Institut für die Geschichte der Kunst, das wenig später geschlossen wurde. Nur zwei Wochen im Monat durfte er im Kunstinstitut in Kiew arbeiten. Die Ausstellung seiner Werke in der Moskauer Tretjakow-Galerie wurde von der Kritik negativ aufgenommen, die anschließende Präsentation in Kiew kurz nach der Eröffnung wieder geschlossen. 1930 wurde Malewitsch festgenommen und verhört. 1932 berief man ihn zum Leiter eines Forschungslabors des Russischen Museums in Leningrad, wo er bis zu seinem Tod 1935 arbeitete. Seine Werke wurden danach erst wieder 1988 in einer großen Retrospektive in St. Petersburg gezeigt.

MOSIAGIN, Pjotr

Er hat das Filmplakat zu *Stenka Rasin* im Jahr 1914 geschaffen, das in der russischen Stadt Jaroslawl herausgegeben wurde. Darüber hinaus gibt es weder zu Leben noch Werk des Künstlers weitere Zeugnisse.

NAUMOW, Alexander Iljitsch

(1899 – 1928)

Naumow studierte von 1909 – 1917 in Moskau an der staatlichen Stroganow-Schule für angewandte Kunst und an den WChUTEMAS; er war Mitglied der Vereinigung junger Künstler (OBMUChU) und der Gruppe „Oktjabr". 1921 – 1928 betätigte er sich als Bühnenbildner an Moskauer Theatern, u. a. auch am Bolschoi-Theater. Darüber hinaus gestaltete er Bücher für den Verlag SIF. Er gehörte zu den führenden Filmplakatkünstlern in den 1920er Jahren und arbeitete auch mit Nikolai Prusakow, Grigori Borisow und Pjotr Schukow zusammen.

PIMENOW, Juri (Georgi) Iwanowitsch

(1903 – 1977)

Der Maler, Bühnenbildner und Grafiker Pimenow, Absolvent der WChUTEMAS in Moskau (1920 – 1925), gehörte 1923 zu den Gründungsmitgliedern der Gesellschaft für Staffelmalerei (OST). Von 1928 – 1931 war er Mitglied in der Vereinigung der Künstler des revolutionären Plakats. Zunächst als Illustrator für verschiedene russische Zeitschriften tätig, arbeitete er von den 1930er bis in die 1960er Jahre auch als Filmplakatkünstler. Darüber hinaus entwarf er Kostüme und Bühnenbilder für mehr als dreißig Aufführungen in Moskauer Theatern. Während des Zweiten Weltkrieges war er mitverantwortlich für die Organisation und Gestaltung der „ROSTA-Fenster". Pimenows Werk umfasst Genrebilder, Porträts und Stillleben, seit den 1930er Jahren bestimmte dabei der offizielle „Sozialistische Realismus" sein Werk. Er erhielt verschiedene staatliche Auszeichnungen für seine Kunst (Staatspreis der UdSSR 1947 und 1950; Leninpreis, 1967) und war Autor einiger Bücher.

PRUSAKOW, Nikolai Petrowitsch

(1900 – 1952)

Nach seiner Ausbildung an der Stroganow-Schule (1911–1920) und den WChUTEMAS (1918 – 1924) in Moskau gehörte Prusakow zu den Gründungsmitgliedern der Vereinigung junger Künstler (OBMUChU). Er entwarf ab den

1920er Jahren politische Plakate und gestaltete bis 1941 als ständiger Mitarbeiter der staatlichen Filmfirmen auch Kinoplakate, z. T. gemeinsam mit Grigori Borisow, Alexander Naumow und Pjotr Schukow. Er beteiligte sich an den „ROSTA-Fenstern", schuf Ölbilder und monumentale Wandgemälde (Haus der Pioniere in Moskau) und wirkte bei der Gestaltung der sowjetischen Pavillons auf internationalen Ausstellungen mit (Köln, Helsinki, Prag, Paris u.a.). Prusakow war auch als Bühnenbildner und Ausstatter in verschiedenen Moskauer Theatern ein gefragter Künstler. 1944 übernahm er außerdem eine Lehrtätigkeit im Fach Glasgestaltung am Moskauer Institut für dekorative und angewandte Kunst (MIPIDI).

RABITSCHEW, Isaak Benjewitsch
(1896 – 1957)
Nach seinem Studium an der Kiewer Schule der Künste und den WChUTEMAS in Moskau gestaltete Rabitschew während des Bürgerkrieges Agitationszüge und wirkte in den 1920er Jahren bei verschiedenen Zeitschriften mit. Er schuf darüber hinaus Film- und Propagandaplakate und war auch als Bühnenbildner und Ausstatter an Theatern in Moskau, Odessa, Charkow und Minsk tätig.

RODTSCHENKO, Alexander Michailowitsch
(1891 – 1956)
Rodtschenko gehört zu den großen russischen Avantgarde-Künstlern des 20. Jahrhunderts. Er hat in den Bereichen Malerei, Bildhauerei, Collage, Fotografie und Design (Buch- und Zeitschriftengestaltung, Werbung und Plakate) neue Wege beschritten und war in den frühen 1920er Jahren auch international erfolgreich. Gegen Ende des Jahrzehnts geriet er jedoch in Konflikt mit dem Stalinismus und der neuen offiziellen Kunstauffassung. Die letzten zwanzig Jahre seines Lebens blieb ihm der Kunstbetrieb verschlossen und er geriet in Vergessenheit. Nach dem Besuch der Kunstschule in Kasan als Gasthörer, wo er 1914 auch seine spätere Frau Warwara Stepanowa kennen lernte, setzte er zwei Jahre lang sein Studium an der Moskauer Stroganow-Schule fort. Während seiner Zeit als Professor an den WChUTEMAS bzw. am WChUTEIN (1920 – 1930) und seiner Tätigkeit am INChUK (Institut für Künstlerische Kultur) beschäftigte er sich mit der Gestaltung von Ausstellungen (z. B. der Internationalen Art-Déco-Ausstellung in Paris, 1925), von Büchern, Kleidung, Geschirr, Möbeln und Zeitschriften (z. B. als Mitarbeiter der Zeitschrift LEF). Seine Hinwendung zur Fotografie, die durch ungewöhnliche und atemberaubende Perspektiven gekennzeichnet ist, veranlasste ihn, Fotos als innovatives Ausdrucksmittel in Büchern und Plakaten einzusetzen. Die Verwendung der Fotomontage, u. a. für ein Buch des Dichters Majakowski, aber auch bei Plakaten, machte Rodtschenko zu einem Pionier dieser Technik. Er arbeitete zudem als Bühnenbildner und Filmausstatter. Während der 1920er Jahre war er für SOWKINO tätig und entwarf einige Filmplakate.

RUKLEWSKI, Jakow Timofejewitsch
(1894 – 1965)
Der in Smolensk geborene Ruklewski erhielt seine Ausbildung zwischen 1906 und 1915 in privaten Kunstateliers. 1924 zog er nach Moskau und leitete bis 1930 die für die Werbung zuständige Betriebsabteilung von SOWKINO. Seine künstlerische Karriere begann Ruklewski mit der Fassadenwerbung für die Lichtspielhäuser, aber schon bald entstanden auch die ersten einer ganzen Reihe von politischen Plakaten. Im Laufe der 1920er Jahre hatte er sich zudem einen hervorragenden Ruf als Filmplakatkünstler erworben, nicht zuletzt durch seine häufige Zusammenarbeit mit den Brüdern Stenberg. Ab 1925 nahm er an sowjetischen und internationalen Ausstellungen teil und erhielt 1927 eine Ehrenurkunde bei der Internationalen Ausstellung in Monza.

RYTSCHKOW, Grigori Nikolajewitsch
(1885 – 1972)
Rytschkow absolvierte die Stroganow-Schule für angewandte Kunst in Moskau (1911), an der er anschließend selbst unterrichtete, bevor er eine Lehrtätigkeit an den WChUTEMAS aufnahm (Aquarell, Zeichnung, Komposition, Innenarchitektur). Er widmete sich vor allem der Malerei, Grafik und Holzskulptur, arbeitete aber in den 1920er Jahren auch viel als Filmplakatkünstler. 1927 wurde er auf der Internationalen Ausstellung in Monza ausgezeichnet.

SCHITKOW, P.
Schitkow war in Moskau tätig und gilt als einer der wenigen professionellen Plakatkünstler aus der Zeit des vorrevolutionären Kinos. Seine Filmplakate stammen aus den Jahren 1912 – 1916.

SCHUKOW, Pjotr Iljitsch
(1898 – 1970)
Schukow erhielt eine Ausbildung als Dekorations- und Ausstattungskünstler an der Stroganow-Schule für angewandte Kunst und den WChUTEMAS in Moskau. In den 1920er Jahren zählte er zu den bekanntesten Vertretern des sowjetischen Filmplakats. Als Ausstellungskünstler war er an wichtigen Projekten in Moskau (z. B. dem „ZPKO", dem „Zentralen Park für Kultur und Erholung"), aber auch im Ausland (u. a. Köln, Philadelphia) beteiligt. Er trug darüber hinaus die Verantwortung für die Festtagsdekorationen von Moskaus Straßen und Plätzen und arbeitete als Bühnenbildner.

SEMENOW-MENES, Semen Abramowitsch
(1895 – 1972)
Der in Weißrussland geborene Semenow-Menes studierte von 1915 bis 1918 an der Charkower Kunstschule (Ukraine). Er beteiligte sich von 1919 bis 1925 an der Produktion der ukrainischen „ROSTA-Fenster" und arbeitete bei der Konzeption von Agitationszügen und -schiffen mit. Ab 1925 lebte er in Moskau, wo er u. a. als Bühnenbildner tätig war. Er wirkte bei der Gestaltung nationaler und internationaler Ausstellungen mit, etwa in Paris (1925), New York (1926) und Monza (1927). In den 1920er Jahren gehörte er zu den prominentesten Vertretern der Filmplakatkunst. Während der 1950er und 1960er Jahre richtete er Pavillons für sowjetische Ausstellungen ein.

SMOLJAK, Nikolai Petrowitsch
(1910 – 1963)
Nach Beendigung seines Studiums an der Kunstfachschule in Samara (ehemals Kuibyschew) 1929 setzte Smoljak seine Ausbildung im Atelier von D. N. Kardowski in Moskau fort. Er arbeitete vorwiegend als Plakatkünstler und schuf ab 1932 Kinoplakate für die Produktionsgesellschaft GLAWKINOPROKAT. Während des Zweiten Weltkrieges gestaltete er in Moskau und Tscheljabinsk „TASS-Fenster". In den 1940er Jahren nahm er an verschiedenen Ausstellungen teil und war für die Allunionshandelskammer in der Exportwerbung tätig; ab 1949 entwarf er überwiegend politische Plakate und wirkte in den 1960er Jahren im Atelier „Agitplakat" des Künstlerverbandes der UdSSR mit.

STENBERG, Wladimir Awgustowitsch
(1899 – 1982)
STENBERG, Georgi Awgustowitsch
(1900 – 1933)
Die Brüder Stenberg stellten für nahezu alle großen Regisseure ihres Landes Filmplakate her und sind ohne Zweifel die wichtigsten Plakatkünstler ihrer Zeit gewesen. Ihr reichhaltiges Schaffen umfasst darüber hinaus die Gestaltung von Moskauer Plätzen und Straßen bei offiziellen Feiern wie auch die Arbeit als Bühnenbildner (von 1922 – 1932 waren sie am Moskauer Kammertheater), Maler und Designer (u.

a. für den Verlag SIF). Sie studierten gemeinsam in ihrer Heimatstadt Moskau an der Stroganow-Schule für angewandte Kunst in den Abteilungen Metallprägung, Emaille- und Keramikmalerei sowie Theaterausstattung (1912 – 1917), später an den SWOMAS Monumentalmalerei, Skulptur, Architektur und Grafik (1917 – 1920). 1919 – 1923 gehörten sie der OBMUChU an und nahmen an nationalen und internationalen Ausstellungen teil. Nachdem Wladimir Stenberg 1915 bereits Dekorationen für Aufführungen in einem Filmatelier angefertigt hatte, entstanden 1924 für SOWKINO die ersten Filmplakate der Brüder, die bis zum Unfalltod Georgis 1933 immer zusammen arbeiteten. Als Mitbegründer und führende Vertreter des Konstruktivismus zählten sie zu den einflussreichsten Künstlern der sowjetischen Avantgarde, und so machte beispielsweise die innovative Verwendung des filmischen Montageprinzips in der Plakatkunst Schule. 1927 erhielten sie eine Ehrenurkunde auf der Internationalen Ausstellung in Monza. Nach dem Tode des Bruders setzte Wladimir die Arbeit am Theater, als Plakatkünstler, Designer und Ausstatter allein fort. 1941 berief man ihn zum Leiter des Majakowski-Museums, 1949 zum leitenden Künstler beim Trust zur Stadtgestaltung Moskaus (MOSGOROFORMLENIE). 1952 wurde er verhaftet, aber schon ein Jahr später rehabilitiert.

TALDYKIN, Alexander Alexejewitsch
(1896 – 1965)
Nach einem Studium an den WChUTEMAS in Moskau arbeitete Taldykin als Bühnenbildner und stattete Aufführungen an Opern- und Theaterhäusern u. a. in Moskau, Lugansk, Wladiwostok, Brjansk und Smolensk aus. Er entwarf noch vor der Revolution einige Filmplakate.

TYRSA, Nikolai Andrejewitsch
(1887 – 1942)
Der aus Armenien stammende Tyrsa studierte 1905 – 1909 Architektur an der Kaiserlichen Akademie der Künste (IACh) in St. Petersburg, danach an der Schule für Zeichnung und Malerei von E. Swanzewa. 1917 gehörte er zu den Gründungsmitgliedern der Vereinigung Freiheit für die Kunst. 1918 – 1922 unterrichtete er selbst als Professor an den Staatlichen freien künstlerischen Werkstätten in St. Petersburg. In den 1920er und 1930er Jahren arbeitete der Maler, Grafiker und für seine Aquarelle sowie Zeichnungen geschätzte Künstler für verschiedene Zeitschriften und illustrierte Kinderbücher. 1924 – 1942 lehrte er am Institut für Zivilingenieure, 1939 – 1942 war er Mitarbeiter im Atelier „Kämpferischer Bleistift" des Leningrader Künstlerverbandes. Er nahm seit 1914 an nationalen und internationalen Ausstellungen teil und war auch im Kunstgewerbe (Glaskunst) aktiv.

WEKSLER, Michail Solomonowitsch
(1898 – 1959)
Nach dem Studium an der Kunstschule seiner Heimatstadt Witebsk bei Kasimir Malewitsch arbeitete Weksler als Maler und Grafiker, seit den 1920er Jahren auch als Plakatkünstler.

WJALOW, Konstantin Alexandrowitsch
(1900 – 1976)
Nach seinem Studium an der Stroganow-Schule für angewandte Kunst (1914 – 1917) und an den WChUTEMAS in Moskau gehörte Wjalow als Maler, Grafiker und Bildhauer zu den führenden Avantgarde-Künstlern des Suprematismus und Konstruktivismus. In den 1920er und 1930er Jahren zeigte er seine Werke auf internationalen Ausstellungen u. a. in Paris, Berlin und New York. Er arbeitete als Plakatkünstler und Buchillustrator, für Zeitungen sowie Zeitschriften und entwarf Bühnenausstattungen. Seine späteren Werke folgen der staatlichen Kunstrichtung des „Sozialistischen Realismus".

WORONOW, Leonid Alexandrowitsch

(1899 – 1938)

Woronow war Grafiker und hat als Plakatkünstler vor allem für die Filmwerbung gearbeitet, oftmals gemeinsam mit Michail Jewstafjew. Ende der 1920er Jahre illustrierte er Bücher für den Verlag SIF.

Abkürzungen

AChR: Assoziation der Künstler der Revolution (1928 – 1932)

AChRR: Assoziation der Künstler des revolutionären Russland (1922 – 1928)

ARMENKINO: Vereinigte Armenische Filmstudios

BELGOSKINO: Filmstudios der Weißrussischen Sozialistischen Sowjetrepublik

GLAWKINOPROKAT: Hauptfilmverleih der UdSSR

GOSKINO: staatliches sowjetisches Filmstudio (1922 – 1924)

INcHUK: Institut für Künstlerische Kultur, Moskau

MESCHRABPOM-RUS: Sowjetische Filmgesellschaft (1924 gegründet, 1928 – 1936 als MESCHRABPOMFILM weitergeführt)

OBMUChU: Vereinigung junger Künstler

ORRP: Vereinigung der Arbeiter des revolutionären Plakats

OST: Gesellschaft für Staffelmalerei

PRESSA: Internationale Presse-Ausstellung in Köln 1928 (Dauer: 6 Monate; 1500 Aussteller aus 48 Ländern)

ROSFILM: Moskauer Filmstudios (gegründet 1932)

ROSTA-Fenster: sowjetische Propagandaplakate der Telegrafen-agentur ROSTA (später TASS)

SIF: Semilia i Fabrika, staatlicher Verlag

SOWKINO: das „Sowjetische Kino" ist ein staatliches Filmstudio, das ab 1934 nur noch LENFILM hieß

SWOMAS: Staatliche Freie Kunstwerkstätten

UKRAINFILM: Filmstudios der Ukraine

WChUTEIN: Höheres Künstlerisch-Technisches Institut (1927 – 1930, 1930 aufgelöst)

WChUTEMAS: Höhere Künstlerisch-Technische Werkstätten (1920 – 1927) in Moskau

WSChW: All-Unions-Landwirtschaftsausstellung, als Schau der sowjetischen Planwirtschaft 1939 in Moskau eingerichtet

WUFKU: All-Ukrainische Foto- und Filmstudios (gegründet 1924)

List of Posters

Alexeev, Georgi Dmitrievich
25 *The Killed Dream*
France (Original title: *Le rêve passe*). Director: Louis Feuillade. Société des Etablissements L. Gaumont, 1911 – Colour lithograph, 106.5 x 72 cm. Moscow, 1910s
41 *Ultus and the Secret of the Night*
Great Britain (Original title: *Ultus and the Secret of the Night*). Director George Pearson. Gaumont British Picture Corporation, 1917 – Colour lithograph, 107 x 71.5 cm. Moscow, 1910s
52 *Being Married by the Satan*
Russia. Director: V. K. Viskovsky. Era Studio, 1917 – Colour lithograph, 112 x 76 cm. Moscow, 1917
53 *Women, Mobilize!*
France. Gaumont – Colour lithograph, 108.5 x 72.5 cm. Moscow, 1910s

Apsit (Apsitis), Alexander Petrovich
21 *The Unfinished Love Song*
Russia. Directors: V. A. Polonsky, Lev Kuleshov. Kozlovsky, Yuriev and Co. Inc., 1918 – Colour lithograph, 105.5 x 70 cm. Moscow, 1918 – 1919

Asaturov (Asaturi), Paul K.
14 *Stenka Razin*
Russia. Director: Vladimir Romashkov. A. O. Drankov Studio, 1908 – Colour lithograph, 102.5 x 68.5 cm. St. Petersburg, 1908

Belsky, Anatoly Pavlovich
83 *The Communard's Pipe*
Based on a short story of the same title by I. G. Ehrenburg. USSR. Director: K. A. Mardjanishvili (Mardjanov). Goskinprom Gruzii, 1929 – Colour lithograph with offset photography, 108 x 74 cm. Moscow, 1929
98 *Saba*
USSR. Director: M. E. Chiaureli. Goskinprom Gruzii, 1929 – Colour lithograph, 108 x 73 cm. Moscow, 1929
102 *Wolves*
USSR. Director: Leo Mur (L. I. Murashko). Goskino, 1925 – Colour lithograph, 72 x 108 cm. Moscow, 1925

Bograd, Izrail Davidovich
68 *Mother*
Based on a novel of the same title by Maxim Gorky. USSR. Director: V. I. Pudovkin. Mezhrabpom-Rus, 1926 – Colour lithograph, 140 x 317 cm. Moscow, 1926
103 *The Collegiate Registrar*
Based on the short story of the same title by A. S. Pushkin. USSR. Director: Y. A. Zheliabuzhsky. Mezhrabpom-Rus, 1925 – Colour lithograph, 72 x 108 cm. Moscow, 1925
119 *The White Eagle*
Based on the story "The Governor" by Leonid Andreev. USSR. Director: Y. A. Protasanov. Mezhrabpomfilm, 1928 – Colour lithograph, 125 x 91 cm. Moscow, 1928
121 *The End of St Petersburg*
USSR. Director: V. I. Pudovkin. Mezhrabpom-Rus, 1927 – Colour lithograph, 125 x 95 cm. Moscow, 1927
127 *Aelita*
USSR. Director: Y. A. Protasanov. Mezhrabpom-Rus, 1924 – Colour lithograph, 72 x 108 cm. Moscow, 1929

Borisov, Grigori Ilyich
Prusakov, Nikolai Petrovich
80 *The House on Trubnaya Square*
USSR. Director: Boris Barnet. Mezhrabpomfilm, 1928 – Colour lithograph, 95 x 135 cm. Moscow, 1928
81 *Khaz-Push*
USSR. Director: A. I. Bek-Nazarov. Armenkino, 1928 – Colour lithograph with offset photography, 72 x 108 cm. Moscow, 1928
140 *Princess Mary*
Based on the short story of the same title by M. Y. Lermontov. USSR. Director: V. G. Barsky. Goskinprom Gruzii, 1927 – Colour lithograph, 125 x 90 cm. Moscow, 1927

Borisov, Grigori Ilyich
Zhukov, Pyotr Ilyich
94 *No Entrance to the City*
USSR. Director: Y. A. Zheliabuzhsky. Mezhrabpomfilm, 1929 – Colour lithograph with offset photography, 122 x 94 cm. Moscow, 1929
167 *The Living Corpse*
Based on the play of the same title by L. N. Tolstoy. USSR. Director: F. A. Otsep. Mezhrabpomfilm and Prometheus-Film-Verleih und Vertriebs-GmbH (Germany), 1929 – Colour lithograph, 108,5 x 73 cm. Moscow, 1929

Dlugach, Mikhail Oskarovich
99 *Gossip*
USSR. Director: I. N. Perestiani. VUFKU, 1928 – Colour lithograph, 108 x 72 cm. Moscow, 1928
109 *The Oyster Princess*
Germany (Original title: *Die Austernprinzessin*). Director: Ernst Lubitsch. Protections AG Union, 1919 – Colour lithograph, 101 x 72 cm. Moscow, 1926

116 *Judge Reitan*
USSR. Director: F. L. Lopatinsky. VUFKU, 1929 – Colour lithograph, 94 x 62 cm. Moscow, 1929

Dortman, T.
50 *Spawn of the Devil*
Russia. Director: B. A. Orlitsky. K. Philipp's Alliance and Adler Companies, 1916 – Colour lithograph, 103.5 x 66 cm. Moscow, 1916

Evstafiev, Mikhail Ilyich
See: Voronov, Leonid Alexandrovich,
Evstafiev, Mikhail Ilyich

Gerasimovich, Iosif Vasilyevich
96 *120 Thousand a Year*
USSR. Director: G. I. Chernyak. Mezhrabpomfilm, 1929 – Colour lithograph, 103 x 71 cm. Moscow, 1929
129 *The Last Cab Driver in Berlin*
Germany (Original title: *Die letzte Droschke von Berlin*). Director: Carl Boese. Rex-Film GmbH, 1926 – Colour lithograph, 72 x 108 cm. Moscow, 1928
165 *The Passionate Prince*
USSR. Director: V. G. Shmidtgoft. Sovkino, 1928 – Colour lithograph, 109 x 72 cm. Moscow, 1928

Kabak, Vladimir Mikhailovich
162 *Miss Mend*
Based on the crime novel of the same title by M. Shaginyan. USSR. Directors: F. A. Otsep, Boris Barnet. Mezhrabpom-Rus, 1926 – Colour lithograph, 74.5 x 109 cm. Moscow, 1926

Kalmanson, Mikhail Sergeyevich
19 *Anna Karenina's Daughter*
Russia. Director: A. A. Arkatov. Prodalent Company, 1916 – Colour lithograph, 106 x 71 cm. Moscow, 1916
20 *The Die Is Cast*
Russia. Director: unknown. Kozlovsky, Yuriev and Co. Inc. – Colour lithograph, 104 x 76.5 cm. Moscow, 1910s
32 *Slavery in Gold Chains*
Unknown – Colour lithograph, 102 x 71.5 cm. Moscow, 1910s
33 *The Queen of the Circus Ring*
Trans-Atlantic Inc. – Colour lithograph, 107 x 72 cm. Moscow, 1910s
34 *Tormented Souls*
Russia. Director: V. P. Kasyanov. Studio D. I. Kharitonov, 1917 – Colour lithograph, 107 x 69 cm. Moscow, 1917
43 *The Mysterious Murder in Petrograd*
Russia. Director: N. L. Minervin. "Minerva" Cooperative, 1917 – Colour lithograph, 107 x 71 cm. Moscow, 1917
44 *When I Was a Mailcoach Man...*
Based on a folk song. Russia. Director: N. P. Larin. Skobelevsky Committee, 1916 – Colour lithograph, 104 x 71 cm. Moscow, 1916
45 *One-Eyed Devil*
Russia. Director: N. P. Larin. Skobelevsky Committee, 1916 – Colour lithograph, 106 x 71 cm. Moscow, 1916
46 *As They Lie*
Russia. Director: V. K. Viskovsky. Studio D. I. Kharitonov, 1917 – Colour lithograph, 71 x 104 cm. Moscow, 1917
56 *The Reaped Sheaf in Love's Harvest*
Russia. Director: M. P. Bonch-Tomashevsky. Era studio, 1917 – Colour lithograph, 106.5 x 71 cm. Moscow, 1917
57 *The Abyss*
Based on "De profundis" by Stanislaw Przybyszewski. Russia. Original Polish title: Topiel. Director: W. Lenczewski. "Polonia Moskva" Society, 1917 – Colour lithograph, 106 x 71 cm. Moscow, 1917

Khomov, Nikolai Mikhailovich
177 *Wanted Protection*
USSR. Director: B. Y. Kazachkov. Rosfilm, 1932 – Colour lithograph, 92 x 60 cm. Moscow, 1933

Klimashin, Viktor Semionovich
176 *Do I Love You?*
USSR. Director: S. A. Gerasimov. Soyuzfilm, 1934 – Colour lithograph, 83.5 x 58 cm. Moscow, 1934

Kliun (Kliunkov), Ivan Vasilyevich
158 *Semiramida's Pearl*
USSR. Director: G. M. Stabovoi. VUFKU, 1929 – Colour lithograph, 107 x 71,5 cm. Moscow, 1929

Lavinsky, Anton Mikhailovich
61 *Battleship Potemkin*
USSR. Director: S. M. Eisenstein. Goskino, 1925 – Colour lithograph with offset photography, 72 x 104 cm. Moscow, 1926
74 *Death Bay*
Based on the story "In the Otrada Bay" by A. S. Novikov-Priboi. USSR. Director: Abram Room. Goskino, 1926 – Colour lithograph with offset photography, 108 x 72 cm. Moscow, 1926
87 *By the Law (Dura Lex)*
Based on the story "The Unexpected" by Jack London. USSR. Director: Lev Kuleshov. Sovkino, 1926 – Colour lithograph, 101 x 72 cm. Moscow, 1926

Litvak, Maxim Mikhailovich
79 *Until Tomorrow*
USSR. Director: Y. V. Tarich. Belgoskino, 1929 – Colour lithograph, 102.5 x 72 cm. Moscow, 1929

Malevich, Kazimir Severinovich
175 *Doctor Mabuse*
Germany (Original title: *Doktor Mabuse, der Spieler*). Director: Fritz Lang. Uco-Film GmbH, 1922 – 1927 – Oil on canvas, 106 x 70.6 cm

Mosiagin, Pyotr
15 *Stenka Razin*
Russia. Director: G. I. Libken. G. I. Libken Cinematographic Studio, 1914 – Colour lithograph, 162.5 x 214 cm. Yaroslavl, 1914

Naumov, Alexander Ilyich
104 *The Traitor*
Based on the story "Matrosskaya Tishina" by Lev Nikulin. USSR. Director: Abram Room. Goskino, 1926 – Colour lithograph, 101 x 72 cm. Moscow, 1926
141 *Bella Donna*
USA. Director: George Fitzmaurice. Famous Players-Lasky Corporation, 1923 – Colour lithograph, 123 x 87 cm. Moscow, 1927
157 *Alim*
USSR. Director: G. N. Tasin. VUFKU, 1926 – Colour lithograph, 101 x 72 cm. Moscow, 1926

Pimenov, Yuri (Georgi) Ivanovich
179 *Boule de Suif*
Based on the short story "Boule de suif" by Guy de Maupassant. USSR. Director: M. I. Romm. Moskinokombinat, 1934 – Colour lithograph, 122 x 83 cm. Moscow, 1935

Prusakov, Nikolai Petrovich
76 *The Ranks and the People*
Based on three stories by Anton Chekhov. USSR. Director: Y. A. Protasanov. Mezhrabpomfilm, 1929 – Colour lithograph with offset photography, 94 x 62 cm. Moscow, 1929
84 *The General Line (Old and New)*
USSR. Directors: S. M. Eisenstein, G. A. Alexandrov. Sovkino, 1929 – Colour lithograph, 72 x 108 cm. Moscow, 1929
97 *The Green Alley*
Germany (Original title: *Die Rothausgasse*). Director: Richard Oswald. Richard Oswald-Produktion GmbH, 1928 – Colour lithograph, 82 x 107 cm. Moscow, 1929
101 *Five Minutes*
USSR. Directors: A. S. Balygin, G. M. Zelondjev-Shipov. Goskinprom Gruzii, 1929 – Colour lithograph, 140 x 108 cm. Moscow, 1929
138 *Up on Kholt*
USSR. Director: L. D. Esakia. Goskinprom Gruzii, 1929 – Colour lithograph, 108 x 73 cm. Moscow, 1929
143 *No Luck*
Germany (Original title: *Die vertauschte Braut*). Director: Carl Wilhelm. Phoebus-Film-AG, 1925 – Colour lithograph, 100 x 71 cm. Moscow, 1927
144 *The Glass Eye*
USSR. Directors: L. Y. Brik, V. L. Zhemchuzhny. Mezhrabpomfilm, 1929 – Colour lithograph, 123 x 94 cm. Moscow, 1929
149 *Strange Woman*
USSR. Director: I. A. Pyriev. Sovkino, 1929 – Colour lithograph with offset photography, 140 x 108 cm. Moscow, 1929
153 *The Communard's Pipe*
Based on the short story of the same title by I. G. Ehrenburg. USSR. Director: K. A. Mardjanishvili (Mardjanov). Goskinprom Gruzii, 1929 – Colour lithograph, 108 x 73 cm. Moscow, 1929

Prusakov, Nikolai Petrovich
See also: Borisov, Grigori Ilyich,
Prusakov, Nikolai Petrovich

Rabichev, Isaak Benyevich
108 *The Doll with Millions*
USSR. Director: S. P. Komarov. Mezhrabpomfilm, 1928 – Colour lithograph, 100 x 52.5 cm. Moscow, 1928

Rodchenko, Alexander Mikhailovich
59 *Kino-Eye – Life Caught Unawares*
USSR. Director: Dziga Vertov. Goskino, 1924 – Colour lithograph, 96 x 71 cm. Moscow, 1924
75 *A Sixth of the World*
USSR. Director: Dziga Vertov. Sovkino, 1926 – Colour lithograph with offset photography, 108 x 70 cm. Moscow, 1927

Ruklevsky, Yakov Timofeevich
71 *October*
USSR. Directors: S. M. Eisenstein, G. A. Alexandrov. Sovkino, 1927 – Colour lithograph, 206 x 100 cm. Moscow, 1927
78 *Café Fanconi*
USSR. Director: M. Y. Kapchinsky. Sovkino, 1927 – Colour lithograph with offset photography, 107 x 72 cm. Moscow, 1927
130 *Strength and Beauty*
Denmark (Original title: *Kraft og Skønhed*). Director: Lau Lauritzen. Palladium, 1927 – Colour lithograph, 70 x 94 cm. Moscow, 1929

Ruklevsky, Yakov Timofeevich
See also: Stenberg, Vladimir Avgustovich; Stenberg, Georgi Avgustovich; Ruklevsky, Yakov Timofeevich

Rychkov, Grigori Nikolayevich
125 *The Poet and the Tsar*
USSR. Director: V. R. Gardin. Sovkino, 1927 – Colour lithograph, 70 x 107 cm. Moscow, 1927

Semionov-Menes, Semion Abramovich
106 *Who Are You?*
USSR. Director: Y. A. Zheliabuzhsky. Mezhrabpom-Rus, 1927 – Colour lithograph, 112.5 x 82.5 cm. Moscow, 1927
107 *Oh, Little Apple...*
USSR. Directors: L. L. Obolensky, M. I. Doller. Mezhrabpom-Rus, 1926 – Colour lithograph, 107 x 72 cm. Moscow, 1927
133 *Mary's Kiss*
USSR. Director: S. P. Komarov. Mezhrabpom-Rus, 1927 – Colour lithograph, 73 x 108 cm. Moscow, 1927
146 *The Doll with Millions*
USSR. Director: S. P. Komarov. Mezhrabpomfilm, 1928 – Colour lithograph, 126 x 92 cm. Moscow, 1928
155 *Turksib*
USSR. Director: Viktor Turin. Vostok-Kino, 1929 – Colour lithograph, 105 x 69 cm. Moscow, 1929
168 *The Girl with the Hat-Box*
USSR. Director: Boris Barnet. Mezhrabpom-Rus, 1927 – Colour lithograph, 111 x 83 cm. Moscow, 1927
170 *Miss Mend*
Based on the crime novel of the same title by M. Shaginyan. USSR. Directors: F. A. Otsep, Boris Barnet. Mezhrabpom-Rus, 1926 – Colour lithograph, 108 x 141 cm. Moscow, 1927

Smoliak, Nikolai Petrovich
178 *Crown Prince of the Republic*
USSR. Director: E. Y. Ioganson. Lenfilm, 1934 – Colour lithograph, 94 x 62 cm. Moscow, 1934

Stenberg, Vladimir Avgustovich
Stenberg, Georgi Avgustovich
60 *Battleship Potemkin*
USSR. Director: S. M. Eisenstein. Goskino, 1925 – Colour lithograph, 70 x 94 cm. Moscow, 1925
73 *October*
USSR. Directors: S. M. Eisenstein, G. A. Alexandrov. Sovkino, 1927 – Colour lithograph, 142 x 100 cm. Moscow, 1927
77 *The Eleventh Year*
USSR. Director: Dziga Vertov. VUFKU, 1928 – Colour lithograph, 107 x 71 cm. Moscow, 1928
82 *Man with the Movie Camera*
USSR. Director: Dziga Vertov. VUFKU, 1929 – Colour lithograph, 106 x 72 cm. Moscow, 1929
88 *SEP*
USSR. Directors: M. E. Verner, P. N. Armand. Gosvoyenkino, 1929 – Colour lithograph, 107 x 73 cm. Moscow, 1929
89 *The Secret Hacienda*
USA (Original title: *The Fighting Demon*). Director: Arthur Rosson. Richard Talmage Productions, Carlos Productions, Truart Film Co., 1925 – Colour lithograph, 102 x 70 cm. Moscow, 1927
91 *The Second Life*
Germany (Original title: *Dr. Bessels Verwandlung*). Director: Richard Oswald. Richard Oswald-Produktion GmbH, 1927 – Colour lithograph, 158 x 72 cm. Moscow, 1928
92 *Berlin: Symphony of a Great City*
Germany (Original title: *Berlin: Die Sinfonie der Großstadt*). Director: Walther Ruttmann. Deutsche Vereins-Film AG/Fox Europa, 1927 – Colour lithograph, 106 x 71 cm. Moscow, 1928
93 *A Commonplace Story*
France (Original title: *La clé de voûte*). Director: Richard Lion. Mappemonde, 1925 – Colour lithograph, 101 x 70 cm. Moscow, 1927
95 *In the Spring*
USSR. Director: M. A. Kaufman. VUFKU, 1929 – Colour lithograph, 105 x 74 cm. Moscow, 1929
105 *The Love Triangle*
USSR. Director: Abram Room. Sovkino, 1927 – Colour lithograph, 101 x 70 cm. Moscow, 1927
110 *A Real Gentleman*
USA (Original title: *A Perfect Gentleman*). Director: Clyde Bruckman. Monty Banks Enterprises, 1928 – Colour lithograph, 108 x 72 cm. Moscow, 1928
111 *The Sold Appetite*
USSR. Director: N. P. Okhlopkov. VUFKU, 1928 – Colour lithograph, 107 x 71 cm. Moscow, 1928
112 *Moulin Rouge*
England (Original title: *Moulin Rouge*). Director: Ewald André Dupont. British International Pictures, 1928 – Colour lithograph, 95 x 63 cm. Moscow, 1929
113 *Tamilla*
USSR / Turkey. Director: E. Mukhsin-Bey, 1927 – Colour lithograph, 107 x 72 cm. Moscow, 1928
120 *Café Fanconi*
USSR. Director: M. Y. Kapchinsky. Sovkino, 1927 – Colour lithograph, 107 x 72 cm. Moscow, 1927

122 *The Green Alley*
Germany (Original title: *Die Rothausgasse*). Director: Richard Oswald. Richard Oswald-Produktion GmbH, 1928 – Colour lithograph, 93 x 70 cm. Moscow, 1929
123 *Zare*
USSR. Director: A. I. Bek-Nazarov. Armenkino, 1927 – Colour lithograph, 142 x 100 cm. Moscow, 1927
124 *Camilla*
USA (Original title: *Camille of the Barbary Coast*). Director: Hugh Dierker. Associated Exhibitors, 1925 – Colour lithograph, 72 x 101 cm. Moscow, 1928
128 *The Three Million Trial*
USSR. Director: Y. A. Protasanov. Mezhrabpom-Rus, 1926 – Colour lithograph, 102 x 79 cm. Moscow, 1926
131 *Distinguished Travellers*
Denmark (Original title: *Raske Riviera-Rejsende*). Director: Lau Lauritzen. Palladium, 1924 – Colour lithograph, 107 x 72 cm. Moscow, 1928
132 *Overcome*
USA (Original title: *Sherlock Jr.*). Director: Buster Keaton. Buster Keaton Productions, 1924 – Colour lithograph, 109 x 72 cm. Moscow, 1927
134 *Turksib*
USSR. Director: Viktor Turin. Vostok-Kino, 1929 – Colour lithograph, 107 x 71 cm. Moscow, 1929
135 *Cement*
Based on the novel of the same title by Fedor Gladkov. USSR. Director: V. Vilner. VUFKU, 1927 – Colour lithograph, 107 x 71 cm. Moscow, 1928
136 *The Eleventh Year*
USSR. Director: Dziga Vertov. VUFKU, 1928 – Colour lithograph, 106 x 71 cm. Moscow, 1928
137 *Man with the Movie Camera*
USSR. Director: Dziga Vertov. VUFKU, 1929 – Colour lithograph, 101 x 71 cm. Moscow, 1929
139 *Niniche*
Germany (Original title: *Niniche*). Director: Victor Janson. Westi-Film, 1925 – Colour lithograph, 100 x 72 cm. Moscow, 1927
142 *Idol of the Public*
USA (Original title: *A Small Town Idol*). Director: Erle C. Kenton. Mack Sennett Comedies, 1921 – Colour lithograph, 108 x 72 cm. Moscow, 1925
145 *The General*
USA (Original title: *The General*). Directors: Buster Keaton, Clyde Bruckman. Buster Keaton Productions, 1926 – Colour lithograph, 109 x 72 cm. Moscow, 1929
147 *Old Number 99*
USA (Original title: *The Night Flyer*). Director: Walter Lang. James Cruze Productions, 1928 – Colour lithograph, 109 x 73 cm. Moscow, 1929
148 *The Screw from Another Machine*
USSR. Director: A. A. Talanov. Proletkino, 1926 – Colour lithograph, 108 x 73 cm. Moscow, 1926
150 *Six Girls Seeking Shelter*
Germany (Original title: *Sechs Mädchen suchen Nachtquartier*). Director: Hans Behrendt. Fellner & Somlo-Film GmbH, 1928 – Colour lithograph with offset photography, 109 x 122 cm. Moscow, 1928
151 *A Cup of Tea*
USSR. Director: N. G. Shpikovsky. Sovkino, 1927 – Colour lithograph with offset photography, 72 x 108 cm. Moscow, 1927
152 *High Society Wager*
Germany (Original title: *Der Wetterwart*). Director: Carl Froelich. Carl Froelich-Film GmbH, 1923 – Colour lithograph, 108 x 73 cm. Moscow, 1927
154 *The Pencil*
USSR. Director: Boris Tseitlin. VUFKU, 1928 – Colour lithograph, 107 x 70 cm. Moscow, 1928
159 *The Policeman*
Sweden (Original title: *Polis Paulus' påskasmäll*). Director: Gustaf Molander. Svensk Filmindustri (SF), 1925 – Colour lithograph, 109 x 72 cm. Moscow, 1928
164 *The General*
USA (Original title: *The General*). Directors: Buster Keaton, Clyde Bruckman. Buster Keaton Productions, 1926 – Colour lithograph, 109 x 72 cm. Moscow, 1929
169 *Fragment of an Empire*
USSR. Director: F. M. Ermler. Sovkino, 1929 – Colour lithograph, 95 x 62 cm. Moscow, 1929
171 *The Girl with the Hat-Box*
USSR. Director: Boris Barnet. Mezhrabpom-Rus, 1927 – Colour lithograph, 121 x 93 cm. Moscow, 1927

Stenberg, Vladimir Avgustovich
Stenberg, Georgi Avgustovich
Ruklevsky, Yakov Timofeevich
72 *October*
USSR. Directors: S. M. Eisenstein, G. A. Alexandrov. Sovkino, 1927 – Colour lithograph, 264 x 204 cm. Moscow, 1927
86 *By the Law (Dura Lex)*
Based on the story "The Unexpected" by Jack London. USSR. Director: Lev Kuleshov. Sovkino, 1926 – Colour lithograph, 108 x 72 cm. Moscow, 1926
126 *Your Acquaintance (The Journalist)*
USSR. Director: Lev Kuleshov. VUFKU, 1927 – Colour lithograph, 101 x 140 cm. Moscow, 1927

Taldykin, Alexander Alexeevich
24 *A Stab in the Back*
Russia. Director: A. I. Ivanov-Gai. A. Taldykin Studio, 1917 – Colour lithograph, 110 x 71.5 cm. Moscow, 1917

Tyrsa, Nikolai Andreevich
172 *The Devil's Wheel*
USSR. Directors: G. M. Kozintsev, L. S. Trauberg. Sevzapkino, 1926 – Colour lithograph, 107 x 72 cm. Leningrad, 1926

Veksler, Mikhail Solomonovich
174 *Children of the Storm*
USSR. Directors: E. Y. Ioganson, F. M. Ermler. Leningradkino, 1926 – Colour lithograph, 70 x 106 cm. Moscow, 1926

Vialov, Konstantin Alexandrovich
117 *A Sixth of the World*
USSR. Director: Dziga Vertov. Sovkino, 1926 – Colour lithograph, 108 x 72 cm. Moscow, 1927
118 *Machinist Ukhtomsky*
USSR. Director: A. A. Dmitriev. Krasnaya Zvezda (PUR), 1926 – Colour lithograph, 107 x 72 cm. Moscow, 1926
163 *Khanuma*
USSR. Director: A. R. Tsutsunava. Goskinprom Gruzii, 1926 – Colour lithograph, 72 x 108 cm. Moscow, 1927

Voronov, Leonid Alexandrovich
Evstafiev, Mikhail Ilyich
66 *October*
USSR. Directors: S. M. Eisenstein, G. A. Alexandrov. Sovkino, 1927 – Colour lithograph, 107 x 137 cm. Moscow, 1927
70 *October*
USSR. Directors: S. M. Eisenstein, G. A. Alexandrov. Sovkino, 1927 – Colour lithograph, 108 x 72.5 cm. Moscow, 1927
90 *Golden Honey*
USSR. Directors: V. M. Petrov, N. Y. Beresnev. Sovkino, 1928 – Colour lithograph, 107 x 71 cm. Moscow, 1928

Yegorov, Vladimir Yevgenievich
54 *The Green Spider*
Russia. Director: A. A. Volkov. Studio I. N. Yermoliev, 1916 – Colour lithograph, 106 x 72 cm. Moscow, 1916

Zhitkov, P.
28 *A Woman's Truth*
Russia. Director: B. V. Chaikovsky. A. Khanzhonkov and Co. Inc., 1917 – Colour lithograph, 107 x 72 cm. Moscow, 1917
30 *Life Goes By, Art Is Forever*
Russia. Director: C. Sabinsky. Studio I. N. Yermoliev, 1916 – Colour lithograph, 107.5 x 71.5 cm. Moscow, 1916
31 *The Scoundrel*
Russia. Director: B. V. Chaikovsky. A. Khanzhonkov and Co. Inc., 1917– Colour lithograph, 107.5 x 71.5 cm. Moscow, 1917
36 *Ivanov, Pavel*
Russia. Director: A. A. Arkatov. Zhivo-Kinetofon, 1916 – Colour lithograph, 107 x 70 cm. Moscow, 1916
37 *The King of Paris*
Based on the novel "Le Roi de Paris" by Georges Ohnet. Russia. Director: Yevgeni Bauer. A. Khanzhonkov and Co. Inc., 1917 – Colour lithograph, 158 x 70 cm. Moscow, 1917
38 *The Moon Beauty*
Russia. Director: Yevgeni Bauer. A. Khanzhonkov and Co. Inc., 1916 – Colour lithograph, 71.5 x 105 cm. Moscow, 1916
55 *Lea Lifshitz*
Russia. Director: W. A. Starewich. A. O. Drankov Studio, 1917 – Colour lithograph, 109 x 75 cm. Moscow, 1917

Zhukov, Pyotr Ilyich
See: Borisov, Grigori Ilyich; Zhukov, Pyotr Ilyich

Anonymous
16 *Manoeuvres*
Russia. A. O. Drankov Studio – Colour lithograph, 102.5 x 69 cm. St. Petersburg, 1910s
17 *It Was in Spring*
Russia. Director: N. Turkin. A. Khanzhonkov and Co. Inc., 1916 – Colour lithograph, 107 x 73 cm. Moscow, 1916
18 *Guilty though Guiltless*
Based on the comedy of the same title by A. N. Ostrovsky. Russia. Director: C. Sabinsky. Studio I. N. Yermoliev, 1916 – Colour lithograph, 106 x 69 cm. Moscow, 1916
22 *The Storm*
Based on the play of the same title by A. N. Ostrovsky. Director: Kai Hansen. Pathé Frères Moscow, 1915 – Colour lithograph, 55 x 80.5 cm. Moscow, 1910s
26 *The Golden Idols*
No data – Colour lithograph, 107 x 71 cm. Moscow, 1910s
27 *The Shame of the Romanov House*
Russia. Director unknown. Obnovlenie Society, 1917 – Colour lithograph, 107 x 72 cm
29 *The Golden Twist*
Russia. Director: P. I. Chardynin. Studio D. I. Kharitonov, 1917 – Colour lithograph, 106.5 x 71.5 cm. Moscow, 1917

35 *In the Café-Concert Lights*
Russia. B. V. Chaikovsky. A. Khanzhonkov and Co. Inc., 1916 – Colour lithograph, 92 x 64 cm. Moscow, 1916
39 *Doctor Krainsky*
Russia. Director: M. P. Bonch-Tomashevsky. Era Studio, 1917 – Colour lithograph, 106.5 x 71 cm. Moscow, 1917
40 *The Queen of Spades*
Based on the short story of the same title by A. S. Pushkin. Russia. Director: Y. A. Protasanov. Studio I. N. Yermoliev, 1916 – Colour lithograph, 122 x 82.5 cm. Moscow, 1916
42 *Revenge of the Devil*
France. Société Française des Films Éclair – Colour lithograph, 102 x 68 cm. Moscow, 1910s. Designed in the studio of V. Voinov and V. Ulyanishchev.
48 *The Purchased Bride*
Film adaptation. Russia. Director: N. N. Arbatov. G. I. Libken Cinematographic Studio, 1915 – Colour lithograph, 106 x 71 cm. Moscow, 1915
49 *The Tale of the World*
Russia. Director: S. Y. Veselovsky. G. I. Libken Cinematographic Studio, 1916 – Colour lithograph, 106.5 x 71.5 cm. Moscow, 1916
51 *Sin*
Russia. Director: Y. A. Protasanov. Studio I. N. Yermoliev, 1916 – Colour lithograph, 106 x 70 cm. Moscow, 1916
58 *A Woman's Autumn*
Based on the novel "L'automne d'une femme" by Marcel Prévost. Russia. Director: A. A. Gromov. A. Khanzhonkov and Co. Inc., 1917 – Colour lithograph,106 x 72 cm. Moscow, 1917
62 *Battleship Potemkin*
USSR. Director: S. M. Eisenstein. Goskino, 1925 – Colour lithograph, 108 x 72.5 cm. Moscow, 1926
63 *Mother*
Based on a novel of the same title by Maxim Gorky. USSR. Director: V. I. Pudovkin. Mezhrabpom-Rus, 1926 – Colour lithograph, 108 x 72 cm. Moscow, 1926
64 *October*
USSR. Directors: S. M. Eisenstein, G. A. Alexandrov. Sovkino, 1927 – Colour lithograph, 75.5 x 109 cm. Moscow, 1927
65 *October*
USSR. Directors: S. M. Eisenstein, G. A. Alexandrov. Sovkino, 1927 – Colour lithograph, 72 x 157 cm. Moscow, 1927
100 *The Heir of Genghis Khan (Storm over Asia)*
USSR. Director: V. I. Pudovkin. Mezhrabpomfilm, 1929 – Colour lithograph, 131 x 91 cm. Moscow, 1929
114 *The Career of Rosine*
France (Original title: *Le mariage de Rosine*). Director: Pierre Colombier. Films de France, 1926 – Colour lithograph, 108 x 72 cm. Moscow, 1927
115 *Radio and the Lion*
USA (Original title: *No control*). Directors: Scott Sidney, E. J. Babille. Metropolitan Pictures Corporation of California, 1927 – Colour lithograph, 108 x 71 cm. Moscow, 1929
156 *Toguyi Island*
USSR. Director: I. Malakhov. Gosvoyenkino, 1929 – Colour lithograph, 62 x 107 cm. Moscow, 1929
160 *In the Gardens of Avarra*
France (Original title: *Aux Jardins de Murcie*). Directors: Louis Mercanton, René Hervil. Société des Films Mercanton, 1923 – Colour lithograph, 108 x 73 cm. Moscow, 1926
161 *Two Armoured Cars*
USSR. Director: S. A. Timoshenko, Sovkino, 1928 – Colour lithograph, 94 x 62 cm. Moscow, 1928
166 *Enthusiasm: Symphony of the Donbas*
USSR. Director: Dziga Vertov. Ukrainfilm, 1930 – Colour lithograph, 63 x 88 cm. Kiev, 1931
173 *Stepan Khalturin*
USSR. Director: A. V. Ivanovsky. Sevzapkino, 1925 – Colour lithograph, 108 x 72.5 cm. Leningrad, 1925

Lista de carteles

Alexéyev, Gueorgui Dmítriyevich
25 *El sueño muerto*
Francia (título original: *Le rêve passe*). Director: Louis Feuillade. Société des Etablissements L. Gaumont, 1911 – Litografía en color, 106,5 x 72 cm. Moscú, década de 1910
41 *Ultus y el secreto de la noche*
Reino Unido (título original: *Ultus and the Secret of the Night*). Director: George Pearson. Gaumont British Picture Corporation, 1917 – Litografía en color, 107 x 71,5 cm. Moscú, década de 1910
52 *Los coronó Satanás*
Rusia. Director: V. K. Viskovski. Estudio Era, 1917 – Litografía en color, 112 x 76 cm. Moscú, 1917
53 *Mujeres, ¡movilizaos!*
Francia. Gaumont – Litografía en color, 108,5 x 72,5 cm. Moscú, década de 1910

Apsit (Apsitis), Alexandr Petróvich
21 *La canción de amor interminable*
Rusia. Directores: V. A. Polonski, Lev Kuléshov. Sociedad anónima Koslovski, Yúryev y Cía., 1918 – Litografía en color, 105,5 x 70 cm. Moscú, 1918 – 1919

Asatúrov (Asaturi), Paul K.
14 *Stenka Rasin*
Rusia. Director: Vladímir Romáshkov. Estudio de A. O. Dránkov, 1908 – Litografía en color, 102,5 x 68,5 cm. San Petersburgo, 1908

Belski, Anatoli Pávlovich
83 *La pipa del partidario de la Comuna*
Adaptación del relato homónimo de I. G. Ehrenburg. URSS. Director: K. A. Marchanishvili (Marchánov). Goskinprom Grusiyi, 1929 – Litografía en color con fotografía en offset, 108 x 74 cm. Moscú, 1929
98 *Saba*
URSS. Director: M. E. Chiaureli. Goskinprom Grusiyi, 1929 – Litografía en color, 108 x 73 cm. Moscú, 1929
102 *Lobos*
URSS. Director: Leo Mur (L. I. Murashko). Goskino, 1925 – Litografía en color, 72 x 108 cm. Moscú, 1925

Bograd, Israil Davídovich
68 *La madre*
Adaptación de la novela homónima de Maxim Gorki. URSS. Director: V. I. Pudóvkin. Meshrabpom-Rus, 1926 – Litografía en color, 140 x 317 cm. Moscú, 1926
103 *El registrador colegiado*
Adaptación del relato homónimo de A. S. Pushkin. URSS. Director: Y. A. Shelyabushski. Meshrabpom-Rus, 1925 – Litografía en color, 72 x 108 cm. Moscú, 1925
119 *El águila blanca*
Adaptación del relato *El gobernador*, de Leonid Andréyev. URSS. Director: Y. A. Protasánov. Meshrabpomfilm, 1928 – Litografía en color, 125 x 91 cm. Moscú, 1928
121 *El fin de San Petersburgo*
URSS. Director: V. I. Pudóvkin. Meshrabpom-Rus, 1927 – Litografía en color, 125 x 95 cm. Moscú, 1927
127 *Aelita*
URSS. Director: Y. A. Protasánov. Meshrabpom-Rus, 1924 – Litografía en color, 72 x 108 cm. Moscú, 1929

Borísov, Grigori Ilíich
Prusákov, Nikolai Petróvich
80 *La casa de la plaza Trubnaya*
URSS. Director: Boris Barnet. Meshrabpomfilm, 1928 – Litografía en color, 95 x 135 cm. Moscú, 1928
81 *Jas-Push*
URSS. Director: A. I. Bek-Nasárov. Armenkino, 1928 – Litografía en color con fotografía en offset, 72 x 108 cm. Moscú, 1928
140 *Princesa Mary*
Adaptación del relato homónimo de M. Y. Lérmontov. URSS. Director: V. G. Barski. Goskinprom Grusiyi, 1927 – Litografía en color, 125 x 90 cm. Moscú, 1927

Borísov, Grigori Ilíich
Zhúkov, Piotr Ilíich
94 *Prohibido entrar en la ciudad*
URSS. Director: Y. A. Shelyabushski. Meshrabpomfilm, 1929 – Litografía en color con fotografía en offset, 122 x 94 cm. Moscú, 1929
167 *El cadáver vivo*
Adaptación de la obra de teatro homónima de L. N. Tolstoi. URSS. Director: F. A. Ozep. Meshrabpomfilm y Prometheus-Film-Verleih und Vertriebs-GmbH (Alemania), 1929 – Litografía en color, 108,5 x 73 cm. Moscú, 1929

Dlúgach, Mijaíl Oskárovich
99 *El chisme*
URSS. Director: I. N. Perestiani. VUFKU, 1928 – Litografía en color, 108 x 72 cm. Moscú, 1928
109 *La princesa de las ostras*
Alemania (título original: *Die Austernprinzessin*). Director: Ernst Lubitsch. Protections AG Union, 1919 – Litografía en color, 101 x 72 cm. Moscú, 1926

116 *El juez Reitan*
URSS. Director: F. L. Lopatinski. VUFKU, 1929 – Litografía en color, 94 x 62 cm. Moscú, 1929

Dortman, T.
50 *Un secuaz de Satán*
Rusia. Director: B. A. Orlitski. Empresas Alliance y Adler, de K. Philipp, 1916 – Litografía en color, 103,5 x 66 cm. Moscú, 1916

Evstáfiev, Mijaíl Ilíich
Véase: Vorónov, Leonid Alexándrovich, Evstáfiev, Mijaíl Ilíich

Guerasímovich, Yosif Vasílyevich
96 *120.000 al año*
URSS. Director: G. I. Chernyak. Meshrabpomfilm, 1929 – Litografía en color, 103 x 71 cm. Moscú, 1929
129 *El último cochero de Berlín*
Alemania (título original: *Die letzte Droschke von Berlin*). Director: Carl Boese. Rex-Film GmbH, 1926 – Litografía en color, 72 x 108 cm. Moscú, 1928
165 *El príncipe apasionado*
URSS. Director: V. G. Shmidthof. Sovkino, 1928 – Litografía en color, 109 x 72 cm. Moscú, 1928

Jómov, Nikolai Mijáilovich
177 *Se busca protección*
URSS. Director: B. Y. Kasájkov. Rosfilm, 1932 – Litografía en color, 92 x 60 cm. Moscú, 1933

Kabak, Vladímir Mijáilovich
162 *Miss Mend*
Adaptación de la novela policiaca homónima de M. Shaguinyan. URSS. Directores: F. A. Ozep, Boris Barnet. Meshrabpom-Rus, 1926 – Litografía en color, 74,5 x 109 cm. Moscú, 1926

Kálmanson, Mijaíl Serguéyevich
19 *La hija de Ana Karenina*
Rusia. Director: A. A. Arkátov. Compañía Prodalent, 1916 – Litografía en color, 106 x 71 cm. Moscú, 1916
20 *La suerte está echada*
Rusia. Sociedad anónima Koslovski, Yúryev y Cía. – Litografía en color, 104 x 76,5 cm. Moscú, década de 1910
32 *Esclavos con cadenas de oro*
Sin datos – Litografía en color, 102 x 71,5 cm. Moscú, década de 1910
33 *La reina de la arena del circo*
Sociedad anónima Trans-Atlantik – Litografía en color, 107 x 72 cm. Moscú, década de 1910
34 *Almas atormentadas*
Rusia. Director: V. P. Kasyánov. Estudio D. I. Jaritónov, 1917 – Litografía en color, 107 x 69 cm. Moscú, 1917
43 *El misterioso asesinato en Petrogrado*
Rusia. Director: N. L. Minervin. Cooperativa Minerva, 1917 – Litografía en color, 107 x 71 cm. Moscú, 1917
44 *Cuando yo era cochero postal...*
Adaptación de una canción popular. Rusia. Director: N. P. Larin. Comité Skobelevski, 1916 – Litografía en color, 104 x 71 cm. Moscú, 1916
45 *El diablo tuerto*
Rusia. Director: N. P. Larin. Comité Skobelevski, 1916 – Litografía en color, 106 x 71 cm. Moscú, 1916
46 *Cuando mienten*
Rusia. Director: V. K. Viskovski. Estudio D. I. Jaritónov, 1917 – Litografía en color, 71 x 104 cm. Moscú, 1917
56 *La gavilla segada en la cosecha de amor*
Rusia. Director: M. P. Bonch-Tomashevski. Estudio Era, 1917 – Litografía en color, 106,5 x 71 cm. Moscú, 1917
57 *El abismo*
Basada en la obra *De profundis*, de Stanislaw Przybyszewski. Rusia. Título original polaco: Topiel. Director: W. Lenczewski. Sociedad Polonia Moskwa, 1917 – Litografía en color, 106 x 71 cm. Moscú, 1917

Klimashin, Víktor Semyónovich
176 *¿Te quiero?*
URSS. Director: S. A. Guerasímov. Soyuzfilm, 1934 – Litografía en color, 83,5 x 58 cm. Moscú, 1934

Kliun (Kliúnkov), Iván Vasílyevich
158 *La perla de Semíramis*
URSS. Director: G. M. Stabovoy. VUFKU, 1929 – Litografía en color, 107 x 71,5 cm. Moscú, 1929

Lavinski, Anton Mijáilovich
61 *El acorazado Potemkin*
URSS. Director: S. M. Eisenstein. Goskino, 1925 – Litografía en color con fotografía en offset, 72 x 104 cm. Moscú, 1926
74 *La bahía de la muerte*
Adaptación del relato *En la bahía de Otrada*, de A. S. Novíkov-Priboy. URSS. Director: Abram Room. Goskino, 1926 – Litografía en color con fotografía en offset, 108 x 72 cm. Moscú, 1926
87 *Por la ley*
Adaptación del relato *Lo inesperado*, de Jack London. URSS. Director: Lev Kuléshov. Sovkino, 1926 – Litografía en color, 101 x 72 cm. Moscú, 1926

Lítvak, Maxim Mijáilovich
79 *Hasta mañana*
URSS. Director: J. V. Tarij. Belgoskino, 1929 – Litografía en color,
102,5 x 72 cm. Moscú, 1929

Malévich, Kasimir Severínovich
175 *El doctor Mabuse*
Alemania (título original: *Doktor Mabuse, der Spieler*). Director:
Fritz Lang. Uco-Film GmbH, 1922–1927 – Óleo sobre lienzo, 106
x 70,6 cm

Mosiaguin, Piotr
15 *Stenka Rasin*
Rusia. Director: G. I. Libken. Estudio cinematográfico de G. I. Libken,
1914 – Litografía en color, 162,5 x 214 cm. Yaroslavl, 1914

Naumov, Alexandr Ilíich
104 *El traidor*
Adaptación del relato *Matrosskaya Tishina*, de Lev Nikulin. URSS.
Director: Abram Room. Goskino, 1926 – Litografía en color,
101 x 72 cm. Moscú, 1926
141 *Bella Donna*
EE. UU. (título original: *Bella Donna*). Director: George Fitzmaurice.
Famous Players-Lasky Corporation, 1923 – Litografía en color,
123 x 87 cm. Moscú, 1927
157 *Alim*
URSS. Director: G. N. Tasin. VUFKU, 1926 – Litografía en color,
101 x 72 cm. Moscú, 1926

Piménov, Yuri (Gueorgui) Ivánovich
179 *Bola de sebo*
Adaptación del relato *Boule de suif (Bola de sebo)*, de Guy de Maupas-
sant. URSS. Director: M. I. Romm. Moskinokombinat, 1934 – Litografía
en color, 122 x 83 cm. Moscú, 1935

Prusákov, Nikolai Petróvich
76 *Los funcionarios y la gente*
Adaptación de tres cuentos de Anton Chéjov. URSS. Director: Y. A. Pro-
tasánov. Meshrabpomfilm, 1929 – Litografía en color con fotografía en
offset, 94 x 62 cm. Moscú, 1929
84 *La línea general (Lo viejo y lo nuevo)*
URSS. Directores: S. M. Eisenstein, G. A. Alexándrov. Sovkino, 1929 –
Litografía en color, 72 x 108 cm. Moscú, 1929
97 *El callejón verde*
Alemania (título original: *Die Rothausgasse*). Director: Richard
Oswald. Richard Oswald-Produktion GmbH, 1928 – Litografía en
color, 82 x 107 cm. Moscú, 1929
101 *Cinco minutos*
URSS. Directores: A. S. Balygin, G. M. Selóndshev-Schípov. Goskinprom
Grusiyi, 1929 – Litografía en color, 140 x 108 cm. Moscú, 1929
138 *Encima del Jolt*
URSS. Director: L. D. Esakia. Goskinprom Grusiyi, 1929 – Litografía en
color, 108 x 73 cm. Moscú, 1929
143 *Mala suerte*
Alemania (título original: *Die vertauschte Braut*). Director: Carl Wilhelm.
Phoebus-Film-AG, 1925 – Litografía en color, 100 x 71 cm. Moscú, 1927
144 *El ojo de cristal*
URSS. Directores: L. J. Brik, V. L. Shemjushni. Meshrabpomfilm,
1929 – Litografía en color, 123 x 94 cm. Moscú, 1929
149 *Extraña mujer*
URSS. Director: I. A. Piryev. Sovkino, 1929 – Litografía en color con
fotografía en offset, 140 x 108 cm. Moscú, 1929
153 *La pipa del partidario de la Comuna*
Adaptación del relato homónimo de I. G. Ehrenburg. URSS. Director:
K. A. Marchanishvili. Goskinprom Grusiyi, 1929 – Litografía en color,
108 x 73 cm. Moscú, 1929

Prusákov, Nikolai Petróvich
Véase también: Borísov, Grigori Illich,
Prusákov, Nikolai Petróvich

Rabíchev, Isaak Benyévich
108 *La muñeca de los millones*
URSS. Director: S. P. Komárov. Meshrabpomfilm, 1928 – Litografía en
color, 100 x 52,5 cm. Moscú, 1928

Ríchkov, Grigori Nikoláyevich
125 *El poeta y el zar*
URSS. Director: V. R. Gardin. Sovkino, 1927 – Litografía en color,
70 x 107 cm. Moscú, 1927

Ródchenko, Alexandr Mijáilovich
59 *Cine-ojo – La vida al improvisto*
URSS. Director: Dsiga Vértov. Goskino, 1924 – Litografía en color,
96 x 71 cm. Moscú, 1924
75 *La sexta parte del mundo*
URSS. Director: Dsiga Vértov. Sovkino, 1926 – Litografía en color
con fotografía en offset, 108 x 70 cm. Moscú, 1927

Ruklevski, Yákov Timoféyevich
71 *Octubre*
URSS. Directores: S. M. Eisenstein, G. A. Alexándrov. Sovkino, 1927 –
Litografía en color, 206 x 100 cm. Moscú, 1927

78 *Café Fanconi*
URSS. Director: M. Y. Kapchinski. Sovkino, 1927 – Litografía en color
con fotografía en offset, 107 x 72 cm. Moscú, 1927
130 *Fuerza y belleza*
Dinamarca (título original: *Kraft og Skønhed*). Director: Lau Lauritzen.
Palladium, 1927 – Litografía en color, 70 x 94 cm. Moscú, 1929

Ruklevski, Yákov Timoféyevich
Véase también: Stenberg, Vladímir Avgústovich,
Stenberg, Gueorgui Avgústovich,
Ruklevski, Yákov Timoféyevich

Semyónov-Menes, Semyón Abramóvich
106 *¿Tú quién eres?*
URSS. Director: Y. A. Shelyabushski. Meshrabpom-Rus, 1927 – Litogra-
fía en color, 112,5 x 82,5 cm. Moscú, 1927
107 *Oh, manzanita...*
URSS. Directores: L. L. Obolenski, M. I. Dóler. Meshrabpom-Rus,
1926 – Litografía en color, 107 x 72 cm. Moscú, 1927
133 *El beso de Mary Pickford*
URSS. Director: S. P. Komárov. Meshrabpom-Rus, 1927 – Litografía en
color, 73 x 108 cm. Moscú, 1927
146 *La muñeca de los millones*
URSS. Director: S. P. Komárov. Meshrabpomfilm, 1928 – Litografía en
color, 126 x 92 cm. Moscú, 1928
155 *Turksib*
URSS. Director: Víktor Turin. Vostok-Kino, 1929 – Litografía en color,
105 x 69 cm. Moscú, 1929
168 *La chica de la sombrerera*
URSS. Director: Borís Barnet. Meshrabpom-Rus, 1927 – Litografía en
color, 111 x 83 cm. Moscú, 1927
170 *Miss Mend*
Adaptación de la novela policiaca homónima de M. Shaguinyan. URSS.
Directores: F. A. Otsep y Borís Barnet. Meshrabpom-Rus, 1926 – Lito-
grafía en color, 108 x 141 cm. Moscú, 1927

Smóliak, Nikolai Petróvich
178 *El príncipe heredero de la República*
URSS. Director: E. Y. loganson. Lenfilm, 1934 – Litografía en color,
94 x 62 cm. Moscú, 1934

Stenberg, Vladímir Avgústovich
Stenberg, Gueorgui Avgústovich
60 *El acorazado Potemkin*
URSS. Director: S. M. Eisenstein. Goskino, 1925 – Litografía en color,
70 x 94 cm. Moscú, 1925
73 *Octubre*
URSS. Directores: S. M. Eisenstein, G. A. Alexándrov. Sovkino, 1927 –
Litografía en color, 142 x 100 cm. Moscú, 1927
77 *El undécimo año*
URSS. Director: Dsiga Vértov. VUFKU, 1928 – Litografía en color,
107 x 71 cm. Moscú, 1928
82 *El hombre con la cámara*
URSS. Director: Dsiga Vértov. VUFKU, 1929 – Litografía en color,
106 x 72 cm. Moscú, 1929
88 *SEP*
URSS. Directores: M. E. Verner, P. N. Armand. Gosvoyenkino, 1929 –
Litografía en color, 107 x 73 cm. Moscú, 1929
89 *El demonio combatiente*
EE. UU. (título original: *The Fighting Demon*). Director: Arthur Rosson.
Richard Talmadge Productions, Carlos Productions, Truart Film Co.,
1925 – Litografía en color, 102 x 70 cm. Moscú, 1927
91 *La segunda vida*
Alemania (título original: *Dr. Bessels Verwandlung*). Director: Richard
Oswald. Richard Oswald-Produktion GmbH, 1927 – Litografía en color,
158 x 72 cm. Moscú, 1928
92 *Berlín: sinfonía de una gran ciudad*
Alemania (título original: *Berlin: Die Sinfonie der Großstadt*). Director:
Walther Ruttmann. Deutsche Vereins-Film AG/Fox Europa, 1927 –
Litografía en color, 106 x 71 cm. Moscú, 1928
93 *Una historia convencional*
Francia (título original: *La clé de voûte*). Director: Roger Lion. Mappe-
monde, 1925 – Litografía en color, 101 x 70 cm. Moscú, 1927
95 *En primavera*
URSS. Director: M. A. Kaufman. VUFKU, 1929 – Litografía en color,
105 x 74 cm. Moscú, 1929
105 *Cama y sofá – El tercio pequeñoburgués*
URSS. Director: Abram Room. Sovkino, 1927 – Litografía en color,
101 x 70 cm. Moscú, 1927
110 *Un auténtico caballero*
EE. UU. (título original: *A Perfect Gentleman*). Director: Clyde Bruckman.
Monty Banks Enterprises, 1928 – Litografía en color, 108 x 72 cm.
Moscú, 1928
111 *El apetito vendido*
URSS. Director: N. P. Ojlópkov. VUFKU, 1928 – Litografía en color,
107 x 71 cm. Moscú, 1928
112 *Moulin Rouge*
Reino Unido (título original: *Moulin Rouge*). Director: Ewald André
Dupont. British International Pictures, 1928 – Litografía en color,
95 x 63 cm. Moscú, 1929
113 *Tamilla*
URSS / Turquía. Director: E. Mujsin-Bey, 1927 – Litografía en color,
107 x 72 cm. Moscú, 1928

120 *Café Fanconi*
URSS. Director: M. Y. Kapchinski. Sovkino, 1927 – Litografía en color,
107 x 72 cm. Moscú, 1927
122 *El callejón verde*
Alemania (título original: *Die Rothausgasse*). Director: Richard
Oswald. Richard Oswald-Produktion GmbH, 1928 – Litografía en
color, 93 x 70 cm. Moscú, 1929
123 *Zare*
URSS. Director: A. I. Bek-Nasárov. Armenkino, 1927 – Litografía en
color, 142 x 100 cm. Moscú, 1927
124 *Camilla*
EE. UU. (título original: *Camille of the Barbary Coast*). Director:
Hugh Dierker. Associated Exhibitors, 1925 – Litografía en color,
72 x 101 cm. Moscú, 1928
128 *El proceso de los tres millones*
URSS. Director: Y. A. Protasánov. Meshrabpom-Rus, 1926 – Litografía
en color, 102 x 79 cm. Moscú, 1926
131 *Viajeros distinguidos*
Dinamarca (título original: *Raske Riviera-Rejsende*). Director: Lau
Lauritzen. Palladium, 1924 – Litografía en color, 107 x 72 cm.
Moscú, 1928
132 *Poseídos* (título de la película en español: *El moderno
Sherlock Holmes*)
EE. UU. (título original: *Sherlock Jr.*). Director: Buster Keaton. Bus-
ter Keaton Productions, 1924 – Litografía en color, 109 x 72 cm.
Moscú, 1927
134 *Turksib*
URSS. Director: Víktor Turin. Vostok-Kino, 1929 – Litografía en color,
107 x 71 cm. Moscú, 1929
135 *Cemento*
Adaptación de la novela homónima de Fiódor Gládkov. URSS. Director:
V. Vilner. VUFKU, 1927 – Litografía en color, 107 x 71 cm. Moscú, 1928
136 *El undécimo año*
URSS. Director: Dsiga Vértov. VUFKU, 1928 – Litografía en color,
106 x 71 cm. Moscú, 1928
137 *El hombre con la cámara*
URSS. Director: Dsiga Vértov. VUFKU, 1929 – Litografía en color,
101 x 71cm. Moscú, 1929
139 *Niniche*
Alemania (título original: *Niniche*). Director: Victor Janson. Westi-Film,
1925 – Litografía en color, 100 x 72 cm. Moscú, 1927
142 *El ídolo del público*
EE. UU. (título original: *A Small Town Idol*). Director: Erle C. Kenton.
Mack Sennett Comedies, 1921 – Litografía en color, 108 x 72 cm.
Moscú, 1925
145 *La General* (título de la película en español: *El maquinista
de la General*)
EE. UU. (título original: *The General*). Directores: Buster Keaton,
Clyde Bruckman. Buster Keaton Productions, 1926 – Litografía en
color, 109 x 72 cm. Moscú, 1929
147 *La antigua 99* (título de la película en español: *La voladura
de fuego*)
EE. UU. (título original: *The Night Flyer*). Director: Walter Lang. Ja-
mes Cruze Productions, 1928 – Litografía en color, 109 x 73 cm.
Moscú, 1929
148 *El tornillo de otra máquina*
URSS. Director: A. A. Talánov. Proletkino, 1926 – Litografía en color,
108 x 73 cm. Moscú, 1926
150 *Seis chicas buscan refugio*
Alemania (título original: *Sechs Mädchen suchen Nachtquartier*).
Director: Hans Behrendt. Fellner & Somio-Film GmbH, 1928 – Lito-
grafía en color con fotografía en offset, 109 x 122 cm. Moscú, 1928
151 *Una taza de té*
URSS. Director: N. G. Shpikovski. Sovkino, 1927 – Litografía en color
con fotografía en offset, 72 x 108 cm. Moscú, 1927
152 *Una apuesta mundana*
Alemania (título original: *Der Wetterwart*). Director: Carl Froelich.
Carl Froelich-Film GmbH, 1923 – Litografía en color, 108 x 73 cm.
Moscú, 1927
154 *El lápiz*
URSS. Director: Borís Tseitlin. VUFKU, 1928 – Litografía en color,
107 x 70 cm. Moscú, 1928
159 *El policía*
Suecia (título original: *Polis Paulus' påskasmäll*). Director: Gustaf
Molander. Svensk Filmindustri (SF), 1925 – Litografía en color,
109 x 72 cm. Moscú, 1928
164 *La General*
EE. UU. (título original: *The General*). Directores: Buster Keaton, Clyde
Bruckman. Buster Keaton Productions, 1926 – Litografía en color,
109 x 72 cm. Moscú, 1929
169 *Un pedazo del imperio*
URSS. Director: F. M. Ermler. Sovkino, 1929 – Litografía en color,
95 x 62 cm. Moscú, 1929
171 *La chica de la sombrerera*
URSS. Director: Borís Barnet. Meshrabpom-Rus, 1927 – Litografía en
color, 121 x 93 cm. Moscú, 1927

Stenberg, Vladímir Avgústovich
Stenberg, Gueorgui Avgústovich
Ruklevski, Yákov Timoféyevich
72 *Octubre*
URSS. Directores: S. M. Eisenstein, G. A. Alexándrov. Sovkino, 1927 –
Litografía en color, 264 x 204 cm. Moscú, 1927

86 *Por la ley*
Adaptación del relato *Lo inesperado*, de Jack London. URSS. Director: Lev Kuléshov. Sovkino, 1926 – Litografía en color, 108 x 72 cm. Moscú, 1926
126 *Su conocida (La periodista)*
URSS. Director: Lev Kuléshov. VUFKU, 1927 – Litografía en color, 101 x 140 cm. Moscú, 1927

Taldykin, Alexandr Alexéyevich
24 *La puñalada por la espalda*
Rusia. Director: A. I. Ivánov-Gai. Estudio de A. Taldykin, 1917 – Litografía en color, 110 x 71,5 cm. Moscú, 1917

Tirsa, Nikolai Andréyevich
172 *La rueda del diablo*
URSS. Directores: G. M. Kosíntsev, L. S. Trauberg. Sevzapkino, 1926 – Litografía en color, 107 x 72 cm. Leningrado, 1926

Veksler, Mijaíl Solomónovich
174 *Los hijos de la tormenta*
URSS. Directores: E. Y. logans, F. M. Ermler. Leningradkino, 1926 – Litografía en color, 70 x 106 cm. Moscú, 1926

Viálov, Konstantín Alexándrovich
117 *La sexta parte del mundo*
URSS. Director: Dsiga Vértov. Sovkino, 1926 – Litografía en color, 108 x 72 cm. Moscú, 1927
118 *El maquinista Ujtomski*
URSS. Director: A. A. Dmitriyev. Krásnaya Svesda (PUR), 1926 – Litografía en color, 107 x 72 cm. Moscú, 1926
163 *Januma*
URSS. Director: A. R. Susunava. Goskinprom Grusiyi, 1926 – Litografía en color, 72 x 108 cm. Moscú, 1927

Vorónov, Leonid Alexándrovich
Evstáfiev, Mijaíl Ilíich
66 *Octubre*
URSS. Directores: S. M. Eisenstein, G. A. Alexándrov. Sovkino, 1927 – Litografía en color, 107 x 137 cm. Moscú, 1927
70 *Octubre*
URSS. Directores: S. M. Eisenstein, G. A. Alexándrov. Sovkino, 1927 – Litografía en color, 108 x 72,5 cm. Moscú, 1927
90 *Luna de miel*
URSS. Directores: V. M. Petrov, N. Y. Berésnev. Sovkino, 1928 – Litografía en color, 107 x 71 cm. Moscú, 1928

Yegórov, Vladímir Yevguényevich
54 *La araña verde*
Rusia. Director: A. A. Vólkov. Estudio I. N. Yermólyev, 1916 – Litografía en color, 106 x 72 cm. Moscú, 1916

Zhítkov, P.
28 *La verdad de una mujer*
Rusia. Director: B. V. Chaikovski. Sociedad anónima A. Janshónkov y Cía., 1917 – Litografía en color, 107 x 72 cm. Moscú, 1917
30 *La vida es un instante, el arte es para siempre*
Rusia. Director: T. G. Sabinski. Estudio I. N. Yermólyev, 1916 – Litografía en color, 107,5 x 71,5 cm. Moscú, 1916
31 *El bribón*
Rusia. Director: B. V. Chaikovski. Sociedad anónima A. Janshónkov y Cía., 1917 – Litografía en color, 107,5 x 71,5 cm. Moscú, 1917
36 *Ivánov, Pável*
Rusia. Director: A. A. Arkátov. Shivo-Kinetofón, 1916 – Litografía en color, 107 x 70 cm. Moscú, 1916
37 *El rey de París*
Adaptación de la novela *Le Roi de Paris*, de Georges Ohnet. Rusia. Director: Yevgueni Bauer. Sociedad anónima A. Jánshonkov y Cía., 1917 – Litografía en color, 158 x 70 cm. Moscú, 1917
38 *Belleza lunar*
Rusia. Director: Yevgueni Bauer. Sociedad anónima A. Jánshonkov y Cía., 1916 – Litografía en color, 71,5 x 105 cm. Moscú, 1916
55 *Lea Lifshitz*
Rusia. Director: V. A. Starevicz. Sociedad anónima A. Dránkov, 1917 – Litografía en color, 109 x 75 cm. Moscú, 1917

Zhúkov, Piotr Ilíich
Véase: Borísov, Grigori Ilíich; Zhúkov, Piotr Ilíich

Anónimo
16 *Maniobras*
Rusia. Estudio de A. O. Dránkov – Litografía en color, 102,5 x 69 cm. San Petersburgo, década de 1910
17 *En primavera*
Rusia. Director: N. Turkin. Sociedad anónima A. Janshónkov y Cía., 1916 – Litografía en color, 107 x 73 cm. Moscú, 1916
18 *Los inocentes culpables*
Adaptación de la comedia homónima de A. N. Ostrovski. Rusia. Director: T. G. Sabinski. Estudio I. N. Yermólyev, 1916 – Litografía en color, 106 x 69 cm. Moscú, 1916
22 *La tempestad*
Adaptación de la obra *La tormenta*, de A. N. Ostrovski. Director: Kai Hansen. Pathé Frères Moscú, 1915 – Litografía en color, 55 x 80,5 cm. Moscú, década de 1910

26 *Ídolos dorados*
Sin datos – Litografía en color, 107 x 71 cm. Moscú, década de 1910
27 *La infamia de la Casa Románov*
Rusia. Director desconocido. Cooperativa Obnovlenie, 1917 – Litografía en color, 107 x 72 cm.
29 *El remolino de oro*
Rusia. Director: P. I. Chardinin. Estudio D. I. Jaritónov, 1917 – Litografía en color, 106,5 x 71,5 cm. Moscú, 1917
35 *En los focos del café concierto*
Rusia. Director: B. V. Chaikovski. Sociedad anónima A. Janshónkov y Cía., 1916 – Litografía en color, 92 x 64 cm. Moscú, 1916
39 *Doctor Krainski*
Rusia. Director: M. P. Bonch-Tomashevski. Estudio Era, 1917 – Litografía en color, 106,5 x 71 cm. Moscú, 1917
40 *La dama de picas*
Adaptación del cuento homónimo de A. S. Pushkin. Rusia. Director: Y. A. Protasánov. Estudio I. N. Yermólyev, 1916 – Litografía en color, 122 x 82,5 cm. Moscú, 1916
42 *La venganza del diablo*
Francia. Société Française des Films Éclair – Litografía en color, 102 x 68 cm. Moscú, década de 1910. Diseñado en el estudio de V. Vóinov y V. Ulyaníshchev.
48 *La novia comprada*
Adaptación literaria. Rusia. Director: N. N. Arbátov. Estudio cinematográfico de G. I. Libken, 1915 – Litografía en color, 106 x 71 cm. Moscú, 1915
49 *El cuento del mundo*
Rusia. Director: S. Y. Veselovski. Estudio cinematográfico de G. I. Libken, 1916 – Litografía en color, 106,5 x 71,5 cm. Moscú, 1916
51 *Pecado*
Rusia. Director: Y. A. Protasánov. Estudio I. N. Yermólyev, 1916 – Litografía en color, 106 x 70 cm. Moscú, 1916
58 *El otoño de una mujer*
Adaptación de la novela *L'automne d'une femme*, de Marcel Prévost. Rusia. Director: A. A. Grómov. Sociedad anónima A. Janshónkov y Cía., 1917 – Litografía en color, 106 x 72 cm. Moscú, 1917
62 *El acorazado Potemkin*
URSS. Director: S. M. Eisenstein. Goskino, 1925 – Litografía en color, 108 x 72,5 cm. Moscú, 1926
63 *La madre*
Adaptación de la novela homónima de Maxim Gorki. URSS. Director: V. I. Pudóvkin. Meshrabpom-Rus, 1926 – Litografía en color, 108 x 72 cm. Moscú, 1926
64 *Octubre*
URSS. Directores: S. M. Eisenstein, G. A. Alexándrov. Sovkino, 1927 – Litografía en color, 75,5 x 109 cm. Moscú, 1927
65 *Octubre*
URSS. Directores: S. M. Eisenstein, G. A. Alexándrov. Sovkino, 1927 – Litografía en color, 72 x 157 cm. Moscú, 1927
100 *El descendiente de Chinguis Jan* (título de la película en español: *Tempestad sobre Asia*)
URSS. Director: V. I. Pudóvkin. Meshrabpomfilm, 1929 – Litografía en color, 131 x 91 cm. Moscú, 1929
114 *La boda de Rosine*
Francia (título original: *Le mariage de Rosine*). Director: Pierre Colombier. Films de France, 1926 – Litografía en color, 108 x 72 cm. Moscú, 1927
115 *La radio y el león*
EE. UU. (título original: *No control*). Directores: Scott Sidney, E. J. Babille. Metropolitan Pictures Corporation of California, 1927 – Litografía en color, 108 x 71 cm. Moscú, 1929
156 *La isla de Toguyi*
URSS. Director: I. Malájov. Gosvoyenkino, 1929 – Litografía en color, 62 x 107 cm. Moscú, 1929
160 *En los jardines de Murcia*
Francia (título original: *Aux Jardins de Murcie*). Directores: Louis Mercanton, René Hervil. Société des Films Mercanton, 1923 – Litografía en color, 108 x 73 cm. Moscú, 1926
161 *Dos blindados*
URSS. Director: S. A. Timoshenko. Sovkino, 1928 – Litografía en color, 94 x 62 cm. Moscú, 1928
166 *Entusiasmo: sinfonía del Donbass*
URSS. Director: Dsiga Vértov. Ukrainfilm, 1930 – Litografía en color, 63 x 88 cm. Kiev, 1931
173 *Stepán Jalturin*
URSS. Director: A. V. Ivánovski. Sevzapkino, 1925 – Litografía en color, 108 x 72,5 cm. Leningrado, 1925

Liste des affiches

Alexeiev, Guéorgui Dmitrievitch
25 *Le rêve évanoui*
France (titre original : *Le rêve passe*). Réalisateur : Louis Feuillade. Société des Etablissements L. Gaumont, 1911 – Lithographie en couleur, 106,5 x 72 cm. Moscou, années 1910
41 *Ultus et les mystères de la nuit*
Grande-Bretagne (titre original : *Ultus and the Secret of the Night*). Réalisateur : George Pearson. Gaumont British Picture Corporation, 1917 – Lithographie en couleur, 107 x 71,5 cm. Moscou, années 1910
52 *Mariés par Satan*
Russie. Réalisateur : V. K. Viskovski. Studio Ère, 1917 – Lithographie en couleur, 112 x 76 cm. Moscou, 1917
53 *Femmes, mobilisez vous !*
France. Gaumont – Lithographie en couleur, 108,5 x 72,5 cm. Moscou, années 1910

Apsit (Apsitis), Alexandre Petrovitch
21 *Le chant d'amour inachevé*
Russie. Réalisateurs : V. A. Polonski, Lev Koulechov. Société par actions Kozlovsky, Youriev et Cie, 1918 – Lithographie en couleur, 105,5 x 70 cm. Moscou, 1918 – 1919

Asatourov (Asaturi), Paul K.
14 *Stenka Razine*
Russie. Réalisateur : Vladimir Romachkov. Studio d'A. O. Drankov, 1908 – Lithographie en couleur, 102,5 x 68,5 cm. Saint-Pétersbourg, 1908

Belski, Anatoli Pavlovitch
83 *La pipe du communard*
D'après la nouvelle éponyme d'I. G. Ehrenbourg. URSS. Réalisateur : K. A. Mardjanichvili (Mardjanov). Goskinprom Gruzii, 1929 – Lithographie en couleur avec photographie offset, 108 x 74 cm. Moscou, 1929
98 *Saba*
URSS. Réalisateur : M. E. Tchiaoureli. Goskinprom Gruzii, 1929 – Lithographie en couleur, 108 x 73 cm. Moscou, 1929
102 *Les loups*
URSS. Réalisateur : Léo Mur (L. I. Murashko). Goskino, 1925 – Lithographie en couleur, 72 x 108 cm. Moscou, 1925

Bograd, Izraïl Davidovitch
68 *La mère*
D'après le roman éponyme de Maxime Gorki. URSS. Réalisateur : V. I. Poudovkine. Meshrabpom-Rus, 1926 – Lithographie en couleur, 140 x 317 cm. Moscou, 1926
103 *Le maître de poste*
D'après le récit éponyme d'A. S. Pouchkine. URSS. Réalisateur : Y. A. Jeliaboujski. Meshrabpom-Rus, 1925 – Lithographie en couleur, 72 x 108 cm. Moscou, 1925
119 *L'aigle blanc*
D'après le récit *Le Gouverneur* de Léonid Andreïev. URSS. Réalisateur : Y. A. Protasanov. Meshrabpomfilm, 1928 – Lithographie en couleur, 125 x 91 cm. Moscou, 1928
121 *La fin de Saint-Pétersbourg*
URSS. Réalisateur : V. I. Poudovkine. Meshrabpom-Rus, 1927 – Lithographie en couleur, 125 x 95 cm. Moscou, 1927
127 *Aelita*
URSS. Réalisateur : Y. A. Protasanov. Meshrabpom-Rus, 1924 – Lithographie en couleur, 72 x 108 cm. Moscou, 1929

Borisov, Grigori Ilitch
Prousakov, Nicolas Petrovitch
80 *La maison de la place Troubnaia*
URSS. Réalisateur : Boris Barnet. Meshrabpomfilm, 1928 – Lithographie en couleur, 95 x 135 cm. Moscou, 1928
81 *Khaz-Push*
URSS. Réalisateur : A. I. Bek-Nazarov. Armenkino, 1928 – Lithographie en couleur avec photographie offset, 72 x 108 cm. Moscou, 1928
140 *La princesse Mary*
D'après le récit éponyme de M. I. Lermontov. URSS. Réalisateur : V. G. Barski. Goskinprom Gruzii, 1927 – Lithographie en couleur, 125 x 90 cm. Moscou, 1927

Borisov, Grigori Ilitch
Joukov, Piotr Ilitch
94 *La ville interdite*
URSS. Réalisateur : Y. A. Jeliaboujski. Meshrabpomfilm, 1929 – Lithographie en couleur avec photographie offset, 122 x 94 cm. Moscou, 1929
167 *Le cadavre vivant*
D'après la pièce de théâtre éponyme de L. N. Tolstoï. URSS. Réalisateur : F. A. Ozep. Meshrabpomfilm et Prometheus-Film-Verleih und Vertriebs-GmbH (Allemagne), 1929 – Lithographie en couleur, 108,5 x 73 cm. Moscou, 1929

Dlougatch, Mikhaïl Oskarovitch
99 *Commérages*
URSS. Réalisateur : I. N. Perestiani. VUFKU, 1928 – Lithographie en couleur, 108 x 72 cm. Moscou, 1928
109 *La princesse aux huîtres*
Allemagne (titre original : *Die Austernprinzessin*). Réalisateur : Ernst

Lubitsch. Protections AG Union, 1919 – Lithographie en couleur, 101 x 72 cm. Moscou, 1926
116 *Le juge Reitan*
URSS. Réalisateur : F. L. Lopatinski. VUFKU, 1929 – Lithographie en couleur, 94 x 62 cm. Moscou, 1929

Dortman, T.
50 *Un suppôt de Satan*
Russie. Réalisateur : B. A. Orlitski. Société Alliance et Adler de K. Philipp, 1916 – Lithographie en couleur, 103,5 x 66 cm. Moscou, 1916

Evstafiev, Mikhaïl Ilitch
Voir : Voronov, Léonid Alexandrovitch
Evstafiev, Mikhaïl Ilitch

Gerasimovich, Iosif Vasilievitch
96 *120 000 par an*
URSS. Réalisateur : G. I. Tcherniak. Meshrabpomfilm, 1929 – Lithographie en couleur, 103 x 71 cm. Moscou, 1929
129 *Le dernier cocher de Berlin*
Allemagne (titre original : *Die letzte Droschke von Berlin*). Réalisateur : Carl Boese. Rex-Film GmbH, 1926 – Lithographie en couleur, 72 x 108 cm. Moscou, 1928
165 *Le prince ardent*
URSS. Réalisateur : V. G. Schmidthof. Sovkino, 1928 – Lithographie en couleur, 109 x 72 cm. Moscou, 1928

Jitkov, P.
28 *La vérité d'une femme*
Russie. Réalisateur : B. V. Tchaïkovski. Société par actions A. Khanzhonkov et Cie, 1917 – Lithographie en couleur, 107 x 72 cm. Moscou, 1917
30 *La vie ne dure qu'un instant, l'art est éternel*
Russie. Réalisateur : T. Sabinski. Studio I. N. Yermoliev, 1916 – Lithographie en couleur, 107,5 x 71,5 cm. Moscou, 1916
31 *Le scélérat*
Russie. Réalisateur : B. V. Tchaïkovski. Société par actions A. Khanzhonkov et Cie, 1917 – Lithographie en couleur, 107,5 x 71,5 cm. Moscou, 1917
36 *Ivanov, Pavel*
Russie. Réalisateur : A. A. Arkatov. Schivo-Kinetofon, 1916 – Lithographie en couleur, 107 x 70 cm. Moscou, 1916
37 *Le roi de Paris*
D'après le roman *Le Roi de Paris* de Georges Ohnet. Russie. Réalisateur : Evgueni Bauer. Société par actions A. Khanzhonkov et Cie, 1917 – Lithographie en couleur, 158 x 70 cm. Moscou, 1917
38 *La beauté lunaire*
Russie. Réalisateur : Evgueni Bauer. Société par actions A. Khanzhonkov et Cie, 1916 – Lithographie en couleur, 71,5 x 105 cm. Moscou, 1916.
55 *Léa Lifshitz*
Russie. Réalisateur : V. A. Starevitch. Studio d'A. O. Drankov, 1917 – Lithographie en couleur, 109 x 75 cm. Moscou, 1917

Joukov, Piotr Ilitch
Voir : Borisov, Grigori Ilitch ; Joukov, Piotr Ilitch

Kabak, Vladimir Mikhaïlovitch
162 *Miss Mend*
D'après le roman policier éponyme de M. Shaginjan. URSS. Réalisateurs : F. A. Ozep, Boris Barnet. Meshrabpom-Rus, 1926 – Lithographie en couleur, 74,5 x 109 cm. Moscou, 1926

Kalmanson, Mikhaïl Sergejevitch
19 *La fille d'Anna Karénine*
Russie. Réalisateur : A. A. Arkatov. Société « Prodalent », 1916 – Lithographie en couleur, 106 x 71 cm. Moscou, 1916
20 *Les dés sont jetés*
Russie. Société par actions Kozlovsky, Youriev et Cie. – Lithographie en couleur, 104 x 76,5 cm. Moscou, années 1910
32 *Les esclaves aux chaînes d'or*
Néant – Lithographie en couleur, 102 x 71,5 cm. Moscou, années 1910
33 *La reine du cirque*
Société par actions Trans-Atlantique – Lithographie en couleur, 107 x 72 cm. Moscou, années 1910
34 *Les âmes tourmentées*
Russie. Réalisateur : V. P. Kasianov. Studio D. I. Kharitonov, 1917 – Lithographie en couleur, 107 x 69 cm. Moscou, 1917
43 *Meurtre mystérieux à Pétrograd*
Russie. Réalisateur : N. L. Minervine. Coopérative Minerva, 1917 – Lithographie en couleur, 107 x 71 cm. Moscou, 1917
44 *Lorsque j'étais cocher de diligence...*
D'après un chant populaire. Russie. Réalisateur : N. P. Larine. Comité Skobelevski, 1916 – Lithographie en couleur, 104 x 71 cm. Moscou, 1916
45 *Le démon borgne*
Russie. Réalisateur : N. P. Larine. Comité Skobelevski, 1916 – Lithographie en couleur, 106 x 71 cm. Moscou, 1916
46 *Comme ils mentent*
Russie. Réalisateur : V. K. Viskovski. Studio D. I. Kharitonov, 1917 – Lithographie en couleur, 71 x 104 cm. Moscou, 1917
56 *La gerbe récoltée dans le champ de l'amour*
Russie. Réalisateur : M. P. Bontch-Tomachevski. Studio Ère, 1917 – Lithographie en couleur, 106,5 x 71 cm. Moscou, 1917

57 *L'abîme*
D'après l'œuvre *De profundis* de Stanislaw Przybyszewski. Russie. Titre original polonais : *Topiel*. Réalisateur : W. Lenczewski. Société Polonia Moskwa, 1917 – Lithographie en couleur, 106 x 71 cm. Moscou, 1917

Khomov, Nicolas Mikhaïlovitch
177 *En quête de protection*
URSS. Réalisateur : B. Y. Kazatchkov. Rosfilm, 1932 – Lithographie en couleur, 92 x 60 cm. Moscou, 1933

Klimachine, Victor Semionovitch
176 *Si je t'aime ?*
URSS. Réalisateur : S. A. Guerassimov. Sojuszfilm, 1934 – Lithographie en couleur, 83,5 x 58 cm. Moscou, 1934

Klioun (Kliounkov), Ivan Vasilievitch
158 *La perle de Sémiramis*
URSS. Réalisateur : G. M. Stabovoï. VUFKU, 1929 – Lithographie en couleur, 107 x 71,5 cm. Moscou, 1929

Lavinski, Anton Mikhaïlovitch
61 *Le cuirassé Potemkine*
URSS. Réalisateur : S. M. Eisenstein. Goskino, 1925 – Lithographie en couleur avec photographie offset, 72 x 104 cm. Moscou, 1926
74 *La baie de la mort*
D'après le récit *Dans la baie d'Otrada* d'A. S. Novikov-Priboi. URSS. Réalisateur : Abram Room. Goskino, 1926 – Lithographie en couleur avec photographie offset, 108 x 72 cm. Moscou, 1926
87 *Selon la loi*
D'après le récit *The Unexpected* de Jack London. URSS. Réalisateur : Lev Koulechov. Sovkino, 1926 – Lithographie en couleur, 101 x 72 cm. Moscou, 1926

Litvak, Maxime Mikhaïlovitch
79 *À demain*
URSS. Réalisateur : Y. V. Taritch. Belgoskino, 1929 – Lithographie en couleur, 102,5 x 72 cm. Moscou, 1929

Malevitch, Kazimir Severinovitch
175 *Docteur Mabuse*
Allemagne (titre original : *Doktor Mabuse, der Spieler*). Réalisateur : Fritz Lang. Uco-Film GmbH, 1922 – 1927 – Huile sur toile, 106 x 70,6 cm

Mosiagine, Piotr
15 *Stenka Razine*
Russie. Réalisateur : G. I. Libken. Studio cinématographique de G. I. Libken, 1914 – Lithographie en couleur, 162,5 x 214 cm. Yaroslavl, 1914

Naoumov, Alexandre Ilitch
104 *Le traître*
D'après le récit *Matrosskaja Tischina* de Lev Nikouline. URSS. Réalisateur : Abram Room. Goskino, 1926 – Lithographie en couleur, 101 x 72 cm. Moscou, 1926
141 *Bella Donna*
États-Unis (titre original : *Bella Donna*). Réalisateur : George Fitzmaurice. Famous Players-Lasky Corporation, 1923 – Lithographie en couleur, 123 x 87 cm. Moscou, 1927
157 *Alim*
URSS. Réalisateur : G. N. Tassine. VUFKU, 1926 – Lithographie en couleur, 101 x 72 cm. Moscou, 1926

Pimenov, Youri (Guéorgui) Ivanovitch
179 *Boule de Suif*
D'après la nouvelle *Boule de suif* de Guy de Maupassant. URSS. Réalisateur : M. I. Romm. Moskinokombinat, 1934 – Lithographie en couleur, 122 x 83 cm. Moscou, 1935

Prousakov, Nicolas Petrovitch
76 *Les tout-puissants et le peuple*
D'après trois récits d'Anton Tchekhov. URSS. Réalisateur : Y. A. Protasanov. Meshrabpomfilm, 1929 – Lithographie en couleur avec photographie offset, 94 x 62 cm. Moscou, 1929
84 *La ligne générale (L'Ancien et le Nouveau)*
URSS. Réalisateurs : S. M. Eisenstein, G. A. Alexandrov. Sovkino, 1929 – Lithographie en couleur, 72 x 108 cm. Moscou, 1929
97 *La ruelle verte*
Allemagne (titre original : *Die Rothausgasse*). Réalisateur : Richard Oswald. Richard Oswald-Produktion GmbH, 1928 – Lithographie en couleur, 82 x 107 cm. Moscou, 1929
101 *Cinq minutes*
URSS. Réalisateurs : A. S. Balygine, G. M. Selondtchev-Tchipov. Goskinprom Gruzii, 1929 – Lithographie en couleur, 140 x 108 cm. Moscou, 1929
138 *À cheval sur le Holt*
URSS. Réalisateur : L. D. Esakia. Goskinprom Gruzii, 1929 – Lithographie en couleur, 108 x 73 cm. Moscou, 1929
143 *Pas de chance*
Allemagne (titre original : *Die vertauschte Braut*). Réalisateur : Carl Wilhelm. Phoebus-Film-AG, 1925 – Lithographie en couleur, 100 x 71 cm. Moscou, 1927
144 *L'œil de verre*
URSS. Réalisateurs : L. Y. Brik, V. L. Jemtchoujny. Meshrabpomfilm, 1929 – Lithographie en couleur, 123 x 94 cm. Moscou, 1929

149 *Une autre femme*
URSS. Réalisateur : I. A. Pyriev. Sovkino, 1929 – Lithographie en couleur avec photographie offset, 140 x 108 cm. Moscou, 1929
153 *La pipe du communard*
D'après la nouvelle éponyme d'I. G. Ehrenbourg. URSS. Réalisateur : K. A. Mardjanichvili (Mardjanov). Goskinprom Gruzii, 1929 – Lithographie en couleur, 108 x 73 cm. Moscou, 1929

Prousakov, Nicolas Petrovitch
Voir aussi : Borisov, Grigori Ilitch
Prousakov, Nicolas Petrovitch

Rabichev, Isaac Benjevitch
108 *La poupée aux millions*
URSS. Réalisateur : S. P. Komarov. Meshrabpomfilm, 1928 – Lithographie en couleur, 100 x 52,5 cm. Moscou, 1928

Rodtchenko, Alexandre Mikhaïlovitch
59 *Ciné-Œil – La vie à l'improviste*
URSS. Réalisateur : Dziga Vertov. Goskino, 1924 – Lithographie en couleur, 96 x 71 cm. Moscou, 1924
75 *La sixième partie du monde*
URSS. Réalisateur : Dziga Vertov. Sovkino, 1926 – Lithographie en couleur avec photographie offset, 108 x 70 cm. Moscou, 1927

Rouklevski, Yakov Timofeïevitch
71 *Octobre*
URSS. Réalisateurs : S. M. Eisenstein, G. A. Alexandrov. Sovkino, 1927 – Lithographie en couleur, 206 x 100 cm. Moscou, 1927
78 *Café Fanconi*
URSS. Réalisateur : M. Y. Kaptchinski. Sovkino, 1927 – Lithographie en couleur avec photographie offset, 107 x 72 cm. Moscou, 1927
130 *La force et la beauté*
Danemark (titre original : *Kraft og Skønhed*). Réalisateur : Lau Lauritzen. Palladium, 1927 – Lithographie en couleur, 70 x 94 cm. Moscou, 1929

Rouklevski, Yakov Timofeïevitch
Voir aussi : Stenberg, Vladimir Avgustovitch
Stenberg, Guéorgui Avgustovitch
Rouklevski, Yakov Timofeïevitch

Rychkov, Grigori Nikolaïevitch
125 *Le poète et le Tsar*
URSS. Réalisateur : V. R. Gardine. Sovkino, 1927 – Lithographie en couleur, 70 x 107 cm. Moscou, 1927

Semionov-Menes, Semion Abramovitch
106 *Qui es-tu ?*
URSS. Réalisateur : Y. A. Jeliaboujski. Meshrabpom-Rus, 1927 – Lithographie en couleur, 112,5 x 82,5 cm. Moscou, 1927
107 *Ah, petite pomme...*
URSS. Réalisateurs : L. L. Obolenski, M. I. Doller. Meshrabpom-Rus, 1926 – Lithographie en couleur, 107 x 72 cm. Moscou, 1927
133 *Le baiser de Mary*
URSS. Réalisateur : S. P. Komarov. Meshrabpom-Rus, 1927 – Lithographie en couleur, 73 x 108 cm. Moscou, 1927
146 *La poupée aux millions*
URSS. Réalisateur : S. P. Komarov. Meshrabpomfilm, 1928 – Lithographie en couleur, 126 x 92 cm. Moscou, 1928
155 *Le Turksib*
URSS. Réalisateur : Victor Tourine. Vostok-Kino, 1929 – Lithographie en couleur, 105 x 69 cm. Moscou, 1929
168 *La jeune fille au carton à chapeau*
URSS. Réalisateur : Boris Barnet. Meshrabpom-Rus, 1927 – Lithographie en couleur, 111 x 83 cm. Moscou, 1927
170 *Miss Mend*
D'après le roman policier éponyme de M. Shaginjan. URSS. Réalisateurs : F. A. Ozep, Boris Barnet. Meshrabpom-Rus, 1926 – Lithographie en couleur, 108 x 141 cm. Moscou, 1927

Smoliak, Nicolas Petrovitch
178 *Prince héritier de la République*
URSS. Réalisateur : E. Y. Ioganson. Lenfilm, 1934 – Lithographie en couleur, 94 x 62 cm. Moscou, 1934

Stenberg, Vladimir Avgustovitch
Stenberg, Guéorgui Avgustovitch
60 *Le cuirassé Potemkine*
URSS. Réalisateur : S. M. Eisenstein. Goskino, 1925 – Lithographie en couleur, 70 x 94 cm. Moscou, 1925
73 *Octobre*
URSS. Réalisateurs : S. M. Eisenstein, G. A. Alexandrov. Sovkino, 1927 – Lithographie en couleur, 142 x 100 cm. Moscou, 1927
77 *La onzième année*
URSS. Réalisateur : Dziga Vertov. VUFKU, 1928 – Lithographie en couleur, 107 x 71 cm. Moscou, 1928
82 *L'homme à la caméra*
URSS. Réalisateur : Dziga Vertov. VUFKU, 1929 – Lithographie en couleur, 106 x 72 cm. Moscou, 1929
88 *SEP*
URSS. Réalisateurs : M. E. Verner, P. N. Armand. Gosvojenkino, 1929 – Lithographie en couleur, 107 x 73 cm. Moscou, 1929

89 *L'hacienda mystérieuse*
États-Unis (titre original : *The Fighting Demon*). Réalisateur : Arthur Rosson. Richard Talmadge Productions, Carlos Productions, Truart Film Co., 1925 – Lithographie en couleur, 102 x 70 cm. Moscou, 1927

91 *La seconde vie*
Allemagne (titre original : *Dr. Bessels Verwandlung*). Réalisateur : Richard Oswald. Richard Oswald-Produktion GmbH, 1927 – Lithographie en couleur, 158 x 72 cm. Moscou, 1928

92 *Berlin : Symphonie d'une grande ville*
Allemagne (titre original : *Berlin: Die Sinfonie der Großstadt*). Réalisateur : Walther Ruttmann. Deutsche Vereins-Film AG/Fox Europa, 1927– Lithographie en couleur, 106 x 71 cm. Moscou, 1928

93 *Une histoire ordinaire*
France (titre original : *La clé de voûte*). Réalisateur : Richard Lion. Mappemonde, 1925 – Lithographie en couleur, 101 x 70 cm. Moscou, 1927

95 *Au printemps*
URSS. Réalisateur : M. A. Kaufman. VUFKU, 1929 – Lithographie en couleur, 105 x 74 cm. Moscou, 1929

105 *Trois dans un sous-sol*
URSS. Réalisateur : Abram Room. Sovkino, 1927 – Lithographie en couleur, 101 x 70 cm. Moscou, 1927

110 *Un vrai gentleman*
États-Unis (titre original : *A Perfect Gentleman*). Réalisateur : Clyde Bruckman. Monty Banks Enterprises, 1928 – Lithographie en couleur, 108 x 72 cm. Moscou, 1928

111 *Appétit à vendre*
URSS. Réalisateur : N. P. Okhlopkov. VUFKU, 1928 – Lithographie en couleur, 107 x 71 cm. Moscou, 1928

112 *Moulin Rouge*
Angleterre (titre original : *Moulin Rouge*). Réalisateur : Ewald André Dupont. British International Pictures, 1928 – Lithographie en couleur, 95 x 63 cm. Moscou, 1929

113 *Tamilla*
URSS / Turquie. Réalisateur : E. Moukhsin-Bei, 1927 – Lithographie en couleur, 107 x 72 cm. Moscou, 1928

120 *Café Fanconi*
URSS. Réalisateur : M. Y. Kaptchinski. Sovkino, 1927 – Lithographie en couleur, 107 x 72 cm. Moscou, 1927

122 *La ruelle verte*
Allemagne (titre original : *Die Rothausgasse*). Réalisateur : Richard Oswald. Richard Oswald-Produktion GmbH, 1928 – Lithographie en couleur, 93 x 70 cm. Moscou, 1929

123 *Zare*
URSS. Réalisateur : A. I. Bek-Nazarov. Armenkino, 1927 – Lithographie en couleur, 142 x 100 cm. Moscou, 1927

124 *Camilla*
États-Unis (titre original : *Camille of the Barbary Coast*). Réalisateur : Hugh Dierker. Associated Exhibitors, 1925 – Lithographie en couleur, 72 x 101 cm. Moscou, 1928

128 *Le procès des trois millions*
URSS. Réalisateur : Y. A. Protasanov. Meshrabpom-Rus, 1926 – Lithographie en couleur, 102 x 79 cm. Moscou, 1926

131 *Des voyageurs de marque*
Danemark (titre original : *Raske Riviera-Rejsende*). Réalisateur : Lau Lauritzen. Palladium, 1924 – Lithographie en couleur, 107 x 72 cm. Moscou, 1928

132 *Le possédé*
États-Unis (titre original : *Sherlock Jr.*). Réalisateur : Buster Keaton. Buster Keaton Productions, 1924 – Lithographie en couleur, 109 x 72 cm. Moscou, 1927

134 *Le Turksib*
URSS. Réalisateur : Victor Tourine. Vostok-Kino, 1929 – Lithographie en couleur, 107 x 71 cm. Moscou, 1929

135 *Le ciment*
D'après le roman éponyme de Fiodor Gladkov. URSS. Réalisateur : V. Vilner. VUFKU, 1927 – Lithographie en couleur, 107 x 71 cm. Moscou, 1928

136 *La onzième année*
URSS. Réalisateur : Dziga Vertov. VUFKU, 1928 – Lithographie en couleur, 106 x 71 cm. Moscou, 1928

137 *L'homme à la caméra*
URSS. Réalisateur : Dziga Vertov. VUFKU, 1929 – Lithographie en couleur, 101 x 71cm. Moscou, 1929

139 *Niniche*
Allemagne (titre original : *Niniche*). Réalisateur : Victor Janson. Westi-Film, 1925 – Lithographie en couleur, 100 x 72 cm. Moscou, 1927

142 *L'idole du public*
États-Unis (titre original : *A Small Town Idol*). Réalisateur : Erle C. Kenton. Mack Sennett Comedies, 1921 – Lithographie en couleur, 108 x 72 cm. Moscou, 1925

145 *Le mécano de la Générale*
États-Unis (titre original : *The General*). Réalisateurs : Buster Keaton, Clyde Bruckman. Buster Keaton Productions, 1926 – Lithographie en couleur, 109 x 72 cm. Moscou, 1929

147 *La vieille 99*
États-Unis (titre original : *The Night Flyer*). Réalisateur : Walter Lang. James Cruze Productions, 1928 – Lithographie en couleur, 109 x 73 cm. Moscou, 1929

148 *La vis d'une autre machine*
URSS. Réalisateur : A. A. Talanov. Proletkino, 1926 – Lithographie en couleur, 108 x 73 cm. Moscou, 1926

150 *Six jeunes filles en quête d'un refuge*

Allemagne (titre original : *Sechs Mädchen suchen Nachtquartier*). Réalisateur : Hans Behrendt. Fellner & Somio-Film GmbH, 1928 – Lithographie en couleur avec photographie offset, 109 x 122 cm. Moscou, 1928

151 *Une tasse de thé*
URSS. Réalisateur : N. G. Chpikovski. Sovkino, 1927 – Lithographie en couleur avec photographie offset, 72 x 108 cm. Moscou, 1927

152 *Un pari mondain*
Allemagne (titre original : *Der Wetterwart*). Réalisateur : Carl Froelich. Carl Froelich-Film GmbH, 1923 – Lithographie en couleur, 108 x 73 cm. Moscou, 1927

154 *Le crayon*
URSS. Réalisateur : Boris Tseitline. VUFKU, 1928 – Lithographie en couleur, 107 x 70 cm. Moscou, 1928

159 *Le policier*
Suède (titre original : *Polis Paulus' påskasmäll*). Réalisateur: Gustaf Molander. Svensk Filmindustri (SF), 1925 – Lithographie en couleur, 109 x 72 cm. Moscou, 1928

164 *Le mécano de la Générale*
États-Unis (titre original : *The General*). Réalisateurs : Buster Keaton, Clyde Bruckman. Buster Keaton Productions, 1926 – Lithographie en couleur, 109 x 72 cm. Moscou, 1929

169 *Un débris de l'Empire*
URSS. Réalisateur : F. M. Ermler. Sovkino, 1929 – Lithographie en couleur, 95 x 62 cm. Moscou, 1929

171 *La jeune fille au carton à chapeau*
URSS. Réalisateur : Boris Barnet. Meshrabpom-Rus, 1927 – Lithographie en couleur, 121 x 93 cm. Moscou, 1927

Stenberg, Vladimir Avgustovitch
Stenberg, Guéorgui Avgustovitch
Rouklevski, Yakov Timofeïevitch

72 *Octobre*
URSS. Réalisateurs : S. M. Eisenstein, G. A. Alexandrov. Sovkino, 1927 – Lithographie en couleur, 264 x 204 cm. Moscou, 1927

86 *Selon la loi*
D'après le récit *The Unexpected* de Jack London. URSS. Réalisateur : Lev Koulechov. Sovkino, 1926 – Lithographie en couleur, 108 x 72 cm. Moscou, 1926

126 *Votre connaissance*
URSS. Réalisateur : Lev Koulechov. VUFKU, 1927 – Lithographie en couleur, 101 x 140 cm. Moscou, 1927

Taldykine, Alexandre Alexeïevitch

24 *Poignardé dans le dos*
Russie. Réalisateur : A. I. Ivanov-Gai. Studio d'A. Taldykine, 1917 – Lithographie en couleur, 110 x 71,5 cm. Moscou, 1917

Tyrsa, Nicolas Andreïevitch

172 *La roue du diable*
URSS. Réalisateurs : G. M. Kozintsev, L. S. Trauberg. Sevsapkino, 1926 – Lithographie en couleur, 107 x 72 cm. Léningrad, 1926

Veksler, Mikhaïl Solomonovitch

174 *Les enfants de la tempête*
URSS. Réalisateurs : E. Y. Ioganson, F. M. Ermler. Leningradkino, 1926 – Lithographie en couleur, 70 x 106 cm. Moscou, 1926

Vialov, Constantin Alexandrovitch

117 *La sixième partie du monde*
URSS. Réalisateur : Dziga Vertov. Sovkino, 1926 – Lithographie en couleur, 108 x 72 cm. Moscou, 1927

118 *Le machiniste Ukhtomsky*
URSS. Réalisateur : A. A. Dmitriev. Krasnaia Svesda (PUR), 1926 – Lithographie en couleur, 107 x 72 cm. Moscou, 1926

163 *Khanouma*
URSS. Réalisateur : A. R. Tsoutsounava. Goskinprom Gruzii, 1926 – Lithographie en couleur, 72 x 108 cm. Moscou, 1927

Voronov, Léonid Alexandrovitch
Evstafiev, Mikhaïl Ilitch

66 *Octobre*
URSS. Réalisateurs : S. M. Eisenstein, G. A. Alexandrov. Sovkino, 1927 – Lithographie en couleur, 107 x 137 cm. Moscou, 1927

70 *Octobre*
URSS. Réalisateurs : S. M. Eisenstein, G. A. Alexandrov. Sovkino, 1927 – Lithographie en couleur, 108 x 72,5 cm. Moscou, 1927

90 *Miel d'Or*
URSS. Réalisateurs : V. M. Petrov, N. Y. Berejnev. Sovkino, 1928 – Lithographie en couleur, 107 x 71 cm. Moscou, 1928.

Yegorov, Vladimir Jevgenievitch

54 *L'araignée verte*
Russie. Réalisateur : A. A. Volkov. Studio I. N. Yermoliev, 1916 – Lithographie en couleur, 106 x 72 cm. Moscou, 1916

Anonyme

16 *Les manoeuvres*
Russie. Studio d'A. O. Drankov – Lithographie en couleur, 102,5 x 69 cm. Saint-Pétersbourg, années 1910

17 *C'était au printemps*
Russie. Réalisateur : N. Tourkine. Société par actions A. Khanzhonkov et Cie, 1916 – Lithographie en couleur, 107 x 73 cm. Moscou, 1916

18 *Les coupables innocents*
D'après la comédie éponyme d'A. N. Ostrovski. Russie. Réalisateur : T. G. Sabinski. Studio I. N. Yermoliev, 1916 – Lithographie en couleur, 106 x 69 cm. Moscou, 1916

22 *La tempête*
D'après la pièce *L'Orage* d'A. N. Ostrovski. Réalisateur : Kaï Hanzen. Pathé Frères Moscou, 1915 – Lithographie en couleur, 55 x 80,5 cm. Moscou, années 1910

26 *Les idoles dorées*
Néant – Lithographie en couleur, 107 x 71 cm. Moscou, années 1910

27 *La honte de la Maison Romanov*
Russie. Réalisateur : néant. Coopérative Obnovlenie, 1917 – Lithographie en couleur, 107 x 72 cm

29 *Le tourbillon doré*
Russie. Réalisateur : P. I. Tchardynine. Studio D. I. Kharitonov, 1917 – Lithographie en couleur, 106,5 x 71,5 cm. Moscou, 1917

35 *Les feux de la rampe*
Russie. Réalisateur : néant. Société par actions A. Khanzonkov et Cie, 1916 – Lithographie en couleur, 92 x 64 cm. Moscou, 1916

39 *Docteur Krainsky*
Russie. Réalisateur : M. P. Bontch-Tomachevski. Studio Ère, 1917 – Lithographie en couleur, 106,5 x 71 cm. Moscou, 1917

40 *La Dame de Pique*
D'après le récit éponyme d'A. S. Pouchkine. Russie. Réalisateur : Y. A. Protasanov. Studio I. N. Yermoliev, 1916 – Lithographie en couleur, 122 x 82,5 cm. Moscou, 1916

42 *La vengeance du démon*
France. Société Française des Films Éclair – Lithographie en couleur, 102 x 68 cm. Moscou, années 1910. Dessiné dans l'atelier de V. Voïnov und V. Oulianitchev

48 *La fiancée achetée*
Adaptation cinématographique. Russie. Réalisateur : N. N. Arbatov. Studio cinématographique de G. I. Libken, 1915 – Lithographie en couleur, 106 x 71 cm. Moscou, 1915

49 *Le conte du monde*
Russie. Réalisateur : S. Y. Veselovski. Studio cinématographique de G. I. Libken, 1916 – Lithographie en couleur, 106,5 x 71,5 cm. Moscou, 1916

51 *Le péché*
Russie. Réalisateur : Y. A. Protasanov. Studio I. N. Yermoliev, 1916 – Lithographie en couleur, 106 x 70 cm. Moscou, 1916

58 *L'automne d'une femme*
D'après le roman *L'Automne d'une femme* de Marcel Prévost. Russie. Réalisateur : A. A. Gromov. Société par actions A. Khanzhonkov et Cie, 1917 – Lithographie en couleur, 106 x 72 cm. Moscou, 1917

62 *Le cuirassé Potemkine*
URSS. Réalisateur : S. M. Eisenstein. Goskino, 1925 – Lithographie en couleur, 108 x 72,5 cm. Moscou, 1926

63 *La mère*
D'après le roman éponyme de Maxime Gorki. URSS. Réalisateur : V. I. Poudovkine. Meshhrabpom-Rus, 1926 – Lithographie en couleur, 108 x 72 cm. Moscou, 1926

64 *Octobre*
URSS. Réalisateurs : S. M. Eisenstein, G. A. Alexandrov. Sovkino, 1927 – Lithographie en couleur, 75,5 x 109 cm. Moscou, 1927

65 *Octobre*
URSS. Réalisateurs : S. M. Eisenstein, G. A. Alexandrov. Sovkino, 1927 – Lithographie en couleur, 72 x 157 cm. Moscou, 1927

100 *Le descendant de Gengis Khan (Tempête sur l'Asie)*
URSS. Réalisateur : V. I. Poudovkine. Meshrabpomfilm, 1929 – Lithographie en couleur, 131 x 91 cm. Moscou, 1929

114 *Le mariage de Rosine*
France (titre original : *Le mariage de Rosine*). Réalisateur : Pierre Colombier. Films de France, 1926 – Lithographie en couleur, 108 x 72 cm. Moscou, 1927

115 *La radio et le lion*
États-Unis (titre original : *No control*). Réalisateurs : Scott Sidney, E. J. Babille. Metropolitan Pictures Corporation of California, 1927 – Lithographie en couleur, 108 x 71 cm. Moscou, 1929

156 *L'île de Toguyi*
URSS. Réalisateur : I. Malakhov. Gosvojenkino, 1929 – Lithographie en couleur, 62 x 107 cm. Moscou, 1929

160 *Aux jardins de Murcie*
France (titre original : *Aux jardins de Murcie*). Réalisateurs : Louis Mercanton, René Hervil. Société des Films Mercanton, 1923 – Lithographie en couleur, 108 x 73 cm. Moscou, 1926

161 *Deux blindés*
URSS. Réalisateur : S. A. Timochenko, Sovkino, 1928 – Lithographie en couleur, 94 x 62 cm. Moscou, 1928

166 *Enthousiasme : La symphonie du Donbass*
URSS. Réalisateur : Dziga Vertov. Ukrainfilm, 1930 – Lithographie en couleur, 63 x 88 cm. Kiev, 1931

173 *Stepane Khaltourine*
URSS. Réalisateur : A. V. Ivánovski. Sevsapkino, 1925 – Lithographie en couleur, 108 x 72,5 cm. Léningrad, 1925

Plakatliste

Alexejew, Georgi Dmitrijewitsch
25 *Der getötete Traum*
Frankreich (Originaltitel: *Le rêve passe*). Regisseur Louis Feuillade. Société des Etablissements L. Gaumont, 1911 – Farblithografie, 106,5 x 72 cm. Moskau, 1910er Jahre
41 *Ultus. Das Geheimnis einer Nacht*
Großbritannien (Originaltitel: *Ultus and the Secret of the Night*). Regisseur George Pearson. Gaumont British Picture Corporation, 1917 – Farblithografie, 107 x 71,5 cm. Moskau, 1910er Jahre
52 *Der Satan hat sie getraut*
Russland. Regisseur W. K. Wiskowski. Atelier Ära, 1917 – Farblithografie, 112 x 76 cm. Moskau, 1917
53 *Frauen, mobilisiert Euch!*
Frankreich. Gaumont – Farblithografie, 108,5 x 72,5 cm. Moskau, 1910er Jahre

Apsit (Apsitis), Alexander Petrowitsch
21 *Das unvollendete Liebeslied*
Russland. Regisseure W. A. Polonski, Lew Kuleschow. Aktiengesellschaft Koslowski, Jurjew und Co., 1918 – Farblithografie, 105,5 x 70 cm. Moskau, 1918 – 1919

Asaturow (Asaturi), Paul K.
14 *Stenka Rasin*
Russland. Regisseur Wladimir Romaschkow. Atelier von A. O. Drankow, 1908 – Farblithografie, 102,5 x 68,5 cm. St. Petersburg, 1908

Belski, Anatoli Pawlowitsch
83 *Die Pfeife des Kommunarden*
Nach der gleichnamigen Novelle von I. G. Ehrenburg. UdSSR. Regisseur K. A. Mardschanischwili (Mardschanow). Goskinprom Grusiji, 1929 – Farblithografie mit Offset-Fotografie, 108 x 74 cm. Moskau, 1929
98 *Saba*
UdSSR. Regisseur M. E. Tschiaureli. Goskinprom Grusiji, 1929 – Farblithografie, 108 x 73 cm. Moskau, 1929
102 *Wölfe*
UdSSR. Regisseur Leo Mur (L. I. Muraschko). Goskino, 1925 – Farblithografie, 72 x 108 cm. Moskau, 1925

Bograd, Israil Dawidowitsch
68 *Die Mutter*
Nach dem gleichnamigen Roman von Maxim Gorki. UdSSR. Regisseur W. I. Pudowkin. Meschrabpom-Rus,1926 – Farblithografie, 140 x 317 cm. Moskau, 1926
103 *Der Kollegienregistrator* (deutscher Filmtitel: *Der Posthalter*)
Nach der gleichnamigen Erzählung von A. S. Puschkin. UdSSR. Regisseur J. A. Scheljabuschski. Meschrabpom-Rus, 1925 – Farblithografie, 72 x 108 cm. Moskau, 1925
119 *Der weiße Adler*
Nach der Erzählung „Der Gouverneur" von Leonid Andrejew. UdSSR. Regisseur J. A. Protasanow. Meschrabpomfilm, 1928 – Farblithografie, 125 x 91 cm. Moskau, 1928
121 *Das Ende von Sankt Petersburg*
UdSSR. Regisseur W. I. Pudowkin. Meschrabpom-Rus, 1927 – Farblithografie, 125 x 95 cm. Moskau, 1927
127 *Aelita* (deutscher Untertitel: *Der Flug zum Mars*)
UdSSR. Regisseur J. A. Protasanow. Meschrabpom-Rus, 1924 – Farblithografie, 72 x 108 cm. Moskau, 1929

Borisow, Grigori Iljitsch
Prusakow, Nikolai Petrowitsch
80 *Das Haus am Trubnaja-Platz*
UdSSR. Regisseur Boris Barnet. Meschrabpomfilm, 1928 – Farblithografie, 95 x 135 cm. Moskau, 1928
81 *Chaz-Pusch*
UdSSR. Regisseur A. I. Bek-Nasarow. Armenkino, 1928 – Farblithografie mit Offset-Fotografie, 72 x 108 cm. Moskau, 1928
140 *Fürstentochter Mary*
Nach der gleichnamigen Erzählung von M. J. Lermontow. UdSSR. Regisseur W. G. Barski. Goskinprom Grusiji, 1927 – Farblithografie, 125 x 90 cm. Moskau, 1927

Borisow, Grigori Iljitsch; Schukow, Pjotr Iljitsch
94 *Betreten der Stadt verboten*
UdSSR. Regisseur J. A. Scheljabuschski. Meschrabpomfilm, 1929 – Farblithografie mit Offset-Fotografie, 122 x 94 cm. Moskau, 1929
167 *Der lebende Leichnam*
Nach dem gleichnamigen Theaterstück von L. N. Tolstoi. UdSSR. Regisseur F. A. Ozep. Meschrabpomfilm und Prometheus-Film-Verleih und Vertriebs-GmbH (Deutschland), 1929 – Farblithografie, 108,5 x 73 cm. Moskau, 1929

Chomow, Nikolai Michailowitsch
177 *Suche nach Protektion*
UdSSR. Regisseur B. J. Kasatschkow. Rosfilm, 1932 – Farblithografie, 92 x 60 cm. Moskau, 1933

Dlugatsch, Michail Oskarowitsch
99 *Klatsch*
UdSSR. Regisseur I. N. Perestiani. WUFKU, 1928 – Farblithografie, 108 x 72 cm. Moskau, 1928

109 *Die Austernprinzessin*
Deutschland (Originaltitel: *Die Austernprinzessin*). Regisseur Ernst Lubitsch. Protections AG Union, 1919 – Farblithografie, 101 x 72 cm. Moskau, 1926
116 *Richter Reitan*
UdSSR. Regisseur F. L. Lopatinski. WUFKU, 1929 – Farblithografie, 94 x 62 cm. Moskau, 1929

Dortman, T.
50 *Höllenbrut*
Russland. Regisseur B. A. Orlizki. Firma „Alliance" und „Adler" von K. Philipp, 1916 – Farblithografie, 103,5 x 66 cm. Moskau, 1916

Gerasimowitsch, Iosif Wasiljewitsch
96 *120 000 pro Jahr*
UdSSR. Regisseur G. I. Tschernjak. Meschrabpomfilm, 1929 – Farblithografie, 103 x 71 cm. Moskau, 1929
129 *Der letzte Droschkenfahrer von Berlin*
Deutschland (Originaltitel: *Die letzte Droschke von Berlin*). Regisseur Carl Boese. Rex-Film GmbH, 1926 – Farblithografie, 72 x 108 cm. Moskau, 1928
165 *Der leidenschaftliche Prinz*
UdSSR. Regisseur W. G. Schmidthof. Sowkino, 1928 – Farblithografie, 109 x 72 cm. Moskau, 1928

Jegorow, Wladimir Jewgenjewitsch
54 *Die grüne Spinne*
Russland. Regisseur A. A. Wolkow. Studio I. N. Jermoljew, 1916 – Farblithografie, 106 x 72 cm. Moskau, 1916

Jewstafjew, Michail Iljitsch
Siehe: Woronow, Leonid Alexandrowitsch; Jewstafjew, Michail Iljitsch

Kaabak, Wladimir Michailowitsch
162 *Miss Mend*
Nach dem gleichnamigen Kriminalroman von M. Schaginjan. UdSSR. Regisseure F. A. Ozep, Boris Barnet. Meschrabpom-Rus, 1926 – Farblithografie, 74,5 x 109 cm. Moskau, 1926

Kalmanson, Michail Sergejewitsch
19 *Anna Kareninas Tochter*
Russland. Regisseur A. A. Arkatow. Gesellschaft „Prodalent", 1916 – Farblithografie, 106 x 71 cm. Moskau, 1916
20 *Die Würfel sind gefallen*
Russland. Aktiengesellschaft Koslowski, Jurjew und Co. – Farblithografie, 104 x 76,5 cm. Moskau, 1910er Jahre
32 *Sklaven in goldenen Fesseln*
K. A. – Farblithografie, 102 x 71,5 cm. Moskau, 1910er Jahre
33 *Die Königin der Zirkusarena*
Aktiengesellschaft „Trans-Atlantik" – Farblithografie, 107 x 72 cm. Moskau, 1910er Jahre
34 *Gequälte Seelen*
Russland. Regisseur W. P. Kasjanow. Studio D. I. Charitonow, 1917 – Farblithografie, 107 x 69 cm. Moskau, 1917
43 *Der geheimnisvolle Mord in Petrograd*
Russland. Regisseur N. L. Minerwin. Genossenschaft „Minerwa", 1917 – Farblithografie, 107 x 71 cm. Moskau, 1917
44 *Als ich Postkutscher war...*
Nach einem Volkslied. Russland. Regisseur N. P. Larin. Skobelewski-Komitee, 1916 – Farblithografie, 104 x 71 cm. Moskau, 1916
45 *Der einäugige Teufel*
Russland. Regisseur N. P. Larin. Skobelewski-Komitee, 1916 – Farblithografie, 106 x 71 cm. Moskau, 1916
46 *Wie sie lügen*
Russland. Regisseur W. K. Wiskowski. Studio D. I. Charitonow, 1917 – Farblithografie, 71 x 104 cm. Moskau, 1917
56 *Die abgemähte Garbe auf dem Erntefeld der Liebe*
Russland. Regisseur M. P. Bontsch-Tomaschewski. Atelier Ära, 1917 – Farblithografie, 106,5 x 71 cm. Moskau, 1917
57 *Der Abgrund*
Nach dem Werk „De profundis" von Stanislaw Przybyszewski. Russland. Polnischer Originaltitel: Topiel. Regisseur W. Lenczewski. Gesellschaft „Polonia Moskwa", 1917 – Farblithografie, 106 x 71 cm. Moskau, 1917

Klimaschin, Viktor Semjonowitsch
176 *Ob ich dich liebe?*
UdSSR. Regisseur S. A. Gerassimow. Sojusfilm, 1934 – Farblithografie, 83,5 x 58 cm. Moskau, 1934

Kljun (Kljunkow), Iwan Wasiljewitsch
158 *Die Perle von Semiramis*
UdSSR. Regisseur G. M. Stabowoj. WUFKU, 1929 – Farblithografie, 107 x 71,5 cm. Moskau, 1929

Lawinski, Anton Michailowitsch
61 *Panzerkreuzer Potemkin*
UdSSR. Regisseur S. M. Eisenstein. Goskino, 1925 – Farblithografie mit Offset-Fotografie, 72 x 104 cm. Moskau, 1926
74 *Die Todesbucht*
Nach der Erzählung „In der Otrada-Bucht " von A. S. Nowikow-Priboi. UdSSR. Regisseur Abram Room. Goskino, 1926 – Farblithografie mit Offset-Fotografie, 108 x 72 cm. Moskau, 1926

87 *Nach dem Gesetz (Dura Lex)*
Nach der Erzählung „The Unexpected" von Jack London. UdSSR. Regisseur Lew Kuleschow. Sowkino, 1926 – Farblithografie, 101 x 72 cm. Moskau, 1926

Litwak, Maxim Michailowitsch
79 *Bis morgen*
UdSSR. Regisseur J. W. Taritsch. Belgoskino, 1929 – Farblithografie, 102,5 x 75 cm. Moskau, 1929

Malewitsch, Kasimir Sewerinowitsch
175 *Doktor Mabuse*
Deutschland (Originaltitel: *Doktor Mabuse, der Spieler*). Regisseur Fritz Lang. Uco-Film GmbH, 1922 – 1927 – Öl auf Leinwand, 106 x 70,6 cm

Mosiagin, Pjotr
15 *Stenka Rasin*
Russland. Regisseur G. I. Libken. Kinematographisches Studio von G. I. Libken, 1914 – Farblithografie, 162,5 x 214 cm. Jaroslaswl, 1914

Naumow, Alexander Iljitsch
104 *Der Verräter*
Nach der Erzählung „Matrosskaja Tischina" von Lew Nikulin. UdSSR. Regisseur Abram Room. Goskino, 1926 – Farblithografie, 101 x 72 cm. Moskau, 1926
141 *Bella Donna*
USA (Originaltitel: *Bella Donna*). Regisseur George Fitzmaurice. Famous Players-Lasky Corporation, 1923 – Farblithografie, 123 x 87 cm. Moskau, 1927
157 *Alim*
UdSSR. Regisseur G. N. Tasin. WUFKU, 1926 – Farblithografie, 101 x 72 cm. Moskau, 1926

Pimenow, Juri (Georgi) Iwanowitsch
179 *Fettklößchen*
Nach der Novelle „Boule de suif" („Fettklößchen") von Guy de Maupassant. UdSSR. Regisseur M. I. Romm. Moskinokombinat, 1934 – Farblithografie, 122 x 83 cm. Moskau, 1935

Prusakow, Nikolai Petrowitsch
76 *Ränge und Menschen*
Nach drei Erzählungen von Anton Tschechow. UdSSR. Regisseur J. A. Protasanow. Meschrabpomfilm, 1929 – Farblithografie mit Offset-Fotografie, 94 x 62 cm. Moskau, 1929
84 *Die Generallinie (Das Alte und das Neue)*
UdSSR. Regisseure S. M. Eisenstein, G. A. Alexandrow. Sowkino, 1929 – Farblithografie, 72 x 108 cm. Moskau, 1929
97 *Die grüne Gasse*
Deutschland (Originaltitel: *Die Rothausgasse*). Regisseur Richard Oswald. Richard Oswald-Produktion GmbH, 1928 – Farblithografie, 82 x 107 cm. Moskau, 1929
101 *Fünf Minuten*
UdSSR. Regisseure A. S. Balygin, G. M. Selondschew-Schipow. Goskinprom Grusiji, 1929 – Farblithografie, 140 x 108 cm. Moskau, 1929
138 *Auf dem Cholt*
UdSSR. Regisseur L. D. Esakia. Goskinprom Grusiji, 1929 – Farblithografie, 108 x 73 cm. Moskau, 1929
143 *Pech gehabt*
Deutschland (Originaltitel: *Die vertauschte Braut*). Regisseur Carl Wilhelm. Phoebus-Film-AG, 1925 – Farblithografie, 100 x 71 cm. Moskau, 1927
144 *Das Glasauge*
UdSSR. Regisseure L. J. Brik, W. L. Schemtschuschni. Meschrabpomfilm, 1929 – Farblithografie, 123 x 94 cm. Moskau, 1929
149 *Die fremde Frau*
UdSSR. Regisseur I. A. Pyrjew. Sowkino, 1929 – Farblithografie mit Offset-Fotografie, 140 x 108 cm. Moskau, 1929
153 *Die Pfeife des Kommunarden*
Nach der gleichnamigen Novelle von I. G. Ehrenburg. UdSSR. Regisseur K. A. Mardschanischwili. Goskinprom Grusiji, 1929 – Farblithografie, 108 x 73 cm. Moskau, 1929

Prusakow, Nikolai Petrowitsch
Siehe auch: Borisow, Grigori Iljitsch,
Prusakow, Nikolai Petrowitsch

Rabitschew, Isaak Benjewitsch
108 *Die Puppe mit den Millionen*
UdSSR. Regisseur S. P. Komarow. Meschrabpomfilm, 1928 – Farblithografie, 100 x 52,5 cm. Moskau, 1928

Rodtschenko, Alexander Michailowitsch
59 *Kino-Auge*
UdSSR. Regisseur Dsiga Wertow. Goskino, 1924 – Farblithografie, 96 x 71 cm. Moskau, 1924
75 *Ein Sechstel der Erde*
UdSSR. Regisseur Dsiga Wertow. Sowkino, 1926 – Farblithografie mit Offset-Fotografie, 108 x 70 cm. Moskau, 1927

Ruklewski, Jakow Timofejewitsch
71 *Oktober* (deutscher Untertitel: *10 Tage, die die Welt erschütterten*)
UdSSR. Regisseure S. M. Eisenstein, G. A. Alexandrow. Sowkino, 1927 – Farblithografie, 206 x 100 cm. Moskau, 1927

78 *Café Fanconi*
UdSSR. Regisseur M. J. Kaptschinski. Sowkino, 1927 – Farblithografie mit Offset-Fotografie, 107 x 72 cm. Moskau, 1927
130 *Kraft und Schönheit* (deutscher Filmtitel: *Pat und Patachon: Kraft durch Schönheit*)
Dänemark (Originaltitel: *Kraft og Skønhed*). Regisseur Lau Lauritzen. Palladium, 1927 – Farblithografie, 70 x 94 cm. Moskau, 1929

Ruklewski, Jakow Timofejewitsch
Siehe auch: Stenberg, Wladimir Awgustowitsch,
Stenberg, Georgi Awgustowitsch,
Ruklewski, Jakow Timofejewitsch

Rytschkow, Grigori Nikolajewitsch
125 *Der Dichter und der Zar*
UdSSR. Regisseur W. R. Gardin. Sowkino, 1927 – Farblithografie, 70 x 107 cm. Moskau, 1927

Schitkow, P.
28 *Die Wahrheit einer Frau*
Russland. Regisseur B. W. Tschaikowski. Aktiengesellschaft A. Chanschonkow und Co., 1917 – Farblithografie, 107 x 72 cm. Moskau, 1917
30 *Das Leben ist ein Augenblick, die Kunst ist eine Ewigkeit*
Russland. Regisseur T. Sabinski. Studio I. N. Jermoljew, 1916 – Farblithografie, 107,5 x 71,5 cm. Moskau, 1916
31 *Der Lump*
Russland. Regisseur B. W. Tschaikowski. Aktiengesellschaft A. Chanschonkow und Co., 1917– Farblithografie, 107,5 x 71,5 cm. Moskau, 1917
36 *Iwanow, Pawel*
Russland. Regisseur A. A. Arkatow. Schiwo-Kinetofon, 1916 – Farblithografie, 107 x 70 cm. Moskau, 1916
37 *Der König von Paris*
Nach dem Roman „Le Roi de Paris" („Der König von Paris") von Georges Ohnet. Russland. Regisseur Jewgeni Bauer. Aktiengesellschaft A. Chanschonkow und Co., 1917 – Farblithografie, 158 x 70 cm. Moskau, 1917
38 *Mondschönheit*
Russland. Regisseur Jewgeni Bauer. Aktiengesellschaft A. Chanschonkow und Co., 1916 – Farblithografie, 71,5 x 105 cm. Moskau, 1916
55 *Lea Lifschitz*
Russland. Regisseur W. A. Starewicz. Aktiengesellschaft A. Drankow, 1917 – Farblithografie, 109 x 75 cm. Moskau, 1917

Schukow, Pjotr Iljitsch
Siehe: Borisow, Grigori Iljitsch
Schukow, Pjotr Iljitsch

Semenow-Menes, Semen Abramowitsch
106 *Wer bist du?*
UdSSR. Regisseur J. A. Scheljabuschski. Meschrabpom-Rus, 1927 – Farblithografie, 112,5 x 82,5 cm. Moskau, 1927
107 *Ach, Äpfelchen...*
UdSSR. Regisseure L. L. Obolenski, M. I. Doller. Meschrabpom-Rus, 1926 – Farblithografie, 107 x 72 cm. Moskau, 1927
133 *Der Kuss von Mary*
UdSSR. Regisseur S. P. Komarow. Meschrabpom-Rus, 1927 – Farblithografie, 73 x 108 cm. Moskau, 1927
146 *Die Puppe mit den Millionen*
UdSSR. Regisseur S. P. Komarow. Meschrabpomfilm, 1928 – Farblithografie, 126 x 92 cm. Moskau, 1928
155 *Turksib*
UdSSR. Regisseur Viktor Turin. Wostok-Kino, 1929 – Farblithografie, 105 x 69 cm. Moskau, 1929
168 *Das Mädchen mit der Hutschachtel*
UdSSR. Regisseur Boris Barnet. Meschrabpom-Rus, 1927 – Farblithografie, 111 x 83 cm. Moskau, 1927
170 *Miss Mend*
Nach dem gleichnamigen Kriminalroman von M. Schaginjan. UdSSR. Regisseure F. A. Ozep und Boris Barnet. Meschrabpom-Rus, 1926 – Farblithografie, 108 x 141 cm. Moskau, 1927

Smoljak, Nikolai Petrowitsch
178 *Kronprinz der Republik*
UdSSR. Regisseur E. J. Ioganson. Lenfilm, 1934 – Farblithografie, 94 x 62 cm. Moskau, 1934

Stenberg, Wladimir Awgustowitsch
Stenberg, Georgi Awgustowitsch
60 *Panzerkreuzer Potemkin*
UdSSR. Regisseur S. M. Eisenstein. Goskino, 1925 – Farblithografie, 70 x 94 cm. Moskau, 1925
73 *Oktober* (deutscher Untertitel: *10 Tage, die die Welt erschütterten*)
UdSSR. Regisseure S. M. Eisenstein, G. A. Alexandrow. Sowkino, 1927 – Farblithografie, 142 x 100 cm. Moskau, 1927
77 *Das elfte Jahr*
UdSSR. Regisseur Dsiga Wertow. WUFKU, 1928 – Farblithografie, 107 x 71 cm. Moskau, 1928
82 *Der Mann mit der Kamera*
UdSSR. Regisseur Dsiga Wertow. WUFKU, 1929 – Farblithografie, 106 x 72 cm. Moskau, 1929

88 *SEP*
UdSSR. Regisseure M. E. Werner, P. N. Armand. Goswojenkino, 1929 – Farblithografie, 107 x 73 cm. Moskau, 1929
89 *Die geheime Hazienda*
USA (Originaltitel: *The Fighting Demon*). Regisseur Arthur Rosson. Richard Talmadge Productions, Carlos Productions, Truart Film Co., 1925 – Farblithografie, 102 x 70 cm. Moskau, 1927
91 *Das zweite Leben*
Deutschland (Originaltitel: *Dr. Bessels Verwandlung*). Regisseur Richard Oswald. Richard Oswald-Produktion GmbH, 1927– Farblithografie, 158 x 72 cm. Moskau, 1928
92 *Berlin: Die Sinfonie der Großstadt*
Deutschland (Originaltitel: *Berlin: Die Sinfonie der Großstadt*). Regisseur Walther Ruttmann. Deutsche Vereins-Film AG/Fox Europa, 1927– Farblithografie, 106 x 71 cm. Moskau, 1928
93 *Eine gewöhnliche Geschichte*
Frankreich (Originaltitel: *La clé de voûte*). Regisseur Richard Lion. Mappemonde, 1925 – Farblithografie, 101 x 70 cm. Moskau, 1927
95 *Im Frühling*
UdSSR. Regisseur M. A. Kaufman. WUFKU, 1929 – Farblithografie, 105 x 74 cm. Moskau, 1929
105 *Liebe zu dritt* (deutsche Filmtitel auch: *Bett und Sofa; Dritte Kleinbürgerstraße*)
UdSSR. Regisseur Abram Room. Sowkino, 1927 – Farblithografie, 101 x 70 cm. Moskau, 1927
110 *Ein wahrer Gentleman* (deutscher Filmtitel auch: *Monty, der Wüstling*)
USA (Originaltitel: *A Perfect Gentleman*). Regisseur Clyde Bruckman. Monty Banks Enterprises, 1928 – Farblithografie, 108 x 72 cm. Moskau, 1928
111 *Der verkaufte Appetit*
UdSSR. Regisseur N. P. Ochlopkow. WUFKU, 1928 – Farblithografie, 107 x 71 cm. Moskau, 1928
112 *Moulin Rouge*
England (Originaltitel: *Moulin Rouge*). Regisseur Ewald André Dupont. British International Pictures, 1928 – Farblithografie, 95 x 63 cm. Moskau, 1929
113 *Tamilla*
UdSSR / Türkei. Regisseur E. Muchsin-Bej, 1927 – Farblithografie, 107 x 72 cm. Moskau, 1928
120 *Café Fanconi*
UdSSR. Regisseur M. J. Kaptschinski. Sowkino, 1927 – Farblithografie, 107 x 72 cm. Moskau, 1927
122 *Die grüne Gasse*
Deutschland (Originaltitel: *Die Rothausgasse*). Regisseur Richard Oswald. Richard Oswald-Produktion GmbH, 1928 – Farblithografie, 93 x 70 cm. Moskau, 1929
123 *Zare*
UdSSR. Regisseur A. I. Bek-Nasarow. Armenkino, 1927 – Farblithografie, 142 x 100 cm. Moskau, 1927
124 *Camilla* (deutscher Filmtitel: *Die Frau aus der Tiefe*)
USA (Originaltitel: *Camille of the Barbary Coast*). Regisseur Hugh Dierker. Associated Exhibitors, 1925 – Farblithografie, 72 x 101 cm. Moskau, 1928
128 *Der Drei-Millionen-Prozess*
UdSSR. Regisseur J. A. Protasanow. Meschrabpom-Rus, 1926 – Farblithografie, 102 x 79 cm. Moskau, 1926
131 *Vornehme Reisende* (deutscher Filmtitel: *Pat und Patachon: Geheimnisvoller Goldschatz*)
Dänemark (Originaltitel: *Raske Riviera-Rejsende*). Regisseur Lau Lauritzen. Palladium, 1924 – Farblithografie, 107 x 72 cm. Moskau, 1927
132 *Besessen* (deutscher Filmtitel: *Sherlock Junior*)
USA (Originaltitel: *Sherlock Jr.*). Regisseur Buster Keaton. Buster Keaton Productions, 1924 – Farblithografie, 109 x 72 cm. Moskau, 1927
134 *Turksib*
UdSSR. Regisseur Viktor Turin. Wostok-Kino, 1929 – Farblithografie, 107 x 71 cm. Moskau, 1929
135 *Zement*
Nach dem gleichnamigen Roman von Fjodor Gladkow. UdSSR. Regisseur W. Wilner. WUFKU, 1927 – Farblithografie, 107 x 71 cm. Moskau, 1928
136 *Das elfte Jahr*
UdSSR. Regisseur Dsiga Wertow. WUFKU, 1928 – Farblithografie, 106 x 71 cm. Moskau, 1928
137 *Der Mann mit der Kamera*
UdSSR. Regisseur Dsiga Wertow. WUFKU, 1929 – Farblithografie, 101 x 71 cm. Moskau, 1929
139 *Niniche*
Deutschland (Originaltitel: *Niniche*). Regisseur Victor Janson. Westi-Film, 1925 – Farblithografie, 100 x 72 cm. Moskau, 1927
142 *Der Publikumsliebling*
USA (Originaltitel: *A Small Town Idol*). Regisseur Erle C. Kenton. Mack Sennett Comedies, 1921 – Farblithografie, 108 x 72 cm. Moskau, 1925
145 *Der General*
USA (Originaltitel: *The General*). Regisseure Buster Keaton, Clyde Bruckman. Buster Keaton Productions, 1926 – Farblithografie, 109 x 72 cm. Moskau, 1929
147 *Die Alte Nr. 99*
USA (Originaltitel: *The Night Flyer*). Regisseur Walter Lang. James Cruze Productions, 1928 – Farblithografie, 109 x 73 cm. Moskau, 1929
148 *Die Schraube von einer anderen Maschine*
UdSSR. Regisseur A. A. Talanow. Proletkino, 1926 – Farblithografie, 108 x 73 cm. Moskau, 1926

150 *Sechs Mädchen suchen Nachtquartier*
Deutschland (Originaltitel: *Sechs Mädchen suchen Nachtquartier*). Regisseur Hans Behrendt. Fellner & Somio-Film GmbH, 1928 – Farblithografie mit Offset-Fotografie, 109 x 122 cm. Moskau, 1928
151 *Eine Tasse Tee*
UdSSR. Regisseur N. G. Schpikowski. Sowkino, 1927 – Farblithografie mit Offset-Fotografie, 72 x 108 cm. Moskau, 1927
152 *Eine Wette in feinen Kreisen*
Deutschland (Originaltitel: *Der Wetterwart*). Regisseur Carl Froelich. Carl Froelich-Film GmbH, 1923 – Farblithografie, 108 x 73 cm. Moskau, 1927
154 *Der Bleistift*
UdSSR. Regisseur Boris Zeitlin. WUFKU, 1928 – Farblithografie, 107 x 70 cm. Moskau, 1928
159 *Der Polizist* (deutscher Filmtitel: *Pat und Patachon als Polizisten*)
Schweden (Originaltitel: *Polis Paulus' påskasmäll*). Regie Gustaf Molander. Svensk Filmindustri (SF), 1925 – Farblithografie, 109 x 72 cm. Moskau, 1928
164 *Der General*
USA (Originaltitel: *The General*). Regisseure Buster Keaton, Clyde Bruckman. Buster Keaton Productions, 1926 – Farblithografie, 109 x 72 cm. Moskau, 1929
169 *Trümmer eines Imperiums*
UdSSR. Regisseur F. M. Ermler. Sowkino, 1929 – Farblithografie, 95 x 62 cm. Moskau, 1929
171 *Das Mädchen mit der Hutschachtel*
UdSSR. Regisseur Boris Barnet. Meschrabpom-Rus, 1927 – Farblithografie, 121 x 93 cm. Moskau, 1927

Stenberg, Wladimir Awgustowitsch
Stenberg, Georgi Awgustowitsch
Ruklewski, Jakow Timofejewitsch
72 *Oktober* (deutscher Untertitel: *10 Tage, die die Welt erschütterten*)
UdSSR. Regisseure S. M. Eisenstein, G. A. Alexandrow. Sowkino, 1927 – Farblithografie, 264 x 204 cm. Moskau, 1927
86 *Nach dem Gesetz (Dura Lex)*
Nach der Erzählung „The Unexpected" von Jack London. UdSSR. Regisseur Lew Kuleschow. Sowkino, 1926 – Farblithografie, 108 x 72 cm. Moskau, 1927
126 *Ihre Bekannte (Die Journalistin)*
UdSSR. Regisseur Lew Kuleschow. WUFKU, 1927 – Farblithografie, 101 x 140 cm. Moskau, 1927

Taldykin, Alexander Alexejewitsch
24 *Der Stich in den Rücken*
Russland. Regisseur A. I. Iwanow-Gai. Studio von A. Taldykin, 1917 – Farblithografie, 110 x 71,5 cm. Moskau, 1917

Tyrsa, Nikolai Andrejewitsch
172 *Das Teufelsrad*
UdSSR. Regisseure G. M. Kosinzew, L. S. Trauberg. Sewsapkino, 1926 – Farblithografie, 107 x 72 cm. Leningrad, 1926

Weksler, Michail Solomonowitsch
174 *Die Kinder des Sturms*
UdSSR. Regisseure E. J. Ioganson, F. M. Ermler. Leningradkino, 1926 – Farblithografie, 70 x 106 cm. Moskau, 1926

Wjalow, Konstantin Alexandrowitsch
117 *Ein Sechstel der Erde*
UdSSR. Regisseur Dsiga Wertow. Sowkino, 1926 – Farblithografie, 108 x 72 cm. Moskau, 1927
118 *Maschinist Uchtomski*
UdSSR. Regisseur A. A. Dmitrijew. Krasnaja Swesda (PUR), 1926 – Farblithografie, 107 x 72 cm. Moskau, 1926
163 *Hanuma*
UdSSR. Regisseur A. R. Zuzunawa. Goskinprom Grusiji, 1926 – Farblithografie, 72 x 108 cm. Moskau, 1927

Woronow, Leonid Alexandrowitsch
Jewstafjew, Michail Iljitsch
66 *Oktober* (deutscher Untertitel: *10 Tage, die die Welt erschütterten*)
UdSSR. Regisseure S. M. Eisenstein, G. A. Alexandrow. Sowkino, 1927 – Farblithografie, 107 x 137 cm. Moskau, 1927
70 *Oktober* (deutscher Untertitel: *10 Tage, die die Welt erschütterten*)
UdSSR. Regisseure S. M. Eisenstein, G. A. Alexandrow. Sowkino, 1927 – Farblithografie, 108 x 72,5 cm. Moskau, 1927
90 *Goldener Honig*
UdSSR. Regisseure W. M. Petrow, N. J. Beresnew. Sowkino, 1928 – Farblithografie, 107 x 71 cm. Moskau, 1928

Anonym
16 *Manöver*
Russland. Atelier von A. O. Drankow – Farblithografie, 102,5 x 69 cm. St. Petersburg, 1910er Jahre
17 *Es war im Frühling*
Russland. Regisseur N. Turkin. Aktiengesellschaft A. Chanschonkow und Co., 1916 – Farblithografie, 107 x 73 cm. Moskau, 1916

18 *Die schuldlos Schuldigen*
Nach der gleichnamigen Komödie von A. N. Ostrowski. Russland. Regisseur T. G. Sabinski. Studio I. N. Jermoljew, 1916 – Farblithografie, 106 x 69 cm. Moskau, 1916
22 *Das Gewitter*
Nach dem Stück „Das Gewitter" von A. N. Ostrowski. Regisseur Kai Hansen. Pathé Frères Moskau, 1915 – Farblithografie, 55 x 80,5 cm. Moskau, 1910er Jahre
26 *Goldene Idole*
K. A. – Farblithografie, 107 x 71 cm. Moskau, 1910er Jahre
27 *Die Schande des Hauses Romanow*
Russland. K. A. zum Regisseur. Genossenschaft Obnowlenie, 1917 – Farblithografie, 107 x 72 cm
29 *Der Goldene Wirbel*
Russland. Regisseur P. I. Tschardynin. Studio D. I. Charitonow, 1917 – Farblithografie, 106,5 x 71,5 cm. Moskau, 1917
35 *Im Licht des Café-Concerts*
Russland. Regisseur B. W. Tschaikowski. Aktiengesellschaft A. Chanschonkow und Co., 1916 – Farblithografie, 92 x 64 cm. Moskau, 1916
39 *Doktor Krainski*
Russland. Regisseur M. P. Bontsch-Tomaschewski. Atelier Ära, 1917 – Farblithografie, 106,5 x 71 cm. Moskau, 1917
40 *Pique Dame*
Nach der gleichnamigen Erzählung von A. S. Puschkin. Russland. Regisseur J. A. Protasanow. Studio I. N. Jermoljew, 1916 – Farblithografie, 122 x 82,5 cm. Moskau, 1916
42 *Die Rache des Teufels*
Frankreich. Société Française des Films Éclair – Farblithografie, 102 x 68 cm. Moskau, 1910er Jahre. Entworfen im Atelier von W. Woinow und W. Uljanischtschew.

48 *Die gekaufte Braut*
Literaturverfilmung. Russland. Regisseur N. N. Arbatow. Kinematographisches Studio von G. I. Libken, 1915 – Farblithografie, 106 x 71 cm. Moskau, 1915
49 *Das Weltmärchen*
Russland. Regisseur S. J. Weselowski. Kinematographisches Studio von G. I. Libken, 1916 – Farblithografie, 106,5 x 71,5 cm. Moskau, 1916
51 *Sünde*
Russland. Regisseur J. A. Protasanow. Studio I. N. Jermoljew, 1916 – Farblithografie, 106 x 70 cm. Moskau, 1916
58 *Reife Jahre einer Frau*
Nach dem Roman „L'automne d'une femme" von Marcel Prévost. Russland. Regisseur A. A. Gromow. Aktiengesellschaft A. Chanschonkow und Co., 1917 – Farblithografie, 106 x 72 cm. Moskau, 1917
62 *Panzerkreuzer Potemkin*
UdSSR. Regisseur S. M. Eisenstein. Goskino, 1925 – Farblithografie, 108 x 72,5 cm. Moskau, 1926
63 *Die Mutter*
Nach dem gleichnamigen Roman von Maxim Gorki. UdSSR. Regisseur W. I. Pudowkin. Meschrabpom-Rus, 1926 – Farblithografie, 108 x 72 cm. Moskau, 1926
64 *Oktober* (deutscher Untertitel: *10 Tage, die die Welt erschütterten*)
UdSSR. Regisseure S. M. Eisenstein, G. A. Alexandrow. Sowkino, 1927 – Farblithografie, 75,5 x 109 cm. Moskau, 1927
65 *Oktober* (deutscher Untertitel: *10 Tage, die die Welt erschütterten*)
UdSSR. Regisseure S. M. Eisenstein, G. A. Alexandrow. Sowkino, 1927 – Farblithografie, 72 x 157 cm. Moskau, 1927

100 *Der Erbe von Dschingis Khan* (deutscher Filmtitel: *Sturm über Asien*)
UdSSR. Regisseur W. I. Pudowkin. Meschrabpomfilm, 1929 – Farblithografie, 131 x 91 cm. Moskau, 1929
114 *Die Karriere von Rosine*
Frankreich (Originaltitel: *Le mariage de Rosine*). Regisseur Pierre Colombier. Films de France, 1926 – Farblithografie, 108 x 72 cm. Moskau, 1927
115 *Das Radio und der Löwe* (deutscher Filmtitel: *Ein Mädel vom Zirkus*)
USA (Originaltitel: *No control*). Regisseure Scott Sidney, E. J. Babille. Metropolitan Pictures Corporation of California, 1927 – Farblithografie, 108 x 71 cm. Moskau, 1929
156 *Die Toguji-Insel*
UdSSR. Regisseur I. Malachow. Goswojenkino, 1929 – Farblithografie, 62 x 107 cm. Moskau, 1929
160 *In den Gärten von Avarra*
Frankreich (Originaltitel: *Aux Jardins de Murcie*). Regisseure Louis Mercanton, René Hervil. Société des Films Mercanton, 1923 – Farblithografie, 108 x 72 cm. Moskau, 1926
161 *Zwei Panzerwagen*
UdSSR. Regisseur S. A. Timoschenko. Sowkino, 1928 – Farblithografie, 94 x 62 cm. Moskau, 1928
166 *Enthusiasmus: Die Donbass-Sinfonie*
UdSSR. Regisseur Dsiga Wertow. Ukrainfilm, 1930 – Farblithografie, 63 x 88 cm. Kiew, 1931
173 *Stepan Chalturin*
UdSSR. Regisseur A. W. Iwanowski. Sewsapkino, 1925 – Farblithografie, 108 x 72,5 cm. Leningrad, 1925